Artists of the Pacific Northwest

To my husband Bill—
For his patience and for sharing
this adventure with me

ARTISTS OF THE PACIFIC NORTHWEST

A Biographical Dictionary,
1600s–1970

by MARIA SHARYLEN

McFarland & Company, Inc., Publishers
Jefferson, North Carolina, and London

British Library Cataloguing-in-Publication data are available

Library of Congress Cataloguing-in-Publication Data

Sharylen, Maria.
 Artists of the Pacific Northwest : a biographical dictionary,
1600s–1970 / Maria Sharylen.
 p. cm.
 Includes bibliographical references and index.
 ISBN 0-89950-797-2 (lib. bdg. : 50# alk. paper) ∞
 1. Artists—Pacific Northwest—Biography—Dictionaries.
I. Title.
N6528.S52 1993
709′.2′2795—dc20
 [B] 92-566-93
 CIP

Manufactured in the United States of America

McFarland & Company, Inc., Publishers
 Box 611, Jefferson, North Carolina 28640

ACKNOWLEDGMENTS

I WOULD LIKE to express my appreciation to the many living artists represented here whose enthusiasm and support have made the job of writing this book such a pleasure. I must also thank the thousands of artists no longer among us, whose art continues to enrich us all and through whose works we are able to relive history.

A special thanks to Edan Milton Hughes (Artists in California) who so freely lent his time, his experience and his sense of style to the pages of this text. To Matthew Gerber (Matthews Gallery, Portland) for his invaluable data. To Ethyl and Clyde Archibald who so vividly remember the days of "The Attic Studio" in Portland (1929–67), and the many fine artists who worked within its walls, Clyde himself among them.

I am also indebted to artists Ned Mueller (Washington) and Jan Kunz (Oregon) and to Anna Eason of the Lawrence Gallery. To Barbara Schenk, Boise State University. To the Anchorage Museum of Fine Art and History; to Ian Thom, Senior Curator, and Cheryl Siegel, Librarian, Vancouver BC Art Gallery and Museum; to Ernest Atkinson for his patience in guiding me through the word processor. To my assistant, Barbara Grothaus, for her tenacity and exasperating preciseness; and to McFarland for helping make this dream a reality.

Most of all, my thanks to my children for their prayers, and to my husband Bill who smiled along the rainy roads, in the dusty old book stores, and through the endless trips to libraries, galleries, and antique shops. And for all his hours spent alone listening to the sound of the typewriter. To my parents, Frank and Marie, for their undying confidence.

To all I give my heartfelt thanks.

CONTENTS

INTRODUCTION

I STOOD ALONE on the deck of our home on Bainbridge Island, watching the steam from my coffee cup interlace with the early morning fog. I listened to the ferries on their way to and from Seattle and tried to visualize the ships of long ago as they arrived here along the Pacific Northwest Coast.

As early as 1543 they came, carrying with them artists or perhaps crew members who could draw. I imagined their feelings as they recorded the scenes before them. The first account of a voyage to these shores was a book published by Captain James Cook in 1776 which contains many drawings, maps and charts. European and American explorers arrived here from the late eighteenth to mid-nineteenth centuries accompanied by the first professional artists.

Some early names stand out. Paul Kane, an artist and writer, arrived in 1840 and lived among the local Indian tribes, setting down their way of life on canvas and in script. His highly successful *Wanderings of an Artist Among the Indians* was published in 1859. Thaddeus Welch, known as "Oregon's First Finished Artist," crossed the Plains with his family in 1847. William Samuel Parrott, whose glowing mountain vistas gained him national recognition in his lifetime, arrived in Washington in 1859. Except for a twenty-year period in Portland as an artist and teacher, he lived out his life in the wilds. Cleveland Rockwell came to the region in 1868 after working as a cartographer during the Civil War. His luminous landscapes echo the works of the Hudson River artists of the East Coast.

And so they came, the dreamers, amateur and professional, some with an enormous talent, some with but a simple courage and a desire to record. The falls at the mouth of a river, the Native American inhabitants and their life before "civilization," the military forts, mountains and dense forests, the Gold Rush, Indian Wars, the coming of the railway, storms, and drought — all were themes of which great works of art were made.

As the twentieth century approached, new art associations both public and private began to appear, the first two being the Portland Art Club in 1885 and the Portland Art Association in 1892. The Seattle Fine Art Society was born in 1906 but was not to have a permanent location until the formation of the Seattle Art Museum in 1933. Ambrose Patterson and Mark Tobey arrived in 1918 and helped form the "Seattle Twelve," a modernist fellowship. C. S. Price, a former cowboy artist from Wyoming, arrived in Portland in 1928 and remained until his death in 1950. He was a most charismatic artist and teacher who drew an intensely loyal following among adherents to the avant garde who admired his abstract expressionistic themes.

Eliza Rosanna Barchus is in this distinguished company. Widowed at an early age, she raised four children on the income from her art. A prolific landscapist, she executed thousands of scenes of Oregon, and traveled from Northern California to Washington. She was to become known as "The Oregon Artist." Barchus arrived in Portland in 1880 and remained until her death in 1959 at 102 years of age.

Clyde Leon Keller, Thayne Logan and others of "The Attic Studio" met weekly in Portland from 1929 to 1967; Emily Carr and Frederick Horseman Varley in Vancouver, B.C., in their individual ways shared the cultural leadership of their country. Many already famous artists such as Albert Bierstadt, America's foremost landscapist; Thomas Moran, George Catlin, John Mix Stanley, Frederick Schaffer, and Thomas Hill produced inspirational works from the majestic surroundings they found in the region.

If we are to record a region's art history we should begin by focusing on the setting in which the works were produced. Although the Pacific Northwest maintains a position of artistic importance, creative endeavors here have remained for the most part an untold story.

There are many factors to consider beyond the obvious scenic beauty of the area. That the artists who dedicated themselves to this particular part of the world drew upon their natural environment is undeniable; there is, however, little evidence of a definable attitude that characterizes the art of this particular region. (Note that this discussion does not address the very distinctive Native American or folk art.)

There appears to have been in the Pacific Northwest a disinclination to follow the popular motifs emerging from New York or any of the other trendsetting schools. This attitude applies even to trends within the region itself. One easily recognizes the unique dissimilarity between the art produced in the area's two major cities, Portland and Seattle.

It seems unlikely that a geographical area of such similar environmental and industrial traditions should be so artistically diverse, drawing independent views from similar visions. One important factor in the development of these two cities is the existence of California, whose cultural setting developed early, around the 1860s, and achieved prideful notoriety almost instantly. Artists flocked to California for many reasons, the main being its cultural atmosphere, its scenery, and its agreeable climate. They brought with them an awareness of national trends and traveled widely back and forth to the Eastern and European markets. The task of distinguishing between the California artists and those of Oregon and Washington has been difficult, for many frequently crossed the imaginary line.

When recording the cultural history of the Pacific Northwest we are obliged to include Alaska, for although it was not a state during most of the years covered by this text, it is too closely aligned to the region to be omitted. Alaska was truly an unspoiled land that beckoned to the most adventurous of spirit. Among the relatively few artists working there four names stand out: Sydney Laurence, Eustace Ziegler, Theodore Lamber, and Jules Dahlager. This group is widely known as "The Alaska Four." Rockwell Kent arrived in 1918 to create his *Wilderness Journal,* which was probably his first critically praised work. The name Fred Machetanz also comes to mind, for he has made this remote land, its people, and its wildlife his life.

In the process of compiling and documenting information about artists of the Pacific Northwest for my own use as an artist and collector, I realized this material needed to be collected in a form accessible to anyone interested in the subject. At the time no source provided a ready listing of these artists. Now, years later, with the birth of this book, even the names of obscure, never before listed talents have been liberated from darkened attics, estate sales, and antique stores.

It is not my intention to critique or judge an artist's worth by the extent of his or her previous listings, but simply to present the heretofore unpublished names alongside those of greater prominence in a logical, easy to read format.

Catalogued herein are painters, sculptors, illustrators, engravers, lithographers, commercial artists, photographers and craftsmen (as pertaining to fine art) and teachers. Entries provide as many as possible of the following: birth and death dates with locations; a general biographical sketch including education, memberships and exhibitions; awards received; and location of works (an ever-changing element).

Some birth dates, and many death dates, were unavailable. Readers should note that the absence of a death date is not necessarily intended to indicate that the artist is alive. Any additional data that readers can provide on the artists listed or on others that were omitted is most welcome.

At some time in their careers the artists represented here have all actively worked within the geographical boundaries of Oregon, Washington, Idaho, British Columbia and Alaska prior to 1970. Many have continued to work in the region after 1970 as well. Please note this text does not necessarily include regional Native American folk art for there are many volumes already dedicated to this subject.

This directory is designed to aid students of history, librarians with the need for a quick reference, collectors, curators and scholars.

Maria Sharylen

THE ARTISTS

—A—

AARIS, HAMILTON PETER (1906–) Painter, oil, watercolor, pastel, portraits. Sculptor. Printmaker. Ceramicist. Teacher. Born in Portland Oregon. Pupil: Sidney Bell; University of Oregon. Member: Oregon Society of Artists; American Artists Professional League; Arts and Crafts Society. Teacher, portrait painting. Author of articles: *The Spectator*; *Oregonian*. Many awards in Oregon State Fairs from 1935 to 1939.

ABBOTT, FLORENCE Painter. Lived in Whatcom County, Washington, 1909. Exh: Alaska-Yukon Pacific Expo, Seattle, 1909.

ABBOTT, PRUDENCE JERNBERG (1888–1957) Painter. Craftsperson. Lived in Portland, Oregon, 1924–32. Member: Oregon Society of Artists, 1930. Exh: Portland Spectator.

ABBOTT, T. O. (MRS.) Painter. Lived in Tacoma, Washington, 1891. Member: Tacoma Art League.

ABDY, ROWENA MEEKS (1887–1945) Painter, landscapes. Illustrator. Decorator. Pupil: Mark Hopkins Art Institute in San Francisco. She was primarily a California artist who traveled widely in the West. Worked in Europe after 1913. Produced landscapes from her converted car studio, mainly California scenes. Work: Seat-tle Art Museum; Palace Legion of Honor, San Francisco.

ABRAMS, KATHERINE DELANEY Painter, watercolor. Lived in Alaska around turn of the century.

ABRAHAMS, THEODORE H. Painter. Lived in Seattle Washington, 1923.

ACHEY, MARY ELIZABETH MICHAEL (1832–1885) Painter, landscapes, military/army scenes. Woodcarver. Needlework designer. Born in Scotland. Moved to Aberdeen, Washington, in 1862 where she opened her studio. She lived at various times in Oregon, California and Washington. Exh: Washington State Historical Society. Known as Colorado's first professional artist.

ACKER, EARL VERNON, SR. (1899–1985) Painter. Lived in Tacoma, Washington, 1936–1984. Exh: Pacific Gallery. Member: Puget Sound Group of Northwest Men Painters. Brother of Perry Miles Acker.

ACKER, PERRY MILES (1903–1990) Painter. Teacher. Pupil: E. Ziegler. Work: Seattle Art Museum; Frye Museum, Seattle; Metropolitan Museum, New York. Teacher: University of Washington; University of Idaho. Award: Northwest Marine Ex-

1

hibition, 1972; Northwest Watercolor Society, 1974, president in 1960; Puget Sound Group of Northwest Men Painters, president in 1959.

ACKLEY, HERBERT (1905–) Painter, oil, watercolor, tempera. Member: American Artists Congress. Exh: San Francisco Museum of Art; Portland Art Museum, 1934–1936; Seattle Art Museum, 1934–36.

ACTOR, HJORDIS, S. (1905–) Painter, watercolor. Printmaker. Pupil: University of Washington, Seattle. Member: Lambda Rho. Award: Northwest Printmakers, 1929.

ADAMS, DR. FREDRICK W. (1880–) Painter, oil. Lived in Seattle, Washington, 1944. Member: Puget Sound Group of Northwest Men Painters, 1937. Exh: Seattle Art Museum; Physicians Art Club, New York.

ADAMS, RHODA (1909–) Painter, oil, watercolor. Decorator. Pupil: Museum Art School, Portland, Oregon; Art Students League of New York. Exh: Portland Art Museum; Seattle Art Museum.

ADAMSON, AMY L. (1909–) Painter, oil, watercolor. Printmaker. Pupil: Victoria School of Art; California College of Arts and Crafts, Oakland; London, England. Member: Island Arts and Crafts Society, Victoria, B.C. Exh: B.C. House, London; Vancouver B.C. Art Gallery.

ADAMSON, MARY Painter. Lived in Tacoma and Seattle, Washington, 1908–09.

ADKISON, KATHLEEN GEMBERLING Painter. Pupil: Mark Tobey. Work: Seattle Art Museum; Cheney Cowles Museum, Spokane. Exh: Northwest Annual, Seattle, 1947–71; Northwest Artists, Seattle World's Fair; Pennsylvania Academy of Fine Arts; solo show, University of Washington; Museum of Art, Pullman Washington; University of Oregon Museum of Art, Eugene. Instructor: Washington State University.

ADNEY, TAPPAN (1868–1950) Painter, illustrator. Pupil: Art Students League, New York. Illustrations for *Harper's Weekly & Collier's Weekly* of Alaska and Northwest scenes.

AGATE, ALFRED THOMAS (1812–1846) Painter, oil, landscapes. Study: National Academy of Design. Chief artist for the Wilkes Expedition in 1838. Worked with the Bureau of Engravings in Washington, D.C., rendering his drawings into illustrations of the Pacific Coast from Alaska to the tip of California.

AGNER, HENNRIETTA E. Painter. Teacher. Lived in Spokane, Washington, 1912.

AGNEW, MARTHA A. K. Painter, oil. Lived in Seattle, Washington, 1941. Member: Women Painters of Washington.

AHGUPUK, GEORGE A. (early 20th cent.) Painter. Drawings, Alaskan scenes.

AHKAVANA, LARRY (1946–) Sculptor, marble and alabaster. Craftsman, glass blowing and mask forms. Born in Fairbanks, Alaska. Lives in Seattle, Washington. Study: Institute of American Indian Arts, Santa Fe, New Mexico; Allen Houser; Cooper Union School of Art, New York. Work: Anchorage Ritchfield Corporation, Anchorage, Alaska; Visual Art Center of Alaska. Exh: Anchorage Historical & Fine Arts Museum, 1969–77; Smithsonian Institute Portrait Gallery, Washington, D.C., 1972; solo show, Governor's Gallery at Alaska State Museum, Juneau, 1977.

AHLBERG, FLORENCE MARIA (1902–) Painter. Printmaker. Pupil: Portland Academy of Fine Arts.

AHLBLAD, OTTO Painter. Lived in Seattle, Washington, 1954. Member: Puget Sound Group of Northwest Men Painters.

AIKEN, ZELMA R. (1910–) Painter, oil, landscapes, still life. Lived in Puyallup, Washington, 1975. Self-taught.

AITKEN, MELITA (1866–1943) Artist. Vancouver, B.C.

AKIN, LOUIS B. (1868–1913) Western painter. Illustrator. Born in Portland, Oregon, died in Flagstaff, Arizona. Pupil: Chase and DuMond, New York. Began as a sign painter in Portland. In 1886 he built a cabin in the Cascade Mountains of Oregon to study Rocky Mountain goats. In 1903 he lived in a Hopi pueblo and was initiated into the Hopi secret society. Spent the rest of his life in Arizona depicting the life of the Hopi Indian and Southwestern landscapes.

AKRIGHT, JAMES G. (1880–) Painter, oil. Pupil: Mary Allen, Lake Stevens, Washington.

ALBERT, DRUSILLA (1909–) Sculptor, terra cotta. Printmaker. Pupil: Pennsylvania Academy of Fine Arts, Philadelphia; Italo Griselli, Florence, Italy. Award: Annual Exhibition of Northwest Artists, 1935. Exh: Seattle Art Museum, 1935–37; National Architects Exhibition, New York.

ALBERT, PHILLIP F. (1902–) Painter, Architect. Lived in Seattle, Washington. Architect: U.S. Corps of Engineers.

ALBRECHT, CARL Painter. Lived in Spokane, Washington, 1907.

ALBRECHT, FREDERICK E. Painter. Illustrator. Lived in Seattle, Washington. Pupil: New York School of Fine & Applied Arts; Art Students League, New York; John Sloan.

ALCORN, ROWENA CLEMENT LUNG (1905–) Painter, oil. Printmaker, etching. Lived in Tacoma, Washington. Pupil: University of Idaho; Santa Barbara State College; Santa Barbara School of Art; De Witt Parshall; Carl Oscar Borg. Member: Women Painters of Washington; American Federation of Arts. Work: Home of first white family in Idaho, Chamber of Commerce, Lewiston; Navajo Indian Princess, Washington State Museum, Seattle; many others in public buildings. Exh: Golden Gate International Exposition, 1939; Seattle Art Museum, 1936; Portland Art Museum, 1934; Chicago Art Institute, 1935; Teacher: College of Puget Sound, 1930–35.

ALDEN, JAMES (1810–1877) Watercolorist. A descendant of John and Priscilla Alden. Member: Wilkes expedition sent to California to survey and chart the Sacramento River. In 1848–60 he was assigned to the Coast Survey which surveyed and charted the West Coast from Mexico to the Canadian border. Known for his watercolor sketches for the Northwest Boundary Survey report, 1857–61.

ALDEN, JAMES MADISON (1834–1922) Painter, watercolor. Topographer. Depicted scenes of the California and Northwest Coast, 1851–61, U.S./Canadian Boundary Survey. Served as topographer in San Francisco in 1853–57 with the Pacific Coast Survey commanded by his uncle, James Alden. He also served in the same capacity on the Canadian border for the next four years. He died in Orlando, Florida in 1922.

ALEXANDER, HELENE J. Painter. Lived in Seattle, Washington, 1914–29.

ALEXANDER, ROBERT S. (1916–) Painter, oil, pastel, portraits, fresco. Pupil: Vancouver School of Art. Designed fresco panels for the Vancouver Hotel, street and building decorations for the visit of King George of England in 1939. Exh: Vancouver Art Gallery 1936–38; Edmonton Museum of Arts, Alberta.

ALEXANDER, WILLIAM (1767–1816) Illustrator. Engraver. Did engraved illustrations for Vancouver's Voyages, London, 1798. Also, completed the drawings from Daniells sketches which accompanied Vancouver's 'Voyage to the North Pacific.'

ALISKY, CHARLES WILLIAM (1866–1946) Painter. Together with wife/artist Charlotte Duncan studied in Munich, 1890. They maintained a studio in Portland, Oregon until 1898, when they divorced and he returned to California.

ALLAN, JAMES Painter. Exh: Seattle Fine Arts Society, 1922–25.

ALLEN, ALICE Painter, watercolor. Lived in Whitman County, Washington, 1909.

ALLEN, CHARLES H. (1871–1946) Painter. Lived in Seattle, Washington, 1914. Exh: Smithsonian Institute before 1914.

ALLEN, CHARLES P.B. Painter, watercolor. Illustrator. Commercial artist. Born in Tacoma, Washington. Pupil: University of Washington; Art Center School, Los Angeles. Worked for *Saturday Evening Post, Life Magazine* and others.

ALLEN, CHET M., JR. Painter, watercolor. Draftsman. Lived in Seattle, Washington, 1953. Exh: Seattle Art Museum, 1949.

ALLEN, CLAY H. (MRS.) Painter. Member: Seattle Fine Arts Society, 1925.

ALLEN, DOROTHY H. Painter. Lived in Tacoma, Washington, 1932.

ALLEN, FRANK PHILLIP FR. (1881–1943) Painter. landscapes, Architect. Pupil: Art Institute of Chicago. After the turn of the century he settled in Seattle, Washington, where he served as architect and director of works for the Alaska-Yukon Expo, Seattle, in 1909. Became Director of Works for the California Pacific Exposition.

ALLEN, HILDURE PETERSON (1888–1949) Painter. Lived in Seattle in the 1920's. Pupil: Edgar Forkner. Member: Seattle Fine Art Society, 1923.

ALLEN, LUNELLA C. Painter. Lived in Seattle, Washington, 1940. Member: Seattle Fine Art Society, 1925.

ALLEN, MARION BOYD (1862–1941) Painter, portraits, landscapes. Born in Boston she did not hesitate to ride over miles of rough trails and to live in remote cabins to find inspriation in the mountain ranges of Washington and Oregon. She also painted the Indians of the Southwest.

ALLEN, MARY GERTRUDE STOCKBRIDGE (1869–1949) Painter, oil, watercolor. Sculptor. Teacher. Pupil of Anna Hills, Laguna Beach, California; Michel Jacobs, New York; Frederick H. Varley, Vancouver, B.C. Member: Women Painters of Washington; Pacific Coast Painters, Sculptors and Writers; life honorary member: Altrusa Club.

ALLEN, RUDOLPH GREGORY (1887–1969) Painter, watercolor, miniatures. Drawing, pen & ink. Commercial artist. Lived in Seattle, Washington. Nature pictures of the Northwest.

ALLEN, RUTH (1916–) Painter, oil, watercolor. Sculptor. Born in Gig

Harbor, Washington. Lived in Seattle, Washington, 1941. Pupil: University of Washington, Seattle; Hermans Sachs, Los Angeles. Member: Art Student League, Los Angeles. Exh: Exposition Park Museum, Los Angeles; Santa Monica Library.

ALLER, WILLIAM Painter, watercolor. Lived in Spokane, Washington, 1950. Member: Washington Art Association.

ALLIS, C. HARRY (1870–1938) Painter, landscapes. Was primarily a California artist. Work: University of Oregon, Eugene.

ALLISON, MARGARET PROSSER (1913–) Painter, oil. Ceramic sculpture. Pupil: University of Washington, Seattle. Exh: Seattle Art Museum, 1938–39.

ALLPORT, EDITH (1914–) Painter, watercolor, gouache. Member: Art Students League of New York; American Federation of Arts. Exh: Portland Art Museum, 1938; New York School of Fine and Applied Art, 1940. Teacher in Montana.

ALMOND, KATE Early instructor at the New Territorial University of Washington, 1880.

ALPS, GLEN EARL (1914–) Teacher. Printmaker. Study: University of Washington, MFA. Professor, (Chairman) University of Washington, 1945. Member: Northwest Printmakers, treasurer, 1949–51.

ALSOP, JULIA A. Painter, oil. Drawing, pen & ink. Teacher. Lived in Tacoma, Washington, 1897–1933. Member: Tacoma Art League, 1933.

AMERO, EMILIO (1900–) Painter, oil, murals. Lithographer. Teacher. Born in Mexico. Pupil: National School Fine Arts, Mexico City; Diego Rivera. Teacher: Cornish Art School, Seattle. Member: Puget

Sound Group of Northwest Men Painters. Exh: Seattle Art Museum, 1946. Teacher: Cornish Art School, Seattle.

AMES, ANNE Painter, oil, pastel, portraits. Born in Victoria, B.C. Pupil: Art Students League of New York; Ambrose Patterson, Seattle; Mark Tobey, Seattle; Florence, Italy. Exh: Seattle Art Museum. President of Museumic and Art Foundation, Seattle. Member: Women Painters of Washington.

AMESS, FREDRICK ARTHUR (1909–) Painter, oil, watercolor. Teacher. Pupil: Vancouver School of Art, B.C. Awards: B.C. Society of Fine Art, Vancouver. Exh: National Gallery, Ottawa; Seattle Art Museum.

AMESS, JAMES HENRY OSBORNE (1875–) Painter, oil, watercolor. Drawing. Pupil: LCC Central School of Arts; Goldsmith's Institute, London. Member: B.C. Society of Fine Arts, Vancouver. Exh: National Exhibition, Toronto, 1919; Vancouver Art Gallery.

AMMON, CHARLES (-1948) Commercial artist. Lived in Portland, Oregon, until his death in 1948. Works produced in Washington dated 1885.

AMRUD, MARJORIE Painter, watercolor. Lived in Seattle, Washington, 1936. Exh: Seattle Art Museum.

AMUNDSEN, NORMAN C. (1926–) Painter, watercolor, landscapes, serigraphs. Pupil: Burney School of Art. Member: Puget Sound Group of Northwest Men Painters. Exh: Frye Museum, Seattle; Seattle Art Museum.

ANDERBERG, MILDRED O. (–1975) Painter. Died in Seattle, Washington, 1975. Member: Women Painters of Washington, 1949.

ANDERSON, A. ROE Painter. Lived in Spokane, Washington, 1907.

ANDERSON, ADDIE F. (1859–)
Painter, oil, pastel. Drawing. Lived in
Ellensburg, Washington, 1941. Pupil:
Grant Wright, New York; Arthur
Loomis, Peoria, Illinois; Frank
Peyroud, Chicago; A. Doering, Berlin.

ANDERSON, ANNA M. (1885–)
Painter, oil, watercolor. Lived in Port-
land, Oregon, 1940. Pupil: Clyde Kel-
ler; Maude Wanker; Florence Pelton,
Portland. Member: Oregon Society of
Artists; Portland Art League. Exh:
Portland Art Museum; Corcoran Art
Gallery, Washington, D.C. Teacher.

ANDERSON, C. BRYCE Painter. Il-
lustrator. Lived in Portland, Oregon,
1940. Member: The Attic Sketch
Group, Portland.

ANDERSON, COLLIER, H.
Painter. Lived in Shelton, Washing-
ton, 1940. Exh: Tacoma Art League.

ANDERSON, FRANCIS A. (1898–)
Painter. Writer. Engraver. Lived in
Seattle, Washington, 1950.

ANDERSON, FREDERICK (1917–)
Painter, abstracts in acrylic and ink.
Lived in Auburn, Washington, 1960.
Exh: Henry Gallery, University of
Washington, 1951, 1959; Seattle Art
Museum, 1953; regular exhibitor in the
Northwest and California. Teacher:
University of Washington since 1946.

ANDERSON, GORDON Sculptor.
Cartoonist. Teacher. Pupil: University
of Washington, BA & MA. Teacher:
Seattle University; Cornish Art
School, Seattle. Cartoonist & illustra-
tor for magazines. Numerous church,
public and private commissions.

ANDERSON, GUY IRVING (1906–)
Painter, oil, watercolor, murals. Pupil:
Gifford Beal; Kimon Nicolaides, New
York: Tiffany Foundation. Exh:
Tiffany Grant, Seattle Art Museum;
Oakland Art Association; Rockefeller
Center, 1938; Corcoran Art Gallery,
Washington, D.C.; Anderson Gal-

leries, New York. Teacher: Spokane
Art Center. Work: murals, Hilton Inn;
Seattle-Tacoma Airport; Seattle Op-
era House; Seattle World's Fair, 1962;
Seattle Public Library. WPA artist.

ANDERSON, HELMA N. Painter.
Lived in Seattle, Washington, 1919.

ANDERSON, JACK D. Painter, wa-
tercolor. Commercial artist. Lived in
Seattle, Washington, 1944. Exh: Seat-
tle Art Museum, 1940.

ANDERSON, JAMES A. (-1908)
Painter, watercolor. Lived in Tacoma,
Washington, 1890. Moved to Portland,
Oregon. Member: Oregon Association
of Artists, 1895. Exh: Oregon Histori-
cal Society.

ANDERSON, JOHN O. Painter, wa-
tercolor, landscapes. Illustrator. Stu-
dent and friend of Frederick Taylor to-
gether painting the Washington
landscapes in the late 1800's.

ANDERSON, KENNETH B. (1908–)
Painter, watercolor. Printmaker.
Drawing. Born in Seattle, Washing-
ton. Pupil: University of Washington,
Seattle. Art Director, Walt Disney
Studio, Los Angeles for Snow White
& Pinocchio.

ANDERSON, NANCY Painter.
Lived in Seattle, 1924. Exh: Painters
of the Pacific Northwest.

ANDERSON, O.R. (MRS.) Painter,
landscapes. Lived in Lake Stevens,
Washington, 1924–26.

**ANDERSON, RUTH SHIRLEY
BROWN (1912–)** Painter, oil, wa-
tercolor, pastel, murals. Pupil: Cor-
nish Art School, Seattle. Member:
Women Painters of Washington.
Work: Franklin High School, Seattle;
Garfield High School.

ANDERSON, WILLIAM R. Painter,
Wood carver. Lived in Spokane,
Washington, 1908.

ANDRE, FRANCOISE Painter, modernist. Vancouver, B.C., 1940's. Friend of Mark Tobey.

ANDREW, WILLIAM O. Artist. In Tacoma, Washington, 1893–94.

ANDREWS, CORA MAE (1860–) Painter, oil, watercolor, pastel. Mainly self-taught. Exh: Oregon Society of Artists. Signs her paintings, "CMA".

ANDREWS, E. W. (MISS) Artist. Exh: Seattle Society Artists, 1908.

ANDREWS, ELIZABETH A. Artist. Lived in Seattle, Washington, 1914.

ANDREWS, IDA M. Painter, watercolor. Lived in Salem, Oregon, 1940. Study: University of Washington, Seattle; California College of Arts and Crafts, Oakland. Member: Arts and Crafts Society, Portland. Art Supervisor, Salem Public Schools, Oregon.

ANDREWS, L. J. P. O. (early 20th century) Painter, oil, watercolor, pastel. Lived in Parma, Idaho. Member: League of Idaho Artists, 1937–38.

ANDREWS, WILLIAM (MRS.) Painter, oil, still lifes. Lived in Jefferson County, Washington, 1909. Exh: Alaska-Yukon Pacific Expo, 1909.

ANGELL, TONY (1940–) Painter, birds & wildlife. Sculptor. Pupil: University of Washington, Seattle. Work: Tacoma Art Museum; Cornell University; Ornithological College of the Pacific; Northwest Bell; many more. Important American artist.

ANNE-LISE Painter, oil, expressionist. Singer. Teacher. Born in Denmark. Study: vocal training, the Royal conservatory, Denmark; Milan. Studio in Salem, Oregon, where she has lived and worked since the 1960's. Selected from among 100 American artists in September, 1991, Association Pour La Promotion Du Patrimonie Artistique Francais. Vocal teacher: Pacific Lutheran University, Tacoma.

ANTHONY, MARGARET Painter, oil, portraits, landscapes. Lived in Spokane, Washington, 1934. Exh: Seattle Art Museum, 1934.

ANTLERS, MAX H. (1873–1952) Painter. Settled in San Francisco in the 1920's. Exhibited paintings of Crater Lake, Oregon in 1947 which would suggest he traveled north for inspiration.

APPEL, KEITH KENNETH (1934–) Painter. Sculptor. Pupil: Mankato State College. Exh: All-Alaska Exhibition; Alaska Centennial, 1967. Teacher: Professor of Art, University of Alaska, Anchorage. Member: Alaska Artists Guild; Alaska State Arts Council.

ARCHER, M. R. Artist. Lived in Seattle, Washington, 1901.

ARCHIBALD, CLYDE (1903–) Painter, pastel, figures and portraits. Sculptor, bronze plaques. Born in Albany, Oregon. Lived in Portland. Operated "The Attic" studio along with his wife, Ethel from around 1939–67 where they conducted life classes. This became a meeting place for such Oregon notables as Edw. B. Quigley, Albert Patecky, Thayne Logan and Clyde L. Keller. Member: Oregon Society of Artists.

ARISS, BRUCE (1911–) Painter. Muralist. Illustrator. Born in White Salmon, Washington. Moved to Monterey, California and is primarily known as a California artist.

ARMOUR, ELECTA M. Artist. Lived in Seattle, Washington, 1909. Exh: Seattle Society of Artists, 1908.

ARMSTRONG, ANNA T. Artist. Member: Tacoma Art League, 1891–92.

ARMSTRONG, GLORIA FLETCHER (–1939) Painter. Lived in Seattle, Washington. Pupil: Edgar

Forkner. Exh: Pacific Coast Painters, 1935; Tacoma Garden Club, 1936.

ARMSTRONG, LANG (1906–) Painter, watercolor. Cartoonist. Chief artist, Spokane American Engraving Company. Sports page cartoonist, *Spokane Review*.

ARMSTRONG, LILLIAN A. Artist. Lived in Tacoma, Washington, 1891. Member: Tacoma Art League, 1892.

ARMSTRONG, MAYBELLE L. Painter, oil. Lived in Spokane, Washington, 1953. Exh: Pacific Coast Art Exposition, 1948.

ARMSTRONG, NETTIE Artist for *Tacoma News Tribune*. Lived in Tacoma, Washington, 1923. Exh: Ferry Museum, 1919.

ARMSTRONG, RACHEL M. (1899–1980) Painter, watercolor, miniatures. Born in Kent, Washington, died in Tacoma. Pupil: R. Alcorn. Signed her paintings "Rae".

ARMSTRONG, SAMUEL JOHN (1893–) Painter, oil, murals. Illustrator. Cartoonist. Founded Armstrong School of Art in Tacoma, Washington, in 1923. Art editor, *Tacoma News Tribune*, 1918. Moved to Santa Barbara California in the 1930's. Award: first prize, Pacific Northwest Expositon, Seattle, 1927; third prize, Northwest Independent Salon, Seattle, 1928. Work: Ferry Museum, Tacoma; Temple of Justice, Olympia, Washington.

ARMSTRONG, WILLIAM Painter. Accompanied Colonel Wolseley's expedition to the Red River (B.C.), in 1870.

ARMSTRONG, WILLIAM WEAVER (1862–1906) Painter, landscapes. Primarily a California artist he painted scenes from Santa Cruz to Oregon. Work: Oakland Museum.

ARNOLD, HERBERT Artist. Lived in Seattle, Washington, 1929.

ARNOLD, RICHARD (1923–) Painter. Muralist. Designer. Director: School of Art, University of Washington, 1977.

ARNOLD, SARAH E. Artist. Teacher. Lived in Tacoma, Washington, 1890. Teacher: College of the Puget Sound.

ARNTSON, CATHARINE O. (–1956) Painter. Lived in Seattle, Tacoma and Olympia, Washington.

AROUNI, LYNETTE (1915–) Painter, oil, watercolor, tempera, charcoal, murals. Illustrator. Lived in Great Falls, Montana, 1940. Pupil: Art Center School; Chouinard Art Institute, Los Angeles. Exh: Seattle Art Museum.

AROUNI, N.G. (1888–) Painter, oil, watercolor. Printmaker. Etcher. Exh: Herrick Hall, Montana.

ARTER, HELEN E. (1909–1982) Painter, oil. Commission artist. Born in North Dakota. Lived in Ellensburg, Washington. Exh: Pacific Northwest Artists Annual, 1951.

ARTHURS, GEORGE WESLEY (1893–1943) Painter. Born in Brooks, Oregon. Settled in Los Angeles in 1915.

ASH, FRANCIS J. Painter, watercolor. Exh: Seattle Art Museum. 1953.

ASHFORD, FRANK CLIFFORD (1880–1960) Artist. Born in Iowa. Moved to Seattle, Washington, 1915. Lived in Salem, Oregon, in 1948. Pupil: Chicago Art Institute; Pennsylvania Academy of Fine Arts; William Merrit Chase; the New York School of Art; in Paris, France, 1909–11. Work: South Dakota State Capitol.

ASHTON, LUCILLE Painter, oil. Lived in Everett, Washington, 1948.

Exh: Pacific Coast Art Exposition, 1948.

ASIA, THERESE (1914–) Painter, oil, watercolor. Craftsperson, ceramics. Lived on Mercer Island, Washington, 1982. Pupil: Seattle University & Museum School. Member: Northwest Women Painters; Northwest Watercolor Society; National League American Pen Women.

ASMAR, ALICE (1929–) Painter, medium, casein, inks, acrylics & oil. Printmaker. Teacher. Pupil: Lewis & Clark College, Washington (teacher 1955–58); University of Washington; Melcarth; Archipenko; scholarship to the Ecole Nationale Superieure des Beaux-Arts, Paris. Winner of many awards.

ASPELL, PETER Artist. Lived in Vancouver, B.C., 1930's. Winner: Emily Carr Trust Scholarship. Became a war artist during World War II.

ATKINS, ELLEN L. Artist. Studio in Kirkland, Washington, 1930.

ATKINS, H. CLINTON Artist, Lived in Spokane, Washington, 1915.

ATKINSON, CHARLOTTE ANN (CUMMINS) (1927–) Painter, watercolor, acrylic. Craftsperson. Floral Designer. Painted genre scenes in the primitive, naive style. Lived in Central Oregon. Study: Compton Community College, California; mainly self-taught.

ATKINSON, JOHN S. Painter, oil, watercolor, landscapes, figural. Designer, theater sets. Architect. Pupil: University of California, Berkeley & Davis. Settled in Bend, Oregon, from Grass Valley California.

ATKINSON, LEO FRANKLIN (1896–) Painter, mural. Born in Sunnyside, Washington. Pupil: Seattle Art Club. Seattle, 1926. Work: murals, the American Theater, Bellingham: Columbian Theater, Baton Rouge Louisiana.

ATKINSON, LUCY K Painter, oil. Teacher: Burney School of Fine Arts, Seattle, 1945. Exh: Seattle Art Museum, 1945, 1947.

ATKINSON, PORTER Painter, oil. Lived in Seattle, Washington, 1946. Exh: Seattle Art Museum, 1946.

ATKINSON, ROSE EMMA (1856–1927) Painter, oil. Born in Ohio, died in Pierce County Washington.

ATTRIDGE, IRMA GERTRUDE (1894–) Painter. Pupil: Chouinard Art Institute, Los Angeles. Exh: Los Angeles Museum of Art, 1944; Frye Museum, Seattle, Washington, 1957.

ATTWELL, ALBERT W. (1911–) Painter, oil, gouache, watercolor. Portland, Oregon. Study: University of Washington and College of Arts and Crafts, Oakland, California. Head of Art Department, Fergus County High School, Lewistown, Idaho.

ATWOOD, F. N. Artist. Lived in Seattle, Washington, 1912.

AUSTIN, DARRYL (1907–) Painter, oil, genre, enchanted people and beast paintings. Muralist. Born in Raymond, Washington. Grew up in Oregon. Pupil: University of Oregon. Exh: Annual National Expo, 1941–46.

AUSTIN, HELEN (1911–) Painter, oil, tempera. Designer. Illustrator. Pupil: University of Oregon, Eugene; Thomas Hart Benton. Member: National League of American Pen Women. Supervisor of Art, North Kansas City Public Schools.

AUSTIN, PAT (1937–) Printmaker. Educator. Pupil: University of Alaska; A. Duffs Combs, 1965; University of Washington. Work: Anchorage Historical & Fine Arts Museum, Alaska; Alaska State Council of the Arts. Exh:

All-Alaska Juried Exhibtion, Anchorage, 1966. Teacher: University of Alaska.

AUTH, ROBERT R. (1936) Painter. Pupil: Washington State University. Exh: Boise Art Gallery. Member: Idaho Art Assocation.

AVAKIAN, VICTORIA Painter. Designer. Pupil: School of Architecture and Allied Arts; University of Oregon, Eugene; Associate Professor of Applied Design, 1940.

AVERILL, ELWOOD D. Artist. Seattle, Washington, 1944. Member: Puget Sound Group of Northwest Men Painters, 1946. Exh: Seattle Art Museum, 1945.

AVRIETT, ESTELLE Painter, oil, landscapes. Lived in Tacoma, Washington, 1907–33; Spokane, 1913. Member: Tacoma Art League, 1916–33.

AYER, G. EARL Painter. Lived in Seattle, 1924.

——B——

BAAR, LOU BARNUM Painter, oil. Lived in Seattle, Washington, 1946. Exh: Seattle Art Museum, 1946, 1949.

BAARSLAG, LILLA MARIE (1913) Painter, oil, watercolor, landscapes, seascapes, batiks. Lived in Tacoma, Washington, 1991. Member: Pacific Gallery Artists. Work: Northwest Forts & Trading Posts, Washington; State Historical Society.

BABBITT, HAL. (1909–) Painter, oil, watercolor. Lived in Mason City, Washington, 1940. Pupil: Oregon State College, Corvallis; Museum Art School, Portland, Oregon.

BABCOCK, EVERETT P Painter. Draftsman. Lived in Tacoma, Washington, 1912. Exh: Tacoma Art League, 1895.

BACK, SIR GEORGE (1796–1878) Draftsman. Early Canadian engraver.

BAER, CHELNESHA O. Artist. Lived in Seattle, Washington, 1917.

BAGLEY, MINNIE B. Artist, Studio in Tacoma, Washington, 1903.

BAILEY, BERTHA ELIZABETH DAY (1888–1967) Etcher, Musician. Teacher. Lived in Tacoma, Washington. Teacher, Tacoma art schools, retired in 1935.

BAILEY, G. W. Artist. Lived in Seattle, Washington, 1901.

BAILEY, INEZ HILL Painter, tempera. Lived in Spokane, 1950. Member: Washington Art Association. Exh: Seattle Art Museum, 1953.

BAIN, LILLIAN PHERNE (1873–1947) Painter, oil, Printmaker, etching. Lived in Salem, Oregon. Pupil: Art Students League of New York; Frank DeMond; Joseph Pennell; Guy Rose. Member: Oregon Society of Artists. Exh: National Academy Exhibition. Assistant to Frank DeMond for ten years.

BAIN, M. A. (1880–) Painter, oil, watercolor, pencil. Lived in Vancouver, B.C. Pupil: Chouinard Art Institute, Los Angeles; Millard Sheets, Los Angeles; Thomas W. Fripp, Vancouver; Otis Art Institute, Los Angeles. Exh: B.C. Society of

Fine Arts, Vancouver, B.C. Member: Arts & Letters Club, Vancouver.

BAIRD, ROBERT L. (1913–) Painter, oil, clay and plaster work. Lived in Portland, Oregon, 1940. Pupil: California College of Arts and Crafts, Oakland; San Francisco Art Students League.

BAKER, ALICE HOLGERSON (1891–1960) Painter, oil, watercolor. Teacher. Born in Tacoma, Washington. Pupil: Washington State Normal School (Central Washington University).

BAKER, C. B. Painter. Lived in Seattle, Washington, 1910. Painted the scenery for the Empress Theater, Seattle, 1914.

BAKER, JANE MARGARET (1908) Painter. Teacher. Born in Spokane, Washington. Pupil: Washington State University, Seattle. Exh: Seattle Art Museum, 1945–46; widely throughout the United States during the 1940's.

BAKER, JENNETT M. (1878–1919) Painter, oil. Lived in Tacoma, Washington, 1906–1916. Died in Los Angeles, California. Member: Tacoma Art League, 1916. Exh: gold medal, Alaska-Yukon Pacific Expo, Seattle, 1909.

BAKER, KATHERENE B. (MRS. JAY) (–1924) Painter. Teacher. Born in Chicago. Lived in Seattle, Washington. The Katherene B. Baker Memorial Prize is awarded every year to an artist under 40 years of age at the annual Exhibition of the Painters of the Pacific Northwest.

BAKER, RALPH BERNARD (1932) Painter. Teacher. Pupil: University of Washington. Work: City of Seattle, University of Calgary Museum of Art; Northwest Collection at the University of Oregon Museum of Art. Exh: Northwest Annual; Seattle

Art Museum; Edmonton Art Museum; Portland Art Museum. Associate Professor of Art, University of Oregon. Many awards.

BAKKER, RIBALD Painter, oil, landscapes.

BALDINGER, WALLACE SPENCER Painter. Teacher, University of Oregon, Eugene, 1944.

BALDWIN, FRANCES (1907–) Painter. Pupil: California School of Fine Art; Art Students League, New York, 1937; Mills College, 1941 under F. Leger, M. Sterne and Mark Rothko. Member: San Francisco Art Association; San Francisco Society of Women Artists, president 1951–52. Exh: Portland, Oregon Museum of Art, 1937–39.

BALDWIN, JANE MARGARET (1908–1991) Printmaker, wood blocks. Painter, watercolor, acrylic. Born and lived in Spokane, Washington, 1947. Pupil: Washington State University. Exh: Cheney Cowles Museum, Spokane Washington; Portland Art Museum, 1937, 1938; Denver Art Museum; Spokane Art Association, 1935; Seattle Art Museum, 1941–46; San Francisco Museum of Art, 1943–44; Oakland Art Gallery, California, 1945. Work: Library of Congress, Washington, D.C., 1944. Teacher: Washington State College.

BALDWIN, MARIAN AND ELE-ANOR As children, the Baldwin sisters were members of the Friday Night Club that met in the home of William Keith in Berkeley, California. They later moved and worked in Boise, Idaho.

BALDWIN, WARREN N. Painter. Lived in Spokane, Washington, 1908, 1940. Member: Spokane Society of Washington Artists, 1903.

BALFOUR, ROBERTA (1871–) Painter. Studied in London and Paris.

During the 1920's she was a resident of San Francisco, then Carmel. Work: Vancouver Armory.

BALL, MARGARET SCOTT (1909–) Painter, oil, watercolor. Ceramic sculpture. Born in Payette, Idaho. Studied in Santa Fe, New Mexico (ceramic sculpture). Pupil: University of Idaho, Moscow; University of Oregon.

BALLATOR, JOHN R. (1909–) Painter, oil, tempera, fresco. Born in Portland, Oregon. Pupil: Museum Art School, Portland; University of Oregon, Eugene; Yale University. Member: American Artists Congress. Work: many murals in the Northwest as well as Washington, D.C. Exh: Seattle Art Museum; shows in New York City.

BALLINGER, HARRY RUSSELL (1892–) Painter. Muralist. Lived in Port Townsend, Washington. Article in American Artist, June 1965.

BALLOU, BERTHA (1891–1978) Painter, portraits, landscapes, indians. Sculptor. Muralist. Etcher. Teacher. Lived in Spokane, Washington. Pupil: Dumond; Bosley; Tarbell; Randolph-Macon Women's College; Art Students League, New York; Corcoran Art School. Work: Eastern Washington Historical Museum; Spokane Public Library; Spokane County Courthouse. Instructor: Holy Name College, Washington.

BAMFORD, THOMAS (1861–) Painter, oil, watercolor. Born Liverpool, England. Lived in Victoria, B.C., 1940. Member: Island Arts and Crafts Society. Exh: Vancouver Art Gallery; Ontario Society of Artists; Ottawa Art Gallery. He accompanied survey parties into Vancouver Island and the mainland's wilderness.

BANFORD, DANIEL A. Artist. Lived in Tacoma, Washington, 1907.

BANISTER, ROBERT BARR (1921) Painter, oil, watercolor. Art Dealer. Pupil: University of Oregon; Portland State University. Member: Oregon Arts Commission.

BANITON, HILDA Painter, watercolor. Lived in Whitman County, Washington, 1909. Exh: Alaska-Yukon Pacific Expo, Seattle, 1909.

BANKS, VIRGINIA (1920–1985) Painter, oil, watercolor, miniatures, abstracts. Teacher. Born in Massachusetts. Lived in Seattle, Washington. Study: Pennsylvania Academy of Fine Art; Brooklyn Museum; Chicago Art Institute. Exh: San Francisco Museum of Art, 1947; Washington State Fair, 1949; Seattle Art Museum, 1949.

BANKSON, GLEN PAYTON (1890–) Painter, landscapes, stil lifes, murals. Born in Hope, Washington. Lived in Spokane, Washington, 1973. Member: Spokane Art Association, Washington.

BANNER, ALFRED JAMES (1911–) Painter, oil, tempera. Teacher. Lived in Tacoma, Washington, 1942. Pupil: University of Washington. Teacher: Stadium High School in Tacoma, Washington. Exh: Seattle Art Museum, 1938.

BARBER, DONALD R. Painter, watercolor. Member: Puget Sound Group of Northwest Men Painters, 1940. Exh: Seattle Art Museum, 1940.

BARCHUS, ELIZA ROSANNA LAMB (1857–1959) Painter, oil, landscapes. Born in Salt Lake City, Utah. Lived in Portland, 1940. Pupil: William Parrott, Portland. Award: silver and gold medals, Portland Mechanics Fair, 1888 & 1890; gold medal, Lewis & Clark Centennial Exposition, Portland, 1905. Paintings purchased by Woodrow Wilson, Theodore Roosevelt, and William Jennings Bryan. Exh: National Academy of Design,

New York 1890; Pan American Exposition, Buffalo & Charleston. Known as "The Oregon Artist". Honored in 1972 by the Oregon State Legislature. Although she lived to be 102 years old she was forced to retire in 1935 due to failing eyesight. Signed her paintings "Barchus".

BARKER, CHARLES F. (1875–) Painter, oil, watercolor, landscapes. Born in London. Lived in Vancouver, B.C., 1940. Pupil: John Innes. Member: Island Arts and Crafts Society, Victoria.

BARKER, OLYMPIA PHILOMENIA (1881–1949) Painter. Born in Ireland. Lived in Seattle, Washington, 1940. Pupil: Ziegler; Forkner; Patterson, Seattle, Washington. Exh: Seattle Art Museum, 1931–40; Exhibtion of Art, Victoria, B.C.

BARKER, SELMA CALHOUN (1893–) Painter, oil, pen & ink, cowboy life, western. Born and lived in Idaho. Pupil: George Eugene Schroeder; mainly self-taught. Member: Idaho Artists Association. Author of stories and poems.

BARKSDALE, MARAJANE. (1910–) Painter, oil, watercolor. Printmaker. Born in Indiana. Lived in Seattle, Washington, 1940. Member: Northwest Printmakers. Exh: Seattle Art Museum 1934–37.

BARNARD, HILDA N. (1892–) Painter, oil, watercolor. Lived in Seattle, Washington, 1982. Pupil: P. Camfferman. Member: Women Painters Washington, 1962. Exh: Frye Museum, Seattle.

BARNARD, P. B. Commercial artist. Lived in Spokane, Washington, 1924.

BARNES, ALBERT HENRY (1879–1920) Painter, oil. Photographer. Writer. Early Northwest landscape photographs & paintings. Member: Tacoma Arts Club. Authored "Alpine Regions of Wonder", 1911. Was a photographer and artist on an expedition organized by the Washington State Historical Society to explore the Pacific Coast of Washington. He did not always sign his works.

BARNES, ELEANOR S. Artist. Lived in Seattle, Washington, 1954. Member: Women Painters of Washington, 1938–54.

BARNUM, RAYMOND O. Commercial artist. Lived in Seattle, Washington, 1944.

BARRETT, B. J. Artist. Lived in Seattle, Washington, 1912.

BARRETT, FERNAND (1906–) Painter, oil. Illustrator. Lived in Seattle, Washington, 1941. Study: The Cornish Art School, Seattle; in Europe.

BARRETT, OLIVER Sculpture. Professor, University of Oregon, Eugene, in the 1940's.

BARRY, MARIETTE A. Painter. Lived in Seattle, Washington, 1921.

BARTLETT, DANA (1882–1957) Painter. Important California plein-aire artist. Worked for a time early in his career for Forster and Kleiser as a commercial artist in Portland, Oregon. He worked in San Francisco and finally moved to Los Angeles.

BARTO, VIVIAN NORMAN Painter, oil, watercolor, pastel, pen & ink. Born in Iowa. Lived in Southern Oregon, 1940. Member: Southern Oregon Art Association. Work: "Crater Lake at Sunrise", Portland Oregon Post Office. Exh: Corcoran Art Gallery, Washington, D.C.

BARTON, HARRY L. Painter. Lived in Seattle, Washington. Member: Puget Sound Group of Northwest Men Painters. Artist for the Sterling Theaters, Seattle, 1940.

BARZO, KAREL Painter, oil, portraits, landscapes. Lived in Seattle, Washington, 1940. Exh: Seattle Art Museum, 1939.

BASS, ELIZABETH E. Artist. Lived in Seattle, Washington, 1907.

BATCHELOR, ANN Painter, British Columbian Landscapes. Moved into Emily Carr's Studio in Vancouver when Emily vacated around 1910.

BATES, CLARENCE E. (1910–) Painter, oil, watercolor. Sculptor, wood, plaster, ceramic. Born in Portland Oregon. Lived in Salem, Oregon, 1940. Pupil: University of Oregon, Eugene; Cornish Art School, Seattle. Exh: Seattle Art Museum; San Francisco Museum of Art, 1936–39.

BATES, ELINOR B. (1915–) Painter, oil, fresco, tempera. Lithographer. Born in Michigan. Lived in Portland, Oregon, 1937–40; Scottsdale, Arizona, 1941; California, 1960. Pupil: California College of Arts and Crafts; School of Fine Arts, San Francisco, 1937, 1938. Exh: San Francisco Art Association Annual Graphic Show, 1938.

BATISTE, FRANCIS OLIVER (INDIAN NAME: SIS-HULAK) (1920–) Painter. Printmaker. Modeling, plaster of Paris. Born on a reservation in New Mexico. Lived in Oliver, B.C., 1940. Pupil: Santa Fe Indian School, New Mexico. Many awards in Canada, United States, Paris, London, Vienna, Prague.

BAUGHMAN, FRANK Artist. Lived in Seattle, Washington, 1963. Member: Puget Sound Group of Northwest Men Painters, 1950.

BAUGHMAN, MILDRED L. (1916–) Painter, oil, watercolor. Sculptor. Exh: Seattle Art Museum, 1937–39.

BAUM, FRANZ (1888–) Painter, oil, tempera, graphic art. Born in Germany. Lived in Seattle, Washington, 1940. Pupil: Royal Munich Academy of Art.

BAUMGRAS, PETER (1827–1903) Painter, portraits, mining scenes, still lifes, Yosemite landscapes. Born in Germany. Immigrated to United States in 1853. Spent many years in Washington, D.C. where Abraham Lincoln was one of his sitters. Moving to California, 1869–77, he followed portrait commissions to Oregon during 1872–74.

BAXTER, IAIN Painter. Sculptor. Modernist landscapes of Vancouver, B.C. around 1960's. Mixed mediums and forms.

BAXTER, MARGARET ANNE (1918–) Painter, oil, watercolor, pastel. Printmaker. Born and lived in Seattle, Washington. Pupil: University of Washington; Dorothy D. Jensen. Member: Women Painters of Washington. Exh: Seattle Art Museum, 1938 & 1940.

BAYLOR, ELWOOD (MID 1800'S) Painter, oil. Realistic Oregon landscapes and portraits. Works found in and about Southern Oregon, 1895.

BEACH, ANNA Artist. Lived in Seattle, 1901–32.

BEACH, BESSIE L. Artist. Lived in Seattle, Washington, 1901–21.

BEACH, CELIA MAY SOUTHWORTH (1872–) Painter, oil, pastel. Drawing. Lived in Burley, Idaho.

BEALL, JEAN CORY (–1978) Painter, watercolor. Muralist. Exh: Seattle Art Museum, 1939. Member: Women Painters of Washington. Work: murals in Olympic Hotel, Seattle; Washington State Captiol, Olympia.

BEAMAN, JAMES B. (MRS.) Painter, oil. Lived in Ellensburg,

Washington, 1947. Exh: Seattle Art Museum, 1947.

BEAMENT, THOMAS, HAROLD (1898–1984) Painter, landscapes, marines, lakes, eskimos in the Arctic, 1947. He was a Naval War Artist, 1943–47. He traveled the ten Canadian provinces as well as Europe and the U.S. Worked in the realistic style.

BEANLANDS, (MRS) Founding member B.C. Society of Fine Arts, 1933.

BEARDIN, MELVIN D. Painter, oil, landscapes. Lived in Hoodsport, Washington, 1947. He and friend, L.D. Updyke won national recognition with murals for the 1939 World Fairs in San Francisco & New York.

BEARDSLEE, MARY B Artist. Lived in Seattle, Washington, 1921.

BEATTY, JOHN WILLIAM (1869–1941) Painter, Canadian landscapes. Teacher. Pupil: Cruikshank & F. M. Bell-Smith, in Paris; Laurens; Constant. Canadian Northern Railway commissioned Beatty to paint scenes of the laying of tracks throughout the Rockies.

BEBB, HELEN (-1955) Art Teacher. Lived in Seattle, Washington. Member: first chairperson, Women Painters of Washington, 1930.

BEBEE, ROBERT C. Painter, watercolor. Lived in Seattle, Washington, 1940, 1944. Exh: Seattle Art Museum, 1940.

BECKER, CARL P. Painter, oil. Lived in Yakima, Washington, 1937. Exh: Seattle Art Museum, 1937.

BECKER, ELIZABETH S. (MRS.) Painter, oil. Lived in Spokane, Washington, 1901.

BEDFORD, FREDERICK G. D. Illustrator for the Navy, his "Esquimalt from Anchorage H.M.S. Shah" is a precisely defined coastal panorama of Vancouver Island (B.C.) in the 1880's, executed in watercolors.

BEDFORD, GUY Artist. Lived in Seattle, Washington, 1912.

BEECHER, HARRIET FOSTER (1854–1915) Painter, portraits, Indians, landscapes. Pioneer Seattle artist. One of the few women artists selected to serve on the Panama-Pacific International Expo's Advisory Committee for the West. Charter member: Society of Seattle Artists. Beecher was one of the most important 19th-20th century western women artists. Pupil: St. Mary's Academy, South Bend Indiana. Moved to San Francisco in 1875 to study at the San Francisco School of Design where she received the Alvord and Avery medals for her work. Moved to the Puget Sound in 1880. In 1881 she established the Fine Arts Studio in Seattle.

BEEK, ALICE ENGLEY (1876–1951) Painter, watercolor. Sculptor. Lithographer. Born in Rhode Island. Lived in Tacoma, Washington. Pupil: De Chavannes; Burleigh; Ertz in Europe. Teacher and Director at Annie Wright Seminary, Tacoma. Member: Tacoma Art League, Washington. Won many top prizes at the Paris Expo Internationale in 1900 & 1901; grand prize and gold medal at the Alaska-Yukon Pacific Expo, 1909, Seattle.

BEGGS, HELENE WARDER (1882–) Artist. Designed seal for Northwestern University School of Law.

BEIL, CHARLES A. Sculptor, traditional western style. Friend of Charles Russell. Was a working Montana cowboy. Settled in Banff, Canada.

BELCH, FLORA U. Painter, portraits. Lived in Tacoma, Washington, 1892–99.

BELL, ALISTAIR MACREADY Painter, all mediums, landscapes, sea islands and tidal waters. Vancouver, B.C. School, 1930's. A Modernist.

BELL, ARTHUR W. Artist. Lived in Seattle, Washington, 1919.

BELL, CECIL CROSLEY (SPIKE) (1906–1970) Painter, oil, watercolor. Lithographer, Etcher. Pupil: John Sloan; Art Students League, New York. Exh: Pennsylvania Academy of Fine Art, 1938; Whitney Museum, 1936, 1938, 1939. Retrospective Exh: Tacoma Art Museum, 1974.

BELL, DOROTHY (1893–) Painter, oil, watercolor. Printmaker. Craftsperson. Pupil: Vancouver School of Art, B.C.

BELL, EVA S. Artist. Lived in Seattle, Washington, 1902.

BELL, F. Artist. Member: Tacoma Art League, 1892. Exh: First Annual Western Washington Industrial Exposition, 1891.

BELL, IDA S. Artist. Lived in Spokane, Washington, 1919.

BELL, SIDNEY (1888–) Painter, oil, watercolor, pastel, portraits, still lifes. Born London, England. Lived in Portland, Oregon, 1940. Studied at Royal College of Arts and National Art Training School, London. Teacher: Ladies College, Cheltenham, England. Exh: London; San Francisco; Portland; Salem, Oregon. Involved in the "inner circle" of Portland Artists from the 1920's.

BELL, T. CLARKE Painter. Lived in Spokane, Washington, 1950. Member: Washington Art Association.

BELL, VERONA Artist. Member: Tacoma Art League, 1892. Exh: First Annual Western Washington Industrial Exposition, 1891.

BELL, WILLIAM ABRAHAM (1841–1921) Illustrator. Doctor who was *Harper's* illustrator in 1867. Kansas-Pacific survey sketch artist and photographer of the Indian War. Writer. Returned to England where he wrote and illustrated "New Tracks in North America".

BELL-SMITH, FREDERIC MARLETT (1846–1923) Painter. Illustrator, landscapes, mountains, London Streets, coastal, glaciers. Lived in Vancouver, B.C. and Toronto.

BELLAMY, TENNS FRANCIS (1906–) Painter, watercolor. Drawing. Architect. Born in Idaho. Lived in Seattle, Washington, 1940. Exh: Seattle Art Museum. Pupil: University of Washington, Seattle.

BELLEFLEUR, LEON (1910–) Painter, abstracts. Canadian artist. Exh: Vancouver, B.C., 1950.

BELLER, ALVIN JACOB (1902–1968) Painter, watercolor, pastel. Photographer. Pupil: Art Students League, New York; Breckenridge; Charles Hawthorne; Doug Kingman. Primarily a California artist, he traveled extensively throughout the United States, Canada and Mexico.

BENDER, A. C. Painter, oil, landscapes. Lived in Seattle, Washington, 1910.

BENDER, WILLIAM J. Painter, oil, landscapes. Commercial artist. Lived in Seattle, Washington, 1957.

BENDIXEN, GEORGE (1883–) Painter, oil, murals. Born in Norway. Lived in Oregon, 1940. Pupil: Robert Henri. Work: many murals in public buildings in Washington and Oregon. Exh: Portland Art Museum; Buffalo Fine Arts Academy. Paintings used to illustrate "Land of the Free".

BENEDICT, E. Z. Artist. Lived in Asotin, Washington, 1902.

BENEFIEL, EULAH (–1981) Painter, oil, watercolor. Sculptor.

Lived in Bellingham, Washington. Commissioned to paint 4 oils for President Kennedy's command ship, the *Wright* just prior to his death.

BENNER, ANNA Painter. In 1887 she had established a studio in Portland, Oregon with artist May Thornton, returning in 1896 to San Francisco.

BENNETT, ELTON (1910–1974) Painter, oil. Printmaker, silkscreen prints of Washington seascapes & landscapes. Born in Cosmopolis, Washington, died in Samoa. Pupil: Portland Art Museum School; Washington State University. Painted 2 large murals for Grays Harbor College, Aberdeen, Washington. Although he was a dedicated artist working twelve hours a day in his studio, he was a very private person, not participating in any art groups or organizations. A rugged individualist he charged very little for his work, refusing to allow commercialization of any kind, frequently turning down many large orders. He died aboard a plane headed for Pago Pago in 1974. Works: Current (1992) Laurence Gallery in Oregon.

BENNETT, RUTH MANERVA (1899–1960) Painter. Engraver. Primarily a California artist, the University of Washington published 12 woodcuts in 1927.

BENSEN, BERTHA L. Artist. Lived in Seattle, Washington, 1918.

BENSON, EDNA GRACE (1887–) Painter. Designer. Teacher. Born in Iowa. Lived in Seattle, Washington, 1964. Pupil: Chicago Academy of Fine Art, Fountainebleau School of Fine Art, France; New York School of Fine Art. Member: Pacific Arts Association. Professor of Design, University of Washington.

BENTLEY, PERCY Artist. Photographer. Lived in Vancouver, B.C., 1930's.

BENTON, COLONEL JAMES GILCHRIST (1820–1881) Painter. Graduate of West Point in 1842. Pupil: topographical & figure drawing from Robert W. Weir.

BENZ, MILDRED WIGGINS Painter. Lived in Toppinish, Washington, 1924.

BERGTHORSON, CHRIS Commercial artist. Pupil: Vancouver, B.C. Art School, 1945.

BERKMAN-HUNTER, BERNECE Painter. Pupil: Chicago Art Institute. Exh: Seattle Art Museum, 1946.

BERNARD, L. CHRISTOPHER Artist. Lived in Spokane, Washington, 1908.

BERNARD, LILLIAN E. Painter, oil, pastel. Lived in Spokane, Washington, 1907.

BEROTH, LEON A. (-1980) Illustrator. Cartoonist, landscapes, figures.

BERQUEST, EDWIN Painter, watercolor. Show card writer. Lived in Seattle, Washington, 1941.

BERRY, LILLIAN E. Artist. Lived in Seattle, Washington, 1916.

BERRY, MYRA P. Artist. Lived in Seattle, Washington, 1907.

BERRY, WILLIAM AUGUSTUS (1933–) Graphic artist. Teacher. Exh: Anchorage Museum, Alaska.

BERTRAND, FRANK H. Painter. Photographer. Lived in Seattle, Washington, 1940.

BEST, ALICE M. LEVEQUE (1869–1926) Painter, oil, watercolors. Wife of Arthur Best. Exh: Alaska-Yukon Pacific Expo, Seattle, 1909.

BEST, ARTHUR WILLIAM (1859–1935) Painter. Work: University of Oregon; Charles M. Russell Gallery, Montana. Played a clarinet along with his brother Harry Cassie in a band that

traveled west dissolving in Portland, Oregon. Became well known for his paintings of the Grand Canyon.

BEST, HARRY CASSIE (1863–1936) Painter, oil, landscapes of the Northwest, California and Arizona. Became known as the artist of the Yosemite Valley and the California mountains. In 1891 he was with a band who played in Silverton Oregon where he also did landscape paintings. In 1895 he sold a painting of Mount Hood for $100, quit the band and left for San Francisco with his brother, Arthur William Best.

BEST, NELLIE G. (1906–) Painter, murals. Craftsperson. Ceramics. Lived in Sterling, Washington. Pupil: University of Oregon, Eugene. Exh: Oregon Artists Association.

BETHERS, RAY (1902–) Painter. Engraver. Illustrator. Printmaker. Born in Corvallis, Oregon. Pupil: University of Oregon, Corvallis; the Grande Chaumiere, Paris; Piazzoni and Armin Hansen, San Francisco; the Art Students League, New York; Grand Central School, New York. Work: Library of Congress.

BEURHAUS, GENEVIEVE Painter, oil, landscapes, still lifes. Exh: Tacoma Art League, 1915.

BEVENS, MAYBELLE K. Artist. Lived in Seattle, Washington, 1907–09.

BEVLIN, MARJORIE ELLIOTT (1917–) Painter, all media. Writer. Pupil: University of Colorado; University of Washington, College of Architecture. Exh: National Academy of Design, New York.

BEYER, JOAN READ (1920–) Painter, portraits, landscapes. Sculptor. Ceramist, figural. Raised in the Northern California town of Scotia. During WWII she moved to New York City where she attended many art classes. Returning to the Pacific Coast in 1958 she opened her own studio/gallery in the historic town of Jacksonville, Oregon, where she is currently living.

BEYGRAU, PAUL T. Artist. Lived in Seattle, Washington, 1918.

BIBERMAN, EDWARD (1904–1986) Painter, murals. Primarily a California artist, his works are in the Portland Oregon Library.

BIDWELL, J. R. (MRS.) Artist. Exh: Western Washington Fair, Puyallup, Washington, 1906.

BIDWELL, LILLIAN E. (1903–1985) Painter, oil, watercolor. Born in Michigan. Lived in Tacoma, Washington, 1904–54.

BIERSTADT, ALBERT (1830–) Painter, landscape. He was probably the most popular landscape painter of his day, traveling extensively in the western states producing paintings of Mt. Rainier, Mt. Saint Helens, Mt. Adams and Mt. Hood in the Northwest. Renowned artist in his own time.

BIESOIT, ELIZABETH K. GALL (1920–) Painter. Pupil: University of Washington, Seattle; Colorado University; Alexander Archipenko. Exh: Oakland Art Gallery; Denver Art Museum; Seattle Art Museum, 1940, 1945. Worked as a civilian photographer for the army in 1940. Taught sculpture at the University of Washington. Received many awards.

BIGLOW, MAUD MINER Painter, drawing. Member: Tacoma Art League, 1891–92. Illustrated book, *From the Land of Snow Pearls*, 1892. Signed MMB.

BILES, JAMES NORMAN (1865–1914) Painter. Pupil: Art Students League, New York; L'Academie Julian, Paris, 1909. Returned to Portland as a commercial artist.

BILLINGSLEY, H. JOY (1915–) Painter, oil, pastel, fresco. Sculptor, stone, marble, clay. Draftsman. Pupil: University of Washington, Seattle. Teacher, Vashon Island Washington.

BILLINGTON, LINA Artist. Lived in Seattle, Washington, 1912.

BIMROSE, ARTHUR SYLVANUS, FR. (1912–) Cartoonist. Pupil: San Francisco Art Institute; University of Oregon. Work: Staff artist, *The Oregonian*, Portland 1937–39. Received the Freedom Foundation Award.

BINNING, BERTRAM CHAS. (1909–) Painter. Teacher. A native of Vancouver, B.C. Pupil: Vancouver, B.C. School of Art; University of Columbia, 1940's; Henry Moore, London. Exh:Biennial of Canadian Painting, 1955.

BINNS, FRANK (1912–) Painter, oil. Born in Seattle, Washington. Pupil: University of Oregon, Eugene; Clyde Keller; Sidney Bell, Portland. Member: Oregon Society of Artists. Exh: Oregon Artists, Meier & Frank Exposition, Portland, 1937–39; State Fair, Salem, Oregon, 1938.

BIRDSALL, BYRON (1937–) Painter, watercolor, landscapes. Born in Arizona. Pupil: Seattle Pacific College; Stanford University. Work: Anchorage Historical & Fine Arts Museum. Exh: All-Alaska Exhibition; Anchorage Historical and Fine Arts Museum, 1978. Award: Alaska Watercolor Society, first place, 1976.

BIRKMAN, AGNES (1871–1955) Painter, oil, watercolors, china. Lived in Seattle, Washington. Teacher: College of Fine Arts, University of Washington, Seattle, 1912.

BIRLEY, PATIENCE. (1905–) Painter, pastel, animals. Lived in Victoria, B.C. Studied in England; Belgium. Exh: B.C. Artists Exhibition, Victoria, 1937 & 1938.

BISAZZA, CHARLOTTE M. (– 1940) Designer. Teacher. Born in San Francisco. Lived in Seattle, Washington. Pupil: University of Washington, Seattle; Pratt Institute, New York. Member: Women Painters of Washington; Art Teachers Association, Seattle; Carnegie Scholarship, University of Oregon, Eugene; Design Magazine.

BISHOP, FLORA MELISSA Painter, oil. Lived in Seattle, Washington, 1934. Study: California School of Fine Arts; Clyde Leon Keller. Member: Women Artists of Washington; Seattle Art Association.

BISHOP, RALPH J. Painter, watercolor. Architect. Lived in Tacoma, Washington, 1931.

BIXEL, WINIFRED L. Painter. Museumic teacher. Exh: Tacoma Art League, 1940.

BLACK, E. Painter in Idaho in the 1870's.

BLACK, MARY C. WINSLOW (1873–1943) Painter. Pupil: Art Students League, New York. Moved to Santa Barbara, California, in the 1890's, remarrying and moving to Monterey. Primarily a California artist. Work: Seattle Art Museum.

BLACK, R. M. (MRS.) Artist Lived in Snohomish, Washington, 1907.

BLACKMAN, CARRIE HORTON (1856–1935) Painter. Study: Paris; St. Louis School of Fine Arts. Member: Society of Western Artists. Award: Alaska-Yukon Pacific Expo, Seattle, 1909.

BLACKSTOCK, DOROTHY E. LYONS (1914–) Painter, oil, pastels, portraits. Pupil: Leon Derbyshire. Portrait painter of many prominent persons of the Northwest.

Member: Women Painters of Washington. Exh: State Museum, Olympia.

BLACKWELL, RUBY CHAPIN (1876–) Painter, landscapes, floral watercolors. Born in New York. Lived in Tacoma, Washington, 1940. Pupil: Alice Beek, Tacoma.

BLACKWELL, WINONAH R. (1885–) Painter, watercolor, still lifes, flowers. Pupil: Hassam; Harrison. Lived in Seattle, Washington, 1929–1979.

BLADEN, RONALD Painter. Sculptor. Pupil: Max Maynard, Victoria, 1932. Later became an eminent New York sculptor.

BLAIKIE, J. RUTHEFORD Painter, oil, landscapes. Member: Vancouver Island Arts and Crafts Society, Victoria, B.C., 1913. Exh: Vancouver Island Arts and Crafts Society, 1910.

BLAINE, MAHLON Painter. Illustrator. Born in Oregon. Illustrator for local newspaper in Albany, Oregon, until 1917 when he moved to San Francisco. Exh: Oregon Historical Society. Member: The Attic Sketch Group, Portland Oregon.

BLAIS, GEORGE Sculptor. Lived in Eugene, Oregon, 1940.

BLAKE, ALETHA ARLEN Painter, miniatures. Studio in Salem, Oregon, in 1923–26. Moved to Los Angeles in 1932.

BLAKE, EDGAR LESLIE (1860–1949) Commercial artist, landscapes, still lifes. Lived in Edmonds, Washington. Pupil: Chicago Art Institute; Edinburgh; Paris. Member: Puget Sound Group of Northwest Men Painters.

BLAKELOCK, RALPH ALBERT (1847-1919) Painter, landscapes. A foremost American landscape painter, he lived among the Plains Indians and sketched across the Rockies and Sierra Nevada Mountains. He traveled widely through the West Coast towns and into the Northwest. Despite his considerable skill, his paintings did not sell well, and he and his large family lived in poverty. He suffered a mental breakdown in 1899 and was forced to live the rest of his life in institutions.

BLAKESLEY, FLORA B.R. Painter, oil. Exh: Tacoma Fine Art Association, 1932.

BLAND, JAMES A. (1856–1929) Painter, watercolor, Canadian coastal rivers, boats.

BLASHKO, ABE (1920–) Painter, oil. Printmaker, lithographs. Born & lived in Seattle, Washington. Member: Washington Artists Union. Exh: Seattle Art Museum; Northwest Printmakers, 1940.

BLASHKO, BECCY (1913–) Drawing, pen and ink. Born and lived in Seattle, Washington. Pupil: Cornish Art School, Seattle. Handicraft & art teacher.

BLATCHLY HARRY W. (1865–1942) Painter. Printer. Born in England. Lived in Seattle, Washington. Son of Canadian artist, William D. Blatchly. Exh: Second Annual Western Washington Industrial Exposition, 1892.

BLAUVELT, ELSIE MAVIS (1890–1989) Painter, oil, landscapes, still lifes. Lived in Tacoma, Washington.

BLECK, MIETZE (1911–) Painter. Designer. Teacher. Lived in Juneau, Alaska. Member: Alaska Arts and Crafts Association. Author/Illustrator: "Crossed Roads", 1937.

BLEEG, ALICE WILHELM (1895–) Craftsperson, metal, pottery, weaving. Born and lived in Portland, Oregon. Pupil: Mills College; Wellesley College. Member: Arts and

Crafts Society, Portland. Exh: Portland Art Museum.

BLODGETT, MINNIE A. Artist. Lived in Seattle, Washington, 1932.

BLOGG, H. A. Painter. Architect. Lived in Seattle, Washington, 1924.

BLOMBERG, HATTIE Painter, watercolor, landscapes. Musician. Studied in Germany. Exh: Seattle Art Museum, 1946.

BLOMFIELD, JAMES J. (1872–1951) Painter, watercolor. Moved to Vancouver, B.C. in 1887 where he executed numerous public commissions, including the Parliament Buildings.

BLOOD, ELIZABETH A. Artist. Lived in Tacoma, Washington, 1902.

BOBAK, BRUNO Painter, watercolor. Teacher, Vancouver, B.C. School of Art, 1940's. Work: Collection Vancouver Art Gallery.

BOBAK, MOLLY Artist. Lived in Vancouver, B.C.. Member: Labor Arts Guild, 1944. Work: The National Gallery of Canada. Wife of Bruno Bobak.

BOCCASINI, RUDOLPH P. Painter. Lived in Spokane, Washington, 1912–21.

BODDY, EVA M. Painter. China decorator. Lived in Seattle. Washington, 1920.

BODSON, A. Painter, oil, landscapes.

BOHLMAN, EDGAR (LEMOINE) (1909–) Painter. Designer. Photographer. Member: Portland Art Association. Work: Settings and costumes for the American Opera Company, New York Theatre.

BOHLMAN, HERMAN T. (1872–) Painter, oil. Born and lived in Portland, Oregon. Pupil: Clyde L. Keller. Member: Oregon Society of Artists; American Artists Professional League.

BOISSEAU, ALFRED (1823–1901) Painter. Photographer. Early Canadian.

BOK, HANS (1914–) Painter, oil, watercolor, murals. Born in Missouri. Lived in Seattle, 1940. WPA artist. Member: Washington Artists Union.

BOLSTAD, HARRIET M. Painter, oil. Exh: Seattle Art Museum, 1949.

BONATH, HARRY (1903–1976) Painter, oil, watercolor. Born in Ohio. Lived in Seattle, Washington, 1940. Pupil: California School of Fine Arts, San Francisco; Maynard Dixon. Member: Puget Sound Group of Northwest Men Painters; Puget Sound Group. Exh: Seattle Art Museum from 1935, solo shows, 1937, 1961; Legion of Honor, San Francisco. Art Director, Erwin Wasey Advertising.

BOND, MILDRED V. Artist. Lived in Seattle, Washington, 1917.

BONESKE, DORIS A. (1924–1983) Painter. Born Tacoma, Washington. Pupil: University of Washington, Seattle.

BONGART, SERGEI Painter. Teacher. Pupil: Kiev Art Academy. Work: National Academy of Design; Frye Art Museum, Seattle; Laguna Beach California Art Association Gallery. Exh: Metropolitan Museum of Art, New York; Kiev Museum of Russian Art. Member: American Watercolor Society, 1969. Studios in California and Idaho, where he held summer workshops.

BONWELL, E. Illustrator. Four illustrations included in the publication of 1867, "Beyond the Mississippi" by Albert D. Richardson. Scenes produced from Kansas to Oregon which are two street scenes in Portland and Leavenworth.

BORDUAS, PAUL-EMILE Painter. Lived in Vancouver, B.C., 1940's. Exh: Biennial of Canadian Painting.

BOREIN, JOHN EDWARD (1872–1945) Painter, western genre scenes. Illustrator. Etcher. Writer. Work: Cowboy Hall of Fame; Glenbow-Alberta Institute; Gilcrease Museum. Pupil: San Francisco Art School. Became a cattle driver selling his first sketches to a publication in Los Angeles. Sketched in Mexico for two years in 1897–99; to Oakland as a staff artist on the *San Francisco Call*. In 1901 he teamed with Maynard Dixon on a sketching trip north through the Sierras to Oregon and Idaho. After a short stay in New York City he returned to Oakland in 1909 sketching in Oregon. Charles Russell found work for Borein in Western Canada in 1912–13.

BOREN, JAMES (1921–) Painter, watercolors, western scenes. Illustrator. Teacher. Art Director. Pupil: Kansas City Art Institute, MA, 1951. Teacher: Saint Mary's College, Kansas. Traveled to the far West and the Northwest before moving to Denver. He worked as a commercial illustrator. In 1965 he became the first art director of the National Cowboy Hall of Fame. Has won many awards for his watercolor paintings at the annual Cowboy Artists of America.

BORGESON, MAY ST. DENIS Painter, landscapes. Lived in Seattle, Washington, 1926.

BORGHI, GUIDO (1903–) Painter, oil on canvas & on paper, watercolor, gouache, dry brush. Born in Switzerland. Lived in Rupert, Idaho, 1940. Pupil: Charles Colson; George Luks; Europe. Member: Society of Independent Artists; Bronx Animal Painters; Art Students League of New York, 1933; National Academy, New York, 1940.

BORGLUM, ELIZABETH JAYNES (1848–1922) Painter, landscapes. Study: art and music in Boston; New York; Paris; William Keith, San Francisco. Married renowned artist John Gutzon de la Mothe Borglum. Exh: Alaska-Yukon Pacific Expo, Seattle, 1909 (silver medal). Settled in California after her divorce where she opened a studio in Sierra Madre.

BORGLUM, JOHN GUTZON de la MOTHE (1867–1941) Sculptor. Painter. Born near Bear Lake, Idaho. Monumental Western sculptor. Pupil: William Keith; Virgil Williams; Julian Academy; Ecole des Beaux-Arts, Paris. Returned to California in 1893–94. Was compared to Rodin in Europe. Work: Mt Rushmore National Memorial; Lincoln, Capitol Rotunda, Washington. He was also an independent politician who identified with the agrarian revolt in the Northwest and served as exposé investigator for President Wilson.

BORNSTEIN, JULIUS Artist. Lived in Tacoma, Washington, 1909.

BORZO, KAREL (1888–) Painter, oil, pastel. Born in Holland. Exh: Seattle Art Museum, 1939, 1946; Oakland, California, 1939.

BOSCH, LODEWYK Painter. Arrived in Victoria, B.C. from Holland in 1930. Known as an artist and critic he brought the mystique of the European avant-garde to the Northwest.

BOSSERMAN, LYMAN W. (1909–) Painter, watercolor. Draftsman. Born in LaPorte, Indiana. Member: Puget Sound Group of Northwest Men Painters, 1945.

BOSWORTH, IDA Artist. Lived in Seattle, Washington, 1921.

BOTHWELL, DORIS (DORR) HODGSON (1902–) Painter. Printmaker. Pupil: University of Oregon. Teacher: the Parsons School of De-

sign, New York. Spent over two years in Paris on a Rosenberg Fellowship. Semi-abstractist of primitive people and their culture. Non-representational. Primarily a California artist.

BOTTS, CLAUDE D. Artist. Lived in Seattle, Washington, 1916.

BOUL, JACK Painter, oil. Exh: Seattle Art Museum, 1949.

BOVEE, ALICE M. Artist. Lived in Seattle, Washington, 1909.

BOVEN, VERN LEROY (1903–) Painter, oil. Craftsman. Born in Chicago. Lived in Boise, Idaho, 1940. Pupil: Chicago Art Institute. Exh: Boise Art Association, 1933.

BOWER, LUCY SCOTT (1864–1934) Painter, oil, impressionist. Well-known portrait painter and poet. Lived in Portland, Oregon from 1889–96. Lived in England and France between 1904 and 1934. She was greatly influenced by the French impressionistic style. Pupil: Philadelphia Academy of Fine Arts; New York School of Art; Academie Julien, Paris. Member: Oregon Artists Association. Exh: Northwest Industrial Expo, Portland, 1889. Husband, John Bower died in 1912 when she traveled to and exhibited in New York, Paris and London. Died in her Paris studio when her gas heater malfunctioned.

BOWERS, CHERYL OLSEN (1938–) Painter. Pupil: San Francisco Art Institute, MFA (with honors); University of California, Berkeley. Work: University Museum, Bellingham, Washington; University Museum, Berkeley; Whitney Museum of American Art, New York.

BOWMAN, ANNETTE S. Painter. Teacher. Tacoma Public Schools, 1891. Work: Washington State Historical Society.

BOWMAN, GEOFFREY (1928–) Painter. Printmaker. Born in San Francisco. Primarily a California artist. Exh: Yakima Washington Valley Junior College, 1959.

BOYD, BRUCE Commercial artist. Vancouver, B.C. Art School, 1945.

BOYD, ELIZABETH I. Art instructor. Lived in Tacoma, Washington, 1907.

BOYD, LILLIAN J. Artist. Lived in Spokane, Washington, 1914.

BOYD, STEPHEN Artist. Lived in Seattle, Washington, 1926.

BOYDEN, MARGERY DAVIS (1912–) Painter, watercolor. Born in Philadelphia. Lived in Astoria, Oregon, 1940. Pupil: University of Michigan; Art Students League, New York; John James Clarkson; Ann Arbor. Exh: Henry Gallery, University of Washington, Seattle; Seattle Art Museum.

BOYER, LEOLIN Painter, watercolor. An Oregon artist from the mid 20th century.

BOYINGTON, GREGORY "PAPPY" (1913–1988) Painter, oil, landscapes. Pupil: University of Washington. Began painting in a WWII prisoner of war camp. Famous military career. Settled in California painting landscapes and desert scenes.

BOYLE, GERTRUDE FARQUHARSON (1876–1937) Sculptor. Primarily a San Francisco, California artist. Exh: gold medal, Alaska-Yukon Pacific Expo, Seattle, 1909.

BOYLER, LEOLIN Painter, watercolor, landscapes, coastal scenes. Lived in Portland, Oregon from the 1950's to the 70's.

BOYNTON, RAYMOND SCEPTRE (1883–1951) Painter, murals. Exh: Chicago Society of Artists. He lived and worked for seven years in Spokane, Washington, before moving

to San Francisco in 1915. He executed many murals. Widely known for his murals and canvases of the Mother Lode Country and old California and West Coast landmarks.

BRACKEN, CHARLES W. (1909–) Painter, watercolor. Sculptor. Born in Pennsylvania. Lived in Seattle, 1934. Pupil: University of Washington, Seattle; Chicago Academy of Fine Arts. Exh: Henry Art Gallery, University of Washington, Seattle; Seattle Art Museum. Art Director, Evans & Stults, Chicago.

BRADFIELD, EMMA Painter, oil, watercolor. Pupil: Chicago Art Institute; Cincinnati Art Academy; Frank Duveneck. Member: Western Writers, Seattle, Washington.

BRADFORD, WILLIAM (1830–1892) American Marine Painter, arctic landscapes. Was on several exploring expeditions to the North Pole. He was, by far, the best known of the early Arctic painters.

BRADLEY, EBER R. Painter. Lived in Seattle, Washington, 1920.

BRADLEY, EMMA L. (1846–1919) Painter, oil, watercolor, landscapes, still lifes. At turn of century her sketches of mountains and roses were in demand worldwide. Member: Tacoma Art League. Founder of the *Everett Herald* and editor of the *Tacoma Daily Ledger*.

BRADLEY, REGINALD A. (1867–1971) Painter. Born in England. The lure of the Wild West brought him to the United States in 1888. Worked as a cowboy and Indian fighter. Left the Calvary in 1894 to become a rancher in Northern California and Oregon. Became a competent landscape painter later in life. Work: Hall of Congress, Washington, D.C.; Modoc County, California Museum.

BRADLEY, RUTH Painter, oil, Northwest landscapes. Active in Oregon mid-1960's.

BRADLEY, SALLY COLE (1910–) Painter, watercolor. Born in Seattle, Washington. Pupil: Cornish Art School, Seattle; Otis Art Institute, Los Angeles. Member: Painters of Washington. Exh: widely in Washington and California in the 1970's.

BRAKKEN, ANDREW Painter. Lived in Arlington, Washington, 1924.

BRAMLEY, (MISS) CHRIS Painter. Lived in Vancouver, B.C., 1940.

BRAND, EDYTHE HEMBROFF (1906–) Painter, oil, watercolor. Printmaker, etching. Born in Canada. Lived in Vancouver, B.C., in 1940. Pupil: California College of Arts and Crafts, Oakland; California School of Fine Arts, San Francisco; André L'Hote, Paris. Member: B.C. Society of Fine Arts, Vancouver. Exh: Salon des Independents, Paris; B.C. Artists Exhibition, Vancouver; B.C. Society of Fine Arts, Vancouver. Teacher, special art classes, Crofton House School, Vancouver.

BRAND, FREDRICK Artist. Teacher: University of British Columbia, 1930's.

BRAND, PHILIP Painter, Cabinetmaker. Lived in Mercer Island, Washington, in 1940.

BRAND, YVONNE (1905–1944) Illustrator, born in Riverton, Washington, settling in San Francisco.

BRANDBERRY, ALICE Artist. Lived in Seattle, Washington, 1907–10.

BRANNAN, LOU (MRS. GEORGE)
Commercial Artist. Lived in Spokane, Washington, 1931.

BRANSON, MATE E. Painter. Lived in Tacoma, Washington. 1891–96. Member: Tacoma Art League, 1892.

BRASK, GUDRUN (1908–)
Painter, oil, watercolor. Born in Denmark. Lived in Seattle, Washington, 1940. Pupil: Royal Academy of Fine Arts, Copenhagen. Exh: Seattle Art Museum.

BRAZEAU, WENDELL P. (1910–)
Painter, oil. Printmaker, pen & ink. Born in Spokane, Washington. Lived in Seattle, Washington, 1940. Pupil: University of Washington, Seattle; California School of Fine Arts, San Francisco. Exh: Northwest Printmakers. Works in abstracts.

BREAKEY, HAZEL M. (1890–)
Painter, oil, watercolor. Drawing, pencil. Born in Wisconsin. Lived in Bellingham, Washington, 1940. Pupil: California School of Arts and Crafts; Carnegie Scholarship, University of Oregon, Eugene. Supervisor of Art, Western Washington College of Education, Bellingham.

BREAR, SAMUEL D., JR. Artist. Lived in Tacoma, Washington, 1895–96.

BREARLEY, F. Painter, oil, landscapes. Lived in Oregon, mid-20th century. Canvas, titled: "Mt. Hood".

BRECKENRIDGE, MARIETTA S.
Artist. Lived in Tacoma, Washington, 1908. Member: Tacoma Art League, 1916.

BRENNER, CARL CHRIST (1838–1888) Born in Bavaria and died in Kentucky. Not much is known about this folk artist except for his works of the Olympian Mountain Range in Washington.

BREUER, HENRY JOSEPH (1860–1932) Painter. Illustrator, landscapes. Primarily a California landscape painter he traveled the coast from Santa Barbara to the Northwest living in a horse-drawn wagon and showed in the Seattle Exposition, 1909. Art editor of a California magazine, 1892–93. His style was influenced by the Barbizons, only somewhat more realistic.

BREWERTON, GEORGE DOUGLAS (1827–1901) Painter, oil, pastel, landscapes. Writer. Poet. Born in Rhode Island. Exh: National Academy, 1854–55. Painted in New York, California, and the Southwest. While in the army he once traveled with Kit Carson. Retired to Tacoma, Washington, at the turn of the century.

BREYMAN, EDNA CRANSTON
Painter. Lived in Portland, Oregon, 1913.

BRIEN, E. A. Painter, oil. Award: Western Washington Fair, 1906.

BRIGGS, A. SHELLY Artist. Lived in Tacoma, Washington, 1898.

BRIGGS, FRANK (MRS.) Painter, watercolor. Lived in Whatcom County, Washington, 1909.

BRINLEY, DANIEL PUTNAM (1879–1963) Painter, landscapes, murals. Illustrator, western Canada. Work: murals in many public offices along with stained glass designs. Pupil: Art Students League, New York; Paris; Florence, Italy. Member: Association of American Painters and Sculptors. Exh: a radical 1913 Armory Show. His watercolors and drawings were used as illustrations in Canadian travel books of the Rockies and British Columbia by Gordon Brinley in 1938.

BRISACK, DORIS K. (1903–1984) Painter. Lived in Tacoma, Washington. Pupil: California School of Fine Arts.

BRISSEY, FORREST L. (1895–1946) Artist. Lived in Seattle, Washington, 1918. Primarily a California artist.

BRISTOL, FRANCIS Painter, tempera. Lived in Spokane, Washington, 1942. Teacher: Spokane Art Center. WPA artist.

BRISTOL, OLIVE P. (1890(?)–1976) Painter, oil. Teacher. Born in Wyoming. Lived in Seattle, Washington. Pupil: Art Students League, New York, E. Ziegler, E. Forkner, L. Derbyshire. Member: Women Painters of Washington 1940–60.

BRISTOL, TANCI (1915–) Painter. Pupil: University of Southern California. Primarily a California artist. Exh: Portland Art Museum, 1939.

BRITT, PETER (1819–) Painter, oil, portraits, landscapes. Photographer. Early settler of Oregon in 1852. Studied in Switzerland. Studio in Jacksonville, Oregon. He took the first photographs in the state. Also became known for his many landscapes in both photography and oils.

BRIZZOLARI, JEROME Artist. Lived in Tacoma, Washington, 1935.

BROBST, SAMUEL V. Painter, commercial. Lived in Seattle, Washington, 1916.

BROCKMAN, PAUL M. Painter. Muralist. Interior decorator. Lived in Seattle, Washington, 1927.

BRONSDON, HELEN L. Painter. Teacher. Pupil: Pratt Normal, Boston. Art teacher, Tacoma Washington High School, 1908.

BROOK, HESTER CLARK (1904–1960) Painter, watercolor, pastel. Jewelry maker. Pupil: University of Washington; Seattle Pacific University. Member: Women Painters of Washington. Exh: Seattle Art Museum; Frye Museum, Seattle; Northwest Watercolor Society.

BROOKS, ALLAN (1869–) Painter, oil, watercolor. Illustrator. Born in India. Lived in Okanagan Landing, B.C., 1940. Founding member of the B.C. Society of Fine Arts, 1933.

BROOKS, HATTIE E. Painter, oil. Museumic Teacher. Lived in Tacoma, Washington, 1893. Exh: Washington Historical Society.

BROTCHE, JEAN Painter, oil. Teacher, Burney School of Fine Arts, Seattle. Exh: Seattle Art Museum, 1949.

BROTEN, WES (1911–) Painter, watercolor. Born in Portland, Oregon. Lived in Stanwood, Washington. Pupil: University of Washington. Exh: Frye Museum; many more throughout the Northwest.

BROTHERTON, DOROTHY (–1956) Artist. Lived in Seattle, Washington. Member: Women Painters of Washington, 1945–56.

BROTHERTON, MRS. WILBER J. (1894–) Painter, oil, watercolor, pastel, landscapes. Born in Philadelphia. Lived in Ellensburg, Washington, 1941. Pupil: Chicago Art Institute; mainly self-taught.

BROTZE, EDWARD FREDERICK (1868–1939) Painter. Commercial artist. Moved to Seattle, Washington, in 1905. Worked for the *Seattle Times* until 1939.

BROWN, BENJAMIN CHAMBERS (1865–1942) Painter, landscapes. Lithographer. Etcher. Important California plein-aire artist. Exh: bronze medal, Portland Oregon Exposition, 1905; silver medal, Alaska-Yukon Pacific Expo, Seattle, 1909. Work: Boise Idaho Public Library; many other public buildings in the West.

BROWN, ELDON M. Painter, watercolor, impressionist, landscapes. Active in the 1915's–70's in Oregon.

BROWN, EUGENIA J. (1858–1961) Painter. Teacher for over 65 years. Lived in Seattle, Washington.

BROWN, EYLER (1895–) Painter. Architect. Printmaker. Born in Ohio. Lived in Eugene, Oregon, 1940. Pupil: University of Oregon, Eugene; Royal College of Art, London. Professor of Architecture and Etching, University of Oregon.

BROWN, GRAFTON TYLER (1841–1918) Painter, landscapes. Lithographer. Born in Pennsylvania. Maintained a studio in Victoria, B.C. in 1869 exhibiting landscapes. Moved to British Columbia in 1882 joining the geological survey party led by Amos Bowman to explore the east side of the Cascade Mountains painting the area in watercolor sketches. Traveled in Western Washington, Tacoma, and was residing in Portland, Oregon, by mid 1880's. He had a studio in Portland from 1886–89. There is one known oil of the Grand Canyon.

BROWN, JANE Commercial artist. Lived in Spokane, Washington, 1931.

BROWN, MRS. JONAS Painter, oil. Lived in Boise, Idaho, in the early 1870's.

BROWN, LORRAINE Artist. Lived in Seattle, Washington, 1923–27.

BROWN, MARGARETTA FAVORITE (1818–1897) Painter, oil. Work: Idaho State Historical Society.

BROWN, MARIE BAARSLAY Painter. Lived in Home, Washington, 1990. Taught: University of Washington.

BROWN, MARY SPARLING Painter, oil. Lived in King County, Washington, 1909. Exh: Alaska-Yukon Pacific Expo, Seattle, 1909.

BROWN, MIRA Painter, impressionistic landscapes. Active in Oregon in the 1940's.

BROWN, PATRICK COWLEY Artist. Illustrator. Lived in Vancouver, B.C.. Official war artist during WWII. Exh: Allied Arts War Service Council.

BROWN, VIRGINIA WHITE Painter, oil. Born in Minnesota. Lived in Klamath Falls, Oregon, 1940. Member: American Artists Professional League; Oregon Society Artists.

BROWN, WILLA M. (1868–) Painter, oil, watercolor, landscapes. Born in Pennsylvania. Lived in Portland Oregon, 1940. Pupil: Parrott; Hagerup; Wanker.

BROWN, WINFIELD Commercial artist, watercolor, acrylics. Photographer. Lived in Tacoma, Washington, 1946. Member: Puget Sound Group of Northwest Men Painters.

BROWNE, BELMORE (1880–1953) Painter, Alaska, murals. Designer. Explorer. Writer. Mountaineer. Pupil: Chase; Beckwith; Academie Julian, Paris. Member: Alberta, SA. He wrote "The Conquest of Mt. McKinley", 1913. Director: Santa Barbara School of Arts, 1930–34.

BROWNING, AMZEE DEE (1892–) Illustrator. Craftsperson. Lived in Tacoma, Washington, 1941. Pupil: G. T. Hueston. Member: Tacoma Art League, 1941.

BROWNING, TOM Painter, oil, watercolor, landscapes, wildlife, figurative, western genre. Born in Ontario, Oregon. Pupil: University of Oregon; Ned Jacob; Lowell Ellsworth Smith; William R. Reese; Harley Brown; R. Schmid. Exh: C. M. Russell Show; Museum of Native American Culture, Spokane, Washington; Northwest Rendezvous Group. Founder, Arbor Green Publishers. Many national awards.

BRUCE, WILLIAM BLAIR (1857–1906) Painter, Canadian landscapes, villages, cattle, horses.

BRUSETH, ALF (1900–) Painter. Teacher. Commercial artist. Lived in Seattle, Washington, 1940. Study: Cornish Art School, Seattle.

BRUSH, CATHERINE DAILEY (1915–) Painter, oil, watercolor. Lived in Seattle, Washington. Pupil: Art Students League, New York; Eustace Ziegler, Seattle; Leon Derbyshire, Seattle. Member: Women Painters of Washington. Exh: Seattle Art Museum.

BRYANT, JULIA C. Painter. Lived in Tacoma, Washington, 1930. Exh: Annual Art Show, Tacoma.

BRYCE, R. Painter, genre scenes in the Washington Territory around 1883.

BUBB, B. C. Artist. Lived in Seattle, Washington, 1910.

BUBB, T. H. Artist. Lived in Seattle, Washington, 1901.

BUCHAN, ALEXANDER Scenic artist, Morgan's Theater. Lived in Tacoma, Washington, 1888.

BUCHANAN, HELEN (1907–1975) Painter, watercolor. Printmaker. Born in Juneau, Alaska. Lived in Gig Harbor, Washington. Member: Puget Sound Group of Northwest Men Painters; Tacoma Art League. Pupil: Brandt; Colby; Knapp; Post & Wood. Exh: Washington State Historical Society, 1968.

BUCK, JEAN Artist. Lived in Tacoma, Washington, 1930. Exh: Tacoma Fine Arts Association, 1930.

BUCKINGER, ROBERT H. (1920–) Painter, oil, watercolor. Lived in Seattle, Washington, 1941.

BUCKNER, KAY LAMOREUX (1935–) Painter. Draftsman. Pupil: University of Washington; Claremont Graduate School. Work: many public buildings in the Northwest. Exh: Seattle Art Museum; University of Oregon.

BUCKNER, PAUL EUGENE (1933) Sculptor. Teacher. Pupil: University of Washington; Claremont Graduate School. Work: many public buildings in the Northwest. Exh: Seattle Art Museum; Portland Art Museum. Professor of Sculptor, University of Oregon, Eugene. Received many awards.

BUELL, HORACE H. (1867–1919) Painter, portraits. Lived on the West Coast and in Portland, Oregon, 1900. Died in New York City where he was head of the Buell Scenic Company.

BUETTGREN, FRANK Painter. Lived in Seattle, Washington, 1932.

BUETTGREN, PETER (–1928) China Painter. Lived in Seattle, Washington, 1926.

BUGBEE, JOAN SCOTT Sculptor, Teacher. Pupil: University of Montana; Art Students League, New York; National Academy of Design. Work: many public commissions in Alaska.

BULL, ANNA Artist. Lived in Seattle, Washington, 1932.

BULL, WILLIAM HOWELL (1861–1940) Painter, landscapes. Illustrator. Primarily a Northern California artist working also in Washington and Oregon. He founded the California Society of Artists along with Piazzoni, Martinez, Campbell, Neilson and Sandona in 1902.

BULLARD, CORINNE V. Painter. Teacher. Lived in Tacoma, Washington, 1905–07.

BULSON, HARRIET F. Painter, portraits. Lived in San Francisco, California, 1880–90; Portland, Oregon, 1905–13.

BUMP, ELVIRA (1856–) Painter, oil, pastel. Lived in Portland, Oregon, 1940. Pupil: H. T. Gunn, New York. Member: Oregon Society of Artists.

BUNCE, LOUIS DEMOTT (1907–) Painter, oil, pastel. Pupil: Art Students League, New York; H. T. Gunn, New York; Portland Art Museum School. Exh: solo show, Seattle Art Museum, 1939; Portland Art Museum, 1945, 1947, 1956; University of Washington, 1947; National Serigraph Society, New York, 1947; Willamette University, Salem, Oregon, 1948; Santa Barbara Museum of Art, 1948.

BUNDAS(Z) RUDOLPH E. (1911–) Painter, oil, watercolor, landscapes. Commercial artist. Lived in Seattle, Washington, 1943. Study: art fellowship in Europe. Professor of Art: Seattle University. Member: Puget Sound Group of Northwest Men Painters; Northwest Art Society. Exh: widely since 1933, receiving many awards.

BUNDY, PERDY G. Artist. Lived in Seattle, Washington, 1919.

BURBANK, ELBRIDGE AYER (E. A.) (1858–1949) Painter. Pupil: Chicago Art Institute. First professional job; *Northwest Magazine*, painting scenery along the route of Northern Pacific Railroad. Painted Indian portraits (1,200 works). Lived with the local tribes of the Pacific Coast as well as the Southwest. Personal friend of Geronimo and was only artist to paint him from life. His first exhibition of Indian portraits was in Philadelphia in 1897. His two major collections are in the Newberry Library and the Smithsonian Institution. His given Indian name was Many Brushes.

BURFITT, FRANK F. (1881–1955) Craftsman, mosaic in wood, without artificial coloring. Born in Newfoundland. Lived in Portland, Oregon. Active there from 1929 working in exotic wood mosaics portraying portraits, landscapes, ships. He also did stone mosaics and wood crafts. Member: American Artists Professional League. Exh: Golden Gate International Exposition, San Francisco, 1939; Oregon State Fair; Canadian Pacific Expo, Vancouver, B.C., 1940.

BURGESS, HENRIETTA (1897–) Painter. Writer. Teacher. Lecturer, Oriental designs & textiles. Lived in Seattle, Washington, 1933. Study: Wong of Tsing Hua, Peking, China. Member: Northwest Printmakers.

BURKHART, HELEN SOVEREIGN (1909–) Painter, watercolor, tempera. Born in Quebec. Lived in Wenatchee, Washington, 1940. Pupil: Washington State College, Pullman. Exh: Seattle Art Museum, 1932.

BURKHEIMER, LENA W. (1877–) Painter. Lived in Seattle, Washington, 1925. Member: Seattle Fine Art Society.

BURKMAN, ELSIE H. Painter, watercolor. Lived in Seattle, Washington, 1949. Exh: Seattle Art Museum.

BURLEY, JOSEPHINE Painter. Lived in Ellensburg, Washington, 1948. Exh: Pacific Northwest Art, Spokane.

BURLINGAME, PRICE (1913–) Painter, oil. Born in Missouri. Lived in Owsego, Oregon, 1940. Pupil: Reed College, Portland; Museum Art School, Portland. Director of Art, Crook County High School, Prineville, Oregon.

BURN, DORIS Painter, watercolors, drawing, pen & ink. Illustrator. Born in Portland, Oregon. Pupil: University of Oregon; Hawaii; Washington. Living on Waldron Island in the Puget Sound in the 1960's in a very rustic lifestyle. Her home there has no run-

ning water, no electricity or telephone. She has illustrated many children's books.

BURNLEY, JOHN EDWIN (1896–) Painter, oil, portraits. Commercial artist. Teacher. Born in Victoria, B.C. Lived in Seattle, Washington, 1941. Pupil: Tadama; Ziegler. Founded the Burnley School of Fine Art in Seattle. Member: Northwest Watercolor Society.

BURNS, DORA E. Artist. Lived in Seattle, Washington, 1910.

BURNS, FANNY DIKE Painter, oil, pastel. Printmaker. Born in Illinois. Lived in Boise, Idaho in 1940. Pupil: Chicago Art Institute; Chicago Academy of Fine Arts. Charter member: Boise Art Association.

BURNS, MILTON (1853–1933) Painter. Illustrator. Engraver. He was a sailor/artist aboard his studio boat. Work: Arctic Expedition 1869; National Academy of Design, with J. G. Brown. Illustrated for *Harper's*. Friend of Winslow Homer.

BURR, ALFRED B. (1854–1942) Painter. Engraver; *The West Shore* magazine in the 1880's. Born in Connecticut. Lived in Seattle, Washington, 1901–19. Employed by the Portland *Oregonian* newspaper 17 years.

BURTON, RALPH WILLIAM (1905–1984) Painter, landscapes, portraits, harbors. Canadian artist.

BUSH, AGNES SELENE, Painter. Seattle, Washington, 1926. Pupil of Ella S. Bush; Paul Gustin.

BUSH, BEVERLY Sculptor. Pupil: University of Washington; National Academy of Design; Art Students League. Exh: Seattle Art Museum; Audubon Artists. National Association of Women Artists, 1958.

BUSH, ELLA SHEPARD (1863–1948) Painter, oil, miniatures, por-

traits. Born in Illinois. Lived in Seattle in 1888; Spokane in 1903. Founded the Seattle Art School in 1894. She took her students on sketching trips. Her classes for women were possibly the first in the area. Art studio in Seattle in 1907–12. Moved to California in 1916. Member: California Society Miniature Painters. Exh: silver medal, Alaska-Yukon Pacific Expo, Seattle, 1909. Major force in Seattle, forming the Conservatory of the Arts.

BUSH, HERBERT C. Painter. Member: Tacoma Art League, 1933.

BUSH, KATHRINE DAILY Painter. Lived in Seattle, Washington, 1935. Exh: Women Painters of Washington.

BUSHNELL, DELLA OTIS (1858–1960) Painter, oil, watercolor, portraits. Lived in Seattle, Washington. Pupil: J. L. Wallace. Member: Women Painters of Washington, Seattle, 1937. Exh: Seattle Art Museum; Grant Gallery, New York, 1938–39.

BUSSELL, LOUISE E. Painter, oil. Lived in Tacoma, Washington, 1928. Exh: Washington State Arts & Crafts.

BUTLER, BESSIE SANDERS Painter, oil, watercolor. Lived in Seattle, Washington, 1910. Exh: Washington State Arts & Crafts.

BUTLER, HOWARD RUSSELL (1856–1934) Painter, portraits, landscapes, marines. A New York City attorney. Primarily an Eastern painter he accompanied the U.S. Naval Observatory Expedition to Baker, Oregon, in 1918 to paint the June 8 solar eclipse. He produced many landscapes and marine scenes while in Oregon.

BUTLER, JENNIE B. Artist. Lived in Seattle, Washington, 1918.

BUTLER, JOHN D. (1890–) Painter, oil, watercolor. Printmaker. Pupil: University of Washington, Seat-

tle. Studied in Munich; Paris; New York. Member: Society of Washington Artists; Washington Watercolor Club.

BUTLER, MAUDE KIMBALL (1880–1963) Painter, watercolor. Teacher to 1935. Member: Vancouver, (WA) Art Group. Mainly self-taught. Her daughter became a congresswoman from Washington.

BUTMAN, FREDERICK A (1820–1871) Painter. One of the first artists in the West to devote himself exclusively to landscapes, he sketched in Yosemite and in Oregon's Columbia River area in the 1860's traveling a thousand miles up the river. Said to be a showy painter selling his landscapes in California for as much as $8,000 in gold. Traveled to Europe in 1869.

BUTTE, ANNIE (1925–) (WIFE OF BRUCE W. BUTTE) Painter, oils, watercolor, acrylic, primitive style. Teacher. Born in Southern California. Living in Jacksonville, Oregon. Pupil: Art Center College of Design, Los Angeles; Art Students League, New York.

BUTTE, BRUCE WALLACE (1920–) Painter, watercolor, oil. Teacher, workshops nationally. Born

in Seattle Washington, 1920. Living in Jacksonville, Oregon, (1992). Member: Puget Sound Group of Northwest Men Painters; Bohemian Club, San Francisco; Northwest Watercolor Society; Jacksonville Art Alliance; Past-president, Society of Communication Arts, San Francisco; National Society of Illustrators; Aspen Colorado Design Conference, charter member. Exh: Seattle Art Museum, 1940; Salem, (Ore.) Art Museum.

BUTTERWORTH, ELLEN Painter. Photographer. Lived in Seattle, Washington, 20th century.

BUTTS, WALTON FRANCIS (1922–) Printmaker, silkscreen. Lived in Hoquiam, Washington, 1975. Pupil: University of Washington.

BYERS, MARYHELEN (1902–) Painter, oil, watercolor. Pupil: L'Hote, Paris. Member: Seattle Society Fine Arts, 1933. Exh: Seattle Art Museum, 1934. Professor of Painting, University of Washington, Seattle.

BYHAM, DONALD M. Painter, watercolor. Lived in Seattle, Washington, 1949. Exh: Seattle Art Museum, 1949.

—C—

CADENASSO, GIUSEPPE LEONE (1858–1918) Painter, landscapes, plein-air. Important California artist working in and around San Francisco. Exh: Alaska-Yukon Pacific Expo, Seattle, 1909, gold medal.

CAHILL, ARTHUR JAMES (1878–1970) Painter, portraits. Illustrator. Caricaturist. Born in San Francisco, California. He worked as an illustrator for San Francisco newspapers. Art ed-

itor for *Sunset Magazine*. Painted in Northern California and Oregon where he died at 91 years of age.

CALDER, ART (1893–) Painter, oil. Born in London. Lived in Vancouver, B.C., 1940. Pupil: Collins-Baker, London; Frederick H. Varley and James Macdonald, Vancouver. Exh: B.C. Artists Exhibtion, 1935–38.

CALDER, WILLIAM Painter. Lived in Vancouver, B.C., 1930's. Winner: Emily Carr Scholarship.

CALDWELL, EDNA MAE Artist. Lived in Tacoma, Washington, 1925.

CALLAHAN, KENNETH (1907–1986) Painter, oil, watercolor. Writer. Lived in Seattle, Washington. Member: Group of Twelve; Puget Sound Group of Northwest Men Painters; Artists Council; Northwest Printmakers. Exh: Annual Exhibition of Northwest Artists 1925, 1934, 1935; Whitney Museum of American Art; Museum of Modern Art, New York; Walker Gallery, New York; Corcoran Art Gallery, Washington, D.C.; New York World's Fair, 1939; Golden Gate International Expo, San Francisco, 1939. Author: *Seattle Times*, Magazine of Art News; Art Digest. Curator: Seattle Art Museum.

CALLOWAY, ADA Painter, pastel. Lived in Snohomish County, Washington, 1909. Exh: Alaska-Yukon Pacific Expo, Seattle, 1909.

CALVERT, FRANK Painter. Part of an art colony in Bellevue, Washington, at the beginning of the 20th century. The Beaux Arts community disappeared after 1909.

CAMBELL, CHARLES Painter, landscapes. Lived in Sacramento, California, in 1865 painted the mountain scenery of Northern California and Oregon.

CAMBERN, MURIAL H. (1883–1975) Painter, oil, murals. Drawings, pen & ink. Born in England. Lived in Tacoma, Washington, 1925. Illustrator for the Tacoma Times. Painted murals for the Garden Terrace, Winthrop Hotel, Tacoma.

CAMERON, CRISSIE (1877–1951) Painter, watercolor, still life, harbor scenes. Born in Canada. Lived in Tacoma, Washington, 1941. Teacher: Tacoma primary & secondary schools for 47 years, retired in 1942. Pupil: Stanford University; Edgar Forkner, Seattle. Member: Women Painters of Washington. Exh: Seattle Art Museum; Paris and London.

CAMERON, DONALD STEWART (1866–) Painter, oil, watercolor, pastel. Born in Scotland. Lived in Victoria, B.C., 1940. Pupil: South Kingston Art Institute. Exh: Northern Art Society, Scotland; many times in Victoria and Vancouver.

CAMERON, JOSEPHINE E. (1925–) Painter. Pupil: Portland Museum Art School; Seattle College. Award: Alaskan Exhibition, 1957, Anchorage. Work: Henry Gallery, University of Washington, Seattle; Sandy High School, Sandy Oregon.

CAMERON, KATE Painter. First teacher at the Museum Art School in Portland, Oregon, 1909.

CAMFFERMAN, MARGARET GOVE (1881–1964) Painter, oil, watercolor, pastel. Born in Minnesota. Lived in Langley, Whidbey Island, Washington from 1915. Pupil: André L'Hote, Paris; Robert Henri. Member: Seattle Group of Twelve; Women Painters of Washington; Northwest Academy of Arts. Exh: Seattle Art Museum; Palace of the Legion of Honor, San Francisco; San Francisco Museum of Art; Portland Art Museum; Municipal Art Committee Show, New York. With her husband, founded the art colony "Brachenwood" on Whidbey Island.

CAMFFERMAN, PETER MARIENUS (1890–1957) Painter, oil, watercolor. Printmaker, etching, wood engraving. Teacher. Born in Holland. Lived in Langley, Whidbey Island, Washington from 1915. Pupil: André L'Hote, Paris. Member: Seattle Group of Twelve; Northwest Academy of Arts. Exh: Seattle and Portland Art

Museums; Palace of the Legion of Honor, San Francisco; Museum of Modern Art, New York; Chicago World's Fair; Golden Gate International Expo, San Francisco, 1939.

CAMPBELL, ARLENE (1916–) Painter, oil. Teacher. Lived in Twisp, Washington, 1973. Painted the remaining mining and homestead buildings in the Methow Valley, Washington.

CAMPBELL, G. F. Artist. Lived in Seattle, Washington, 1907.

CAMPBELL, HELEN Printmaker, linoleum block. Sculptor. Ceramics. Born in Canada. Lived in Seattle, Washington, 1941. Pupil: University of Washington. Exh: Northwest Printmakers, 1940.

CAMPBELL, JANET Artist. Teacher. Lived in Spokane, Washington, 1941. Art instructor at the Spokane Art Center. WPA artist.

CAMPION, HOWARD Painter, portraits. He was the artist who painted the posthumous painting of General Edward Richard Sprigg Canby which was presented to his widow in 1873.

CANARIS, PATTI ANN (1919–) Painter. Pupil: Washington State University, Eastern Montana State, University of Montana, BFA (with honors). Work: fountain design for office center, Spokane, Washington, 1964. Award: Montague Commercial Artist of the Year, 1952.

CANFIELD, HELEN Painter, watercolor. Exh: Alaska-Yukon Pacific Expo, Seattle, 1909.

CAPLAN, IRWIN (1919–) Painter, oil, watercolor, ink. Sculptor. Born and living in Seattle, Washington, 1939. Pupil: University of Washington. Exh: Seattle Art Museum, 1939. Staff artist and cartoonist, *Seattle Star*.

CARDERO, JOSÉ (1768–) Painter. Born in Spain. Commissioned by the Spanish government to accompany Alejandro Malaspina's expedition in 1791 north from California. Returned to British Columbia in 1792 with expeditions led by Galiano and Valdez. Authored the *Relacion del Sutil y Mexicana* containing a written description of the B.C. landscape as well as many drawings.

CAREY, DORN J. Painter, watercolor. Lived in Pullman, Washington, 1949. Exh: Seattle Art Museum, 1949.

CAREY, ROCKWELL W. (1882–) Painter, oil. Printmaker. Born in Oregon. Lived in Portland, Oregon, 1940. Self-taught. Member: American Artists Professional League. Work: mural, public buildings in Northwest.

CARIGNANO, JOSEPH S. F. Artist. Lived in Yakima, Washington, 1918.

CARIUS, FRANZ Sculptor. Lived in Vancouver, B.C., 1950's.

CARL, OLIVE MALSTROM (1903– 1988) Painter, oil, watercolor, pastel. Printmaker. Born in Tacoma, Washington. Lived in Seattle, Washington. Pupil: Seattle Art Museum School; Brandt; O'Hara; Biazza; Tadama; Forkner. Member: Women Painters of Washington. Exh: Seattle Art Museum, 1937; Seattle Fine Arts Society, 1919. Owner and director, Olive Carl School of Art, 1936–76.

CARLANDER, ANNE Painter, oil. Lived in Seattle, Washington, 1949. Exh: Seattle Art Museum, 1949; Henry Gallery, University of Washington, 1951.

CARLISLE, A. H. (MRS.) Artist. Lived in Seattle, Washington, 1910.

CARLSEN, SOREN EMIL (1853– 1932) Painter. Born in Denmark. Settled in Chicago. Important American painter. He maintained a studio in

Boston and New York in 1886 moving to San Francisco the following year as Director of the School of Design. He returned to New York in 1891, penniless, to teach at the National Academy of Design, achieving success and recognition, gaining membership in the National Academy. Work: Frye Museum, Seattle, Washington; exhibited in most of the major museums in this country.

CARLSON, CARL W. Painter, oil. Contractor by profession. Lived in Spokane, Washington, 1928–1929.

CARLSON, EDNA P. Artist. Lived in Spokane, Washington, 1908.

CARLSON, HERBERT (1915–) Painter, watercolor. Graphic artist. Teacher: Cornish Art School, Seattle, Washington. Member: Puget Sound Group of Northwest Men Painters, 1953.

CARLSON, LLOYD L. Painter, watercolor. Employed by the Spokane American Engraving Company, 1947.

CARLSON, MARGARET MITCHELL (1892–) Illustrator. Shared a studio in Seattle, Washington with her teachers, Ella Bush and Gertrude Little. Pupil: National Academy of Design; The Art Students League in New York. Eventually moved to California.

CARLSON, SIDNEY M. Painter, oil. Exh: Seattle Art Museum, 1934.

CARMICHAEL, FRANKLIN (1890–1945) Painter, Canadian mountain landscapes, national parks. Engraver. Member of the Canadian Group of Seven.

CARNIN, PHILLIP K. (1884–1976) Painter. Lived in the Northern California town of Mount Shasta for most of his life painting the mountain landscapes of Shasta and the Siskues in Oregon.

CARPENTER, JOSEPH (1828–1911) Painter, watercolor. Teacher. Came to British Columbia as a fugitive from the law in England in 1889. Joined the Benedictine Order at St. Martins College, in Lacey, Washington. Teacher of music and art.

CARPENTER, LEBBEAUS ROSS J. (–1957) Painter, oil, watercolor. Illustrator. Lived in Burton, Washington. Pupil: F. Tadama; E. Forkner. Also lived and worked in Los Angeles. Member: Vashon Island Artists.

CARPENTER, LOUISE M. (1867–1963) Painter, oil, watercolor, landscapes. An important California landscape artist she spent summers with relatives in British Columbia where she painted scenes of that area and the local Indians in oils and watercolors. Exh: Alaska-Yukon Pacific Expo, Seattle, 1909. Work: Oakland Museum; Golden Gate Park Memorial Museum. Member: Carmel Art Association; several others.

CARPENTER, WILLIAM J. Artist. Photographer. Lived in Spokane, Washington, 1907–09.

CARR, EMILY (1871–1945) Painter, oil, watercolor. Engraver. Writer. Born in Victoria, B.C. Work: most major art galleries of Greater Victoria, B.C.; Vancouver, B.C. Art Gallery; National Gallery of Canada. Pupil: San Francisco School of Art, with Lorenzo Latimer. Member: Canadian Group of Painters. Her works depict Canada's Northwest Coast Indian Life, pleine-air landscapes of the forests, mountains. One of the most important artists in the Pacific Northwest.

CARROLL, MRS. FRANK (See MARYHELEN BYERS)

CARSTENS, PAUL M. Artist. Lived in Parkland, Washington, 1907.

CARTER, DUDLEY (1892–) Sculptor. Craftsman. Lecturer. Lived in Bellevue, Washington, 1989. Pupil: Dudly Pratt; Seattle Art Institute, where he took charge of the life classes; Cornish Art School, Seattle. Member: Seattle Art Museum; Carmel Art Association. Exh: Seattle Artists League, 1931; Seattle Art Museum. WPA. Best known for his redwood sculptures, often of Indian motifs.

CARTER, MARGARET H. (1911–) Painter, oil. Drawing, conte crayon, watercolors. Teacher. Born in Vancouver, B.C. Pupil: Vancouver School of Art, member of the graduating association. Exh: B.C. Artists' Exhibition, silver medal for mural decoration, 1934; solo show, Vancouver Art Gallery 1938, drawings and watercolors. Exh: Seattle Art Museum.

CARTWRIGHT, CHARLOTTE Painter, oil, watercolor. Chinapainter. Lived in Seattle, Washington, 1980. Pupil: Leon Derbyshire, 1947. Member: Women Painters of Washington. Exh: Frye Museum; local shows.

CARY, WILLIAM de la MONTAGNE (1840–1922) Painter. Important western genre painter. Illustrator for *Harper's* and *Leslie's* when he was only 20. Took off from New York to the West in 1860 traveling by boat and wagon train to Fort Benton (that was captured by Crow Indians). He left with two other young men traveling west 300 miles meeting up with a railway survey team that took them to Portland, Oregon. Sketching the entire way, he spent the rest of his life painting the West.

CASE, HARRIET M. (1877–1955) Painter, watercolor. Craftswoman. Graphic Artist. Lived in Seattle, Washington. Pupil: University of Washington. Member: Women Painters of Washington.

CASEY, JOHN JOSEPH (1931–) Sculptor. Teacher. Pupil: University of Oregon; California College of Arts & Crafts. Work: University of Oregon, Eugene; State of Oregon, Salem & Pendleton. Exh: Portland Art Museum; Denver Art Museum; Cheney Cowles Museum, Spokane; Seattle Art Museum. Many awards.

CASKEY, JULIA (1909–) Printmaker. Lived in Seattle. Pupil: Cornish Art School, Seattle; University of Washington. Member: Northwest Printmakers, 1940.

CASPER, ELIZABETH (1909–) Painter, watercolor, still lifes. Exh: Alaska-Yukon Pacific Expo, Seattle, 1909.

CASTRO, ROBERT DE Sculptor. Lived in Vancouver, B.C., 1950's.

CATLIN, GEORGE (1796–1872) Painter. Author. Adventurer. Although mainly famous for his depictions of the North American Indians his works are also included in *The Oregon Trail* guide series. He traveled the world tenaciously painting the Native American before civilization changed them forever. He traveled over the Andes to Peru, took passage for San Francisco. Without pause, he continued to the Aleutians and Siberian Kamchatka. He painted seagoing canoes and native houses. He climbed the Mountain on Fire. On the return voyage, he painted the Northwest coastal tribe of Nayas at Smith's Inlet. The Skidegates, Stickeens, Bellas and Hydas all knew the name of Catlin. He had become a legend among the remotest tribes. With the grounding of the schooner on Victoria Island, he hiked overland to Victoria, B.C. and from there embarked for Astoria ascending the Columbia River to The Dalles, Oregon. Wearying of painting the local tribes he bought horses and headed up the Snake River

to paint the Crows. Though his white world had rejected him, these warriors danced with delight at his coming. He returned to Portland, took a steamer to San Diego and headed inland for an Apache village near La Paz.

CATLIN, MINNIE Painter. Member: Tacoma Art League, 1891.

CATTLE, M. D. (MRS) Artist. Lived in Seattle, Washington, 1910.

CAUGHLAN, ORLIN (1891–1985) Painter, oil. Work: Washington State Historical Society Tacoma.

CAUTHORN, JESS DAN Painter, watercolor. Teacher. Owner, manager, Burney School Fine Art. Member: Puget Sound Group of Northwest Men Painters, 1947; American Watercolor Society. Exh: Seattle Art Museum, 1947, 1949.

CAWTHORN, JOAN Painter. Watercolor. Pupil: Oregon College of Art. Member: Women Painters of Washington; Northwest Watercolor Society.

CEDRO, A. Painter. Lived in Medford, Oregon, 1909. Somewhat primitive folk art landscapes of the Northwest including Alaska. Exh: Kennedy Gallery, New York.

CELENTANO, FRANCIS (1928–) Painter, abstractist. Awarded The Fulbright Scholarship for Rome. Teacher. Exh: Whitney Museum, New York. Work: murals, Port of Seattle; Seattle-Tacoma Airport.

CHALK, PAUL W. (1918–) Painter, oil. Lived in Spanaway, Washington. Mainly self-taught.

CHAMBERLAIN, SAMUEL V. (1895–1975) Printmaker. Author. Pupil: University of Washington School of Architecture; Ecole des Beaux Arts, Paris; Royal College of Art, London. Member: Society of American Etchers; National Academy of Design, New York. Exh: Metropolitan

Museum of Art, New York; museums all over the world. He spent his early years in Washington State where he lived in the lumbering town of Aberdeen.

CHAMBERS, H. Painter, oil. Lived in Ellensburg, Washington 1946. Exh: Seattle Art Museum, 1946.

CHAMPNEY, EDWARD FRERE Painter. Architect. Lived in Seattle, Washington, 1926. Member: San Francisco Art Society.

CHAPIN, CHAP Artist. Lived in Spokane, Washington, 1901.

CHAPIN, MARGUERITE Artist. Lived in Seattle, Washington, 1902.

CHAPLIN, EDITH M. (1887–1967) Commercial artist. Lived in Tacoma, Washington.

CHAPLIN, JAMES P. Painter. Designer. Lived in Seattle, Washington, 1921.

CHAPMAN, EDWARD Artist. Teacher. Pupil: F. H. Varley; Vancouver, B.C. Art School, 1930's.

CHAPMAN, MARY Artist. Pupil: F. H. Varley; Vancouver, B.C. Art School, 1930's.

CHAPPELL, BERKLEY WARNER (1934) Painter, abstract expressionism. Printmaker. Work: San Francisco Museum of Art; Henry Gallery, University of Washington, Seattle; Tacoma Museum of Art; University of B.C., Vancouver.

CHARLES, ROSALIA Artist. China painter. Lived in Spokane, Washington, 1913–17.

CHASE, CLARA L. Artist. Lived in Seattle, Washington, 1914.

CHASE, CORWIN WENDELL (1897–1988) Painter, oil, watercolor, pastel, landscapes, seascapes. Printmaker, woodcuts. Born in Seattle,

Washington. Lived in Vaughn, Washington. Mainly self-taught. Specialty: multi-colored block print scenes of Oregon and Washington. A Thoreauian by nature he lived in a cabin he built himself. Exh: Washington State Historical Society, 1964; Tacoma Public Library.

CHASE, DORIS TOTTEN Painter, oil, watercolor. Sculptor. Member: Women Painters of Washington. Exh: Seattle Art Museum, 1949; Henry Gallery, University of Washington, Seattle, 1959; Northwest Watercolor Society, 1960.

CHASE, WALDO S. (1895–1988) Printmaker, woodblock. Teacher. Born in Seattle, Washington. Lived in Union, Washington. Designed tepees installed around the Northwest. Mainly self-taught. He and his brother, Wendell, lived and worked out of their self-designed teepees that they moved around the Northwest mountains.

CHENEY, NAN LAWSON (1897–) Painter, oil, watercolor. Drawing. Lived in Vancouver, B.C. Member: B.C. Society of Fine Arts. Exh: National Gallery, Ottawa, 1932; Vancouver Art Gallery, 1937–1940. Close friend of Emily Carr.

CHENOWETH, J. A. (20th century) Painter. Lived in Salem, Oregon, 1913.

CHENOWITH, WILLIAM B. Painter. Lived in Seattle, Washington, 1945. Exh: Seattle Art Museum, 1945.

CHESHIRE, CRAIG GIFFORD (1936) Painter, Teacher. Pupil: University of Oregon; David McCosh. Work: Museum of Art, Eugene. Exh: Northwest Artists Annual, Seattle; Artists of Oregon; Northwest Painters, Smithsonian Institute, Washington, D.C.

CHESNEY, LETITIA (1875–) Painter, Craftsperson. Born in Kentucky. She lived in the town of Winslow on Bainbridge Island in Washington's Puget Sound from 1929–1933. Pupil: Sawyer; N.Bentz. Member: Seattle Art Institute. Work: Queen Anne Hill Branch Library, Seattle.

CHESNEY, MARY (1872–) Painter. Craftsperson. Teacher. Lived on Bainbridge Island in the Puget Sound, Washington. Member: Seattle Art League. Work: Queen Anne Hill Library, Seattle, 1940. Work: Alaska-Yukon Pacific Expo, Seattle, 1909.

CHESSE, RALPH (1900–1991) Painter, murals. Born in New Orleans. He came to California in 1923 settling in San Francisco. He died in Ashland, Oregon at the age of 91. In 1934, he became a WPA artist painting frescoes in Coit Tower, "Playground". A modern colorist.

CHESTER, CHARLOTTE WANETTA Painter. Printmaker. Pupil: Pennsylvania Academy of Fine Arts; numerous workshops in United States; Europe. Work: Smithsonian Institute, Washington, D.C. Award: too numerous to mention. Member: Allied Artists, Spokane; Washington Art Association.

CHEW, ALICE M. Painter, oil, watercolor. Lived in Seattle, Washington. Exh: San Francisco Art Society, 1908.

CHIDESTER, EDITH Painter, oil, landscapes. Lived in Spokane, Washington, 1905.

CHILBERG, GUS Painter, oil, landscapes. Lived in Everett, Washington, 1925.

CHILSTROM, BETTY (circa 1931) Painter. Exh: Annual Oregon Exhibition, 1948.

CHILSTROM, GLADYS (1897–1988) Painter, oil, landscapes. Lived

in Portland, Oregon. Charter member: The Oregon Society of Artists.

CHIN, ANDREW N. (1915–) Painter, watercolor, landscapes. Teacher. Illustrator for Boeing Aircraft. Born in Seattle, Washington. Member: Puget Sound Group of Northwest Men Painters, 1946; Northwest Watercolor Society. Exh: Seattle Art Museum: Frye Museum, Seattle; Chinese Art Club.

CHINN, CALVIN F. V. Painter. Draftsman. Lived in Seattle, Washington, 1951. Member: Puget Sound Group of Northwest Men Painters, 1946.

CHITTENDEN, ALICE BROWN (1859–1944) Painter, portraits, florals. Began her studies at the School of Design in San Francisco in 1877 and later taught there for over 40 years. Primarily a California artist she traveled widely in the United States and Europe. Award: silver medals, Lewis & Clark Expo, Portland, Oregon, 1905; Alaska-Yukon Pacific Expo, Seattle, 1909.

CHONG (MR. FAY) (1912–) Painter, watercolor, Chinese ink, murals. Printmaker. Born in China. Lived and died in Seattle, Washington. Pupil: Leon Derbyshire; Mark Tobey, Washington. Exh: Philadelphia; Oakland; Seattle Art Museum; Northwest Printmakers, 1940. WPA artist.

CHOY, TERENCE TIN-HO (1941–) Painter. Teacher. Born in Hong Kong. Pupil: University of California, at Berkeley; Elmer Bishoff; David Hockney. Work: Alaska State Museum, Juneau; University of Alaska, Anchorage & Fairbanks; many others. Teacher: Art Instructor, De Young Museum Art School. Professor of Art, University of Alaska.

CHRISTENSEN, TED, JR. (1911–) Painter, oil. Modeling in clay. Lived in

Vancouver, Washington. Pupil: Clyde Keller. Member: Oregon Society of Artists; Fine Arts Hobbies Club, Vancouver; Vancouver Art Fair. Exh: Oregon Artists, Meier & Frank, 1937.

CHUBB, FRANCES FULLERTON (1913–) Painter. Teacher. Engraver. Pupil: College of Puget Sound; George Heuston. Member: Tacoma Art Association; Tacoma Artists Guild. Illustrated, *Lumber Industry in Washington*, 1939. Teacher: College of the Puget Sound. Exh: Seattle Art Museum, 1939–42.

CHURCH, ELSIE (1897–) Painter, oil, watercolor. Modeling in clay. Born in Canada. Studied in England. Lived in Seattle, Washington, 1944.

CHURCH, FAY HOFFMAN Painter, portraits, landscapes, post-impressionist style. Lived in Lake Oswego, (Portland) Oregon, 1940's-50's. Pupil: College of Fine Arts, Syracuse University; Paris; many other schools in the United States.

CHURCH, FREDERIC EDWIN (1826–1900) Painter, landscapes. Illustrator. Important American artist. Pupil: Chicago Academy of Design; Art Students League, New York; National Academy of Design. Work: Metropolitan Museum of Art. Traveled extensively in the Far North, Arctic. "The Icebergs", "Aurora Borealis" are some of his more famous works.

CHURCH, STUART HOFFMAN (1931–) Painter, expressionist, abstracts. Born in Massachusetts. Spent his youth in Portland, Oregon, where he exhibited at 14 years of age. He studied and exhibited in Italy among other European countries. Son of artist Fay Hoffman Church.

CHURCHILL, CARRIE E. Artist. Lived in Spokane, Washington, 1926–29.

CHURCHILL, E. T. Artist. Lived in Seattle, Washington, 1907.

CIANCI, VITO Painter, British Columbia landscapes. Pupil: Vancouver, B.C. Art School, 1928. An outdoor plein-air artist.

CLAGUE, JAMES T. Commercial artist, watercolor. Lived in Seattle, Washington, 1920–24. Engraver for Seattle Engraving Company.

CLAPP, CHARLOTTE I. Painter, oil. Lived in Medina, Washington, 1934. Member: Women Painters of Washington, 1934–40.

CLAPP, W. H. (1870–1954) Painter. Born in Montreal. Raised in Oakland, California. Pupil: Brymners, Montreal, Exh: Salon d'Automne, Paris. Settled in Oakland and in 1918 became curator of the Oakland Art Gallery. Was one of the founders of the Society of Six in California in 1923, never returning to Canada.

CLARK, ALLAN (1896–1950) Painter. Sculptor. Architect. Teacher. Pupil: George Z. Heuston; Art Students League, New York; the Far East. Work: 18 terra cotta figures & 3 lifesize stone figures for the University of Washington Library. Exh: Tacoma Art League, 1916; Seattle Art Museum; in the United States and abroad. He eventually settled in Santa Fe, New Mexico, where he was a member of the Santa Fe Painters and Sculptors.

CLARK, EMMA A. Artist. Lived in Seattle, Washington, 1917.

CLARK, HARRISON Painter. Lived in Tacoma, Washington, 1925. Member: Tacoma Fine Arts Association.

CLARK, HERBERT Artist. Lived in Seattle, Washington, 1929.

CLARK, HOMER W. Painter. Lived in Seattle, Washington, 1934.

CLARK, KAY CUNNINGHAM (1916–) Painter, oil, watercolor, pastel. Printmaker. Photographer. Born in Seattle, Washington, lived on Vashon Island, Washington, 1941. Pupil: University of Washington. Member: Women Painters of Washington; Bainbridge Island Camera Club. Exh: Seattle Art Museum, 1936–38.

CLARK, LOYAL Artist. Lived in Spokane, Washington, 1925.

CLARK, LUCILLE (1897 –) Painter, watercolor. Craftsperson, weaving. Born in Boulder, Colorado. Lived in Issaquah, Washington, 1958. Pupil: University of Washington, Seattle. Exh: Seattle Art Museum, 1937, 1939.

CLARK, MAVIS L. Painter, oil. Exh: Puget Sound Group of Northwest Men Painters, 1951; Tacoma Art League.

CLARK, R. F. Painter. Lived in Portland, Oregon, 1933.

CLARK, RUTH JACOBSON (1876–1958) Painter, oil, still lifes, landscapes. Born in Michigan. Lived in Tacoma, Washington, 1951. Self-taught. Member: Tacoma Art League. Exh: Washington State Historical Society, solo show, 1945.

CLARK, WILLIAM GIBBONS Commercial artist. Lived in South Yakima, Washington, 1941.

CLARKE, FRANK (1885–1973) Painter. Lived in Glenns Ferry, Idaho. Teacher. Pupil: Chicago Art Institute.

CLAUSEN, G. BURRIDGE (1908–) Sculptor. Pupil: Museum Art School, Portland, Oregon. Exh: Portland Art Museum; Seattle Art Museum; Western Washington Fair, Puyallup.

CLAUSEN, PETER Painter, oil, watercolor, landscapes. Lived in Tacoma, Washington, 1907.

CLAUSSEN, ESTELLE Painter, oil. Etcher. Lived in Everett, Washington, 1932. Member: Women Painters of Washington, 1931, 1932.

CLAYES, ALICE DES (1890–) Painter, Canadian coastal, horses, farms.

CLAYES, BERTHA DES ARCA (1877–) Painter, pastel, Canadian farms, landscapes, children, genre.

CLEAVER, MABEL (1878–) Painter, oil, watercolor. Pupil: Maude Wanker; California College of Arts and Crafts, Oakland. Settled in La Grande, Oregon. Exh: American Artists Professional League; Portland Art Museum, 1944.

CLEELAND, DAVID Painter. Lived in Redmond, Washington, 1924.

CLEMENT, CATHERINE (1881–) Painter. Lived in Portland, Oregon, 1915.

CLEMMER, FRANCIS SHERWOOD (1908–) Painter. Graphic artist. Designer. Sculptor. Born in Yakima, Washington. Lived in Seattle, Washington, 1941. Pupil: University of Washington, Seattle. Industrial designer, Boeing Aircraft Company.

CLEMMER, GEORGIA M. (1908–) Painter, oil, pencil. Designer. Decorator. Born in Cle Elum, Washington. Lived in Seattle, Washington, 1941.

CLIFFORD, JANE BILLAUX (1903–) Painter, oil. Lived in Vancouver, B.C. Born and studied in London, England. Exh: honorable mention, B.C. Artists Exhibition, Vancouver, 1935, 1936.

CLIFTON, WINNIFRED G. Painter, watercolor. Lived in Seattle, Washington, 1946–57. Exh: Seattle Art Museum, 1946.

CLINGENPEEL, C. Painter, watercolor, still lifes.

CLISE, JOCELYN (1923–) Painter. Engraver. Lithographer. Born in Seattle, Washington. Pupil: University of Washington: Cornish Art School, Seattle. Exh: Northwest Printmakers, 1945.

CLOGSTON, EVELYN BELLE (1906–) Painter. Teacher. Member: American Artists Professional League, many awards with this association. Exh: Salem, Oregon State Fair.

CLOSE, MARJORIE PERRY (1899–1978) Painter, oil. Lecturer. Pupil: California School of Fine Arts; University of California; Chicago Art Institute; San Francisco Art Institute. Exh: National Association of Women Artists; National Academy of Design; solo shows, Frye Museum, Seattle, Washington, 1971–73.

CLOTHIER, ROBERT Sculptor. Lived in Vancouver, B.C., 1950's.

CLYMER, JOHN FORD (1907–1989) Painter, oil. Illustrator. Lived in Ellensburg, Washington. Pupil: Vancouver (B.C.) School of Art; Grand Central Art School with F. H. Varley; N. C. Wyeth; New York Society of Illustrators Hall of Fame, 1982. Member: Cowboy Artists of America; National Academy of Western Art. His first illustrations were done for Canadian magazines followed by *The Saturday Evening Post* (more than 80) and *Field & Stream*. He retired from illustration after 40 years to paint the history of the West retracing the steps of Lewis & Clark following the Oregon Trail. Painting the Northwest brought him more fame than 40 years of illustration.

CLYNCH, CAREN Painter, oil. Lived in Seattle, Washington, 1952. Exh: Seattle Art Museum, 1946.

COAN, HELEN E. (1859–1938) Painter, oil, watercolor, Mexican and

Chinese genre, missions and California adobes. Illustrator. Pupil: Art Students League, New York, with William M. Chase. Settled in Los Angeles in 1884 where she taught at the Art Students League. Award: medals, Alaska-Yukon Pacific Expo, Seattle, 1909.

COAST, OSCAR REGAN (1851–1931) Painter, landscapes. Born in Salem, Oregon when it was recovering from the Gold Rush depletions. Worked "plein-air" in California specializing in desert scenes. Died in Santa Barbara.

COATES, ROSS ALEXANDER (1932–) Painter. Art Historian. Pupil: University of Michigan; Chicago Art Institute; New York University, MA & PhD. Work: many public commissions nationally and in the Northwest. Chairman, Department of Fine Arts, Washington State University, 1977.

COBLENTZ, GEORGE WILLIAM (1896–1973) Painter. Designer. Teacher. Cartoonist for the *Los Angeles Evening Herald*, 1923. Born in Vaughn, Washington, died in Van Nuys, California. Exh: solo show, Washington State Historical Society Museum, Tacoma. He traveled widely and painted in every state in the United States.

COCHRAN, BERYL OTIS (1904–) Painter. Born in Monterey, California. Pupil: M. DeNeale Morgan in Carmel. She spent her summers painting in her Vancouver Island family home in British Columbia. Her paintings include landscapes, old adobes, cypress trees, marines and coastals of the Monterey Peninsula in British Columbia. Member: Carmel Art Association; Royal Vancouver Art Association.

COCKING, MAR GRETTA (1894–) Painter, oil, watercolor. Born in Wisconsin. Pupil: University of Oregon,

Eugene; Chicago Art Institute; California College of Arts and Crafts. Exh: Portland Art Museum, 1935. Head of Art Department, Spearfish, South Dakota Normal School.

CODE, ERNVA WILLARD (1900–) Painter, oil. Craftsperson, batik, puppetry. Member: B.C. Society of Fine Arts, Vancouver. Exh: Royal Canadian Academy; Canadian National Exhibition, Toronto; Seattle Art Museum; Vancouver Art Gallery.

COGSWELL WILLIAM F. (COGGSWELL) (1819–1903) Painter, portraits. In 1887 the people of Portland commissioned him to execute a portrait of Dr. John McLoughlin, which was formally presented to the Oregon Pioneer Association in 1887.

COLBORNE, ELIZABETH ALINE Painter, watercolor. Printmaker. Teacher. Designer. Lived in Bellingham, Washington, 1941. Pupil: Rockwell Kent; Robert Henri. Member: National Association of Women Painters; American Watercolor Society. Considered to be the first producing artist in the Northwest region of Washington State.

COLBURN, ROBERT L. Artist, Lived in Longview, Washington, 1930.

COLDWELL, ARDATH (1913–) Painter, watercolor, landscapes. Sculptor. Born in Portland, Oregon then moved to Salem. Primarily a California artist, working in San Francisco since 1950, concentrating on watercolors and hand weaving.

COLE, ELIN (MRS.) Painter, oil, landscapes. Teacher. Lived in Centralia, Washington, 1932.

COLEMAN, ARTHUR PHILEMON (1852–1939) Painter, watercolor. Geologist. Teacher. Alpinist. Pupil: Cobourg College Institute; Victoria University, MA; University of Breslau, PhD. President of the Alpine

Club of Canada and author of many scientific papers. Coleman was an amateur watercolorist painting the Candian West.

COLEMAN, EDMUND THOMAS (1823–1892) Painter. Achieved reputation as an artist before arriving in Victoria, B.C. in 1863 as a gold seeker. Studied in London. Member: Tacoma Fine Art Association. Exh: Portland Art Museum; Seattle Art Museum. Produced a rare essay in 1868, "On The Beauties of the Scenery as Surveyed from Beacon Hill" which won a prize for the best essay on Beacon Hill's vista. Established a studio in Victoria traveling and sketching all over Vancouver Island and the coasts of Washington and Oregon. He climbed the mountain peaks of the Northwest lecturing and writing and illustrating his experiences.

COLLIER, ESTELLE E. (1880 or 81–) Painter, oil, watercolor, pastel. Member: Tacoma Fine Art Association. Designed Wallpapers.

COLLINGS, CHARLES JOHN (1848– 1931) Painter, watercolor landscapes, Canadian Coastal and woodland scenes combining the Asian perception of Hiroshige and the feel of Turner. Greatly honored in his time as one of the finest colorists of the day and was compared with Turner. Exh: Carroll Gallery, London, 1912; Royal Academy.

COLLINS, GEORGE B. (1834– 1905) Painter, mountain landscapes of Northern California and Oregon and missions scenes during 1889– 1905. Born in Delaware. Died in San Francisco.

COLLINS, JAMES A. Artist. Lived in Spokane, Washington, 1921.

COLLYER, LOUISE D. Painter, watercolor, china. Born in Newaukum, Washington. Lived in Tacoma, Wash-

ington, 1940. Member: Tacoma Fine Art League, 1915. Pupil: F. W. Southworth.

COLMAN, SAMUEL (COLEMAN) (1832–1920) Painter, West of the Hudson River School genre around 1870. He also collected oriental art and was a writer. Pupil: A. B. Durand, New York. Traveled and studied in Paris, Spain and Morocco. Exh: National Academy of Design, New York. Began a series of paintings in 1870 of Western subjects beginning with Medicine Bow and Yosemite Valley. He visited the Pacific Coast perhaps including Alaska around 1899.

COLP, LAURA B. Painter, oil, wild flowers, landscapes. Born in Newaukum, Washington. Maintained a studio in Tacoma, 1929–32.

COLYER, VINCENT (1825–1888) This artist served as special U.S. Indian Commissioner from the late 1860's to early 70's. He made many drawings including "On The Big Canadian River", 69. "The Home of the Yackamas, Oregon." Exh: Columbia River works, National Academy. He served as Indian Commissioner visiting tribes all over the United States and Alaska by 1871 during which time he made hundreds of sketches, watercolors some reproduced in Congressional reports and five Alaskan illustrations in *Harper's Weekly*.

COMFORT, CHARLES Painter, modernist, muralist. Lived in Vancouver, B.C. in the 1930's.

COMPTON, DAISY I. Artist. Lived in Spokane, Washington, 1911.

CONANT, LOUISE Painter, oil, watercolor. Lived in Pacific County, Washington, 1909. Exh: Alaska-Yukon Pacific Expo, Seattle, 1909.

CONAWAY, GERALD (1933–) Painter, Sculptor. Pupil: University of Washington, Seattle. Work: Anchor-

age Fine Arts Museum, Alaska; many public commissions in Alaska and the Northwest.

CONDON, GRATTAN (1887–) Painter. Teacher. Illustrator. Lived in Eugene, Oregon. Pupil: Los Angeles School of Art & Design.

CONDON, MARY E. Painter. Teacher. Lived in Tacoma, Washington, 1891. Member: Tacoma Art League, 1891.

CONDON, STELLA C. (1889–) Painter, watercolor. Born in Minnesota. Lived in Seattle, Washington, 1941. Pupil: Mark Tobey. Director: Childrens Free Creative Art School.

CONGER, JOHN R. D. (MAJOR) (1843–1912) Painter. Drawings, crayon, pencil. Known for his historical sketches of Tacoma and the Northwest Coast. A post Civil War Washington pioneer he was a purser on several coastal and Puget Sound steamers. Exh: Washington State Historical Society, 1982.

CONKLIN, KATE M. Artist. Lived in Spokane, Washington, 1916.

CONNOLLY, ANN A. Artist. Lived in Spokane, Washington, 1912.

CONRAD, NANCY R. (1940–) Painter, oil, acrylics. Pupil: Houston Museum of Fine Arts. Exh: Pacific Artists Show; Tacoma Museum of Fine Arts, Washington.

CONSER, HELEN LOUISE (1899–1980) Painter. Muralist. Teacher. Born in Portland, Oregon. Settled in San Francisco in the early 1930's. Member: Society of Western Artists.

CONVERSE, EVELYN SCHEDREN (1903–) Painter, sepia watercolor. Lived in Sandy, Oregon, 1940. Self-taught. Exh: Multnomah County Fair, Gresham Oregon.

CONE, FLORENCE M. CURTIS (20th century) Painter, landscapes, gardens. Lived in Seattle, Washington.

COOK, BLANCHE H. (see McLANE)

COOK, CLYDE BENTON (1860–1933) Painter. Teacher. Lived in Salem, Oregon, 1940. Studied in Germany. Member: Portland Art Club.

COOK, THERESA Artist. Lived in Spokane, Washington, 1913, 1915.

COOK, WALTER F. Artist. Painter. Lived in Seattle, Washington, 1921.

COOK, WILLIAM R. Artist. Lived in Spokane, Washington, 1889.

COOKE, CHARLES CLYDE BENTON (1860–1933) Painter, oil, landscapes. Commercial artist. Teacher. Pupil: Royal Academy, Germany. Work: Oregon Historical Society.

COOKE, JUDY HELEN (1922–) Painter. Teacher. Pupil: University of California at Berkeley; University of Oregon at Eugene, PhD. Work: Alaska State Museum, Juneau; Alaska Historical & Fine Arts Museum, Anchorage; Smithsonian Institute, Washington, D.C.

COOKE, MARIETTA A. Painter, watercolor. Teacher. Lived in Tacoma, Washington, 1892. Study: Annie Wright Seminary, Tacoma. One of its instructors in 1891. Member: Tacoma Art League, 1892.

COOKSON, STANLEY A. Commercial artist, oil. Lived in Seattle, Washington, in the 1930's. Painted a series of harbor scenes along the Pacific Coast from San Francisco to Vancouver Island.

COOLEY, MARION Artist. Lived in Everett, Washington, 1941.

COOLIDGE, MARY E. Painter, watercolor. Ivory miniatures. Lived in Seattle, Washington, 1918.

COOMBS, RAPHAEL (RAY)
Painter, watercolor. Sketched a portrait of Leschi and the Indian War of 1855. Listed in Washington State Historical Society pamphlet #3. Lived in Seattle, Washington, 1932.

COONS, MINNIE Artist. Lived in Spokane, Washington, 1913.

COOPER, ASTLEY DAVID MIDDLETON (1856–1924) Painter, Illustrator for Frank Leslie's Illustrated Newspaper traveling throughout the West. He became famous as a painter of the Old West and Indians. Settled in San Francisco and was in demand as a portraitist later moving to San Jose. Though he was capable of producing masterpieces, his work faltered badly because of alcoholism.

COOPER, ELIZABETH ANNE (1877–1936) Painter, marines, flowers. Lithographer. Printmaker. Woodblocks. Author. Craftsperson. Born in England. Lived in Seattle, Washington. Pupil: University of Washington: Mark Hopkins Art School, San Francisco. Member: Group of Twelve, Seattle, Washington. Exh: Palace of the Legion of Honor, San Francisco; Women Painters of Washington. Exh: Seattle Art Museum, solo show, 1936. Art Critic.

COOPER, FREDERICK G. (1883–1962) Cartoonist. Illustrator. Writer. Born in McMinnville, Oregon. Moved to San Francisco in 1902 where he was a member of the Salmagundi Club; Bohemian Club.

COOPER, JAMES DR. (1830–1902) Railway survey artist. Illustrator. Naturalist. Medical Doctor. Was commissioned by Governor Stevens of New York to act as doctor for the Pacific Railroad Survey Expedition for a northern route to the Pacific. He is credited with two publications, "Mt Rainier from Whitby's Island" & "Mt.

Rainier viewed from near Steilacoom and the Puget Sound". He was also a zoologist for the Geological Survey of California and produced a priceless collection of the natural history of California and Washington.

COOPER, NORMAN Artist. Lived in Vancouver, B.C. in the 1930's.

COPELAND, HELEN C. (1905–) Painter, oil, watercolor. Craftsperson, metal work. Lived in Portland, Oregon. Member: Oregon Society of Artists. Exh: Art Museum, Columbus Ohio.

COPELAND, PAUL WORTHINGTON (1899–1971) Painter, oil. Teacher. Writer. Lived in Seattle, Washington, 1970. Teacher for many years in Seattle public schools. Member: Puget Sound Group of Northwest Men Painters. Exh: Seattle Art Museum, 1949.

COPLEY, LAVENDE JUHL Painter. Lived in Spokane, Washington, 1950. Member: Washington Art Association.

CORBETT, CHRISTABEL Painter. Spokane, Washington, in the 1950s. Member: Washington Art Association.

CORBETT, JOSEPHINE GILMER Painter, oil, still lifes. Lived in Spokane, Washington, 1927. Exh: Tacoma Womens Club, 1921; Seattle Fine Arts Society, 1927; Spokane Art Club.

CORDERA/CARDERO, JOSE/JOSEF (1768–) Artist. Sketcher. Mapmaker. The book, *Malaspina in California*, published by John Howell Books, 1960 tells of the vessel's voyage to the Northwest Coast in 1791 during which Cordero made drawings from California to Vancouver, B.C. Island. A second voyage to Vancouver Island in which he executed at least 25 additional sketches of natives living on

the Island including maps of the region.

CORLEY, WARD Painter, oil, tempera. Lived in Seattle, Washington, 1949. Exh: Seattle Art Museum, 1949; Henry Gallery, University of Washington, 1951, 1959.

CORNFORD, ELAINE (1914–) Painter, oil, watercolor. Decorator. Printmaker. Sculptor. Born in Portland. Lived in St. Helens, Oregon, 1940. Pupil: Museum Art School, Portland, Oregon; Chouinard Art Institute, Los Angeles. Member: American Artists Professional League. Many first place prizes at the Oregon State Fairs in the 1930's. Exh: Allied Arts Festival, Los Angeles, 1936, 1937.

CORR, CECILIA G. (1914–) Painter, oil, watercolor, tempera. Drawing, pen & ink. Lived in Seattle, Washington. Member: Seattle Artists League. Exh: Seattle Art Museum, 1939. Pupil: Cornish Art School, Seattle; American Artists School, New York.

CORREA, FLORA HORST (1908–) Painter, oil, watercolor, acrylic. Born in Seattle, Washington. Lived on Mercer Island, 1986. Pupil: University of Washington, BA; Kenneth Callahan; Sergei Bongart. Work: Seattle First National Bank Collection; others. Exh: Puget Sound Area Exhibition; solo show, Frye Museum, 1976; University Oregon Invitationals; Northwest Watercolor Annual Seattle; Women Painters of Washington Annual.

CORRELL, RICHARD (1904–) Painter, oil, stencil air brush, murals. Printmaker. Born in Missouri. Lived in Seattle, Washington, 1941. Member: Washington Artists Union. Exh: Northwest Printmakers, Seattle, 1938, 1939; California Society of Etchers, San Francisco; Oakland Art Association; Museum of Modern Art (MOMA) New York, 1942.

CORY, FANNY YOUNG (1877– 1972) Painter, beaches. Illustrator. Cartoonist. Lived in Stanwood, Washington.

COSGROVE, STANLEY Painter. Lived in Vancouver, B.C., 1940's. Exh: Biennial of Canadian Painting.

COSTIGAN, NATALIE (1921–) Painter, oil, watercolor. Lived in Seattle, Washington, 1939. Exh: Seattle Art Museum, 1939. Pupil: Cornish Art School.

COUGHLAN, A. T. Painter. He is known to have painted in Oregon during the 1870's and 80's. Works: Mouth of the Willamette and The Steamers in the Willamette River at Portland.

COUGHLIN, T. L. Painter, oil. An artist from San Francisco spent some time in Portland painting a large (5x8') oil of the Columbia River with two steamers.

COUGHTRY, GRAHAM (1931–) Painter. Pupil: Montreal Museum of Fine Arts; Ontario College of Art. He painted in France and Spain on an Eaton scholarship; Canadian Council fellowship to Europe in 1960. Exh: Guggenheim International Awards, 1958; Vancouver, B.C. Annual, 1961.

COURT, RORALIND VEAZIE Painter, watercolor. Lived in Spokane, Washington, 1950. Member: Washington Art Association.

COUSE, EANGER IRVING (1866– 1936) Painter, oil. Pupil: National Academy of Design in New York; Ecole des Beaux-Arts, Paris. He met and married an Oregon girl and moved there where he painted on the family's ranch near Roosevelt, Washington for over two years. Unfortunately the paintings did not sell. Consequently they moved to the coast of Normandy

where he produced a great body of work before moving to Taos, New Mexico and becoming a legend in Indian Art.

COUSELAND, VIVIAN Sculptor. Lived in Vancouver, B.C., 1950's.

COUTTS, GORDON (1868–1937) Painter, landscapes, figures. Illustrator. Teacher. Writer. Pupil: Rossi; Lefebvre; Fleury; Julien Academy, Paris. Exh: London. Instructor of Art in New South Wales, Australia. Exh: Alaska-Yukon Pacific Expo, Seattle, 1909; Henry Gallery, University of Washington.

COVENTRY ROBERT Painter, oil, watercolor. Lived in Vancouver, B.C.

COVERLY, MAUD M. Painter, watercolor. Lived in Spokane, Washington, 1909. Exh: Alaska-Yukon Pacific Expo, Seattle, 1909.

COWLEY, BROWN PATRICK GEORGE Painter, oil, tempera. Lived in Vancouver, B.C. 1940's. Work: National Museums of Canada.

COX, ANNA E. Artist. Lived in Seattle, Washington, 1901.

COX, ANNA W. Painter, oil, landscapes. Lived in Tacoma, Washington, 1920. Exh: Tacoma Fine Arts Assoc, 1916, 1919.

COX, BERNICE Painter. Teacher. Lived in Burton, Washington, 1895. Teacher of art at Vashon Island College, Washington, 1894–95.

COX, BRITOMARTE IRVING (1887–1984) Painter, watercolor, landscapes, seascapes, miniatures. Commercial artist. Born in Washington. She was a resident of Sacramento in 1922 before settling in San Diego.

COX, CHARLES BRINTON (1864–1905) Painter. Pupil: Thomas Eakins; Pennsylvania Academy of Fine Arts; Art Students League of New York. Member: Paris Art Association. Exhibited his western art in 1890 traveling extensively in Oregon, Calif, Texas and Mexico. His work is included in the Stenzel Collection, Portland, Oregon.

COX, EUGENIA VINCENT Painter, oil, landscapes, seascapes, genre. Painted in Spain. Lived in Bend, Oregon, from 1950.

COX, JOHN ROGERS (1915–) Painter. Lived in Wenatchee, Washington. Pupil: University of Pennsylvania: Pennsylvania Academy of Fine Arts, 1938. Work: Cleveland Museum; Butler Institute. Exh: Metropolitan Museum, New York. Teacher: Figure drawing & painting, Chicago Art Institute, 1948.

COX, LYDA MORGAN (1881–) Painter, oil, landscapes. Teacher. Home and studio in Seattle, Washington, 1924–29. Member: Seattle Fine Arts Society, 1923; Seattle Art Directors Society, 1925.

COX, WILLARD R. (1902–1974) Commercial artist. Illustrator. Member: Puget Sound Group of Northwest Men Painters, 1933. Exh: Oakland Art Gallery. Primarily a California artist.

COX, WILLIAM Artist. Lived in Bellingham, Washington, 1913.

COXE, REGINALD CLEVELAND (1855–) Painter. Engraver. Writer. Teacher. Born in Maryland. Lived in Seattle, Washington, 1921. Pupil: Gerome in Paris, 1879: National Academy of Design, 1876. Director: Seattle School of Industrial and Commercial Arts, 1921.

COY, DORA MAY (1920–1981) Painter, watercolor. Born in Tacoma, Washington. Member: Northwest Watercolor Society; Women Painters of Washington; Pacific Gallery Artists.

COYLAR, P. M. Painter, watercolor, woodland scenes.

COZINE, EDWARD M. (1914–1970) Sculptor. Born in Tenino, Washington. Died in Tacoma. Exh: Tacoma Art League, 1940.

CRAIG, M. H. Artist. Lived in Seattle, Washington, 1909.

CRAIG, THOMAS THEODORE (1909–1969) Painter, oil, watercolor, landscapes, portraits. Illustrator. Printmaker. Muralist. Primarily an important California artist, he traveled as an artist-correspondent in Italy for *Life Magazine*. Work: Seattle Art Museum; many others.

CRAIN, BERNARD (1908–) Painter, oil. Lived in Silverton, Washington, 1941.

CRANDALL, FRANCIS E. (1868–1929) Painter, watercolor, marine & woodland views around Tacoma, Washington. Teacher: watercolor classes at the Frye Museum, Seattle, 1900; Whitman College for 7 years. Member: Tacoma Art League, 1916. Exh: Alaska-Yukon Pacific Expo, Seattle, 1909; Tacoma Fine Art Association, 1916.

CRAVATH, RUTH (1902–) Sculptor, portrait busts. Lived in Poulsbo, Washington. Pupil: Stackpole; Bufano. Lived in San Francisco for a time.

CREASE, JOSEPHINE Painter. Member: Victoria Islands Arts and Crafts Society around 1910. Painted in the very realistic tradition.

CRESSMAN, VERA GENE Painter, watercolor. Exh: Tacoma Art League, 1919.

CRESSON, MARGARET Sculptor. Award: National Academy of Design, 1927; Society of Washington Artists, 1937. Work: many public monuments.

CRESSWELL, WILLIAM Painter, watercolor, landscape. Born in England in the 1850's. Immigrated to Canada.

CRISLER, ANCIL B. Artist. Lived in Spokane, Washington, 1911.

CRITTENDEN, EMMA Painter, watercolor, rural landscapes. Settled in the Yakima Valley in 1904 from Kentucky. Very popular artist in the Yakima, Washington, area in the 1930's & 1940's.

CROALL, ANNA S. Artist. Lived in Seattle, Washington, 1912.

CROCKER, ANNA BELLE (1867–1961) Painter, figures, landscapes. Curator of the Portland Art Museum until 1936. Member: Prestigious Sketch Club. Pupil: F. V. DeMond; Art Students League, New York.

CROCKER, MRS. J. A. Painter, oil, landscapes. Lived in Oregon in the early 1880's.

CRONYN, GEORGE W. (20th century) Painter. Lived in Portland, Oregon.

CROOK, DONALD Painter, oil, acrylic. Commercial & Fine artist. Known as the Norman Rockwell of Western Art. Exh: Heritage Award, Favell Museum, Klamath Falls, Oregon; many others.

CROOK, JOHN MARION Painter. Lived in Astoria, Oregon in the 1920's. Exh: Oakland Art Gallery, 1928; Painters of the Pacific Northwest, 1925; Work: Oregon Historical Society.

CROOKALL, JAMES Artist. Photographer. 1930's. Work: Vancouver City Archives.

CROSBY, BELLE Artist. Member: Tacoma Art League, 1891.

CROSS, FREDERICK GEORGE (1881–1941) Painter, watercolor, Canadian prairies. Sculptor. Immigrated to the Canadian West as a railway sur-

vey and land development artist in 1906. Exh: Canadian Racific Railway Exhibition, 1921; most important Canadian exhibitions.

CROSS, J. R. Artist. Lived in Seattle, Washington, 1901.

CROSSER, HAZEL F. Painter, oil. Exh: Seattle Art Museum, 1947.

CROW, LOUISE (1891–) Painter, genre, Indians. Lived in Seattle, Washington. Pupil: Gustin; Chase; Duveneck; Chaumiere. Lived and worked in Paris and Rome. Taught art in Seattle from 1928 until 1939, returning to Santa Fe, New Mexico.

CROWELL, PERS (1910–1990) Painter. Commercial artist. Illustrator. Began his career in Portland, Oregon in 1937. Also produced some western and cowboy paintings. Member: The Attic Sketch Group, Portland. Moved to Raleigh, North Carolina, in the 1980's.

CROWLEY, CAROLINE C. Artist. Lived in Seattle, Washington, 1909.

CROWSON, HELEN Painter. Fashion Illustrator. Member: The Attic Studio, Portland, Oregon, 1929–67.

CROZIER, WILLIAM K. JR. (1926–) Designer. Craftsman, jewelry. Pupil: Washington State University. Work: The Henry Gallery, University of Washington, Seattle; Cheney Cowles Museum, Spokane.

CRUTCHER, LEWIS P. Painter, watercolor. Draftsman. Exh: Seattle Art Museum, 1946.

CUBIT, GALE E. Painter. Exh: Tacoma Civic Art Association, 1932.

CULBERTSON, JOSEPHINE M. (1852–) Painter. Etcher. Pupil: Chase; Dow. Exh: Alaska-Yukon Pacific Expo, Seattle, 1909.

CULLER, JOHN R. Painter. Lived in Spokane, Washington, 1950. Exh: Pacific Northwest Artists, 1948.

CULVERWELL, ALBERT (1913–) Painter, oil, watercolor. Designer (stage). Lived in Seattle, Washington. Pupil: Cornish Art School, Seattle. Exh: Seattle Art Museum; Portland Art Museum, 1932.

CUMMING, WILLIAM LEE (1917–) Painter, oil, watercolor, tempera. Sculptor. Lived in Seattle, Washington. Member: Washington Artists Union. Exh: Seattle Art Museum, 1938–39.

CUMMINS, MADGE M. (1900–) Painter, oil, watercolor, pastel, landscapes, still life. China painter. Teacher. Born in Indiana. Moved to Compton, California in 1929. Lived and worked in Bend, Oregon. Sold the most WWII war bonds in Southern California.

CUNEO, CYRUS CINCINNATI (1878–) Painter, portraits. Although he lived in England he painted extensively in California and the Pacific Northwest for the *Illustrated London News*. Many of his paintings were destroyed during WWI. In 1908 he traveled through California and Western Canada as the last of the Special Artists for the publication.

CUNNINGHAM, F. C. (1902–) Painter, oil, watercolor. Illustrator. Born in Ireland. Lived in Vancouver, B.C., 1940. Pupil: Frederick H. Varley: James Macdonald. Studied in Europe. Exh: Canadian National Academy, Toronto.

CURRIER, EDWARD WILSON (1857–1918) Painter, oil, watercolor. Primarily a California artist. Pupil: Chicago Academy of Fine Arts. Exh: Alaska-Yukon Pacific Expo, Seattle, 1909.

CURTIS, EDWARD SHERIFF (1868–) Illustrator. Photographer. Born in Wisconsin. Work: University of New Mexico; UCLA; British Museum, London. He is famous for his documentations of the American Indian Tribes, done under the patronage of J. Pierpont Morgan.

CURTIS, ELIZABETH L. (1892–) Painter, murals. Teacher. Born and lived in Seattle, Washington, 1941. Study: University of Washington, Seattle. Exh: Annual Exhibition of Northwest Artists; Northwest Printmakers.

CURTIS, LELAND (1897–) Painter. Illustrator, landscapes. Worked in Seattle, Washington, before moving to Los Angeles in 1914. He served as official artist of the U.S. Antarctica Expedition in 1939–40 and again in 1957. A member of many California associations.

CUSHMAN, AGNES Artist. Lived in Seattle, Washington, 1926.

CUTTING, FRANCIS HARVEY (1872–1964) Painter, landscapes. Although he lived and painted in Northern California he traveled extensively in the Pacific Northwest painting the Columbia River, Crater Lake and others.

CUTTS, GERTRUDE SPURR (1858–1941) Painter, watercolor, portraits, Canadian villages, mountains, coast, boats.

—D—

DACK, EARL R. Painter. Lived in Seattle, Washington, 1960. Member: Puget Sound Group of Northwest Men Painters, 1950.

DAGGETT, MAUDE (1883–1941) Sculptor. Lived in Pasadena, California, 1911. Study: Rome and Paris. Exh: Paris Salon; Alaska-Yukon Pacific Expo, Seattle, 1909.

DAHL, BERTHA (1891–) Painter, oil, watercolor. Teacher. Born in Norway. Lived in Seattle, Washington, 1960. Pupil: Peter Camfferman; University of Washington. Art teacher, Seattle Public Schools.

DAHLQUIST, E. RAYMOND Printmaker. Lived in Seattle, Washington, 1941. Exh: Seattle Art Museum, 1936–38; Northwest Printmakers, 1940.

DAILEY, MICHAEL (1938–) Painter, abstract figures. Teacher: Washington University, Seattle.

DALTON, ANNA AND ERNEST ALFRED, (20th century) Painters, acrylic, landscapes, cities. Canadian artists.

DALTON, JOHN JOSEPH, (1856–1935) Painter, Canadian Indians. Draftsman, topographical.

DALY, JACK Painter, oil. Lived in Seattle, Washington, 1941. Study: Cornish Art School, Seattle. Exh: Seattle Art Museum, 1938.

DALY, KATHLEEN FRANCIS PEPPER (1898–) Painter, Canadian lakes, mountains, streets. Etcher, graphics, drawings.

DALZELL, PAUL CAVENDAR (1906–) Painter, oil, watercolor. Teacher. Lived in Caldwell, Idaho. Pupil: College of Arts and Crafts, Oakland California; Carnegie Scholarship, University of Oregon, Eugene. Exh: Idaho Artists, 1933, 1937, 1938, 1939.

DAM, CARL WILLIAM (1883–) Painter, oil. Etcher. Lived in Aberdeen, Washington, 1927.

DAMACUS, NIKOLAS Painter, oil, tempera. Teacher. Member: Artists Equity Association, Seattle. Exh: Seattle Art Museum, 1945, 1948.

DAMASDY JULIUS (20th century) Painter, Canadian Coast, beaches.

DAMIANO, BEATRICE PARKINSON (1905–1967) Printmaker, wood block. Craftsperson, wood carver. Ceramicist. Born in Illinois. Lived in Tacoma, Washington. Signed her work "Bea". Self-taught. Opened the first ceramics studio in Tacoma where she taught for several years.

DAMM, ALVIDE Artist. Lived in Tacoma, Washington, 1891.

DANCER, W. H. (MRS.) Painter, oil. Exh: Alaska-Yukon Pacific Expo, Seattle, 1909.

DANES, GIBSON (1910–) Painter. Teacher. Writer. Pupil: University of Oregon; Yale University.

DANGELMAIER. R. Painter, expressionist seascapes. Lived in Oregon in the 1950's.

DANIEL, LILLIAN B. Artist. Lived in Spokane, Washington, 1905.

DANIELL, C. BAMFYLDE (MRS.) Founding member of the B.C. Society Fine Arts. 1933.

DANIELLS, ROY Artist. Teacher: University British Columbia, 1930's-40's.

DANIELS, ALMA E. Painter, pastel, china. Lived in Port Townsend, Washington, 1913–16.

DANIELS, H. W. Artist. Lived in Seattle, Washington, 1910.

DARCE, VIRGINIA CHISM (1919–) Painter. Craftsperson. Designer. Teacher. Born in Portland, Oregon.

Lived in Spokane, Washington, 1947. Pupil: University of Oregon. Member: Washington Art Association. Exh: Portland Art Museum, 1935–38, Palace of the Legion of Honor, San Francisco, 1939.

DARLING, D. E. (1904–) Painter, pastel. Born in North Dakota. Moved to Tacoma, Washington, 1942. Member: Tacoma Art League; president, Pacific Gallery Artists, 1947–48. Exh: Washington State Arts & Crafts.

DARLING, MARJORY ADAMS (MRS. WILLIAM S.) (1897–1984) Painter. Born in Portland, Oregon. Study: scholarship, Portland Art Institute. In her teens she was taken to California for a TB condition. Exh: Laguna Festival of Art; De Young Museum; Frye Museum, Seattle; Smithsonian Institute, Washington, D.C.; Society of Western Artists.

DARLING, WILLIAM C. Painter, landscapes. Costume Designer. Lived in Seattle, Washington, 1933.

DARIOSTIS, DORTHY JEAN RISING (1922–) Painter, oil. Born and lived in Seattle, Washington, 1944. Pupil: Dorothy Milne Rising. Exh: Seattle Art Museum, 1938. Member: Women Painters of the West.

DARMER, CARL A. (1858–1952) Painter, oil, watercolor, landscapes. Architect. Born in Germany. Moved to Tacoma, Washington, in 1884. Educated in Germany. Became leading Tacoma architect & accomplished landscapist. He designed many of Tacoma's buildings, churches, schools & residences.

DAUBENSPECK, WILMA Painter, oil, still lifes. Lived in Seattle, Washington. Exh: Seattle Art Museum, 1939.

DAVENPORT, HOMER CALVIN (1867–1912) Cartoonist. Born and lived in Silverton, Oregon. Studied in

San Francisco, though mainly self-taught. Employed by the Hearst newspapers. Exh: Lewis & Clark Expo, Portland, 1905.

DAVENPORT, THOMAS R. Painter. Music teacher. Member: Tacoma Art League, 1892.

DAVID, V. T. (MRS.) Artist. Lived in Spokane, Washington, 1907.

DAVIDSON, DUNCAN, (1876–) Painter, oil, watercolor. Born in Scotland. Lived in Seattle, Washington, 1944. Pupil: Grier; Grays Harbor School of Art, Aberdeen Washington; Colarossi Academy, Paris.

DAVIDSON, GEORGE An artist with Captain Gray's Expedition of 1792. He made sketches around Vancouver Island.

DAVIDSON, MARY T. Painter. Member: Tacoma Art League, 1898.

DAVIDSON, ROSEMARY Painter. Designer. Moved to Seattle, Washington, 1946. Pupil: University of Washington; Humber; Vane; Howe; Acker; Brose; Bongart; Bruch; Damascus. Member: Seattle Co-Art.

DAVIES, WILLIAM HENRY (19th century) Painter, watercolor, Canadian landscapes, markets, sheep.

DAVIS, ALANSON BEWICK (1909–) Painter, oil. Printmaker. Commercial artist. Born in California. Lived in Seattle, Washington, 1941. Pupil: California School of Fine Arts, San Francisco. Exh: Beaux Arts Gallery, 1933, Palace of the Legion of Honor, San Francisco; Seattle Art Museum, 1939. Assistant Art Director, University of Washington. Instructor in puppetry.

DAVIS, E. E. (MRS.) Artist. Lived in Seattle, Washington, 1902.

DAVIS, FLORENCE I. Painter, watercolor. Lived in Spokane, Washington, 1909. Exh: Alaska-Yukon Pacific Expo, Seattle, 1909.

DAVIS, FRANK Artist. Lived in Walla Walla, Washington, 1902.

DAVIS, GEORGE R. (MRS.) Artist. Owner of the Arcade School of Art, Seattle, Washington, 1901–1907.

DAVIS, GLEN Commercial artist. Lived in Spokane, Washington, 1950. Member: Washington Art Association.

DAVIS, IRENE Painter. Teacher. Lived in Seattle, Washington, 1928. Teacher: San Francisco Art School; Cornish Art School, Seattle, 1926–28.

DAVIS, ISABELLE Painter. Lived in Tacoma, Washington, 1915. Exh: Washington State Commission of Fine Art, Tacoma, 1915.

DAVIS, JOHN B. Painter, oil, tempera. Teacher; Spokane Art Center. Exh: Seattle Art Museum, 1949.

DAVIS JOSEPH H. (DAVISS) (– 1837) Painter, watercolor, Canadian portraits. Designer.

DAVIS, LEONARD MOORE (1864– 1938) Painter, landscape, murals. Illustrator. Studied in Paris. Pupil: Art Students League, New York. Made many trips to Alaska, which he made his specialty, along with U.S. National Parks and the Canadian Rockies. Work: Washington State Art Museum, Seattle; Munic Art Gallery, Seattle; Museum Public Archives of Canada; Yukon Railroad Office. His specialty after 1898 was scenes of Alaska (127 pieces), the Canadian Rockies, (600 pieces).

DAVIS, NORMAN E. Artist. Studio in Seattle, Washington, 1926–30.

DAVIS, OLEA MONTGOMERY (1899–) Sculptor. Lived in Vancouver, B.C. Exh: B.C. Artists Exhibition, 1935–37; many public buildings.

DAVIS, ROBERT M. Painter, oil, western scenes. Exh: Washington State Commission of Fine Art, 1914; Tacoma Art League, 1915; Tacoma Fine Art Association, 1916.

DAVIS, S. J. Artist. Lived in Seattle, Washington, 1910.

DAVIS, WILLIAM P. Artist. Lived in Seattle, Washington, 1922.

DAVYS, ROWENA Artist. Lived in Seattle, Washington, 1901.

DAWE, GLADYS COLE (1898–) Painter, oil, watercolor. Drawing, pen & ink. Teacher. Born in Wisconsin. Lived in Bellingham, Washington, 1940. Pupil: E. Forkner; A. Birkman; E. P. Cole. Exh: Western Washington Fair.

DAY, GEORGE (MRS.) Painter. Interior Decorator. Member: Washington Art Association, Spokane, 1928.

DAY, HELEN H. Painter. Lived in Spokane, Washington, 1930–32. Exh: Spokane Art Festival, 1928.

DAYTON, EDNA Painter, oil. Lived in Cheney, Washington, 1950.

DAYTON, VEDA FERO CARNAHAN (1891–1983) Painter. Born in Washington. Head of the Art Department, College of the Pacific, 1928. Lived the rest of her life in California.

DE ARMOND, DALE B. Printmaker, etching, wood block. Born in North Dakota. Work: Alaska State Museum; Anchorage Historical & Fine Art Museum; Frye Art Museum; Seattle. Award: Alaska Centennial, 1967.

DECAMP, RALPH EARL (1858– 1936) Painter, oil, landscapes. Painted with Charles Russell in Montana.

DECAN, D. H. (MRS.) Painter, oil. Lived in Whatcom County, Washing-ton, 1909. Exh: Alaska-Yukon Pacific Expo, Seattle, 1909.

DEFOREST, HENRY, (1860–1924) Painter, Canadian landscapes, mountains.

DEFOREST, HENRY J. Painter. Lived in Vancouver, B.C. Founding member: Vancouver, B.C. Society of Fine Arts, 1933.

de FOREST, LOCKWOOD Painter. Decorator. Painted Alaskan coastal and glacier landscapes in the summer of 1912.

DEGENHART, PEARL CLARA (1904–) Painter. Pupil: University of Montana; Columbia University; University of California; University of Oregon; Walter Ufer, Taos, New Mexico. Work: San Francisco Museum of Art.

DELAFIELD, DAVID D. Painter, oil. Studio in Pullman, Washington. Exh: Seattle Art Museum, 1949.

DELANE, JOHN D. Painter, oil, landscapes. Lived in Seattle, Washington, 1923. Active in Northern California and the Northwest in the 1890's. Known for his paintings of Mt. Rainier which he signed in block letters "DE-LANE" in the lower left.

DELANE, ROBERT Painter, oil. Known painting of Seattle mountain landscape.

DELANO, GERARD CURTIS (1890– 1972) Painter. Illustrator. Began his career in New York. Moved West in 1933, settling in Colorado. It was a difficult life until he acquired a measure of success illustrating and writing the text for *The Story of the West*, a weekly western magazine feature. His western subjects are not limited to Colorado. He is best known for his paintings of Navajo country. He traveled extensively, painting historical scenes of the Northwest of which

"Northwest Traders in Boat" is but one.

DELANTY, RICHARD (MRS.) Painter, oil. Lived in Port Townsend, Washington, 1882. Exh: H. F. Beecher Studio, Port Townsend, Washington, 1892.

DELAUNAY, A. B. Painter, watercolor. Exh: Alaska-Yukon Pacific Expo, Seattle, 1909; Whitcom County, Washington.

DELLENBAUGH, FREDERICK SAMUEL (–1935) Painter. A true American western landscape artist he illustrated and authored several books on the subject. He also traveled to the Arctic on the Harriman Expedition of 1899.

DEMAINE, GEORGE Painter, oil, watercolor. Lived in Sumner, Washington, 1914. Exh: Tacoma Art League, 1914.

DEMONET, INEZ. (1897–) Painter. Pupil: Corcoran School of Art. Award: Society of Washington Printmakers, Washington; Watercolor Club, 1946.

DENBUTTER Painter, oil, impressionist landscapes.

DENNING, ESTELLA L. (1888–) Painter, oil, watercolor, pastel. Born in Oregon. Lived in Boise, Idaho, 1940. Pupil: St. Francis Academy, Baker, Oregon; University of Idaho; Ethel Fowler, Boise. Art teacher, Whittier School, Boise.

DENNIS, ALICE G. Painter. Member: Tacoma Fine Arts Association, 1925.

DENNIS, GEORGE W. Painter, watercolor. Lived in Wenatchee, Washington. Exh: Seattle Art Museum, 1935–49.

DENNIS, JACQUELINE NOEL Painter. Illustrator. Lived in Tacoma,

Washington, 1945. Signed paintings "J. Noel". Animal illustrations for *Better Homes & Gardens*.

DENNIS, MELBA HOWARD (1909–1964) Painter. Craftsperson. Pupil: Vancouver, B.C. Art School. Teacher: Olympia, Washington, 1945–50.

DENNY, EMILY INEZ (1853–1918) Painter, oil, watercolor, landscapes. Writer. First white girl born in Seattle. Pupil: Harriet F. Beecher; Thomas A. Harrison; the Territorial University of Washington's first class in 1863. Work: Seattle Museum of History & Industry (large collection).

DENSMORE, CATHERINE A. (1910–) Painter, oil, watercolor, pastel. Drawing. Lived in Tacoma, Washington, 1935, 1947. Pupil: Cornish Art School, Seattle; R. Alcorn; L. Derbyshire; Santa Barbara School of Art. Exh: all over the state of Washington. Teacher and director: Armstrong School of Arts, Tacoma.

DENTON, ALPHARETTA Artist. Lived in Spokane, Washington, 1937.

DENTON, MARY H. Painter. Member: Tacoma Art League, 1905–21.

DE PENDER, RENA Artist. Lived in Spokane, Washington, 1923.

DERBYSHIRE, LEON (1896–) Painter. Teacher. Moved to Seattle, Washington, 1940. Pupil: Pennasylvania Academy of Fine Arts; L'Hote; Garber; Breckenridge; Italy; England. Established the Seattle School of Fine Arts, 1940. Maintained a studio and taught there until at least 1969. Exh: Seattle Art Museum; solo show, Frye Museum, 1953. Member: Puget Sound Group of Northwest Men Painters, 1946.

DERRETH, REINHARD Artist. Pupil: Vancouver, B.C. Art School, 1945.

DETLIE, JOHN STEWART Painter, watercolor. Lived in Seattle, Washing-

ton, 1959. Member: Puget Sound Group of Northwest Men Painters, 1946.

DEUTSCH, BORRIS (1892–1978) Painter, murals. Modernist. Printmaker. Born in Lithuania. Lived in Seattle, Washington, 1916–1920. Moved to California in 1920 as a commercial artist and set designer for movies. He specialized in Jewish genre, experimenting with monotypes and other printmaking. Member: many California groups. Exh: Seattle Art Museum, 1930; Portland Art Museum, 1931.

DEUTSCH, HILDA V. (1911–) Painter, watercolor. Sculptor, plaster, cement. Teacher. Lived in Seattle, Washington, 1941. Pupil: Cooper Union; Art Students League of New York. Exh: Rockefeller Center. WPA artist.

DEUTSCHMAN, LAMBERTUS Craftsman, metalwork. Modeling. Born in Amsterdam. Lived in Portland, Oregon, 1940. Work: Trinity Church, Portland; Forest Lawn Cemetery, Los Angeles. Teacher: Arts and Crafts Society, Portland, Oregon.

DEWEY, CAROLYN (1934–) Painter, oil, expressionistic landscapes. Lived in Lake Oswego, (Portland) Oregon, 1992.

DIAMOND, C. T. Artist. Lived in Spokane, Washington, 1908.

DICKENSON, GLEN Painter, watercolor. Exh: Seattle Art Museum, 1940.

DICKERSON, VEOLA Artist. Lived in Centralia, Washington, 1917–18.

DICKIE, JAMES Painter, landscapes. Vancouver, B.C. School, 1930's.

DIKE, DOROTHY JEWELL (1911–) Painter, oil, watercolor.

Craftsperson. Lived in Seattle, Washington. Pupil: University of Washington, Seattle. Exh: Henry Gallery, University of Washington, Seattle, 1935.

DINSMORE, ROBERT C. Painter, tempera. Exh: Seattle Art Museum, 1945.

DIXON, CAPTAIN GEORGE Illustrator. Published illustrations for, *A Voyage Round the World*, in London, 1789. Worked on the Northwest Coast of America, 1785–88.

DIXON, GORDON Sculptor. Lived in Vancouver, B.C., 1950's.

DIXON, MAYNARD LAFAYETTE (1875–1946) Painter. Began as an illustrator in San Francisco. Was fired in 1901 and began his trip with artist friend Ed Borein through the northern part of California covering the Steens Mountain Country in Oregon, the Bannock Indians near Pocatello, Idaho. In 1909 he painted the Nes Perces Indians and illustrated the book, *The Oregon Trail*.

DOAN, T. F. Artist. Lived in Bellingham, Washington, 1913.

DOBIE, HELEN Artist. Pupil: Varley: Vancouver, B.C. Art School, 1930's.

DODD, AUGUSTA Artist. Exh: Womens Club Art Show, Tacoma, Washington, 1930.

DOLE, WILLIAM (1917–) Painter, watercolor. Abstractist. Pupil: University of California, Berkeley. Exh: California Watercolor Society, 1940's. Teacher: Washington State University.

DOLPH, M. D. (MRS. R. J.) (1884–) Painter, oil. Printmaker, dry point. Lived in Hood River, Oregon. Pupil: University of Minnesota; Milwaukee Art League; Chicago Art Institute. Member: Oregon Society of Artists.

Work: "Wild Horses", oil, State Capitol, Cheyenne, Wyoming.

DOMINIQUE, JOHN AUGUST (1893–) Painter, oil, pastel. Printmaker, etchings. Born in Sweden. Lived in Canby, Oregon, 1940. Pupil: Museum Art School, Portland; San Francisco Museum of Art; Otis Art Institute; Los Angeles; Carl Oscar Borg, Hollywood; Armin Hansen, Monterey; Colin Campbell Cooper, Santa Barbara. Member: Oregon Society of Artists; Portland Oregon Art Association. Exh: Portland Art Museum, 1936; Oregon State Fair, 1936–41; Frye Museum, Seattle, 1962.

DONALDSON, HALLIE Painter. Printmaker; Teacher, Seattle Public Schools, 1941.

DORAY, CAPEL AUDREY, (1931–) Painter, acrylic, in the late 50's. Exh: University of British Columbia Fine Arts Gallery, Vancouver, B.C., 1960.

DORN, WALTER (1906–) Painter, oil, watercolor. Born in Missouri. Lived in Seattle, Washington, 1944. Member: Puget Sound Group of Northwest Men Painters. Exh: Frye Museum, 1941; Seattle, Washington. Instrumental in the organization of the Bellevue Washington Arts & Crafts Fair, 1950.

DOSCH, ROSWILL Painter. Lived in Hillsdale, Oregon.

DOSER, MARVEL BEDFORD Artist. Lived in Seattle, Washington, 1920.

DOTY, JOHN WARREN (1870– 1959) Painter. Lived in Portland, Oregon, from 1891–94 where he began his art career. He moved to California settling in the tiny town of Mount Shasta painting mountain landscapes. He later became an important California artist.

DOWLING, COLISTA (1881–1968) Painter, oil, watercolor, murals. Illustrator. Born in Kansas. Lived in Portland, Oregon, 1940. Pupil: Art Students League, New York; University of Oregon; Pennsylvania Academy of Fine Arts, Philadelphia. Member: Oregon Society of Artists. Exh: Portland Art Museum; Oregon Society of Artists. Caricatures by her as "Colista M. Murray" (maiden name) appear in the *Oregonian*, 1906. Illustrations: *Pacific Monthly* magazine. Award: Rose Festival Poster winner, 1914.

DOWNER, KENNETH (1903–) Painter, oil, watercolor, tempera. Born in New York. Lived in Spokane, Washington, 1939–41. Pupil: Art Students League of New York; André L'Hote Academy, Paris. Member: American Artists Union.

DOWNING, ALFRED Painter, watercolor, landscapes. Sketched while surveying trails and river systems in the New World during the late 1800's. Work: Washington State Historical Society sketchbook containing 144 sketches and watercolors.

DRAHOLD, ALFRED (1901–1988) Painter, oil, landscapes. Stage manager and Art Director, Lakewood Theatre, Tacoma, Washington. Born in Czechoslavakia. Lived in Tacoma, Washington, 1941. Pupil: Frank Tabor; Abby Hill; Lional Salmon.

DRAKE, LOUIS C. Artist. Lived in Seattle, Washington, 1917.

DRAYTON, JOSEPH Artist with the Wilkes Expedition, 1838–1842. Work: Oregon Historical Society.

DRESEL, EMIL (1819–1869) Painter. Lithographer. Publisher (see Conrad Kuchel). Painted in Oregon and Northern California in the 1850's. He bought land in Sonoma, California, and became one of California's pioneer vineyardists. Work: Amon Carter Museum, Texas.

DRISCOLL, E. V. Artist. Lived in Seattle, Washington, 1926.

DRISCOLL, HAROLD R. Commercial artist. Lived in Seattle, Washington, 1933.

DRUMM, ALBERTA M. Artist. Lived in Tacoma, Washington, 1940.

DRUMMOND, ALFRED (1901–) Painter, oil, watercolor. Sculptor. Pupil: Massachusetts School of Art, Boston; Art Students League, New York. Exh: Boston Art Club, 1934, 1935; Seattle Art Museum, 1939. Teacher: Fine Arts, College of Puget Sound, Tacoma, Washington.

DRUMMOND, ROBERT LORING (1910–) Painter, oil, watercolor, landscapes. Sculptor. Pupil: Massachusetts School of Art, Boston; Art Students League, New York; Harvard University; Columbia University. Exh: Seattle Art Museum, 1937, 1939; Tacoma Fine Arts Association, 1940.

DRUSE, MARIE C. Painter, oil, still lifes. Teacher. Lived in Yakima, Washington, 1907. Exh: Alaska-Yukon Pacific Expo, Seattle, 1909.

DU BOIS, WILLIAM G. Artist. Engraver. Lived in Seattle, Washington, 1928.

DUCASSE, MABEL LISLE (1895–) Painter. Pupil: Art Students League, New York; University of Washington. Exh: Seattle Fine Arts Society, 1918, 1923, 1925.

DUCHE de FANCY, GASPARD (– 1788) Painter. Engraver. Born in France. He was well known for his paintings and engravings in Europe in 1785. He arrived in Monterey, California, in 1786. He became one of the earliest professional artists known to have painted a California scene and the Northwest Coast.

DUCKER, CLARA ESTELLE Painter, oil, pastel, watercolor. Drawings, crayon, pen & ink, pencil, charcoal. Teacher. Born in Kansas. Lived in Weiser, Idaho, 1940.

DUCKWORTH, ROBERT R. Artist. Worked for the Tacoma Portrait Company, Tacoma, Washington, 1904.

DUDDEN, WINIFRED Artist. Lived in Seattle, Washington, 1934.

DUDLEY, ELLA J. Artist. Studio in Seattle, Washington, 1921.

DUESBURY, HORACE (1851–1904) Painter, portraits. Immigrated from Australia in 1879–88 to Portland, Oregon, to become its first professional figure painter.

DUFF, PERNOT STEWART (1898–) Painter, oil, watercolor. Lived in Waldport, Oregon. Pupil: Museum Art School, Portland, Oregon. Member: American Artists Professional League. Exh: Portland Art Museum; Grumbacher, New York; Oregon Society of Artist.

DUMAS, JACK (1916–) Painter, wildlife, western. Illustrator. Lived in Seattle, Washington, 1966. Pupil: Ernest Norling.

DUMERMUTH, BROTHERS Artist. Lived in Seattle, Washington, 1907.

DUMOND, FRANK VINCENT (1865– 1951) Painter. Born in Rochester, New York. Teacher: Art Students League, New York. Later appointed Director, Department of Fine Arts for Lewis & Clark Centennial Exposition, Portland. Taught Summer classes for Portland Art Association. Work: Portland Art Museum; Denver Art Museum; many others.

DUMOND, HELEN S. (1872–) Artist. Born in Portland, Oregon. Moved to Lyme Connecticut.

DUNCAN, CHARLES Artist. Lived in Seattle, Washington, 1909.

DUNCAN, CHARLOTTE ALISKY Painter. Married artist Charles Alisky in Portland, Oregon. They studied together in Munich in 1890–91. Returning to Portland she maintained a studio there in 1892–93. Marriage ended in divorce and Charles moved to California in 1898. Work: Oregon Historical Society.

DUNCAN, JOHNSON KELLY (19th century) Painter. Lived in the State of Washington.

DUNCOMBE, A. C. (MISS) Artist. Member: Tacoma Art League, 1891.

DUNER, VICTOR Artist. Lived in Seattle, Washington, 1932.

DUNNING, AMATA A. Artist. Member: Spokane Art Club, 1923.

DUPEN, EVERETT GEORGE (1912–) Sculptor. Lived in Seattle, Washington. Pupil: Gage; Snowden; Fulop; Archipenko; Sample. Exh: National Academy of Design, New York; Seattle Art Museum.

DUQUET, EMORY Painter, watercolor. Exh: Seattle Art Museum, 1949.

DWIGHT, MAY E. Painter. Lived in Spokane, Washington, 1922. Pupil: Chicago Academy of Fine Arts, 1926.

DYBWAD, FREDERICK Painter. Commercial artist. Sculptor. Lived in Seattle, Washington, 1954. Member: Puget Sound Group of Northwest Men Painters. Exh: Seattle Art Museum, 1945.

DYCK, J. H. Painter. Lived in Seattle, Washington, 1901.

DYER, JAMES C., JR. Painter, watercolor. Etcher. Lived in Steilacoom, Washington, 1958. Exh: Tacoma Fine Art Association, 1943; Artists of Southwest Washington, 1951.

DYER, THOMAS BENN Artist. Lived in Aberdeen, Washington, 1920.

—— **E** ——

EAGER, MARY BLACKALLER (1906–) Craftsperson, textiles. Lived in Seattle, Washington, 1940. Pupil: International School of Art, Vienna; University of Washington, Seattle; Columbia University. Exh: Henry Gallery, University of Washington, Seattle.

EARLE, PAUL BERNARD (1872–1955) Painter, Canadian coasts, farms.

EASON, MARY E. Artist. Studio in Seattle, Washington, 1930.

EASON, ROSE CORBIN (1905–) Painter, oil, watercolor, landscapes, figural, still lifes. Illustrator. Moved to Olympia, Washington, in 1945 after spending twelve years working in Arizona and New York. Pupil: Philadelphia Museum School of Art; Washington College, Spokane; St. Martin's College, Olympia. Member: American Artists Professional League; founder, past president, Olympia Washington Art League; Spokane Art League; Tucson Arizona Fine Arts Association; Phoenix Fine Arts Association; La Haina Art Society, Hawaii. Exh: nationally in most major cities in the Northwest; Arizona; New York; Florida. Many awards.

EASON, TOM Artist. Studio in Seattle, Washington, 1930.

EASTLAKE, MARY ALEXANDRA BELL (1864–1951) Painter, Canadian genre, landscapes, portraits, gardens. Jewelry designer. Pupil: William M. Chase.

EAVES, JULIA (–1936) Painter, oil, portraits. Lived in Lewiston, Idaho. Pupil: New York Conservatory.

EDADES, VICTORIA A. Painter, portraits. Lived in Seattle, Washington, 1924–26. Exh: Puget Sound Group of Northwest Men Painters.

EDDY, LENA A. Artist. Lived in Spokane, Washington, 1901–05.

EDE, FREDRERIC CHARLES VIPOND (1865–1907) Painter. Canadian genre landscapes, cattle, sheep, ducks, birds.

EDENS, ANNETTE (1889–) Painter, watercolor. Printmaker. Craftsperson. Lived in Bellingham, Washington, 1947. Study: New York School of Fine and Applied Art; University of Washington. Exh: Metropolitan Museum of Art, New York.

EDMONDS, ELMER B. Painter. Cartoonist. Lived in Seattle, Washington, 1926–28.

EDMONDSON, ELIZABETH (1874–) Painter, oil, pastel, watercolor, tempera. Drawing, India ink. Craftsperson, tapestry & china. Born in Corvallis, Oregon. Member: Oregon Society of Artists. Exh: Chicago Art Museum, 1935; Corcoran Art Gallery, 1937, 1939. Manager: Southern Oregon School of Fine and Commercial Arts and Crafts, Medford Oregon.

EDMONDSON, WILLIAM B. (1910–) Painter, oil, tempera. Sculptor, wood. Born in Jackson County, Oregon. Mainly self-taught. Many national awards. Exh: Cincinnati; Chicago; Denver; Portland; Salem, Oregon; Indianapolis.

EDOUARD, R. E. Artist. Lived in Seattle, Washington, 1901.

EDSON, NORMAN STEWART (1879–1968) Painter, oil, seascapes, landscapes. Photographer of Northwest scenic views. Poet. Musician. Teacher. Born in Montreal. Lived on Vashon Island, Washington, 1921–68. Son of celebrated artist Aaron Allan Edson. Lived and studied in Europe before settling in Washington.

EDWARDS, ALLAN WHITCOMB (1915–) Painter, oil, watercolor, portraits. Lived in Vancouver, B.C., 1940. Pupil: John Russell, Toronto. Exh: Canadian National Museum, Toronto.

EGGERS, THEODORE F. (1856–) Painter, watercolor, marine. Printmaker. Born in Germany. Lived in Seattle, Washington, 1941. Member: Puget Sound Group of Northwest Men Artists.

EGRI, RUTH Painter, oil, murals. Lived in Spokane, Washington, 1941. Pupil: Art Students League, New York. Teacher: Spokane Art Center. WPA artist, 1939.

EHRMAN, HYMAN M. (1884–) Sculptor. Born in Russia, 1884. Lived in Portland, Oregon.

EISEL, CHRISTIAN Painter, landscapes. Lived in Oregon at the end of the 1800's.

EITEL, ELEANOR Painter, oil. Exh: Seattle Art Museum, 1936.

ELAM, LOUISE E. (1907–) Painter, oil, watercolor. Craftsperson, jewelry. Lived in Seattle, Washington, 1986. Pupil: University of Washington; Ken Callahan; Mark Tobey. Member: Women Painters of Washington. Exh: Seattle Art Museum; Henry Gallery, University of Washington, Seattle, 1949.

ELDER, KENNETH R. Artist. Lived in Tacoma, Washington, 1934.

ELDREDGE, MARY AGNES (1942–) Sculptor. Contemporary Christian art. Pupil: Vassar College. Work: four copper sculptures, St. Joseph Church, Roseburg, Oregon.

ELDRIDGE, CLARA G. Artist. Lived in Everett, Washington, 1926.

ELGESEM, ERLING Painter. Lived in Spokane, Washington, 1950. Member: Washington Art Association.

ELIOTT, KATE Painter, impressionist. Oregon artist, probably a student of Clyde Keller in Portland.

ELKINS, HENRY ARTHUR (1847– 1884) Painter, landscapes. Greatly influenced by Bierstadt. He traveled constantly in the West making many trips to the mountain regions.

ELLEFLOT, JUNE K. (1912–) Painter, oil. Lived in Tacoma, Washington, 1988. Pupil: W. Phillips; R. Pierce; R. Rhea; F. Dippolito. Member: Puget Sound Group of Northwest Men Painters; Washington State Historical Society.

ELLIOTT, BERTRAM Artist. Lived in Seattle, Washington, 1914.

ELLIOTT, HENRY WOOD Artist. Official artist for Hayden's United States Geological Survey of 1869–71 to Alaska.

ELLIOTT, JESSIE M. (–1948) Painter, oil. Drawing, charcoal. Craftsperson, metal & enamel. Lived in Seattle, Washington, 1940. Opened art school in Seattle in late 1880's. Pupil: Hopkins Art School, San Francisco; Pasadena Institute of Crafts; Franz Bishoff, Los Angeles. Member: Women Painters of Washington. Exh: Seattle Fine Arts Society (now Seattle Art Museum).

ELLIOTT, WALTER O. Painter. Exh: Seattle Art Museum, 1945–46.

ELLIS, ELIZABETH (1921–) Painter, oil, watercolor, acrylic, collage. Born in Maine. Lived in Tacoma, Washington, 1986. Teacher. Pupil: Robert Wood; William Dow. Art Teacher; Washington Community College. Exh: widely in Washington and Texas. Member: past president of the Los Angeles Artists Group.

ELLIS, DR. W. Illustrator. Medical Doctor. Dr. Ellis was the assistant surgeon on the third voyage of Captain Cook, 1776–80. He illustrated and published the account, including a chart in two volumes.

ELLISON, RENA (1905–) Painter, oil, watercolor. Born in Illinois. Lived in McCleary, Washington, 1941. Self-taught artist. Exh: Western Washington Fair, Puyallup, 1938; Teachers College, Chico California around 1940.

ELLSBURY, GEORGE H. (1840– 1900) Artist. Illustrator. Civil War sketch artist and war correspondent for *Harper's Weekly* and *Leslies*. Born in New York. Moved to Centralia, Washington, in 1888 and remained there until his death. Very active as a railroad and land developer.

ELLSPERMAN, WINIFRED Painter, watercolor. Lived in Whatcom County, Washington, 1909. Exh: Alaska-Yukon Pacific Expo, Seattle, 1909.

ELLSWORTH, EDYTH GLOVER (1879–) Painter, oil, watercolor, pastel. Clay Sculptor. Commercial artist. Born and lived in Portland, Oregon. Pupil: Bonny Snow; University of Minnesota; Chicago Art Institute; Chicago Art Academy; Thorpe Institute, Pasadena; Museum Art School, Portland; Henry Wentz, Portland; Clara Stevens, Portland. Member: American Artists' Professional League; Oregon Society of Artists. Work: Portland Womans Club. Exh: Oregon Society of Artists. Commer-

cial artist with Lipman; Wolfe Department Store, Portland. Art Instructor: Lincoln County Art Center.

ELLSWORTH, ELIZABETH H. GLOVER (1914–) Painter, watercolor. Sculptor, clay. Born in Central Point, Oregon. Pupil: University of Oregon; Edyth G. Ellsworth, Portland; Adrien Voisin, San Francisco. Member: Oregon Society of Artists; Mazamas Club, Portland; Meier & Frank, Portland, 1938.

ELMER, CLEMENTINE Painter, Teacher. Lived in Portland, Oregon, the 1940's.

ELMER, MAUD V. Painter. Printmaker. Lived in Seattle, Washington, 1941. Pupil: University of Washington; University of Oregon; Boston School of Design. Member: American Federation of Arts; Pacific Arts Association; Seattle Artists League; Northwest Printmakers. Supervisor of Art, Seattle Board of Education.

ELO, EMMY LOU OSBORNE (MURPHY) (1910–) Painter, oil, watercolor. Born in Seattle, Washington. Lived in Bothell, Washington, 1941. Pupil: Cornish Art School, Seattle; Chicago Art Institute. Member: Women Painters of Washington, charter member. Exh: Northwest Artists, 1935; Seattle Art Museum, 1931, 1937.

ELROD, ROLLAND E. Artist. Lived in Tacoma, Washington, 1958. Exh: Tacoma Art League, 1946.

ELSHIN, JACOB ALEXANDROVITCH (1892–1976) Painter, oil, watercolor. Illustrator. Teacher. Born in Russia, son of a prerevolutionary Russian army general. Moved to Seattle, Washington in 1923. Pupil: Russian Imperial Academy. Member: Puget Sound Group of Northwest Men Painters; Washington Artists Union; Northwest Watercolor Society; Pacific Coasts Artists Association. Exh: Seat-

tle Art Museum, honorable mention, 1936 & 1939; first prize, 1935; 2nd prize, 1937; Palace of the Legion of Honor, 1946; Portland Art Museum; Corcoran Art Gallery, Washington, D.C. Work: murals, Seattle Post Office; Renton Post Office, Renton, Washington.

ELVIDGE, ANITA MILLER (1895– 1981) Painter, watercolor, landscapes. Born in Oakland, California. Lived in Seattle, Washington. Pupil: University of Washington, Seattle; California College of Arts and Crafts, Oakland; New York School of Fine and Applied Art; Cornish Art School, Seattle; National Gallery, Washington, D.C. Member: Women Painters of Washington, president. Husband was Governor of Guam, 1953–56.

ENABIT, MERLIN (1904–1979) Painter, oil, portraits, landscapes. Illustrator for several national publications. Moved to Seattle, Washington, in 1929. Known for "pin-up girls". Member: Awarded a Fellowship to the Royal Art Society of London. Authored and illustrated 3 best selling books for Foster Publications in 1959. In 1944 he moved to Los Angeles where he painted portraits of many famous stars. Moved back to Seattle in 1948. He lectured and conducted workshops all over California, Washington as well as many other states. Served on the faculty of the Chicago Art Institute.

ENGARD, ROBERT OLIVER (1915–) Painter, watercolor. Lithographer. Commercial artist. Born in Pennsylvania. Lived in Spokane, Washington, 1941. Pupil: Washington State University. Member: California Watercolor Society; Washington Art Association. Exh: Seattle Art Museum, 1937–41; Denver Art Museum, 1941, 1945; San Francisco Art Association, 1941; Riverside Museum, Cal-

ifornia, 1946; Oakland Art Gallery, 1941.

ENGDAHL, JUNE GLADYS (1903–) Painter, oil, watercolor, pastel. Born in Tacoma, Washington. Lived in Olympia Washington, 1941. Pupil: Atelier Art Club.

ENGEL, MARY FRANCIS Painter, watercolor. Lived in Seattle, Washington, 1945, 1951. Exh: Seattle Art Museum, 1945.

ENGESET, SYDNEY CARLSON (MRS.) Painter, oil, watercolor. Teacher. Craftsperson. Printmaker. Born and lived in Seattle, Washington, 1969. Pupil: University of Washington; Art Students League, New York. Art Teacher: Seattle Public Schools. Exh: Seattle Art Museum, 1935.

ENGLEDOW, CHARLES O. (1898–) Painter, oil, Drawing. Born in Denver, Colorado. Lived in Seattle, Washington, 1941. Pupil: Leon Derbyshire, Seattle. Advertising artist: Pacific Telephone Company. Member: Puget Sound Group of Northwest Men Painters, 1945.

ENGLEHART, JOSEPH E. (19th century) Painter, landscapes, mountains, Indians. Lived in Tacoma, Washington.

ENGLEHART, JOSEPH JOHN (1867– 1915) Painter, landscapes. Studio in San Francisco, 1880's and 90's. Lived in Tacoma, Washington, 1890's. Maintained a studio in Portland, Oregon, 1902–04. Well known for his landscapes of Washington, Oregon and Northern California. Exh: Lewis & Clark Expo, Portland, Oregon, 1905. Work: Washington State Historical Society; Society of California Pioneers, Sierra Nevada Museum; many major museums. Died in Oakland, California.

ENGLISH, HENRIETTE (1905–) Painter, watercolor. Lived in Seattle, Washington. Pupil: Cornish Art School, Seattle; California School of Fine Arts, San Francisco. Exh: Seattle Art Museum, 1934; San Francisco Museum of Art.

ENGLISH, M. F. Artist. Lived in Seattle, Washington, 1907.

ENNIS, M. LOUISE Artist. Lived in Seattle, Washington, 1925.

ENSIGN, MAYBELLE L. Artist. Lived in Seattle, Washington, 1916.

ENSOR, ARTHUR JOHN (1905–) Painter, murals. Illustrator. Designer. Born in Wales. Worked in Western Canada, 1939. Settled in Victoria, B.C., 1939. Pupil: Royal College of Art in London; Florence; Stockholm. Traveled in Africa painting murals for the Empire Marketing Board. Illustrated books. Work: Science Museum, London.

EPLER, FLORENCE Painter, oil, watercolor. Craftsperson, stained glass. Pupil: University of Washington, Seattle; London School of Arts and Crafts. Exh: Frederick & Nelson, Seattle.

EPLER, VENETIA Painter, portraits. Sculptor. Pupil: London School of Arts and Crafts. Exh: Frederick & Nelson, Seattle, Washington.

EPTING, HENRY (-1911) Painter, landscapes. Known the length of the Pacific Coast from Alaska to Southern California. Said to be one of the master colorists of the Pacific Northwest. Worked for several newspapers including the *Oregonian* in Portland. Was a resident of San Francisco from 1882– 1898. Traveled extensively in Alaska where he lived in solitude, painting. Committed suicide by revolver, body found on Council Crest.

ERICKSON, ANNA Artist. Lived in Tacoma, Washington, 1908.

ERICKSON, LOU Painter. Instructor. Lived in Spokane, Washington, 1941. Exh: Spokane Art Center. WPA artist.

ERICKSON, OLGA S. Painter. oil. Lived in Seattle, Washington, 1957. Exh: Seattle Art Museum, 1945.

ERICKSON, VERA L. (1906–) Painter, watercolor. Teacher. Photographer. Lived in Tacoma, Washington, 1982. Pupil: University of the Puget Sound; Robert Wood, Rex Brandt. Member: Women Painters of Washington. Exh: Seattle Art Museum: Frye Museum, Seattle; Tacoma Art League; Smithsonian Institute, Washington, D.C.

ERIKSON, DORIS (1905–) Painter, oil, watercolor. Sculptor, wood. Born in Massachusetts. Lived in New York, 1940. Pupil: Museum Art School, Portland; Art Students League, New York.

ERNESTI, ETHEL H. (1880–1955) Painter, oil, watercolor, still lifes, portraits, Indians. Lived in Seattle, Washington. Pupil: Henry Richter; E.Forkner; Chicago Art And Handicrafts. Member: Women Painters of Washington. Exh: Seattle Art Museum; Grant Galleries, New York. Wife of Richard Ernesti.

ERNESTI, RICHARD (1856–1946) Painter, oil, watercolor, landscapes, mountains, Indians. Born in Germany. Lived in Seattle, Washington. Pupil: Knorr; Flinzer; Chicago Academy of Design. Member: Puget Sound Group of Northwest Men Painters, 1940. Director of Art Education for the Colorado schools; Pennsylvania State; Drake University. Exh: widely.

ERSKINE, ALICE E. Designer, for the Alaska-Yukon Pacific Expo, Seattle, official seal, 1909. A California artist. Lived in Piedmont, California, 1989.

ESKRIDGE, ROBERT LEE (1891–1976) Painter, oil, watercolor, murals. Author. Pupil: André L'Hote, Paris. Painted in the South Seas and South America. Art Professor: University of Southern California. Member: Olympia Art League. Exh: State Capitol Museum, Olympia. Author of several books.

ESPEY, EDWARD L. (1860–1889) Painter, landscapes. Illustrator. Member: Portland Art Club. Illustrator, "Oregon End of Trail", American Guide Series. Traveled abroad. Library paid $1,000 for one of his works. Died of TB at 29 years of age.

EULBERG, VERONICA A. (1905–) Painter. Designer, stained glass. Born in Portland, Oregon. Pupil: University of Oregon. Exh: Seattle Art Museum; Oregon Artists Exhibition.

EUWER, ANTHONY HENDERSON (1877–1955) Painter, oil, watercolor, pastel. Illustrator. Lived in Portland, Oregon. Moved to Hollywood in the late 1930's. Knew show business people and made book plates for famous personalities. Illustrator of American and English periodicals. Made trip to the Orient in the 1920's which influenced his works.

EVANS, CATHERINE Painter, oil, Drawing. Lived in Seattle, Washington, 1937, 1943. Pupil: University of Washington, Seattle; Alexander Archipenko; Art Students League of New York. Exh: Seattle Art Museum.

EVANS, ETHEL WISNER (1888–1970'S) Painter, oil. Born in Stayton, Oregon. Lived in Seattle, Washington, 1938, 1939. Pupil: Spokane Art League; Otis Art Institute; Chouinard Art Institute, Los Angeles; MacDonald Wright. Member: Post Surrealist Group, Los Angeles. Exh: Los Angeles Museum of Art, 1938; San Diego Art Museum, 1938; Stendahl Gal-

leries, Los Angeles, 1937–39; Seattle
Art Museum, 1939.

EVERETT, ELIZABETH RINEHART
Painter, oil, watercolor. Sculptor.
Born in Ohio. Lived in Seattle, Wash-
ington, 1939–62. Pupil: University of
Washington, Seattle; Pratt Institute,
Brooklyn, New York. Member: Wo-
men Painters of Washington. Exh:
Seattle Art Museum.

EVERETT, HELEN F. (1883–1965)
Painter, watercolor. Lived in Tacoma,
Washington. Teacher. Pupil: Grant
Wood. Teacher: Rio de Janeiro; Tac-
oma, Washington. Member: Puget
Sound Group of Northwest Men
Painters; Women Painters of Washing-
ton.

EWALD, LOUIS (1891–) Painter.
Craftsman. Mosaicist. Pupil: Pennsyl-
vania Museum & School of Industrial
Arts. Work: altar paintings, murals,
gilding on walls and ceilings in 85
churches.

EWART, PETER (1918–) Painter,
Canadian landscapes, lakes, streets,
cowboys, trappers.

EWERS, EMMET E. Commercial
artist. Lived in Seattle, Washington,
1934.

EWING, IRENE S. Artist. Studio in
Seattle, Washington, 1918.

EWING, JOSEPHINE Artist. Lived
in Tacoma, Washington, 1913.

EYL, HAROLD A. Artist. Lived in
Seattle, Washington, 1929.

EYTCHISON, GLEN DAVID Artist.
Designer. Art Director. Musician.
Composer. Graphic Artist. Lived in
Portland, Oregon before moving to
California where he is currently the
Director, Executive Producer of the
Pageant of the Masters, Festival of
the Arts, Laguna Beach California.
Technical art director for the movie
industry as well as the New York
Theater.

**EYTCHISON, M. SHARYLEN
(1937–)** Painter, oil, watercolor.
Drawing, colored pencils, pen & ink.
Illustrator, genre scenes, seascapes,
landscapes. Publisher. Writer. Art his-
torian. Born in Alhambra, California.
Moved to central Oregon 1958. Mem-
ber: Board of Directors (founding
member), Willamette Valley Arts
Council, Oregon; Sage Brush Art As-
sociation, Bend, Oregon; Nevada
County California Art Association;
Big Canyon Art Group, California. Re-
ceived many awards. Specialty: Chil-
dren and people playing on the beach
and in gardens, western and wildlife.
Painted with Esperonza, Glendon,
Mendoza, D. Lemley, J. Bruce, and
others. Work: many private collec-
tions in the Northwest and Cali-
fornia.

—— **F** ——

**FABIEN, ZOTIQUE HENRE (1878–
1935)** Painter, portraits, still lifes.
Sculptor.

FAICK, FRANCES (1907–)
Craftsperson, jewelry and metal work.

Born in Montana. Lived in Oregon
City, Oregon. Pupil: University of Or-
egon, Eugene. Exh: Seattle Art Mu-
seum, 1936–37. Art Teacher; Oregon
City High School.

FAIRBAIRN, ARCHIBALD, M.D. Painter, oil, watercolor, tempera. Born in South Africa. Lived in Victoria, B.C. Pupil: London, England; South Africa; Germany.

FAIRBANKS, AVARD TENNYSON (1897–) Painter. Sculptor. Craftsman, stained glass, mosaic. Study: Art Student's League, New York; Ecole Nationale des Beaux Arts; Yale University; University of Washington. Member: Oregon Society of Artists. Work: bronze doors "Development of the Oregon Country", Portland Oregon; "Pioneer Mothers Memorial Fountain", Vancouver, Washington. Exh: Portland Art Museum; Art Institute of Seattle.

FAIRBANKS, JOHN LEO (1880– 1946) Painter, oil, landscapes, portraits. Illustrator. Sculptor, clay. Muralist. Architect. Etcher. Teacher. Lived in Corvalis, Oregon. Pupil: his father, J. B. Fairbanks; Julien Academy; Colarossi Academy, Paris. Member: Oregon Society of Artists; American Artists Professional League; American Federation of Art.

FAIRBANKS, LEILA C. Artist. Lived in Yakima, Washington, 1932.

FAIVRE, JUSTIN (1902–1990) Painter, oil, watercolor, landscapes, portraits, still lifes, marines. Moved to Portland, Oregon, in 1907; Los Angeles, 1923; San Francisco, late 1920's. Died in Oakland, California. Pupil: the Portland Art Gallery; Howard Ellis. Exh: Oakland Art Gallery. Member: Society of Western Artists. His later works are more abstract.

FANSHAW, HUBERT VALENTINE (1878–1940) Painter, Canadian landscapes, farms, mountains. Printmaker, woodblock prints, graphics.

FARLEY, BETHEL MORRIS (1895–) Painter, oil, watercolor. Drawing. Lived in Pocatello, Idaho.

Exh: Heyburn Art Exhibition, Teton National Park.

FARLEY, LILIAS MARIANNE (1907–) Sculptor, wood. Theater designer. Craftsperson, puppetry. Born in Ontario. Lived in Vancouver, B.C. Pupil: Vancouver School of Art; James Macdonald; Frederick H. Farley. Member: B.C. Society of Fine Arts, Vancouver. Exh: Royal Canadian Academy. Work: murals for new Vancouver Hotel. Many awards for textile designs.

FARNDON, WALTER (1876–1964) Painter, oil, landscapes, genre. Born in England. Lived in Long Island, New York, 1929. Pupil: National Academy of Design. Many awards. Traveled widely from New England and Canada to Alaska. His paintings "The Anchorage Annisquan Creek" and "Lake George" (Canada) were shown by Vose Gallery in Boston.

FARON, CLIFTON A. Painter, oil. Teacher. Lived in Seattle, Washington, 1910. Art instructor, University of Washington. Exh: First Annual Fall Exhibition of the Society of Seattle Artists, 1907.

FARR, DOROTHY (1910–) Painter. Pupil: Portland, Oregon Art Museum School. Work: murals in the Social Security Building, Washington, D.C.

FARWELL, OLIVE L. Artist. Studio in Spokane, Washington, 1915. Member: Spokane Society of Washington Artists, 1902.

FAUNT, JESSIE Painter, oil. Born in England. Lived in Capilano, B.C., 1940. Pupil: Vancouver School of Art; Frederick H. Varley; James Macdonald. Member: B.C. Society of Fine Arts. Teacher.

FAUROT, F. SEYMOUR (1910–) Painter, oil, tempera. Sculptor, wood, clay. Decorator. Born in Caldwell,

Idaho. Lived in Lewiston, Idaho, 1940. Pupil: Mark Tobey; Betty McCrait Morrison; Cornish Art School, Seattle. Exh: solo show, University of Idaho.

FAY, JEAN BRADFORD (1904–) Painter, oil, watercolor. Printmaker. Craftsperson, tapestry. Cartographer. Born in Seattle, Washington. Pupil: Ambrose Patterson; Mark Tobey; Lionel Feininger; University of Washington. Organized the Washington exhibition of paintings for Rockefeller Center, New York, 1936. Founder: Penthouse Art Gallery, 1934–36, where a number of artists later known as The Group of Twelve exhibited. Many awards.

FEE, CHESTER ANDERS (1893–1951) Painter, oil, watercolor. Illustrator, pencil, pen & ink. Author. Born in Pendleton, Oregon. Self-taught. Member: Oregon Society of Artists. Exh: Meier and Frank, Portland.

FEHENBACH, ALBERT Artist. Studio in Vancouver, Washington, 1936.

FEIST, JULIEN Painter, oil, watercolor. Lived in Tacoma, Washington, 1908.

FEJES, CLAIRE Painter. Lived in Fairbanks, Alaska, in an Eskimo whale-hunting community while she painted. Wrote "People of the Noatak", 1966.

FELDENHEIMER, MARIE LOUISE Sculptor, clay, wood, stone. Lived in Portland, Oregon, 1940. Pupil: Museum Art School, Portland. Member: Art Students League of New York. Exh: Portland Art Museum.

FENWICK, MARY PHYLLIS HILL (1913–) Painter, watercolor. Lived in Seattle, Washington, 1941. Member: East Side Art Study Club.

FERGESON, CHARLES Painter. Founding member: Vancouver, B.C. Fine Art Society, 1919.

FERGURSON, WILLIAM Painter, oil, portraits. Lived in Spokane, Washington, 1935.

FERGUSON, ROBERT B. Painter, oil. Lived in Everett, Washington, 1947. Exh: Seattle Art Museum, Seattle, 1947, 1953.

FERRARA MADELINE PAYETTE (1915–) Painter, oil, landscapes. Sculptor. Commercial artist, figure illustrations & landscape. Born in Seattle, Washington. Lived in Auburn, Washington, 1941. Pupil: Seattle Academy of Art. Exh: Seattle Art Museum, 1934; Portland Art Museum, 1935.

FERRIS, NINA G. (1900–1982) Painter, pastel. Photographer. Lived in Tacoma, Washington, 1932. Exh: Tacoma Civic Art Association, 1932.

FERRUZZA, FRANK P. Painter. Lived in Portland, Oregon, the 1950's.

FERRUZZA, MIKE Painter, marine paintings. Lived in Portland, Oregon, the 1950's. Pupil: University of New York, Brooklyn.

FERRY, FRANCES L. Painter, oil, watercolor, landscapes. Pupil: University of Washington; L'Hote, Paris. Exh: Paris, 1933; Seattle Art Museum, 1938; Corcoran Gallery, Washington, D.C. Teacher: University of Washington, 1940.

FERY, JOHN (1859–1934) Painter, oil, watercolor, landscapes, farms, lakes, national parks, many of whom were for the railroads. Born in Hungary of a wealthy and aristocratic family, he organized and led hunting parties to the Northwest until settling there in 1886. Home and studio in Everett, Washington. Worked for *The Oregon Journal*. Exh: Chicago World's Fair, 1893.

FETTERLY, ROBERT F. Painter, watercolor. Lived in Tacoma, Wash-

ington, 1949. Member: Puget Sound Group of Northwest Men Painters. Exh: Seattle Art Museum, 1949.

FEURER, KARL Painter, genre, landscapes, flowers. Born in Austria. Lived in Seattle, Washington, 1924–26. Member: Seattle Fine Arts Society. Exh: Seattle Fine Arts Society.

FEVER, BIRD LE Painter, oil, impressionist, landscapes, seascapes. Lived in Portland, Oregon, the 1930's. Pupil: Clyde L. Keller. Paintings are rare.

FIELD, EDITH L. Artist. Lived in Tacoma, Washington, 1902. Associated with Ferry Museum, 1902.

FIELD, HARRY Artist. Lived in Seattle, Washington, 1918.

FIELD, HERMAN H. (MRS.) Painter, oil. Lived in Seattle, Washington, 1909.

FIELD, MARIAN (1885–) Painter, oil, watercolor. Drawing, graphite. Born in North Dakota. Lived in Salem, Oregon, 1940. Pupil: University of Oregon, Eugene. Work: Klamath Indian Life, Museum of Natural History; University of Oregon (200 botanical drawings). WPA artist.

FIELDS, EARL T. (1900–) Painter, oil, watercolor. Drawing, graphite. Born in Finland. Moved to Seattle, Washington, in 1903. Pupil: University of Washington, MFA, 1933. Member: Group of Twelve; American Artists Congress. Exh: Seattle Art Museum; National Exhibition of American Art, Rockefeller Center 1936, 1938.

FIFE, J. B. Artist. Lived in Seattle, Washington, 1907.

FIFE, W. Painter, watercolor. Came to Washington as ship's carpenter on the *Swiftsure*. Painted watercolor scenes of early Seattle from the fantail of the ship, circa 1871.

FILIPPITS, S. L. L. Painter, oil, landscapes, seascapes. Known work, Olympia, Washington beach scene, 1946.

FINCH, ELINOR GLADYS Painter, watercolor, miniatures on ivory. Lived in Spokane, Washington, 1924. Member: Spokane Society of Washington Artists. Exh: Spokane Society of Washington Artists, 1923.

FINHOLM, WALTER J. (1909–) Painter, oil, watercolor. Printmaker. Sculptor. Craftsman. Lived in Olalla, Washington, 1941. Pupil: University of Washington, Seattle. Exh: Seattle Art Museum, 1934, 1938.

FISCHER, EUDORA B. Painter, watercolor, still life. Teacher. Lived in Seattle, Washington, 1927, 1932.

FISH, BYRON M. (1908–) Painter, oil. Member: Puget Sound Group of Northwest Men Painters, 1945. Exh: Seattle Art Museum, 1945. Primarily a newspaper columnist and writer, his paintings are "cartoons in oils."

FISH, ELLEN S. Painter, watercolor. Exh: Alaska-Yukon Pacific Expo, Seattle, 1909.

FISHER, HOWARD J. (1889–) Painter, oil. Cartoonist. Pupil: Portland Oregon Allied Arts School. Work: Huntington Art Gallery, San Marino, California; Princeton University; national magazines and newspapers; *Oregon Journal*.

FISHER, MARGENE LEINDECKER (1907–) Painter, oil. Sculptor. Lived in Tacoma, Washington, 1951. Pupil: University of Washington. Exh: Seattle Art Museum, 1934–38, Henry Gallery, University of Washington, Seattle, 1935.

FISHER, ORVILLE Painter, abstractist. Pupil: Vancouver, B.C. School of Art, 1934.

FISHER, ORVILLE NORMAN Artist. Illustrator. Vancouver, B.C. Allied Arts War Service Council. Work: National Museums of Canada. During WWII he became a war artist who landed on Normandy on D-Day.

FISHWOOD, HAZEL C. (1889–) Painter, oil, watercolor. Sculptor. Craftsperson, weaving. Born in Nebraska. Lived in Creswell, Oregon, 1940. Pupil: University of Oregon. Member: Pacific Arts Association. Scholarship: Carnegie Art Foundation, 1937, 1939. Art Supervisor; Eugene Public Schools.

FISKEN, JESSIE (1860–1935) Painter, watercolor, miniatures on ivory, landscapes, portraits. Teacher. Born in Scotland. Moved to Seattle, Washington, in 1888. Member: Seattle Fine Arts Society, one of the original members.

FISKEN, RUTH Artist. Lived in Seattle, Washington, 1924–29. Exh: Spokane Art Festival, 1928.

FITZ, J. P. Painter. Founding member: vice-president, Vancouver, B.C. Fine Art Society, 1919.

FITZGERALD, BENJAMIN H. Commercial artist. Lived in Seattle, Washington, 1937.

FITZGERALD, EDMOND JAMES (1912–) Painter, oil, watercolor, pastel. Printmaker, etching, dry point. Born in Seattle, Washington. Pupil: California School of Fine Arts, San Francisco; Mark Tobey, Eustace Zeigler. Exh: Seattle Art Museum, 1937, 1938; American Watercolor Society; New York Watercolor Club; Smithsonian Institution, Washington. Work: many public murals in the Northwest.

FITZGERALD, J. MAURICE (1899– 1973) Painter, oil, watercolor. Printmaker. Born in Oregon. Lived in Seattle, Washington. Pupil: Mark Hopkins Institute, San Francisco; California School of Fine Arts. Member: Puget Sound Group of Northwest Men Painters; Seattle Fine Arts Society, 1929. Exh: Seattle Art Museum.

FITZGERALD, JAMES HERBERT (1910–1973) Painter, oil, watercolor, tempera. Printmaker. Lithographer. Lived in Seattle, Washington. Pupil: Yale Graduate School; Thomas Hart Benton; Henry Varnum Poor. Member: American Artists Congress. Exh: Northwest Artists; Seattle Art Museum 1933–38. In 1941 he was head of the Spokane Art Center WPA program.

FITZGERALD, LIONEL LE MOINE (1890–1956) Painter, abstracts, landscapes, nudes, still lifes. Draftsman. Member: The Canadian Group of Seven. Painted in the west between 1942 and 1949.

FITZGERALD, MAY EASTMAN (1894–) Painter, oil, pastel. Sculptor, wood, bronze, plaster. Craftsperson, ceramicist. Lived in Seattle, Washington, 1942. Pupil: Chicago Academy of Fine Arts; Museum Art School, Portland; University of Washington. Exh: Bon Marche, Seattle, 1934; Portland Art Museum.

FITZMAURICE, J. Founding member: B.C. Society of Fine Arts, Vancouver, 1933.

FLADELAND, MAY Painter. Lived in Spokane, Washington, 1950. Member: Washington Art Association.

FLAGLER, IDA M. (1901–) Painter, oil. Home and studio in Seattle, Washington, 1942. Pupil: Ross Gill, Seattle. Exh: Panama-Pacific International Expo, San Francisco, 1915; widely over the Northwest.

FLAVELLE, ALAN PAGE (1907–) Painter. Teacher. Member: Portland Artists Congress. Exh: Washington

Society of Independent Artists, 1935. WPA artist.

FLECKENSTEIN, OPAL (1912–) Painter, tempera, landscapes. Teacher. Craftsperson. Lived in Spokane, Washington, 1960. Study: University of Washington; Washington State University. Exh: Seattle Art Museum, 1940–43; Denver Art Museum, 1943–46. Teacher: North Idaho Junior College, 1944–46.

FLEMING, HULAN WILLIAM Painter, oil, landscapes, seascapes, western genre. Pupil: Seattle Pacific University, BS in Physics. Worked as a technical illustrator and design engineer at Boeing Aircraft. Became a full-time artist in the 1960's. Exh: Smithsonian Institute, Washington, D.C.; Frye Museum, Seattle; Favell Museum, Klamath Falls, Oregon; galleries in the Northwest. He has won many awards and was chosen one of the "Top 100" in the National Arts for the Parks Competition.

FLETCHER, ELSIE HARTLEY (MISS) (1907–) Painter, oil. Printmaker. Lithographer. Teacher. Pupil: Art Students League of New York; Hans Hoffmann School, New York; Washington State University; University of Oregon. Exh: Cincinnati Art Museum; Chicago Art Institute, 1938; Seattle Art Museum; Portland Art Museum; Spokane Art Museum.

FLETCHER, HELEN M. Artist. Lived in Seattle, Washington, 1909.

FLETCHER, MARY Painter, oil. Lived in Jefferson County, Washington, 1909. Pupil: Harriet Beecher, Port Townsend, Washington, 1891.

FLETCHER, STUART LEIGHTON (1890–1970) Painter, oil. Commercial artist. Lived in Seattle, Washington, 1924–28. Lived mostly in California.

FLINT, A. R. (MRS.) Artist. Lived in North Yakima, Washington, 1906.

FLINT, GRACE Painter, pastel. Lived in Jefferson County, Washington, 1909. Exh: Alaska-Yukon Pacific Expo, Seattle, 1909.

FLYNN, JOHN E. Artist. Lived in Yakima, Washington, 1911.

FLYNN, RUBY M. (1895–) Painter, oil, watercolor, abstracts. Sculptor. Lived in Seattle, Washington, 1941. Pupil: Ziegler; Ambrose Patterson.

FOGG, DELIA KNEELAND (1895–1967) Painter, oil, portraits. Lived in Tacoma, Washington. Pupil: Annie Wright Seminary, Tacoma; Florence, Italy. Charter member: Washington State Historical Society.

FOLEY, CORNELIA MACINTYRE (1909–) Painter, oil, pastel, tempera. Graphic artist. Printmaker. Teacher. Born in Hawaii. Lived in Seattle, Washington, 1940. Lived in Long Island, New York, 1992. Pupil: University of Hawaii; University of Washington; A. Patterson; M. Tennant; Walter Issacs. Exh: Northwest Printmakers, 1934, 1936, 1938; Laguna Beach Art Association, 1938; Seattle Art Museum, 1940.

FOLSOM, HENRIETTA V. Artist. Lived in Spokane, Washington, 1907.

FOLSOM, VIRGINA Artist. Lived in Spokane, Washington, 1905.

FONDA, ANNA L. Painter, oil, still lifes, landscapes. Lived in Tacoma, Washington, 1895. Exh: Washington State Arts & Crafts, 1909.

FOOTE, HOPE LUCILE Designer. Teacher. Lived in Seattle, Washington, 1940. Professor of Interior Design, University of Washington, Seattle.

FORCE, ANNE (1884–1976) Painter, oil. Lived in Seattle, Washington,

1941. Pupil: Boston Museum of Fine Arts; Mark Tobey. Member: Women Painters of Washington. Exh: Seattle Art Museum, 1935–55.

FORDHAM Artist. Drawing, pen & ink. Early to mid 20th century artist. Known work of a Portland, Oregon street scene.

FORESMAN, ALICE CARTER (1868–1958) Painter, miniatures. Teacher. Studio in Seattle Washington, 1917–18. Pupil: Ella Bush. Teacher of art in California. Member: California Society of Miniature Painters. Exh: Corcoran Art Gallery; Seattle Fine Arts Society; Panama Pacific International Expo, 1915.

FORKNER, EDGAR J. (1867–1945) Painter, oil, watercolor, landscapes, still lifes, harbor scenes. Born in Indiana. Lived in Seattle, Washington, 1941. Pupil: Beckwith; Wiles; Dumond; Art Students League, New York. Member: Puget Sound Group of Northwest Men Painters. Exh: Seattle Art Museum, 1935–40; Stendahl Gallery, Los Angeles. Work: represented in many museums. Highly acclaimed as a floral watercolorist and teacher.

FORREST, LINN A. (1905–) Painter, watercolor. Drawing, pencil, pen & ink. Architect. Printmaker, wood block. Born in Ohio. Lived in Juneau, Alaska, 1940. Pupil: University of Oregon. Work: Designer, Timerline Lodge, Mt. Hood, Oregon. Exh: solo show, Portland Art Museum, 1932; Seattle Art Museum. In charge of all totem pole restorations in Alaska for the Forest Service.

FORSBERG, NORMAN Painter, oil, watercolor, serigraphy. Born in Seattle. Lived in Portland, Oregon. Studied in New York City. Member: Board member of the Arts in Oregon Council; Portland Art Museum. Professional artist since 1956.

FORSEY, ADA M. Artist. Lived in Seattle, Washington, 1907.

FORSLUND, AGNES C. (1891–) Painter, oil, pastel. Teacher. Lived in Everett, Washington, 1941.

FORVILY, JOAN (ADELE SUE HODGES) (1907–) Painter, oil. Line drawing. Pupil: Victor de Wilde; Hal Heath; Orson Lynn, San Francisco. Member: American Artists Professional League; Oregon Society of Artists; Skidmore Fountain Artists Association.

FOSDICK, EMILY M. Artist. Lived in Spokane, Washington, 1913.

FOSS, FLORENCE W. (1882–) Sculptor. Award: Society of Washington Artists, 1936.

FOSTER, FREDERICK LUCAS (1842–1899) Painter, watercolor, landscapes. Began as a survey artist in Windsor, Ontario, in 1865 and became a Dominion Land Surveyor. Traveled extensively throughout British Columbia, Saskatchewan.

FOSTER, G. Painter, portraits. Lived in the state of Washington.

FOSTER, MAY O. Artist. Lived in Spokane, Washington, 1932.

FOTHERINGHAM, STUART GANO Painter. Lived in Seattle, Washington, 1927.

FOULKES, LLYN (1934–) Painter, oil, acrylic. Born Yakima, Washington. Pupil: Central Washington College of Education; University of Washington; Chouinard Art Institute. Work: Whitney Museum of American Art, New York; Chicago Art Institute; Los Angeles County Museum of Art; Museum of Modern Art, New York. Award: Medal of France, first place for painting; many others.

FOUNTAIN, GRACE R. (1858–1942) Painter, landscapes. Main-

tained a studio in Portland, Oregon in the 1890's to 1907. Moved to Oakland, California. Exh: Oakland Art Gallery. Work: Southern Pacific Railroad. Painting of Crater Lake loaned to "The Souvenir of Western Women" book as the frontispiece. Work: Oakland Museum, California.

FOUNTAIN, MINNIE Artist. Lived in Port Townsend, Washington, 1893.

FOWLE, MORGAN Painter, watercolor. Active pre 1950. Past president of the Oregon Society of Artists.

FOWLER, CONSTANCE E. Painter, oil, watercolor. Printmaker. Lived in Salem, Oregon, 1941. Pupil: University of Washington; University of Oregon, three Carnegie Scholarships. Exh: Seattle Art Museum; Portland Art Museum; New York World's Fair, 1939; Lagune Beach Museum, 1938; San Francisco Museum of Art, 1939; Wichita Art Museum. Art Instructor: Willamette University, Salem, Oregon.

FOWLER, DANIEL Painter, watercolor landscapes. Early Canadian watercolor landscape painter originally from England, 1850's.

FOWLER, ETHEL LUCILE Painter, oil, watercolor. Lived in Boise, Idaho, 1940. Pupil: Chicago Art Institute; Chouinard Art Institute, Los Angeles. Member: Boise Art Association. Exh: Lewis and Clark Exposition, Portland, 1905.

FOWLER, HARRIETTE R. Artist, Lived in Tacoma, Washington, 1914.

FOWLER, JAMES J. Painter, oil, western landscapes, seascapes. Lived in Portland, Oregon, in the 1930's. Used rubber stamp with name on reverse of paintings.

FOX, NORMAN E. Artist. Lived in Seattle, Washington, 1940.

FRADENBURGH, MABEL Artist. Lived in Spokane, Washington, 1919.

FRALEY, LAURENCE K. (1897–) Sculptor, ceramic, stone, bronze. Lived in Portland, Oregon, 1940. Pupil: H. M. Erham. Member: American Artists Professional League. Award: Annual Exhibition Northwest Artists, 1931. Exh: solo show, Meier & Frank, Portland, 1931.

FRAME, STATEIRA (STATIRA) ELIZABETH (1870–1935) Painter, oil. Lived in Vancouver, B.C., Canada. Pupil: Robert Henri; Armin Hansen. Exh: Seattle, Washington. Member: Founding member, Vancouver, B.C. Society of Fine Arts; Seattle Fine Arts Society. Exh: National Gallery, Montreal and Ottawa; Royal Canadian Academy of Arts. She was known as British Columbia's pioneer in modernism. She never took a lesson but painted with a spontaneity that gave freshness to the Vancouver art scene.

FRANCONE, CLARICE A. Painter, watercolor, landscapes, Northwest landscapes. Lived in Portland, Oregon, the mid 20th century.

FRANK, J. PETER (1903–) Painter, watercolor, Craftsman, weaving, embroidery design, painting on silk. Born and studied in Switzerland; Germany. Lived in British Columbia, 1940. Exh: many galleries in Vancouver, B.C.; Montreal.

FRASER, JOHN A. (1838–1898) Painter, oil, landscapes. Born in England, immigrated to Canada in 1856. Pupil: Royal Academy Schools, London. Founding member: The Society of Canadian Artists, Montreal, 1867; the Ontario Society of Artists, Toronto, 1872; Royal Canadian Academy of Art 1879. Painted the Rocky Mountains for Canadian Pacific Railway in 1886–1888 and traveled widely in British Columbia.

FRASER, VERA (–1963) Painter, oil, watercolor. Pupil: Parsons School of Design, New York. Opened New York studio in 1947. Exh: Seattle Art Museum, 1947; Boston; Toledo; Brooklyn; Oakland; Miami; Whitney Museum; 1950; retrospective, Tacoma Art League, 1964.

FRATER, LILLIE M. Artist. Lived in Tacoma, Washington, 1942

FREDERICK, ADOLPH Artist. Lived in Seattle, Washington, 1910.

FREDERICKSON, ALFRED L. Commercial artist. Lived in Seattle, Washington, 1929.

FREEBURN, G. S. Artist. Lived in Tacoma, Washington, 1924.

FREEDMAN, RUTH (1899–) Painter. Born in Chicago. Lived in Seattle, Washington, 1927. Pupil: Chicago Academy of Fine Arts. Exh: Seattle Fine Art Society, 1921.

FREEMAN, JOHN Painter, oil. Lived in Pullman, Washington, 1949. Exh: Seattle Art Museum, 1949.

FREIFELD, ERIC Artist. Teacher: University Boulevard, Vancouver, B.C., 1940's.

FRENCH, ARTHUR Illustrator, of the city and Puget Sound views for the *Tacoma Daily Ledger*, 1895. Photographer.

FREUND, RUDOLPH Artist. Lived in Seattle, Washington, 1907.

FRIDELL, P. L. Painter, watercolor, cats. A Seattle, Washington artist in the late 20th century.

FRIEDMAN, MARTIN L. Painter, oil. Lived in Seattle, Washington, 1946. Exh: Seattle Art Museum, 1946.

FRIESE, MARGUERITE S. Painter, oil. Lived in Seattle, 1953. Exh: Seattle Art Museum, 1949.

FRIPP, CHARLES EDWIN (1850–1906) Painter, watercolor, Canadian landscapes, Indians. Illustrator. War Correspondent. Born in London. Settled in British Columbia, 1893. Pupil: Royal Academy in Munich. Covered many wars from 1878–1894 for *Graphic* magazine. Participated in the Klondike gold rush in 1898 in Canada and Alaska before covering the Philippines Campaign of the Spanish American War and finally the South African War in 1900. Settled in British Columbia with his brother Thomas.

FRIPP, THOMAS WILLIAM (1864–1931) Painter, oil, watercolor, Canadian landscapes, lake, mountains. Studied in England; Italy. Member: founding member, Vancouver, B.C. Society of Fine Arts, 1919; president, Art & Historical, Scientific Association; The Sketch Club; The Palette & Chisel Club. Exh: National Gallery, Ottawa; Vancouver Art Gallery. Son of George Arthur Fripp and brother of Charles. He arrived in British Columbia in 1893 and after a try at farming opened a small studio in Vancouver. He was one of the founders of the Royal Watercolor Society, England.

FRITZ, MARY H. Artist. Lived in Seattle, Washington, 1918.

FROBESE, FRED E. Artist. Lived in Seattle, Washington, 1932.

FROELICH, WALTER Painter, oil, landscapes, seascapes. Sculptor. Lived in Seattle, Washington, 1962. Pupil: National Academy of Design, New York; Hans Hoffman, Munich, 1927. Teacher: New York; Chicago; Seattle. Exh: Seattle Art Museum, 1947–49; Henry Gallery, University of Washington, Seattle, 1951, 1959.

FROGRETT, EARL (MRS.) Painter, oil. Lived in Kitsap County, Washington. Exh: Alaska-Yukon Pacific Expo, Seattle, 1909.

FROLICH, FINN (1868–1947) Sculptor. Born in Norway. Immigrated to New York in 1890. Lived in Bellevue, Washington, 1908. Died in Carmel California. Pupil: Daniel Chester French; Art Students League, New York; Ecole Nationale, Paris; Ecole des Beaux-Arts, Paris. Director of Sculptor; Alaska-Yukon Pacific Expo, Seattle, 1909; Director: Oakland Art Gallery, 1918. Teacher: University of California at Berkeley. Established Beaux-arts community in Bellvue Washington in 1908.

FROST, GEORGE ALBERT (1843–) Painter. Born in Boston. Lived in California from 1872–1889. Traveled and painted in the Northwest and Alaska. Exh: San Francisco Art Association.

FROST, MARION LAWRENCE (MR.) (1911–) Painter, oil, watercolor. Printmaker. Sculptor. Born in Salem, Oregon. Pupil: Carnegie Scholarships to the University of Oregon, 1937–38. Teacher: Walla Walla Washington Public Schools.

FROULA, EVA B. (1875–) Craftsman, textiles, weaving. Born in Wisconsin. Lived in Seattle, Washington, 1943. Member: Women Painters of Washington; Froula Textile Studio, Seattle.

FRUHURN, G. (MISS) Painter. Member: Tacoma Fine Arts Association, 1925.

FRY, BESSIE ADELAIDE Painter, oil, watercolor, pastel. Printmaker. Pupil: Art Students League of New York; Vancouver School of Art, Frederick H. Varley. Member: Edmonton Art Club; B.C. Society of Fine Arts. Exh: Royal Canadian Academy, 1927, 1930, 1932; Seattle Art Museum. Many awards.

FUERTES, LOUIS AGASSIZ Painter. Specialty: Alaska fauna around 1901.

FUJII, TAKUICHI (1892–) Painter, oil, watercolor. Born in Japan. Lived in Chicago, 1940. Primarily self-taught. Member: Group of Twelve. Exh: Annual Exhibition of Northwest Artists, Seattle Washington; Seattle Art Museum, 1934, 1935, 1940.

FULKERSON, R. ADOLOPHUS Artist. Lived in Tacoma, Washington, 1914–17.

FULLER, JOHN B. Painter. Early Canadian artist active around 1875.

FULLER, RUTH (1893–) Painter, oil, watercolor. Illustrator. Author. Born in Maine. Lived in Spokane, Washington, 1941. Pupil: Chicago Academy of Fine Arts; Chicago Art Institute. Exh: Chicago Art Institute: Seattle Art Museum 1932, 1933. Illustrator for many magazines.

FULLER, STEVEN D. Painter, oil, watercolor, landscapes, abstracts, glass. Sculptor. Professor of Art: University of Washington. Member: Puget Sound Group of Northwest Men Painters, 1950.

FULLER, VIRGINIA L. Painter, transparent watercolor, mixed media, miniatures. Lived in Bend, Oregon, 1992. Study: Cornish Art School, Seattle; Kathryn Schlater; Richard Yip; Phil Tyler; K. Wengi O'Connor; Richard Nelson. Member: Watercolor Society of Oregon; Central Oregon Arts Society. Exh: Watercolor Society of Oregon; many others.

FULTON, CYRUS JAMES (1873–1949) Painter, oil. Pupil: Wentz; H. Schroff; Portland Art Museum School. Member: American Artists Professional League; Oregon Society of Artists; Circle A Art Club, Portland. Exh: Seattle Art Museum; Eugene Chamber of Commerce; Oakland Art Museum. Work: YMCA, Salem & Eugene Oregon.

FULTON, GRACE Artist. Lived in Seattle, Washington, 1969. Member: Women Painters of Washington, 1942–58.

FULTON, LOIS M. Painter, oil, pastel. Born in Asotin, Washington. Lived in Seattle, Washington, 1941. Teacher: for many years at Roosevelt High School, Seattle. Pupil: Eustace Ziegler. Member: Northwest Printmakers; Pacific Arts Association; American Federation of Arts. Exh: Seattle Art Museum.

FULTZ, DANIEL E. Artist. Lived in Spokane, Washington, 1918.

FULWIDER, EDWIN Painter, oil. Lived in Snoqualmie, Washington, 1947. Exh: Seattle Art Museum, 1947.

FUNG, PAUL Painter. Exh: Seattle Fine Arts Society, 1922.

FUNK, J. LEE Painter, oil. Exh: Seattle Art Museum, 1934. Lived in Omak, Washington, 1947.

FUNTER Master of the *Northwest American*, (first vessel ever built in Nootka Sound.) A sketch of Raft-

Cove by Funter and engraved by T. Frost.

FUOG, ARNOLD C. Artist. Lived in Tacoma, 1912; Seattle, Washington, 1917.

FURLONG, CHARLES WELL-INGTON (1874–1967) Painter, landscapes, genre scenes of the West. Illustrator. Writer. Lecturer. Born in Massachusetts he spent ten summers in Pendleton, Oregon. Many more years were spent traveling the back roads, living with the Blackfeet and Crow Indians. In 1921 he illustrated a book, "Let'Er Buck/A Story of the Passing of the Old West". He was considered an explorer, ethnologist. Work: Smithsonian Institute; Cornell University; Dartmouth College.

FURRISS, LILLIAN M. Artist. Lived in Seattle, Washington, 1909.

FURUYA, KIUZO/KINZO (–1929) Painter, mountains, still lifes, nudes. Lived in Portland, Oregon. Exh: Painters of the Pacific Northwest, 1925.

——G——

GAETHE, GEORGE MICHAEL (1898–1982) Painter, watercolor, murals. Lithographer. Pupil: University of Washington, Seattle.

GAETHKE, GEORGE MICHAEL (1898–1982) Painter, watercolor, murals. Lithographer. Lived in San Francisco, 1924. Pupil: University of Washington, Seattle. Member: Many California art associations.

GAGE, EDWARD B. (MRS.) Artist. Lived in Tacoma, Washington, 1891. Member: Tacoma Art League, 1892.

GAGEN, ROBERT FORD (1847–1926) Painter, Canadian landscapes, mountains, marines, coastal.

GALBRAITH, ALEC Artist. Pupil: Fredrick H. Varley, Vancouver, B.C. Art School, 1930's.

GALE, GEORGE W. Painter, oil, landscapes. Studied in Europe. Lived in Tacoma, Washington, 1907, 1917. Exh: Tacoma Art League, 1912. Exh: most prominent piece, "Harvesting the Rushes", the Tacoma Art League, 1912.

GALUCIA, LOUIS H. Artist. Home and studio in Seattle, Washington, 1921, 1922.

GAMBLE, MARY (MRS. THOMAS) Painter. Lived in Spokane, Washington, 1939.

GAMBLE, WILLIAM SYLVESTER (1912–) Painter, oil, watercolor. Printmaker. Sculptor. Commercial artist. Born in Wisconsin. Lived in Seattle, Washington, 1944. Member: Grapha Techna. Exh: Seattle Art Museum, 1934, 1938, 1939. Exh: Annual Exhibition of Northwest Artists 1937, 1938.

GANGLE, MARTINA MARIE (1906–) Painter, oil. Printmaker. Wood Carver. Pupil: Museum Art School, Portland, Oregon. Member: American Artists Congress. Exh: Portland Art Museum; New York World's Fair, 1939; Northwest Printmakers, 1939, 1940. WPA Artist.

GANN, ERNEST K. Painter, seascapes. Author. Lived on San Juan Island in the Puget Sound. Author of "Island in the Sky", 1944; "The High & the Mighty". Exh: Frederick & Nelson, Seattle, Washington.

GARD, CLARA M. Artist. Lived in Tacoma, Washington, 1891. Member: Washington State Historical Society.

GARDNER, H. M. Artist. Lived in Seattle, Washington, 1901.

GARDNER, LELAH BAKER (1902–) Painter, oil, landscapes. Born in Ashton, Idaho. Lived in Ucon, Idaho, 1940. Exh: all over Idaho.

GARLAND, PHILLIP JR. (1920–) Painter, oil, watercolor. Poet. Commercial artist. Cartoonist. Pupil: Art Center School, Los Angeles. Publisher, editor, *Folly Press*. Member: Tacoma Art League, 1945. Signed name: GAR.

GARNER, CLARENCE L. (1881–1977) Painter. Lived in Gray's Harbor Washington. Died on Vashon Island, Washington. Best known for a series of approximately 50 paintings of the historical development of the logging industry in the Northwest in the 1950's. Pupil: Cornish Art School, Seattle. University of Washington, engineering degree, 1903. Exh: Washington State Historical Society, 1955; (honorable mention), Alaska-Yukon Pacific Expo, Seattle, 1909.

GARRIGAN, J. H. Painter, landscapes. Lived in East Portland, Oregon. Work: 40x60 work of the Willamette River in 1873.

GARTRELL, ALICE Painter, oil. Teacher. Exh: Tacoma Civic Art Association, 1932.

GATCH, CLAIRE Painter. Teacher. Third painting instructor, Territorial University of Washington. 1888–1895.

GATES, GEORGE Painter, oil, watercolor. Lived in Spokane, Washington, 1950. Member: Washington Art Association, 1950.

GAUNTLETT, H. VICTOR Artist. Lived in Seattle, Washington, 1960.

GAY, BESSIE H. Artist. Lived in Seattle, Washington, 1921.

GAY, MAY G. (1876–) Craftsperson, metal work. Teacher. Pupil: of University of Oregon, Portland. Teacher: Oregon Public Schools.

GEDNEY Painter, oil, seascapes. Known work, "Surfs Beat", from Sandy, Oregon.

GEGOUX, THEODORE (1850–) Painter, landscapes, still lifes, portraits. Lived in Portland, Oregon. Painted portraits of all the mayors from 1851–1903, all of which are in the Oregon Historical Society. Work:

the "Birth of Oregon", 8'×12'; also "The Birth of Civil Government in Oregon", 7'× 11', four years in the making.

GEIGER, MARIE J. (1887–) Painter, oil, watercolor. Born in Tacoma, Washington. Member: Pacific Coast Painters, Sculptors, Writers. Pupil: University of the Puget Sound; Pacific Lutheran College. Exh: Tacoma Art League, 1940; Western Washington Fair, Puyallup.

GEISE, JONN H. (1936–) Sculptor. Teacher: Cornish Art School, Seattle. Exh: Seattle Art Museum, 1964. Work: sculpture for the Seattle, Tacoma International Airport.

GEISER, BERNARD (1887–) Painter, oil, watercolor, murals, religious subjects. Pupil: Pennsylvania Academy of Fine Art; Bror Norfeldt, Santa Fe. Carnegie Scholarship, University of Oregon, Eugene. Member: American Artists Professional League. Exh: Portland Art Museum; Denver Art Museum; Seattle Art Museum.

GEISER, JOHN Artist. Member: Puget Sound Group of Northwest Men Painters, 1948.

GELLENBECK, ANNA P. (1883– 1948) Painter, oil, watercolor, landscapes. Born in Minnesota. Moved to Tacoma, Washington, 1910–48. She became one of the leading landscape artists in the Northwest receiving international acclaim. Mainly self-taught. Exh: solo show, Ainslee Galleries, New York; Fine Arts Society, Seattle, 1926; solo show, Seattle Fine Art Society, 1926.

GELLERMAN, MILDRED P. Painter, oil. Lived in Seattle, Washington, 1962. Exh: Seattle Art Museum, 1946.

GELLERT, DR. S. M. (1884–) Painter, oil. Drawing, pencil. Lived in Portland, Oregon, 1940. Member: American Physicians' Art Association. Award: San Francisco Museum of Art, 1938.

GENTNER, JOHN (1892–1978) Painter, oil, china. Born in Canada. Lived in Tacoma, Washington, 1947–78.

GERBEL, MARIBETH Painter, oil, portraits. Lived in Seattle, Washington, 1933. Charter member: Women Painters of Washington. Exh: Women Painters of Washington, 1931.

GERLACH, ALBERT A. (1884–) Painter, watercolor, oil. Craftsman, stained glass. Born in Chicago. Lived in Portland, Oregon, 1940. Pupil: Chicago Art Institute. Member: The Attic Studio, Portland. His stained glass works are in many public and private buildings in the Northwest.

GERMAIN, HARRIET MEYER (1909–) Sculptor. Craftsperson, ceramics. Costume designer. Born in Portland, Oregon. Study: University of Oregon, Eugene. Member: University Alumni Art League, University of Oregon. Designed costumes for the Junior and Senior Symphony, Portland 1934–36.

GERSTMAN, THELMA (1916–) Painter, oil, watercolor, sepia. Teacher. Born in Georgia. Lived in Seattle, Washington, 1941. Pupil: Chouinard Art Institute, Los Angeles. Exh: Annual Exhibition of Northwest Artists, 1938; Seattle Art Museum, 1939.

GERTEN, JOHN (1888–) Painter, oil, watercolor. Printmaker, woodblocks, etching. Born in Illinois. Lived in Raymond, Washington, 1941. Exh: Seattle Art Museum, 1936.

GESCHEIT, ABRAHAM Artist. Lived in Seattle, Washington. 1910.

GEVAU, RUTH M. Artist. Lived in Seattle, Washington, 1937.

GEYER, ALBERT (1901–1979) Painter, oil, landscapes. Teacher. Born in Seattle, Washington. Lived in Seattle, Wenatchee and Spokane. Administrator: Spokane School System. Active oil painter with exhibitions and sales in Eastern Washington.

GEYER, CHARLES ANDREW (1809–1853) Botanist. Editor from Germany, traveled extensively in the Northwest. Thirteen plants named in his honor. Produced many sketches of local landscapes and inhabitants.

GIBBS, GEORGE (1815–1873) Painter, sketches. Born in New York. Lived at Fort Steilacoom, Washington, 1850's. His drawings and ethnological materials are in the Smithsonian collection: "Drawings by George Gibbs in the Far Northwest, 1849–51". In 1849 he accompanied the Mounted Rifle Regiment to Oregon, attached to the Indian Commission. Many of his important historical sketches were executed at that time and in Northern California in 1851.

GIBSON, SUSAN (1894–) Painter, watercolor, animals. Lived in Vernon, B.C. Studied in London; Paris. Member: Island Art and Crafts Society, Victoria; Canadian Society of Painters in Watercolor, Toronto.

GIBSON, THOMAS A. Painter, oil. Lived in Seattle, Washington, 1936. Exh: Seattle Art Museum, 1935–36.

GIESAR, JOHN Painter, oil. Lived in Seattle, Washington, 1947. Exh: Seattle Art Museum, 1947, Henry Gallery, University of Washington, Seattle, 1951.

GIFFORD, B. A. Painter, oil, watercolor. Deceased, wife lived in Portland, Oregon, 1940.

GIFFORD, ROBERT SWAIN (1840–1905) Painter, landscapes. Photographer. Etcher. Illustrator. In 1869 he made a sketching tour through Oregon, Washington and California. He was one of the best of the American etchers. Author, "Art Work of the State of Oregon", photographs, 1909.

GIFFORD, SANFORD (1823–1880) Painter, oil, landscapes. Born in New York. Known as a very important Hudson River artist in the 1870's he painted his way through the Rocky Mountains and the Pacific Northwest. Exh: Washington State Historical Society, 1963; Regional Painters of Puget Sound Expo, 1986.

GILADOW Painter, oil, landscapes.

GILBERT, DOROTHY NORLING Printmaker, wood cuts. Lived in Seattle, Washington, 1931. Charter member: Women Painters of Washington, 1931.

GILBERT, HERBERT Painter. Lived in Vancouver, B.C., 1947. Exh: the World Youth Festival in Prague.

GILBERT, LOUISE LEWIS (1900–1987) Painter, oil, watercolor. Printmaker, dry point, aquatint. Lived in Seattle, Washington. Pupil: Eustace Ziegler; L. Derbyshire; Mark Tobey, Seattle, Washington. Member: Women Painters of Washington; Northwest Printmakers; National League of American Pen Women. Exh: Philadelphia Art Alliance; Portland Art Museum, 1939; Print Club, Philadelphia, 1939; Grant Galleries, New York.

GILBERT, RALPH (1884–) Painter, oil. Lived in Salem, Oregon, 1940. Member: Rembrandt Artists Guild; Oregon Society of Artists. Exh: Portland Art Museum; Seattle Art Museum; Carmel Art Gallery, 1927.

GILCHRIST, W. C. Painter, pastel, portraits. Lived in Tacoma, Washing-

ton, 1932. Exh: Tacoma Civic Art Association, 1932.

GILKEY, RICHARD L. (1925–) Painter, oil, tempera, pallet knife, still lifes of flowers, fish & Skagit Valley landscapes. Born in Bellingham, Washington. Lived in Fir Island, Washington, 1940. Exh: Seattle Art Museum, 1947.

GILL, ROSS R. (1887–1969) Painter, oil, watercolor, tempera, landscapes, seascapes, still lifes, murals. Teacher. Born in Kansas. Lived in Bothell, Washington. Pupil: Chicago Art Institute; Art Students League, New York. Member: Puget Sound Group of Northwest Men Painters. Exh: Seattle Art Museum 1935–49. Exh: widely in the Northwest.

GILLAM, WILLIAM CHARLES FREDERICK (1867–1962) Painter. Engraver. Architect. Born in England. Lived in Burlingame, California. Exh: The California State Fair, 1930 (prize). Work: Queen Mary High School, Vancouver, B.C.; The Provincial Normal School, Victoria. Designed many churches in Northern California and England.

GILMORE, WESLEY HERBERT (1909–1989) Painter, landscapes and western genre. Architect. Oregon artist.

GILSTRAP, WILLIAM HENRY (1849–1914) Painter, oil, landscapes, portraits, murals. Teacher. Historian. Moved to Tacoma, Washington in 1890. First curator of the Washington State Historical Society Museum in Tacoma. President: Tacoma Art League.

GINGRICH, ESTER Painter. Lived in Spokane, Washington, 1950. Member: Washington Art Association.

GINTHER, RONALD DEBS (1907–1969) Painter. As an official with the Seattle Cooks and Waiters Union, he specialized in painting poor people, labor & police conflicts during the depression era of the 1930's. Nationally known. Work: Washington State Historical Society.

GIVAN, DORIS PERKINS Painter, watercolor. Lived in Spokane, Washington, 1933. Moved to Moscow, Idaho, 1940. Exh: Seattle Art Museum, 1939.

GIVAN, JANE (1909–) Painter, Japanese brush painting. Designer, costume, textiles. Illustrator, fashion. Lived in Seattle, Washington. Pupil: Cornish Art School Seattle; Schaeffer School of Design, San Francisco. Head of Design Department; Cornish Art School.

GIVLER, WILLIAM H. (1908–) Painter, oil, pastel, tempera. Printmaker, lithography. Etching, aquatint. Born in Nebraska. Lived in Portland, Oregon, 1940. Pupil: Museum Art School, Portland; Art Students League, New York. Exh: Seattle Art Museum; Federal Art Center, Salem, Oregon; New York World's Fair, 1939. Teacher: Museum Art School, Portland, Oregon.

GLASSCOCK, JULIA E. Painter, oil. Exh: Alaska-Yukon Pacific Expo, Seattle, 1909.

GLENN, KENNETH Artist. Lived in Tacoma, Washington, 1951. Member: Puget Sound Group of Northwest Men Painters, 1947.

GLOVER, ELIAS SHELDON (1844–1920) Painter. Lithographer. Sketcher, topographical. Lived in Tacoma, Washington, 1901. During the 1870's he provided drawings which were printed for promotional purposes by local commercial & political interests. Today they have considerable historical interest. Exh: Portland Art Museum; Amon Carter Museum of

Western Art. Member: Tacoma Art League, 1892.

GLOVER, GRACIE Artist. Lived in Tacoma, Washington, 1901. Member: Tacoma Art League, 1891.

GOCHNOUR, H. DON (1910–) Painter, watercolor, oil, landscapes. Printmaker. Architect. Lived in Yakima, Washington, 1941. Pupil: University of Washington, Seattle. Exh: Seattle Art Museum, 1930.

GODDARD, DAVID J. Artist. Lived in Seattle, Washington, 1932.

GODFREY, MARCEL (1893–) Painter, oil, watercolor, pastel. Lived in Oyama, B.C., 1940. Pupil: Guy Pene DuBois, New York; Georges Degorce, Paris. Exh: Cooling Galleries, London, 1935; Vancouver Art Gallery, 1937.

GODOY, ATANASIO ECHEVERRIA y Painter, natural history. Arrived off the British Columbia coast in 1792 with the Quadra expedition.

GOE, LORAINE Painter. Member: Tacoma Fine Arts Association, 1925.

GOERING, HENRY (1871–1944) Painter, oil, landscapes. Born and educated in Germany. Lived in Tacoma, Washington, 1911.

GOING, ARTHUR J. Artist. Lived in Tacoma, Washington, 1895.

GOLDEN, LIBBY (1913–) Painter. Printmaker. Pupil: Cooper Union Art School; Art Students League 1934–42. Exh: Northwest Printmakers; Seattle Museum of Art & Portland Museum of Art; many awards and solo shows.

GOLDSMITH, JAMES J. Artist. Lived in Seattle, Washington, 1914.

GONZALES, BOYER (1909–) Painter. Teacher. Exh: Seattle Art Museum, New York World's Fair, 1939; Pacific Coast Invitational, 1962; What-

com Museum, Bellingham, Washington. Retrospective Exh: 1930-present, Henry Gallery, University of Washington, Seattle. Award: Governors Award of Special Accomendation, State of Washington, 1975.

GONZALES, SALVADOR (1908–) Painter, oil, watercolor. Photographer. Lived in Seattle, Washington, 1941. Pupil: Cornish Art School, Seattle; Mark Tobey. Exh: Seattle Art Museum; Oakland Art Gallery, 1939.

GOODALE, ELLEN Painter. Exh: solo show, Anchorage Museum, 1969.

GOODALE, HARVEY B. (1900–) Painter, oil, landscapes, seascapes. Illustrator. Sculptor. Pupil: Swain School of Design, Massachusetts; Copley Art Guild, Boston. Exh: solo show, Anchorage Museum, 1969. Magazine illustrator.

GOODING EVELYN NELSON. (1914–) Painter, oil, watercolor. Printmaker. Craftsperson, pottery. Teacher. Lived in Olympia, Washington, 1941. Pupil: University of Washington, Seattle. Exh: Seattle Art Museum; Northwest Printmakers.

GOODRICH, DOUG Painter, oil. Lived in Lake Oswego, Oregon, late 20th century.

GOODRICH, L. M. (MRS.) Artist. Lived in Seattle, Washington, 1912.

GOODWIN, J. WALTER (1913–) Painter. Engraver. Born in Seattle, Washington. Lived in Mercer Island, Washington, 1940. Pupil: Eustace Ziegler. Exh: Seattle Art Museum, 1936, 1945.

GOODWIN, RICHARD LA BARRE (1840–1910) Painter, landscapes, still lifes of game and fish of the hunting lodge type. Spent much time in Oregon, Washington and California. Work: Stanford University, California.

GOOS, LYDIA Painter. Craftsperson. Lived in Spokane, Washington, 1950. Member: Washington Art Association, 1950.

GORANSON, PAUL (1911–) Painter, murals. Printmaker, dry point, etching, color block printing. Born in Vancouver, B.C. Pupil: Vancouver School of Art; B.C. College of Art. Member: Canadian Society of Graphic Arts; B.C. Society of Fine Arts. Became a war artist during WWII. His boat was torpedoed from under him in the Atlantic.

GORDON CHARLES S. Painter, oil, watercolor, pastel. Drawing, charcoal. Lived in Portland, Oregon, 1940. Charter member; Oregon Society of Artists. Exh: Portland Art Museum. Member: The Attic Studio of Portland, artists that included Clyde L. Keller.

GORDON, JOSEPHINE Painter. Pupil: University of Guadalajara, Arizona State University. Exh: All-Alaska Exhibition; Artists of Alaska Traveling Show. Member: Alaska Artists Guild. Work: Bank of North Anchorage, Alaska.

GORHAM, AIMEE Craftsperson. Sculptor. Lived in Portland, Oregon, 1940. Pupil: Pratt Institute, Brooklyn New York. Member: American Artists Professional League. Exh: Architectural League of New York, 1938; Golden Gate International Expo, San Francisco, 1939.

GOSS, DALE M. (1910–) Painter, oil, watercolor, tempera. Lithographer. Teacher. Sculptor. Lived in Seattle, Washington. Member: Puget Sound Group of Northwest Men Painters. Exh: Seattle Art Museum, 1938; Portland Art Museum.

GOSS, JOHN Founded the Labor Arts Guild in 1944. Lived in Vancouver, B.C. Marxist member: Labor Progressive Party.

GOSS, LOUISE H. Painter. Lived in Spokane, Washington. 1940.

GOULD, CARL FRELINGHUYSEN (1874–1939) Painter, watercolor. Sculptor. Architect. Born in New York. Lived in Seattle, Washington. Pupil: Paris; Harvard University. Member: Puget Sound Group of Northwest Men Painters, 1932. Exh: Seattle Art Museum, 1937.

GOULD, DOROTHY FAY (MRS. CARL) (-1976) Artist. Lived in Seattle, Washington. Member: Women Painters of Washington.

GOVE, EBEN FRANK (1885–1938) Painter, oil, watercolor, landscapes. Drawing, crayon, pen & ink. Lived in Payette, Idaho. Known for his rugged mountain paintings. Exh: Boise, Idaho.

GOW, J. MACINTOSH Founding member: B.C. Society Fine Arts, Vancouver, B.C., 1933.

GOWDEY, DOROTHY E. Painter, watercolor, sumi ink. Lived in Seattle, Washington, 1986. Member: Women Painters of Washington. 1946.

GOWELL, PRUNDENTISS (MRS.) Painter. Lived in Tacoma, Washington, 1925. Member: Tacoma Fine Art Association, 1925.

GOWING, ARTHUR J. M. Artist. Lived in Tacoma, Washington, 1895.

GRACE, GERALD L. (1918–) Painter, oil, watercolor. Lived in Seattle, Washington, 1957. Member: Puget Sound Group of Northwest Men Painters, 1944; solo show, Seattle Art Museum; Henry Gallery, University of Washington, 1959. Educational Director: Frye Museum, 1954.

GRACHT, J. VAN DER Painter, watercolor. Lived in West Vancouver, B.C., 1940.

GRAFSTROM, OLAF JONAS (1855–1911 OR 1933) Painter. Work: "View of Oregon" De Young Museum, San Francisco; another large canvas, a view of Mt. St. Helens from the Oregon side is dated 1889.

GRAHAM, ALFHILD (MRS. REGINALD) (1903–1984) Painter. Born in Norway. Lived in Tacoma, Washington for 43 years. Member: Tacoma Art League; Tacoma Arts & Science Club.

GRAHAM, ALICE Artist. Lived in Everett, Washington, 1902.

GRAHAM, CHARLES S. (1852–1911) Painter. Western Illustrator. Topographer. Mainly self-taught. As an artist he worked as a topographer in 1873 for a Northern Pacific survey in Montana and Idaho. Illustrator for *Harper's Weekly*. Was also a special correspondent in the West covering the completion of the Northern Pacific Railroad in 1883.

GRAHAM, HOWARD E. Painter, watercolor. Lived in Seattle, Washington, 1935. Exh: Seattle Art Museum, 1935.

GRAHAM, LOUISE M. Painter, oil, watercolor. Lived in Seattle, Washington, 1921.

GRAHAM, WALTER (1903–) Painter, murals for ships, Alaska, Rocky Beach Dam, Wenatchee. Illustrator. Sculptor. Pupil: Chicago Art Institute. Work: Central Washington Museum; Favell Museum, Klamath Falls, Oregon. Exh: Rendezvous of Western Art, Montana; Artists of the Old West.

GRANDE, ELLEN CORLISS Painter, oil. Lived in Seattle, Washington, 1949. Exh: Seattle Art Museum, 1949.

GRANGER, PATRICIA Printmaker. Lived in Monette, Washington. Exh: Northwest Printmakers, 1940.

GRANT, NETTIE M. Artist. Lived in Spokane, Washington, 1907.

GRANT, SARAH J. Artist. Lived in Spokane, Washington, 1918.

GRATE, SHIRLEY (1921–) Painter, oil, watercolor. Lived in Tillamook, Oregon. Member: Oregon Society of Artists. Exh: Portland Art Museum.

GRAVES, HELEN D. (1899–) Painter, oil. Lived in Seattle, Washington, 1941. Pupil: University of Washington; California School of Fine Arts; University of California; Art Student League, New York; Mark Tobey; Peter Camfferman. Member: Women Painters of Washington. Exh: Seattle Art Museum, 1932–34.

GRAVES, MORRIS (1910–) Painter, oil, tempera, gouache. Printmaker. Graves has emerged as one of the important avant-garde artists to come out of the Northwest. Member: Group of Twelve. Exh: solo shows, Seattle Art Museum; Museum of Modern Art in New York; Palace of the Legion of Honor, San Francisco, 1940; Northwest Art Annual. Exh: widely in the United States and abroad.

GRAY, CLAUDE W. Founding member: B.C. Society Fine Arts, Vancouver, 1933.

GRAY, H. L. (MRS.) Painter, oil. Lived in Seattle. Washington, 1901. Exh: Washington State Arts & Crafts, 1909.

GRAY, HELEN E. Artist. Lived in Seattle, Washington, 1929.

GRAY, KATHARINE M. Artist. Studio in Seattle, Washington, 1907–13.

GRAY, MARIE ELISE Painter. Pupil: Derbyshire School of Fine Art; Cornish Art School, Seattle; Allied Artists; Sergei Bongart. Work: Frye Art Museum; University of Oregon; U.S. Steel Company, Seattle. Exh:

Northwest Watercolor Society; American Watercolor Exhibition. Award: gold medal, Northwest Watercolor Exhibition; Bellevue Art Museum; Women Painters of Washington; Olympia Art Association.

GRAY, PERCY (1869–1952) Painter, oil, landscapes. Illustrator. An important California artist, born in San Francisco. Worked for the *San Francisco Call* and for other newspapers when he went to New York for further study. He returned to California in 1906 and began a successful art career in the Bay area of Northern California occasionally traveling to Washington and Oregon for inspiration.

GRAYSON, E. VAUGHAN K. (1895–) Painter, oil, landscapes. Writer. Lived in Summerland, B.C., 1940. Pupil: Columbia University Teachers College; studied in Europe. Teacher: Saskatchewan at Moose Jaw and Regina public schools.

GREATHOUSE, SADIE M. (1889–1987) Painter, landscapes. Member: Laguna Beach Art Association. Retired to Grants Pass, Oregon in 1960 and worked there until her death. Her subjects include landscapes of New Mexico as well as the missions and coastal scenes of the West.

GREAVER, HANNE (1933) Printmaker. Born in Copenhagen. Lived in Canon Beach, Oregon, 1980.

GREAVER, HARRY (1929) Painter. Printmaker. Professor of Art: University of Maine. Lived in Canon Beach, Oregon, 1980.

GREAVES, THEODORE W. (1878–) Painter, watercolor. Studied in England. Exh: Vancouver Art Gallery, 1938; B.C. Artist Exhibition, 1934–38.

GREEN, EMMA EDWARDS (–1942) Painter, landscapes. Designer. Teacher. One of the most important early western artists of Idaho. Designer of the Idaho state seal and the Idaho countryside. She also opened an art school.

GREEN, JOSEPH W. Artist. Lived in Spokane, Washington, 1915.

GREEN, SPENCER C. Painter, watercolor. Lived in Seattle, Washington, 1946. Member: Puget Sound Group of Northwest Men Painters. Exh: Seattle Art Museum, 1946.

GREENBAUM, JOSEPH DAVID (1864–1940) Painter, portraits. Pupil: The School of Design in San Francisco. The earthquake of 1906 destroyed his studio so he moved to Los Angeles where he specialized in portraiture. Exh: Alaska-Yukon Pacific Expo, Seattle, 1909. Known primarily as a California artist.

GREENE, JOSHUA T. Artist. Lived in Spokane, Washington, 1911.

GREENWOOD, LILLIAN CAESAR (1886–1971) Painter, impressionistic landscapes, florals. Born in Wisconsin. Lived in Portland, Oregon. Pupil: Clyde L. Keller; Edward Quigley, Portland. Exh: Portland Art Museum, 1946.

GREENWOOD, MILDRED Painter. Lived in Tacoma, Washington, 1960. Exh: Tacoma Art League, 1940.

GREGWARE, EDWARD Painter, oil, watercolor. Lived in Spokane, Washington. Pupil: Chicago Academy of Fine Arts, 1926.

GREINER, FRANCOIS J. Painter, murals, mosaics. Lived in Seattle, Washington, 1916.

GRELLERT, PAUL J. (1916–) Painter, oil. Sculptor. Printmaker. Born in Germany. Lived in Portland, Oregon, 1940. Pupil: Museum Art School, Portland.

GRIER, AUDA FAY (1898–) Painter, oil. Lived in Portland, Ore-

gon, 1940. Pupil: University of Oregon. Member: Oregon Society of Artists, Portland; American Artists Professional League.

GRIFFEN, EVGANIA C. B. (1904–) Painter, oil. Born in Russia. Lived in Monroe, Washington, 1941. Study: Moscow Russia.

GRIFFIN, KATE M. Artist. Lived in Tacoma, Washington, 1905.

GRIFFIN, RACHAEL SMITH (1906–) Sculptor. Lived in Portland, Oregon, 1940. Teacher. Pupil: Museum Art School, Portland. Exh: Portland Art Museum.

GRIFFIN, WINNIE A. Painter, oil, still lifes. Lived in Tacoma, Washington, 1910. Exh: Alaska-Yukon Pacific Expo, Seattle, 1909.

GRIFFIN, WORTH D. (1895–) Painter, oil. Lived in Pullman, Washington, 1941. Pupil: Chicago Art Institute: George Bellows; Charles Hawthorne. Exh: Hoosier Salon; Seattle Art Museum. Head of the Department of Fine Arts, State College of Washington.

GRIFFITH, JEAN Painter, watercolor. Lived in Seattle, Washington, 1949. Exh: Seattle Art Museum, 1949.

GRIFFITH, JULIUS H. Painter. Etcher, woodcuts. Lived in Vancouver, B.C., 1930's.

GRIFFITH, MARY KATHERINE Painter, oil, landscapes. Lived in Seattle, Washington, turn of the century.

GRIFFITHS, DALE D. Commercial artist. Lived in Seattle, Washington, 1932.

GRIFFITHS, ELSA CHURCHILL Painter, oil, watercolor, miniatures. Born in Chicago. Lived in Seattle, Washington, 1975. Pupil: Ambrose Patterson; Mark Tobey, Seattle, Washington. Member: Women Painters

of Washington, 1932–58; National League of American Pen Women. Exh: Seattle Art Museum, 1936, 1937; Oakland, California, 1939.

GRIFFITHS, KATHARINE M. Painter, oil, watercolor, landscapes, still lifes. Lived in Seattle, Washington, 1928.

GRIFFITHS, JAMES (1814–1896) Painter, china, still lifes, flowers. Member: Royal Canadian Academy of Artists. Originally from England where he was a china painter.

GRIGGS, MARTHA ANN Painter, oil. Lived in Tacoma Washington, 1909. Member: Tacoma Art League, 1891, 1892. Work: Washington State Historical Society.

GRIMM, RAYMOND MAX (1924) Sculptor. Craftsman, glass blower. Work: University of Oregon Museum of Art, Eugene; Fountain Gallery, Portland; many corporate commissions. Exh: Portland Art Museum; St Paul Museum, Minnesota. Professor of Art, Ceramics & Glass: Portland State University. Many awards.

GRISWOLD, JAMES Cartoonist. Editor. Publisher *Western Cleaner and Dryer*, Seattle, Washington, 1942.

GRISWOLD, S. E. (MRS.) Artist. Lived in Seattle, Washington, 1907.

GROESBECK, DANIEL SAYRE (1878–1950) Painter, murals. Illustrator. Etcher. Painted murals in Portland. Primarily a California artist.

GROFSTROM, OLAF Painter, nude saloon murals, western landscapes, cityscapes. Arrived in Portland, Oregon, 1886. Pupil: Academy of Fine Arts, Stockholm.

GRONBECK, JEAN (1926–) Painter, oil, watercolor, acrylic, contemporary impressionism. Lived in Eugene, Oregon, 1980. Pupil: Univer-

sity of Mexico, Mexico City. Work: Smithsonian Institution, Washington, D.C.; many public & private collections.

GROSSCUP, B. S. (MRS.) Artist. Lived in Tacoma, Washington, 1909. Member: Tacoma Art League, 1892.

GROTHJEAN, FRANCESCA C. R. (1871–) Painter. Born in Germany. Lived in Portland, Oregon. Pupil: Puvis de Chavannes, Paris. Exh: Paris Exposition, 1900. Written up in "The Souvenir of Western Women".

GROUT, JOAN Painter, watercolor, landscapes, miniatures. Teacher. Born in the Puget Sound. Member: Northwest Watercolor Society; North Coast Collage Society.

GROVER, RUTH D. Painter. Commercial artist. Active on the Oregon Coast, mid 20th century. Associated with the Lincoln County Art Center, Delake Oregon.

GRUBE, VARA (1903-Ca.1990) (MRS. CHARLES T. HICKEY) Painter, watercolor, landscapes. Printmaker, block print. Designer. Teacher. Born in Seattle, Washington. Pupil: Cornish Art School, Seattle; California School of Fine Arts, San Francisco. Member: Women Painters of Washington; Artists Council; Northwest Printmakers. Exh: Grant Galleries, New York, solo show; Seattle Art Museum, solo show, 1940.

GRUNDY, H. HAL Painter. Founding Member: The Attic Studio, Portland, Oregon, 1929–67. Became an art director in Detroit by 1953.

GRUNDY, JOSIAH (1872–1946) Painter. Ship modeler. Worked in Vancouver, B.C. Settled in California.

GUAY, THERESA Artist. Lived in Seattle, Washington, 1918.

GUE, GEORGE A. Artist. Studio in Yakima, Washington, 1919.

GUILBERT, GLADYS E. Painter, oil, tempera. Lived in Spokane, Washington, 1973. Exh: Seattle Art Museum, 1945–47.

GUNN, MARJORIE Painter, oil. Lived in Spokane, Washington, 1950. Member: Washington Art Association, Spokane, 1950.

GUNN, PAUL JAMES (1922) Painter. Teacher. Work: Portland Art Museum; Seattle Art Museum. Professor of Painting & Printmaking, Oregon State University, 1948; Chairman, 1964.

GUPTILL, THOMAS HENRY (1868–) Painter, oil, watercolor. Lived in Port Angeles, Washington, 1941. Exh: San Francisco Art Association.

GURLEY, IRENE L. BASHAM (1889–1969) Commercial artist. Born in Washington. Worked there until 1927, settling in Los Angeles.

GURNEY, STELLA F. Artist. Lived in Tacoma, Washington, 1917.

GURREY, HARTLEY R. Lithographer. Textile designer (Hawaiian). Pupil: Washington State College; University of Oregon; Art Students League, New York.

GUSTAFSON, VESTA WELLS (1901–) Painter, oil, watercolor. Born in Iowa. Lived in Portland, Oregon, 1940. Pupil: Museum Art School, Portland, Oregon. Member: Oregon Society of Artists, 1937. Exh: Meier and Frank, Portland, Oregon; Portland Art Museum; Seattle Art Museum.

GUSTANOFF, FLORENCE M. (1915–) Painter, oil, watercolor. Drawing, charcoal. Lived in Seattle, Washington, 1940. Pupil: Seattle Fine Arts Society; Leon Derbyshire. Exh: Seattle Art Museum, 1934.

GUSTIN, PAUL MORGAN (1886–1974) Painter, oil, watercolor, mu-

rals, Mt. Rainier, Northwest landscapes. Printmaker. Born in Fort Vancouver, Washington. Lived in Normandy and Seattle Washington, 1940. Pupil: Jean Manheim, Pasadena; Grand Central Art Galleries, New York. Exh: Chicago Art Institute; Panama-Pacific Expo, San Francisco; Pennsylvania Academy of The Fine Arts; Seattle Art Museum. Teacher: University of Washington, 1922, 1923, 1926, 1927. Work: murals in many Northwest buildings.

GUTHRIE, EDGAR K. Painter, watercolor. Lived in Tacoma, Washington, 1946. Exh: Seattle Art Museum, 1946.

GUTHRIE, GALE LEE (1908–) Painter, oil. Printmaker, lithography.

Lived in Seattle, Washington, 1941. Pupil: Julien Academy, Paris; Academy of André L'Hote; Paul Depuy, Paris. Member: National League of American Pen Women. Exh: Royal Scottish Academy, 1935; Royal Academy, London, 1934; The Salon; Societe des Artistes Francais, Paris, 1932–34–36.

GUYLES, JAY (MRS.) Artist. Lived in Seattle, Washington, 1892.

GWINNUP, MATILDA Artist. Lived in Seattle, Washington, 1929.

GYER, ERNEST H., JR. (1900–) Painter. Illustrator. Pupil: George Heuston. Member: Tacoma Fine Arts Association, 1922–33.

—H—

HAAS, MARGARET Artist. Lived in Seattle, Washington, 1916.

HACKETT, RICHARD (1917–1989) Painter, landscapes. Executed landscapes while working for the forest service in Washington from 1944–46.

HACKWOOD, HARRIET CHAPIN MCKINLAY (1874–1956) Painter, oil, watercolor. Settled in Hoquiam, Washington, 1941. The daughter of President William McKinley. Exh: Seattle Art Museum; Palace of the Legion of Honor, San Francisco; WPA Project.

HADER, ELMER STANLEY (1889–1973) Painter. Illustrator. Pupil: Institute of Art, San Francisco; Academie Julian in Paris, 1911–14. Work: University of Oregon, Eugene.

HAFFER, VIRNA (1899–1974) Photographer. Printmaker, block

print. Sculptor. Moved to Tacoma, Washington in 1914. Exh: Winthrop Hotel, Tacoma 1930–39; Juneau, Alaska, 1938; Fairbanks, Alaska, 1939.

HAGER, LUTHER GEORGE (1885–) Painter. Cartoonist. Lived in Seattle, Washington, 1941. Illustrator with the *Seattle Post Intelligencer*, 1905–13.

HAGERUP, NIELSON (NELS) J. (1864–1922) Painter, coastal, marine. Studied in Europe. Sailed to Portland in 1882. Teacher; Bishop Scott Academy & Pacific University in Forest Grove, Oregon. Founder: Portland Art Association. Worked in San Francisco as a coastal and marine painter for almost three decades. Award: gold medals, Lewis & Clark Expo, Portland, 1905; Alaska-Yukon Expo, Seat-

tle, 1909. Work: Oakland Museum; de Young Museum.

HAHN, DR. RUDOLPH A. (– 1942) Painter, portraits. Medical Doctor. Longtime resident of Spokane, Washington.

HAIG, EMILY (1890–) Painter, oil, pastel. A resident of Seattle, Washington by 1941. Pupil: San Francisco Institute of Art.

HAILES, CHARLES J. Painter. Illustrator for the *Tacoma Ledger*, 1895.

HAINES, TED (1927–) Painter, oil, watercolor, pastel, western genre. Drawing, pencil, graphics. Art Director. Living in Gresham, Oregon, (1992).

HALEY, SALLY (1908–) Painter, modernist.

HALL, CARL A. (1921–) Painter. Work: Whitney Museum of Art, New York; Boston Museum; Denver Art Museum. Artist in Residence; Willamette University, Salem, Oregon.

HALL, CHARLES R. Artist. Lived in Seattle, Washington, 1912.

HALL, CYRENNIUS (1840–1904) Painter, western landscapes. Came over on the Oregon trail, 1853–1854. Was in Portland again in the late 1860's. Studied abroad and was active in New York City and Chicago. Painted for a time in Canada as well as the West. One of his more well-known pieces is a portrait of Chief Joseph on his perilous journey to the Colville reservation in the state of Washington in 1878.

HALL, HAROLD Artist. Lived in Seattle, Washington, 1933.

HALL, HARRIET E. Artist. Lived in Seattle, Washington, 1933.

HALL, MARIE Artist. Lived in Whatcom County, Washington. Exh:

Alaska-Yukon Pacific Expo, Seattle, 1909.

HALL, NORMA BASSETT (1889–) Painter. Teacher. Pupil: Portland Art Association School; Chicago Art Institute; London. Work: Smithsonian Institution, Washington, D.C.; California State Library.

HALL, R. R. Artist. Lived in Seattle, Washington, 1907.

HALL, SYDNEY PRIOR (1842–1922) Painter. Born in England. He was an artist guest of the Canadian Pacific Railroad on a three-month, 6,000 mile tour as part of a campaign to attract settlers to Western Canada. He recorded Buffalo Bill's Wild West Show when it visited London in 1887. Returned to Canada for a third visit in 1901.

HALPERN, ROBERT L. Painter, watercolor. Lived in Seattle, Washington, 1951. Exh: Seattle Art Museum, 1947.

HALVORSEN, RUTH ELISE Painter, oil, watercolor. Teacher. Lived in Portland, Oregon, 1940. Pupil: University of Oregon; Pratt Institute, Brooklyn; Columbia University. Member: American Artists Professional League.

HAMILTON, DORA P. Painter, watercolor. Lived in Tacoma, Washington, 1932, 1935. Exh: Tacoma Civic Art Association, 1932.

HAMILTON, ETHEL C. Artist. Lived in Tacoma, Washington, 1912.

HAMILTON, JAMES (1819–1878) Illustrator. Engraver, 1860's. Translated Elisha Kane's sketches on the Grinnell Expedition to the American Arctic. He used Kane's sketches for his own pictures.

HAMILTON, MARY RITER Painter, oil, watercolor, pastel. Drawing, charcoal. Craftsperson, painting

on silk and other materials. Lived in Vancouver, B.C., 1940. Study: Berlin; Venice; eight years in Paris. She arrived in Victoria around 1912. Member: founding member, Vancouver, B.C. Fine Arts Society, 1919. Exh: Vancouver Art Gallery; Panama Pacific International Expo, San Francisco, 1915.

HAMMER, EARL J. Painter, oil, portraits. Known works in Portland, Oregon.

HAMMON, WALTER E. Sculptor. Lived in Seattle, Washington, 1918.

HAMMOND, LEON W. (1869–1951 or 1952) Painter, oil, watercolor. Drawing, pencil, pen & ink. Lived in Everett, Washington, 1941. Pupil: Eustace Ziegler; Edgar Forkner. Owner: Everett Art Studio. Author of "Pen and Brush Lettering".

HAMSHAW, LEONARD B. Painter. Lived in Seattle, Washington, 1964. Member: Puget Sound Group of Northwest Men Painters.

HANDFORTH, THOMAS (1897–1948) Painter, watercolor. Printmaker, etching, lithography. Illustrator. Author of books for children. Born in Tacoma, Washington. Pupil: National Academy of Design, New York; Art Students League of New York; Ecole des Beaux Arts, Paris. Member: American Society of Etchers. Work: Metropolitan Museum of Art, New York; Seattle Public Library; Seattle Art Museum; Fogg Museum, Cambridge.

HANDSACKER, DOROTHY Painter, watercolor. Illustrator. Lived in Tacoma, Washington, 1928. Illustrator, "The Growth of a Nation", containing 317 three-color plates, maps and ink sketches for grade school classes.

HANSEN, JAMES L. Painter, oil, watercolor. Lived in Vancouver, Washington, 1950. Exh: Southwest Washington Fine Arts, Vancouver, 1949.

HANSEN, JAMES LEE (1918–) Sculptor. Lived in Los Angeles, the early 1930's. Pupil: Portland Art Museum School. Work: San Francisco Art Museum; Seattle Art Museum; University of Oregon Art Museum, Eugene; many pulic commissions.

HANSON, ART (1929–) Painter, oil, watercolor. Etcher. Lived on Vashon Island, Washington, 1983. Pupil: University of Washington; Germany on a Fullbright fellowship. Exh: Seattle Art Museum, 1947, 1949, 1952. Won a Pulitzer Prize in 1951 as 'America's most promising & deserving student.'

HANSON, CLAIR L. Painter. Lived in Tacoma, Washington, 1953. Exh: Tacoma Fine Art Association, 1943.

HANSON, J. Painter, landscapes. Well-known Danish artist of Oregon in 1876. Exh: Palace of Art, Portland. Painted the Washington Territory as well.

HANSON, LAWRENCE, (1936–) Sculptor. Teacher. Pupil: University of Minnesota; University of California, Santa Barbara. Work: Henry Gallery, University of Washington; Seattle Art Museum; C. M. Russell Museum, Montana; Cheney Cowles Museum, Spokane; Vancouver School of Art, B.C.

HANSON, RALPH C. Draftsman. Artist. Lived in Spokane, Washington, 1966. Exh: 5th Annual Art Expo, Spokane, 1948.

HANVILLE, MERRILL F. Painter, oil, western scenes. Teacher: Tacoma High Schools. Lived in Tacoma, Washington, 1916. Exh: Tacoma Art League, 1915.

HARDLAND, MARY (1863–1943) Painter, miniatures. Born in England.

Studied in Paris and Dresden. A resident of Southern California. Exh: the Alaska-Yukon Pacific Expo, Seattle, 1909.

HARDMAN, JACK Sculptor, Lived in Vancouver, B.C., 1950's.

HARDWICK, LILY NORLING (1890–1944) Painter, oil, watercolor, portraits, Indians of the State of Washington. Lived in Seattle, Washington. Pupil: Academy of Fine Arts, Chicago; Central Washington College. Member: Women Painters of Washington; Pacific Coast Painters, Sculptors. Exh: Seattle Art Museum, 1932–1940; Frederick & Nelson, Seattle; Palace of the Legion of Honor, San Francisco.

HARDY, AMANDA E.L. (1874–1949) Painter, landscapes. Lived in Tacoma, Washington, 1932. Exh: Tacoma Civic Art Association, 1932.

HARDY, THOMAS AUSTIN (1921–) Painter, oil, watercolor. Sculptor. Born in Redmond, Oregon. Lived in Corvallis, Oregon, 1940. Pupil: Oregon State College, Corvallis. Member: Kappa Kappa Alpha. Exh: Portland Art Museum, 1937–39; Whitney Museum, New York; Seattle Art Museum; international awards & exhibitions.

HARDY, WILLIAM J. Commercial artist. Lived in Spokane, Washington, 1935.

HARKER, KATHERINE VAN DYKE (1872–1966) Painter, landscapes. Printmaker. Pupil: Art Students League, San Francisco; Academie Colarossi, Paris. Teacher in Santa Barbara. Primarily a California artist. Work: University of Washington.

HARKNESS, NELLIE R. Artist. Studio in Seattle, Washington, 1918.

HARLEY, STEVEN W. (1863–1947) Painter. Lived in Alaska and the Northwest States.

HARLOW, FIDELLA FURBER (1876–1970) Painter. Alaskan, Hawaiian landscapes. Studied in San Francisco, 1895. Made a painting trip at the turn of the century to Alaska, Hawaii, settling in the wine country of California.

HARMAN, JEAN C. (1897–) Painter, oil, landscapes. Craftsperson, tooled leather. Lived in Los Angeles, 1940. Pupil: Clyde Keller, Portland Oregon; H. Raymond Henry. Member: Oregon Society of Artists; Glendale Art Association; Women Painters of the West. Exh: City Hall Art Gallery, Los Angeles, 1939.

HARMER, THOMAS COOPER (1865–1930) Painter, heavy impasto oils, watercolor, Washington landscapes. Born in England. Lived in Tacoma, Washington. Pupil: Duveneck; Meakin. Member: Tacoma Art League; Puget Sound Group of Northwest Men Painters; Oakland Art League. Exh: solo show, San Francisco Art Society; Seattle Art Museum, 1929, (then the Seattle Art Institute).

HARNED, MOLLIE B. Painter, oil, watercolor. Lived in Tacoma, Washington, 1907. Exh: Port Townsend Art Show, 1888.

HARNETT, B. J. Painter. Born in England. Known for a painting of Seattle during the great fire in 1889, and Mt. Rainier. Also painted in San Francisco.

HARRELL, ANNIE L. Artist. Lived in Seattle, Washington, 1934.

HARRIS, BESS LARKIN Painter, oil. Work: The Vancouver B.C. Art Gallery, 1948.

HARRIS, LAUREN STEWART (1885–1970) Painter, abstracts. Exh: Canadian Group of Painters, 1937–39, British Columbia. Founder of the Group of Seven. Later moved to Santa Fe, New Mexico, joining the Transcen-

dental Painting Group. Returned to Vancouver in 1940 for 30 years. Important modern landscape and genre artist of Canada.

HARRISON, FLORENCE (1910–) Painter, oil, watercolor. Printmaker. Teacher. Lived in Seattle, Washington, 1941. Pupil: University of Washington. Member: Women Painters of Washington. Exh: Seattle Art Museum, 1933–47.

HARRISON, THEODORA LAWRENSON (–1969) Craftsperson. Lecturer. Born and died in Ireland. Lived in Seattle, Washington, 1941. Known for her heraldy & illumination, she was commissioned to do art work for King George V and the Royal Family of Great Britain. Member: president, Women Painters of Washington. Exh: Seattle Art Museum; Buckingham Palace, London; Grant Galleries, New York; Downtown Gallery, Seattle: Crock of Gold, San Francisco.

HARROD, ALONZO V. (1877– 1939) Painter, watercolor. Commercial artist. Lithographer for North Pacific Bank Note Company. Lived in Tacoma, Washington, 1932. Exh: Tacoma Civic Art Association, 1932.

HARSCHBERGER, ARLOA F. Painter, oil. Lived in Tacoma, Washington, 1932. Exh: Tacoma Civic Art Association, 1932.

HART, AMELIE B. Painter, portraits. Teacher. Writer. Photographer. Born in England. Lived in Seattle, Washington, 1950. Pupil: F. C. Harrison; Thomas Francis. Spent many years in the Orient studying Oriental customs, ideas & art.

HART, CORNELIA (1899–) Painter, oil. Born and lived in Boise, Idaho, 1940. Pupil: Chicago Art Institute; Dalacleuse School, Paris; University of Washington. While still a teen she opened a studio in Boise and

spent one year in Paris at Academie Delecluse. She spent summers on the Monterey Peninsula of California. Returned to Boise in the 1930's. Exh: National Exhibition of American Art, New York, 1937. Founder: Boise Art Association.

HART, G. A. Artist. Lived in Seattle, Washington, 1910.

HART, LANCE WOOD (1891– 1941) Painter, oil, watercolor, pastel, landscapes, murals. Teacher. Designer. Lived in Aberdeen, Washington, 1924–26. Assistant professor of Drawing and Painting at the University of Oregon, Eugene, 1940. Pupil: Chicago Art Institute. Exh: Portland Art Museum; Philadelphia Art Museum; University of Oregon.

HART, RUTH PATTERSON (1910–) Painter, oil, watercolor, pastel, landscapes, coast. Teacher. Born in Seattle, Washington. Active in Portland, Oregon since 1930. Pupil: Art Students League, New York; Mills College, Oakland California; Colorado Springs Fine Arts Centre; Celestini, Florence, Italy. Exh: Portland Art Museum, 1935, 1936; Seattle Art Museum, 1934, 1935; Honolulu Academy of Art, 1934. Art instructor; Riverdale School, Portland, Oregon.

HART, SALLY (1891–) Painter, watercolor, tempera. Drawing, pen & ink. Lived in Portland, Oregon, 1940. Pupil: Museum Art School, Portland; De la Rossi Studio, Paris. Exh: Portland Art Museum; Art Alliance, New York.

HART, THOMAS J. Commercial art teacher at his mother's studio, Amelia Hart Studio, Seattle, Washington, 1950.

HARTGROVE, LUCIA M. Artist. Lived in Tacoma, Washington, 1925.

HARTUNG, MARLOWE (1920–) Painter, watercolor. Born in Seattle,

Washington. Member: National Society of Art Directors; Puget Sound Group of Northwest Men Painters, 1949.

HARTWELL, OLIVE G. Painter. Lived in Tacoma, Washington. Teacher: Annie Wright Seminary, Tacoma, Washington, 1889.

HASELTINE, JAMES LEWIS (1924–) Painter, oil. Administrator. Pupil: Portland Museum Art School, 1947, 1949; Chicago Art Institute. Work: Portland Art Museum; Oakland Art Museum; Library of Congress, Washington, D.C.; Seattle Art Museum; San Francisco Museum of Art. Executive Director: Washington State Arts Commission. Many awards.

HASELTINE, MARGARET WILSON (1925–) Painter, oil, acrylic, semi-abstract land & seascapes, collage. Pupil: Museum Art School, Portland, Oregon; Eastern New Mexico University. Work: University of Oregon Museum; many public commissions.

HASSAM, FREDERICK CHILDE (1859–1935) Painter, impressionist. Important Eastern Impressionist Painter. Etcher. Member: The American Ten. Painted views of Mt. Hood in the Pacific Northwest. Exh: Museum of Modern Art, New York. Work: "Golden Afternoon", Oregon.

HASTINGS, MARION KEITH (1894–) Painter. Teacher. Lived in Seattle, Washington, 1937. Moved to Los Angeles in 1940. Pupil: A. H. Platt; D. J. Connah;, A. H. Hibbard; E. P. Ziegler; Edgar Forkner. Member: Seattle Fine Art Society; Women Painters of Washington; Beverly Hills Art Society. Exh: Women Painters of Washington, 1932; Yakima Washington, 1929–1933.

HASWELL, ROBERT Early illustrator. Original drawings published in the *History of Oregon* by Lyman. Haswell was first mate of the 'Lady Washington', Robert Gray's vessel in 1788.

HATCH, ANNA S. Painter, oil, still lifes, landscapes. Lived in Seattle, Washington, 1910. Exh: Washington State Arts & Crafts, 1909, Seattle.

HATCH, SARAH J. Artist. Lived in Everett, Washington, 1914.

HATHAWAY, ELLA C. Painter, oil. Lived in Salem, Oregon, 1940. Pupil: Chicago Academy of Fine Arts; University of Oregon. Member: Rembrandt Artists Guild, Salem, Oregon; Board of Directors, Salem Art Center; American Artists Professional League, Portland. Art Director: Salem Arts League. Exh: Oregon State Fair.

HAUGLAND, AUGUSTINE (1891–1964) Painter, oil, watercolor, wash. Drawing, pen & ink, crayon, charcoal. Printmaker, wood block. Illustrator. Teacher. Born in Norway. Lived in Tacoma, Washington. Pupil: Art Students League of New York; Pratt Institute, Brooklyn, New York; Metropolitan Art School. Director; Washington Art Institute, Tacoma. Owner & art instructor, Haugland Art School, Tacoma.

HAVIGHORST, DON B. Artist. Lived in Spokane, Washington, 1925.

HAWKINS, N. H. Founding member: B.C. Society Fine Arts, Vancouver, 1933.

HAYES, DR. ISAAC I (1832–1881) Ships surgeon who accompanied the artist Elisha Kane on the Grinnell Expedition to the Arctic. Studied art under Frederic Church who accompanied him on his second expedition in 1860.

HAYES, MERLE Artist. Exh: Everett, Washington Art Exhibit, 1931.

HAYES, W.P. (1885–1974) Painter, Commercial Artist: Oils, Water-

colors. No formal training. A close friend of C.S. Price in Portland, Oregon. Little is known about his long life as an artist for he did not join any organizations or had any exhibitions. A few years before his death a close friend stopped by to check in on him to find him burning his works in the fireplace for his emotional condition had deteriorated. Approximately 300 pieces went up in smoke leaving 100 canvases left for the world.

HAYNE, JOSEPHINE T. (1856–1928) Painter. Lived in Washington.

HAYUNGS, EMMA Artist. Lived in Camas, Washington, 1913.

HAZELGREEN, CLARA E. Artist. Lived in Seattle, Washington, 1923.

HAZELTINE, NEA SMALL (1866–) Painter. Daughter of artist Hazeltine of Baker City, Oregon.

HAZELWOOD, NELLIE J. Artist. Lived in Seattle, Washington, 1932.

HEAGY, QUIDABON HENRY (1907–) Painter, watercolor. Lived in Triplebrook, Vashon Island, Washington, 1947. Illustrated, "Nature Talks". Exh: Seattle Art Museum, 1946.

HEALD, LUBY WELLS (1881–1962) Painter, oil, portraits. Came to Seattle, Washington in 1932. Teacher: Ballard Art Institute, Washington, 1932. Member: Women Painters of Washington, 1954. Exh: Seattle Art Museum, 1946.

HEANEY, CHARLES EDWARD (1897–1950) Painter, oil, tempura, landscapes, fossils. Printmaker, woodcuts, etching. Illustrator. Lived in Portland, Oregon, 1940. Pupil: Museum Art School, Portland; University of Oregon. Member: American Artists Congress; Northwest Printmakers, (prizes), 1929, 1930, 1932, 1936; many other awards. Exh: solo show, Seattle

Art Museum 1935; University of Oregon, 1932; Federal Art Center, Salem, 1938; New York World's Fair, 1939; International Exhibition Printmakers Society of California, Los Angeles, 1930: Portland Art Museum: San Francisco Museum of Art, 1939.

HEATH, AGNES M. Artist. Lived in Puyallup, Washington, 1895.

HEATH, ANNA Teacher. Lived in Tacoma, Washington, in 1895. Teacher and Principal at Tacoma high schools. Member: Tacoma Art League, 1892.

HEATH, CARROLL (1880–) Painter, portraits. Lived in Coeur-D'Alene Idaho, 1940.

HEATH, EDDA MAXWELL (1875–1972) Painter, oil, landscapes, seascapes. Primarily a California artist. Work: Idaho State College, Caldwell, Idaho.

HEATH, FRANK L. (1857–1921) Painter. Born in Portland, Oregon. Moved with his family to Santa Cruz, California.

HEATON, ROBERT A. Painter, oil. Lived in Fircrest, Washington, 1953. Exh: Seattle Art Museum, 1946; solo show, Tacoma Art League, 1947.

HEBERLY, MINNIE B. Painter, oil, landscapes. Pupil: Boston Museum of Fine Art. Exh: Tacoma Art League, 1915.

HEDLUND, SIGNE A. (1900–1967) Painter, oil, watercolor. Printmaker. Craftsperson. Lived in Everett, Washington. Pupil: Peter Camfferman; Edgar Forkner; Dorothy D. Jensen. Member: Women Painters of Washington; Northwest Printmakers. Exh: Seattle Art Museum, 1937–39. Founded the Everett Art League.

HEDRICK, MARY (1869–) Painter, oil, watercolor, Lived in Portland, Oregon, 1940. Pupil: Chicago Art Institute. Member: Oregon Soci-

ety of Artists; American Artists Professional League.

HEIDEL, FREDERICK H (1915) Painter. Teacher. Pupil: University of Oregon; Chicago Art Institute. Work: Portland Art Museum. Exh: Metropolitan Museum of Art, New York, 1951. Member: Portland Art Association.

HEIL, ELIZABETH (1877–) Painter. Craftsperson. Lived in Seattle, Washington, 1915. Pupil: Cincinnati Art Academy.

HELDER, ZAMMA VANESSA (1909–1968) Painter, oil, watercolor. Printmaker, lithography. Teacher. Designer. Born in Lynden, Washington. Lived in Seattle, Washington, 1941. Pupil: University of Washington, Seattle; Art Students League of New York. Member: New York Watercolor Club; National Association of Women Painters; Women Painters of Washington. Exh: Grant Gallery, New York, 1938–39; Portland Art Museum; Seattle Art Museum; many awards and exhibitions nationally. In 1940–41 she documented the construction of the Grand Coulee Dam with a series of watercolors.

HELDERS, JOHN (JOHAN) Artist. Photographer. Exh: Vancouver, B.C. Public Library, 1920's.

HELLUM, INGVALD Artist. Lived in Seattle, Washington, 1918.

HELM, MYRA SAGER (1869–1959) Painter, oil, impressionistic seascapes, florals, mountains, miniatures. Photographer. Illustrator. Author. Born and lived in Portland, Oregon. Painted in Oregon as early as 1919 as noted in works depicting Mt. Hood and Crater Lake. Daughter of Elizabeth Sager Helm, one of seven orphaned children, adopted by missionaries Marcus and Narcissa Whitman. She wrote and illustrated *Lorinda*

Bailey and the Whitman Massacre, 1952.

HELMER, LOUISE Painter, oil. Teacher. Lived in Sedro Woolley, Washington, 1941. Exh: Seattle Art Museum.

HELTZEL, CHARLES (1914–) Painter, oil, landscapes, still lifes, portraits, figures. Born in Salem, Oregon. Lived in Portland, Oregon, 1992. Pupil: Percy Manser; Jefferson Tester. Exh: Canby Oregon, best of show.

HEMBROFF-BRAND, EDYTHE (See Brand)

HEMING, ARTHUR HENRY HOWARD (1870–1940) Painter. Illustrator of wildlife. Author. Teacher. Freelance illustrator for *Canadian Magazine* and *Masseys*, an interpreter of Western Canada. *Harper's Weekly* accepted a series of illustrations on Iroquois Indians. Pupil: Art Students League, New York; Frank Brangwyn, London. Painted just in black white and yellow until he was 60. Illustrator for *The Saturday Evening Post*. Authored many books on the wildlife of Canada traveling extensively into the Canadian wilderness.

HENDERSON, ELLA C. Artist. Lived in Spokane, Washington, 1909.

HENDERSON, JAMES (1871–1951) Painter of Western Canada, landscapes, genre and portraits including Indian models. Studied in Glasgow and London in the traditional style. His portraits of Indian life were immediately successful for exhibitions and collectors.

HENDERSON, OSCAR E. Painter, portraits. Studio in Seattle, Washington, 1917.

HENNE, ELLEN (1915–1991) Painter, oil, portraits. A noted Alaskan artist.

HENNESSY, ALBERT ERNEST
Painter, watercolor. Architect. Printmaker. Pupil: University of Washington, Seattle. Exh: Palace of the Legion of Honor, San Francisco, gold medal (Architechture). AIA design of bridge at Longview, Washington.

HENNESSY, MARY ERCKENBRACH (1910–) Painter, oil, watercolor. Sculptor. Craftsperson, metal work, ceramics. Printmaker, block print. Lived in Seattle, Washington, 1935; San Francisco, 1941. Exh: Golden Gate International Expo, San Francisco, 1940; Seattle Art Museum, 1934–1937. Work: University of Washington's Bagley Hall & Library.

HENNING, FREDERICK Painter, watercolor. Lived in Spokane, Washington, 1948. Exh: Painters of the Pacific Northwest, 1948.

HENNING, FRITZ J. Painter, watercolor, landscapes. Lived in Spokane, Washington, 1949.

HENRY, E. Painter, oil. Lived in Kittitas County, Washington, 1909. Exh: Alaska-Yukon Pacific Expo, Seattle, 1909.

HENSEL, AVALO B. Artist. Lived in Seattle, Washington, 1930. Member: Women Painters of Washington, 1932.

HENSLEY, MERDECES H. (1893–) Painter, oil. Craftsperson, ceramics, weaving, metal work-silver & copper. Printmaker, block print. Lived in Bothel, Washington, 1941. Pupil: University of Washington, Seattle. Member: Northwest Printmakers. Exh: Seattle Art Museum.

HENSTES, F. D. (MRS.) Artist. Lived in Tacoma, Washington, 1891. Member: Tacoma Art League, 1892.

HENTON, ANNIE Artist. Lived in Spokane, Washington, 1913.

HEPLER, CAROLYN (-1964) Artist. Lived on Bainbridge Island, Washington, 1962. Member: charter member, Women Painters of Washington, 1931.

HERARD, MARVIN T. (1929–) Sculptor. Teacher. Pupil: Burnley School of Art, Seattle; University of Washington; Academy of Fine Arts, Florence, Italy. Exh: Palazzo Venezia, Rome; Seattle Art Museum; Governor's Exhibit, State Capitol Museum; Cheney Cowles Museum, Spokane. Instructor: Seattle Public Schools. Associate Professor of Art & Chairman of the Fine Arts Department, Seattle University.

HERCHMER, LAURENCIA Painter. Lived in Vancouver, B.C., 1940.

HERIOT, GEORGE (1776–1844) Painter, watercolor. Watercolor drawings engraved in 1797, "View of Canada" at the Royal Academy, London. Published *Travels Through the Canadas*, 1807.

HERMON Painter, pastel, landscape.

HERRICK, MARY (1910–) Painter, oil, landscapes. Lived in the small coastal town of Dory Cove, Oregon. Painted all her life while raising her family. Exh: the local community gallery.

HERRY, BARONESS CELESTINE (1874–) Painter, pastel. Born in Belgium. Lived in Vernon, B.C., 1940. Member: Okanagan Artists. Exh: B.C. Artists Exhibition, Vancouver.

HESS, MAUD MCPHERSON Painter, watercolor. Teacher. Lived in the Seattle, Washington area, 1930's. Exh: Washington State Arts & Crafts, 1909.

HETROVO, NICOLAI (1896–1956) Painter, watercolor, portraits, landscapes, nonobjective paintings. Architectural Designer, architectural ren-

derings. Born in Russia. Lived in Portland, Oregon, 1940. Pupil: Lukonsky. Decorator of the Imperial Theater. Due to a mental breakdown and suicide attempt, he spent his last months at Agnew California State Hospital. Exh: solo show, de Young Museum, San Francisco, 1949.

HEURLIN, MAGNUS COLCORD (RUSTY) Painter. Illustrator. Pupil: N. C. Wyeth. Specialized in wall-sized canvases illustrating Alaska's early history.

HEUSTON, GEORGE ZELL (1855–1939) Painter, oil, watercolor, aquarelle. Printmaker, wood block. Cartoonist. Lived in Tacoma, Washington, 1926. Pupil: Chicago Art Institute. Exh: Panama-Pacific Expo, San Francisco 1915; Tacoma Art Association; Pacific Coast Painters; Brush & Palette Club, Tacoma; Tacoma Art League. Author of articles in local newspapers. Founder, Director: Heuston Art Classes, 1918–36. Teacher: life classes, College of the Puget Sound, Tacoma. His son is Frank Zell Heuston, his grandson George F. Heuston; both are artists in New York.

HEWES, DOROTHY MARION (1911–) Painter, oil, watercolor, gouache. Born & lived in Yakima, Washington. Pupil: University of Washington, Seattle; Art Center School, Los Angeles; F. Leger Studio in Europe. Exh: Salon des Independents, Paris; Seattle Art Museum; Francis Graves Gallery, Santa Barbara; College of the Puget Sound, Tacoma, Washington; Municipal Art Committee Show, New York, 1938.

HEWITT, LILIAN L. Artist. Lived in Seattle, Washington, 1907.

HEYLMAN, F. L. Artist. Studio in Spokane, Washington, 1902.

HEYWOOD, HERBERT (1893–) Painter, oil, watercolor, tempera. Born in Portland, Oregon. Pupil: Museum Art School, Portland; Oregon State College; University of Oregon. Exh: Portland Art Museum. Director of Art: University of Portland. Work: "Athletics Mural", Pennisula Park, Portland; "Processional", oil mural, University of Portland; Art Museum collection, University of Oregon.

HEYWOOD, MONA G. Painter. Engraver. Lived in Seattle, Washington, 1923. Employed by the Western Engraving & Color Type Company, Seattle, 1923.

HIATT, MAURINE (MAURINE HIATT ROBERTS) (1898–) Painter. Born in Missouri. Lived in Seattle, Washington, 1921–25.

HIBBARD, ELIZABETH HAZELTINE (1894–) Painter, watercolor. Drawing, pencil, crayon. Sculptor, bronze, terra cotta, plaster, wood, stone. Born in Portland, Oregon. Pupil: Portland Museum Art School; Chicago Art Institute; Grande Chaumiere, Paris. Member: National Association of Women Painters & Sculptors; Alumni Association; Chicago Art Institute. Instructor of Art: University of Chicago. Many awards and public monuments.

HIBBARD, JAMES (1936–) Pencil artist. Pupil: Portland Museum Art School. Teacher: Portland State University, Oregon.

HIBERLY, MINNIE B. Painter, oil, landscapes. Lived in Tacoma, Washington, 1939. Study: Boston Museum of Fine Arts. Chairperson of Art: Washington Federation of Women's Clubs. Exh: Tacoma Art League, 1915.

HICKEY, VARA GRUBE (1903–) Painter, watercolor, landscapes. Teacher. Lived in Woodenville, Wash-

ington, 1946. Member: Women Painters of Washington. Exh: solo show, Seattle Art Museum, 1940; Grant Gallery, New York; West Coast Watercolor Society, 1940.

HICKS, LEINA ROSS Painter. Lived in Tacoma, Washington, 1896. Member: Tacoma Art League, 1892. Exh: Western Washington Industrial Exposition, 1891.

HICKS, PEARL (-1955) Painter, oil. Lived in Ellensburg, Washington, 1940–45. Member: Women Painters of Washington. Exh: Seattle Art Museum, 1940–46.

HIGBY, JENNIE (1901–) Painter, oil, pastel, watercolor. Drawing, charcoal. Lived in Boise, Idaho, 1940. Member: Boise Art Association. Pupil: Boise Outdoor Sketch Club. Mainly self-taught. Exh: awards at Idaho State Fairs: Boise Art Gallery. Work: Nazarine Church, Nyssa, Oregon.

HIGGINS, ANNIE Artist. Lived in Tacoma, Washington, 1894.

HIGGINS, M. E. (MRS.) Artist. Lived in Seattle, Washington, 1912.

HIGGINS, MARY I. Art Teacher. Lived in Tacoma, Washington, 1892. Teacher: Tacoma Public Schools. Member: Tacoma Art League, 1891, 1892.

HIGHAM, SYDNEY Painter. Illustrator. Writer. Visited Canada in 1904 as a Special Artist for the *Graphic* to report on immigration to the western provinces as *An Artists Tour Through Canada.*

HIGLIN, RICHARD T. Painter, oil. Lived in Seattle, Washington, 1949. Member: Puget Sound Group of Northwest Men Painters. Exh: Seattle Art Museum, 1949.

HILBIBER, MARGARET D. Painter, landscapes. Lived in Tacoma,

Washington, in 1932. Exh: Tacoma Civic Art Association, 1932.

HILDRETH, J. H. Artist. Lived in Seattle, Washington, 1907.

HILL, ABBY RHODA WILLIAMS (1861–1943) Painter, oil, watercolor, landscapes, America's National Parks, floral still lifes, portraits of Sioux, Flathead and Yakima Indian tribes. Born in Iowa. Moved to Washington in 1889, eventually settling in Tacoma. Pupil: Art Students League, New York; Herman Hease, Munich. Member: Tacoma Fine Art Association; Boston Art Club. Exh: Chicago World's Fair, 1893; Alaska-Yukon Pacific Expo, Seattle, 1909, 2 gold medals; Lewis & Clark Expo, Portland, 1905. Great fame came from commissions by the Great Northern and Northern Pacific railways. Moved to California in 1905, settling in San Diego.

HILL, CHARLES T. Artist. Studio in Seattle, Washington, 1928.

HILL, EDWARD (1843–1923) Painter, landscapes. Studio in Seattle, Washington, 1916. Son of artist Thomas Hill. Arrived in Portland in 1880 and stayed to work there five years. He worked in Seattle in 1916 and died in Hood River, Oregon. He is often confused with his nephew, Edward Rufus Hill.

HILL, HARRIETTE R. (late 19th century) Painter, watercolor, landscapes. Lived in Portland, Oregon. Wife of Rev. Dr. E. P. Hill.

HILL, RAYMOND L. (1891–1980) Painter, oil, watercolor, landscapes, coastal seascapes. Teacher: University of Washington, 1927–61. Studied in Europe. Exh: Denver Art Museum; Beaux Arts, San Francisco; Seattle Art Museum; Tacoma Art League. Henry Gallery, University of Washington, Seattle.

HILL, RUTH (early 20th century) Painter, oil, Northwest coastal landscapes. Lived in Portland, Oregon around 1930.

HILLIS, JEAN Printmaker, linoleum block. Lived in Spokane, Washington, 1941. Exh: Northwest Printmakers, 1940.

HILLYER, STEVE Painter, watercolor, acrylic, aviation and maritime scenes. Born in Oregon. Moved to Alaska in 1960. Exh: Anchorage State Fair; Alaska Railroad. Work: White House Collection, Washington, D.C. Award: Alaska Juried Watercolor Exhibition, 1984, 1985.

HIND, WILLIAM GEORGE RICH-ARDSON (1833–1888) Painter, oil, watercolor, Canada to California landscapes, Indians, lakes. Survey artist who came to the gold fields and Victoria with the Overlanders in 1862. An extremely talented artist who studied in London. He depicted the plains of the new land, the buffalo, the despondent miners on their weary donkeys in sketches in watercolor as well as oils. He opened a studio in Victoria in 1863 and later took a position as professor of drawing at the Toronto Normal School. In the 1870's he sketched in Manitoba and British Columbia.

HINE, HENRY GEORGE (1811–1895) Painter, Engraver. Self-taught. He began as a marine painter with an exhibition in London. He was on the staff of *Punch* and contributed illustrations to the *Illustrated London News*. He was active in the Canadian West in 1847.

HINMAN, L. Painter, oil. Lived in Kittitas County. Washington, 1909. Exh: Alaska-Yukon Pacific Expo, Seattle, 1909.

HINSHAW, BERNARD (1903–) Painter, oil, watercolor. Teacher. Lived in Portland. Oregon, 1940. Pupil: Chicago Art Institute. Member: American Artists' Professional League. Associate Professor of Art: Portland Extension Center, Oregon State System of Higher Education.

HIRSCHORN, ELSIE Painter. Lived in Spokane, Washington, 1950. Member: Washington Art Association, 1950.

HOAG, DAVID (MRS.) Painter, oil. Lived in Yakima County, Washington, 1909. Exh: Alaska-Yukon Pacific Expo, Seattle, 1909.

HOBART, CLARK (1868–1948) Important California artist born in Seattle, Washington.

HOBBS, ISABEL (1885–) Painter, oil, watercolor. Teacher. Born in England. Lived in Victoria, B.C., 1940. Received art teachers' certificate, South Kensington, London. Member: Island Arts & Crafts, Victoria BC. Exh: Vancouver Art Gallery, B.C.; award winner, London, 1913; solo show, Flower paintings, Victoria, 1938.

HOBERG, FELIX H. Artist. Lived in Seattle, Washington, 1930.

HODGE, LYDIA HERRICK Sculptor. Lived in Portland, Oregon. Pupil: University of California; California School of Fine Arts; Paris. Member: National Association of Women Painters.

HODGES, KATHRYN HALL Painter, oil. Lived in Pullman, Washington, 1946. Exh: Seattle Art Museum, 1946.

HODGES, WILLIAM (1744–1797) Painter. Draughtman to the second expedition to the South Seas under Captain Cook. Royal Academician, 1772. Was employed by the Admiralty to finish his drawings and supervise their engraving for publication.

HODGSON, THOMAS Painter. Lived in Vancouver, B.C., 1940's.

Exh: Biennial of Canadian Painting, 1955.

HOELZLE, WILLIAM WENG (1918–) Sculptor. Designer. Lived in Kirkland, Washington, 1940. Pupil: Otis Art Institute, Los Angeles. Member: Bivouac Club; Otis Art Institute Award: Scholarship from Los Angeles County to Otis, 1939–40. Exh: Los Angeles Museum of Art, Summer, 1939; Seattle Art Museum, 1939; Kirkland Public Library, 1939.

HOERNER, BERTA (1891–1976) Painter, miniatures. Illustrator. Pupil: University of Washington, Seattle. Apprenticed at Western Engraving Company. Grew up in New York City, but moved to Seattle in 1909. Painted for a time in California finally moving back to New York with her husband. Wrote and illustrated more than 100 children's books, receiving the Caldecott Award in 1949.

HOESLECH, ROSE Artist. Lived in Seattle, Washington, 1916.

HOFFAR, IRENE Painter, figurative, landscapes. Pupil: F. H. Varley in Vancouver, B.C., around 1930.

HOFFMAN, ELAINE JANET Painter. Pupil: Portland Art Museum; Northwest Watercolor School, with I. Shapiro. Exh: Watercolor Society of Oregon Traveling Tours; Artists of Oregon, Portland Art Museum; American Artists Professional League, New York; Coos Bay Museum; others.

HOFMEISTER, ANDREW L. Painter, oil, watercolor. Lived in Pullman, Washington, 1960. Member: Art faculty, Washington State University, 1946–53. Exh: Seattle Art Museum, 1945, 1946, 1956; Henry Gallery, University of Washington, Seattle, 1951.

HOGG, J. B. (MRS.) Painter, pastel. Lived in Port Townsend, Washington, 1891. Pupil: Harriett Foster Beecher.

HOGUE, HERGBERT GLENN (1891–) Teacher. Craftsman. Teacher: Central Washington College, Ellensburg Washington, 1935–47.

HOHN, CARL Artist. Lived in Seattle, Washington. 1921.

HOHNSTAEDT (HOHNSTEDT, HOLMSTEDT), PETER LANZ (1872–1957) Painter, oil, landscapes. Born in Cincinnati. Pupil: Frank Duveneck. Lived & exhibited in many places, among them Seattle in the 1920's. Member: Seattle Fine Arts Society; Painters of the Pacific Northwest.

HOLCOMB, HARRIET C. Painter, landscapes. Lived in Elma, Washington, 1924–26. Exh: San Francisco Art Society.

HOLCOMB, MAURICE S. (1896–1976) Painter, watercolor, tempera. Commercial artist. Lived in Seattle, Washington, 1940. Pupil: Yasushi Tanaka, University of Washington, Seattle; Otis Art Institute, Los Angeles. Member: Puget Sound Group of Northwest Men Painters. Director of Advertising, North Pacific Bank Note Company, Seattle and Tacoma.

HOLDREDGE, RANSOME GILLETTE (1836–1899) Painter. Illustrator. Studied extensively in Europe and began painting the West in the 1850's. Worked as staff artist at *Scribners* magazine and covered the Custer massacre. Painted extensively in Oregon and California

HOLGATE, EDWIN HEADLEY (1892–) Painter, landscapes. Studied in Paris at the Grande Chaumiere and Julian. A member of the Vancouver Group of Seven from 1931–33. He was attracted by the Indian communities of British Columbia. War artist with the Air Force in Canada and England 1943–44. Painted on the Skeena River, B.C. with A. Y. Jackson.

HOLLIDAY, CHARLES WILLIAM (1870–) Painter, watercolor. Born in London, England. Exh: Vancouver, B.C. Art Gallery, 1931–37; Canadian Pacific Exhibit, Vancouver, 1934; Vancouver Jubilee, B.C. Artists Exhibit, 1935.

HOLLIER, HAROLD S. (1886–) Painter, oil, pastel. Teacher. Lived in Monroe, Washington, 1941. Born and studied in England. Exh: Everett (Washington) Art Group. Instructor of Art, Washington group of WPA.

HOLLIER, LUCY E. (1884–) Painter, oil, pastel. Lived in Monroe, Washington, 1941. Born in England. Exh: Everett (Washington) Art Group of WPA.

HOLLINGSHEAD, M. MARY (1897–) Painter, oil, pastel, watercolor. Pupil: University of California at Berkley; University of Washington, Seattle; Chicago Art Institute; School of Art, Ashland Oregon. Planned the two best study courses for art, rated by Columbia University. Teacher: Boise High School.

HOLLIS, HENRIETTA B. Painter. Lived in Spokane, Washington, 1912.

HOLLISTER, CARLOTTA E. (– 1951) Painter, oil, portraits. Born in Tehachapi, California. Lived in Seattle, Washington, 1951. Pupil: E. Ziegler, Washington; Chicago Art Institute. Member: Women Painters of Washington. Exh: Seattle Art Museum, 1932–38; prize, Spokane County Fair.

HOLLISTON, ALICE Artist. Lived in Tacoma, Washington, 1896.

HOLMES, ALICE BRENNER (MRS. F. MASON) Artist. Lived in Tacoma, Washington, 1916. Exh: Tacoma Art League, 1915.

HOLMES, F. MASON (1865–1953) Painter, oil, landscapes, heavy im-pasto knife. Lived in Tacoma, Washington from 1882–1953. Teacher: University of Puget Sound. Member: Tacoma Fine Arts Association, 1925.

HOLMES, GEORGE L. (MRS.) Artist. Lived in Tacoma, Washington, 1900. Member: Tacoma Art League, 1892.

HOLMES, MILDRED M. (1897–) Painter, oil, pastel. Teacher. Writer. Born Oakland, California. Lived in Portland, Oregon, 1940. Pupil: California College of Arts and Crafts, Oakland; Oregon State College, Corvallis; University of Oregon, Eugene. Member: American Artists Professional League; Kappa Kappa Alpha; Award, Carnegie Scholarship, University of Oregon, 1937. Exh: Meier & Frank, Portland; Oregon State College, 1938; Grumbacher Co. national tour, 1935; Oregon State Fair, Salem; State Director, American Art Week, 1938.

HOLMES, REGINALD Painter. Pupil: Vancouver, B.C. School of Art. 1958.

HOLMES, ROSE Artist. Lived in Tacoma, Washington, 1912.

HOLMES, WILLIAM HENRY (1846–1933) Painter, watercolor. Survey artist. Illustrator. Archaeologist. Art Director. Led a survey party in 1875 to New Mexico, Arizona and Washington. Painted the Grand Canyon. Head curator of anthropology in Chicago's Field Museum in 1894. Director of the National Gallery of Art, 1920.

HOLMFELDT, BARON H. DE D. Artist. Lived in Seattle, Washington, 1910.

HOLMWOOD, LOREN CONRAD (1892–1985) Painter, pastel, portraits. Illustrator. Born in Puyallup, Washington. An accomplished artist by 15 years of age.

HOLT, BENJAMIN CLARK (1916–) Painter, acrylic. Born in Yakima, Wash-

ington. Member: Seattle Art Director's Society; Puget Sound Group of Northwest Men Painters, 1945.

HOLT, HENRY HARRISON (1843–1922) Painter, oils, watercolor. Moved to the Pacific Coast in 1870, to Tacoma, Washington in 1881. Established Holt Art Company in Tacoma, Washington. Member: Tacoma Art League, 1892.

HOLT, JANET LOUVAU (1929–) Painter, oil, watercolor, acrylic, colored pencil, monotypes. Born in San Diego, California, Janet moved to Portland in 1964. Pupil: De Young Museum, San Francisco; Mills College; University of California, Berkeley, BA, 1951. Art Instructor: Pacific Northwest College of Art. Exh: first place, Watercolor Society of Oregon; Portland Art Museum; Trails End Gallery, Vancouver, Washington. Work: Oregon Historical Society; Saint Vincent's Hospital.

HONDIUS, ABRAHAM (1630–1695) Painter, wild Arctic landscapes, genre. Dutch artist.

HONEY, ALBERT A. (MRS.) Artist. Lived in Tacoma, Washington, 1891–95. Member: Tacoma Art League, 1892.

HONG, ANNA HELGA (MRS. EMILLE RUTT) (1889–1984) Painter, oil, landscapes. Lived in Seattle, Washington, 1923. Pupil: University of Washington; Grand Chaumiere in Paris. Exh: Alaska-Yukon Pacific Expo, Seattle, 1909.

HONG, DAVID (MRS.) Painter, oil. Lived in Yakima County, Washington, 1909.

HONISTER-SUTHERLIN, MAUD (1873–1965) Painter, oil, impressionistic landscapes. Born in Oakland, California, lived in Portland, Oregon. Active there from the 1890's. Member: Oregon Society of Artists; American

Artists Professional League. Exh: Portland Art Museum, 1946, 1948.

HONNIGFORT, MARY ELEANOR (1914–) Painter, oil, watercolor. Printmaker. Born in Tacoma, Washington. Lived in Seattle, 1951. Pupil: University of Washington. Exh: Seattle Art Museum, 1936, 1940, 1946; Henry Gallery, University of Washington, Seattle, 1951.

HOOD, HENRY (HARRY) (1876–) Painter, oil, watercolor. Born in Scotland. Lived in Vancouver, B.C., 1940. Member: Founding member, Vancouver, B.C. Society of Fine Arts, 1919. Exh: Royal Canadian Academy, 1935 & 1938; Seattle Art Museum. President of the B.C. Society of Fine Arts Vancouver, B.C.

HOOKER, BERYL O.E. Artist. Lived in Seattle, Washington, 1923.

HOOKER, ELLEN JONES (1901–1974) Painter, oil, miniatures, ivory. Lived in Tacoma, Washington. Pupil: Chicago Art Institute; Lance Hart; Mark Tobey. Exh: American Society of Miniature Painters; Brooklyn & Chicago Society of Miniature Painters.

HOOLE, KATE SMITH (1879–) Painter, oil, watercolor, animal painter. Lived in Vancouver, B.C., 1940. Member: B.C. Society of Fine Arts. Exh: Society of Women Painters; London National Gallery; Royal Canadian Academy; Seattle Art Museum. Teacher: Crofton House School, Vancouver, (9 years); Vancouver Art School, which she helped to found, (8 years).

HOOPER, ROSA (1876–1963) Painter, miniatures. Primarily a California artist. Exh: Alaska-Yukon Pacific Expo, Seattle, 1909, grand prize.

HOOVER, BARBARA Painter, oil, landscapes, Northwest & Alaska coastline scenes. Lived in Grapeview,

Washington, 1947. Exh: Haines Gallery, Seattle, Washington, 1947.

HOOVER, JOHN JAY (1919–) Painter, Indian myths & legends. Sculptor. Pupil: L. Derbyshire School of Fine Arts, Seattle, Washington. Work: Bureau of Indian Affairs, Washington, D.C.; Seattle Art Museum; Heard Museum, Phoenix Arizona; Seattle Art Commission. Work: mural, Tyoneck Tribe, Anchorage Alaska; City Light Company, Seattle, Washington.

HOPKINS, FRANCES ANN BEECHEY (1856–1918) Painter, Canadian genre scenes. Born in England. Worked on the Canadian voyageurs in 1870. Exh: the Royal Academy, London; the Old Watercolour Society, London, beginning in 1872.

HOPKINS, ROBERT Artist. Lived in Seattle, Washington, 1909.

HORDER, NELLIE PROVINE (1885–1978) Painter, watercolor, casein. Pupil: K. Callahan; Mark Tobey. Member: Women Painters of Washington. Exh: Seattle Art Museum, 1953–57; Frye Museum, Seattle. Award: Western Washington Fair, 1951, 1952.

HORIUCHI, PAUL CHIKAMASA (1906–) Painter, oil, collage, landscapes, Sumi brush. Muralist. Born in Japan. Lived in Seattle, Washington, 1935–41. Exh: solo shows, Seattle Art Museum, 1935, 1938, & on into the 50's Work: mural, Seattle World's Fair, 1962; many museums, including Museum of Modern Art, Tokyo. Received a Ford Foundation Grant in 1960.

HORSFALL, ROBERT BRUCE (1868–1948) Painter. Lived in Portland, Oregon.

HORTON, VIDA E. Painter, oil. watercolor, portraits. Lived in Seattle, Washington, 1909. Exh: San Fran-

cisco Art Society, 1908; Alaska-Yukon Pacific Expo, Seattle, 1909.

HOSODA, KURAJU (1885–) Painter, oil, watercolor. Born in Japan. Lived in Seattle, Washington, 1941. Self-taught. Exh: Seattle Art Museum, 1938.

HOTKA, RAY (1913–) Painter, watercolor. Drawing, pencil, pen & ink. Teacher. Born in Iowa. Pupil: Percy Manser; Del Gish; Charles Mulvey, Oregon. University of Iowa, M.S. in science and biology; Two years of art, 1932–34. High school teacher: Pocatello, Idaho, Hood River; The Dalles, Oregon. Member: Oregon Watercolor Society, past president. Award: The Dalles Art Association, charter member and past president; Art Guild of the University of Iowa, honorary student.

HOUGHTON, MERRITT DANA (1846–1918) Painter, oil, watercolor, landscapes, mines, ranches. Photographer. Teacher. Lived in Seattle, Washington. Primarily a Wyoming sketch artist settling in Laramie in 1875. His drawings, maps and paintings of local genre are important historical renderings.

HOULAHAN, KATHLEEN EVA (1887–1964) Painter, portraits, mountain landscapes, floral still lifes. Settled in Seattle, Washington in 1902 making many trips to California. Pupil: Robert Henri, New York. Member: Pacific Coast Painters, Sculptors & Writers, 1940; Seattle Fine Art Society; San Francisco Art Association. Exh: Pan-Pacific International Expo, San Francisco, 1915; Seattle Art Museum.

HOUSE, H. E. HOWARD ELMER (1877–1969) Painter, portraits, landscapes. Lived in Portland, Oregon. Pupil: Chicago Art Institute; Chicago Academy of Fine Art. Member: Amer-

ican Artists Professional League, 1940.

HOUSER, JOAN Painter, watercolor. Exh: Seattle Art Museum, 1947.

HOUSTON, JAMES LOUIN (1908–) Painter, watercolor. Printmaker. Lived in Seattle, Washington, 1940. Pupil: Cornish Art School, Seattle. Exh: Seattle Art Museum 1936–39; San Francisco Museum of Art, 1938. Member: Northwest Puget Sound Group of Northwest Men Painters.

HOVDE, JANE HAMILTON Painter, oil, island motifs. Born on a tug boat between Blakely Island and Anacordes, Washington. Lived in Bellingham, Washington, 1949. Pupil: University of Washington, Mark Tobey; Art Students League, New York. Exh: Seattle Art Museum, 1947, 1949.

HOWARD, ELOISE (1889–) Painter, oil, watercolor. Printmaker. Lived in Portland, Oregon and San Francisco, 1940. Pupil: Museum Art School, Portland; National Academy of Design, New York; Art Students League of New York; Beaux-Arts Institute of Design, New York. Exh: solo show, Portland Art Museum; Art Alliance of America; honorable mention, National Association of Women Painters and Sculptors, New York; San Francisco Art Association; Art Alliance of America.

HOWELL, JAMES (1935–) Painter. Exh: Northwest Watercolor Annual; Frye Museum, Seattle; Puget Sound, Bainbridge Island Washington.

HOWELL, K. L. (MISS) Artist. Lived in Tacoma, Washington, 1891. Member: Tacoma Art League, 1891.

HOWES, ESTELLA E. (1884–1968) Painter. Illustrator, books. Lived in Tacoma, Washington 1907–17. Illustrated *The Mountain Path* & *The Dream of Life & Other Poems*, by M. E. Foster.

HOWLAND, ETHEL HOPKINS (early 20th century) Painter, watercolor, pastel, Northwest landscapes and coastals, impressionistic still lifes. Howland was active in Seattle, Washington between 1915 and 1925. Painted extensively in Oregon and the Bay area of California.

HUBBARD, BELL W. Artist. Studio in Spokane, Washington, 1907.

HUBER, BERNICE M. Painter, watercolor. Lived in Spokane, Washington, 1948. Member: Women Painters of Washington, 1948–52.

HUDSON, HARLOW E. (1906–) Painter, watercolor. Architect. Lived in Eugene, Oregon, 1940. Pupil: University of Oregon; Massachusetts Institute of Technology, MIT; Professor of Architecture, University of Oregon, Eugene.

HUDSON, MURIEL (1890–1959) Printmaker. Painter. Born in Canada. A resident of California in the 1920's and 40's, returning to Victoria, B.C. Work: Smithsonian Institute, Washington, D.C.

HUDSON, RICHARD M. Painter, oil. Lived in Seattle, Washington, 1946. Exh: Seattle Art Museum, 1946.

HUFF, HOWARD L. (1941–) Artist. Teacher: Art Department, Boise State University, Boise, Idaho.

HUGHES, ARCHIBALD J. Artist. Lived in Seattle, Washington, 1916.

HUGHES, EDWARD JOHN (1913–) Painter. Illustrator, primitive, murals at San Francisco Fair, drawings, landscapes, buildings, coastal harbors, ships. Lived in Vancouver, B.C. A student of the Vancouver School.

HUGHES, LOUIS J. (1893–1973) Painter, watercolor. Lived in San

Francisco in the 1920's. Employed as a caricaturist for the *Chronicle*. Made many painting trips into Northern California with Louis Siegriest, Mourice Logan. Member: Puget Sound Group of Northwest Men Artists, 1944.

HUGO, HELEN Painter, oil, gouache. Lived in Spokane, Washington, 1950. Member: Washington Art Association, 1950.

HUKARI, OSCAR (1878–) Painter, oil, pastel. Lived in Hood River, Oregon, 1940. Member: Oregon Society of Artists; American Artists Professional League. Exh: Portland Art Museum, 1934. Exh: Oregon Society of Artists; Multnomah County Fair, Oregon.

HULETTE, VERENA J. Artist. Lived in Seattle, Washington, 1914.

HULME, HAROLD EMLUH (1882–) Painter, oil. Craftsman, copper repousse. Born in England. Lived in Seattle, Washington, 1930. Studied in Paris. Member: Oregon Society of Artists. Exh: Portland Art Museum, 1936: Annual Exhibit of Northwest Artists, 1926.

HUMBER, YVONNE TWINING (1907–) Painter, oil, acrylic. Silkscreen, monoprints. Teacher. Lived in Seattle, Washington, 1982. Pupil: National Academy Design, New York; Art Students League, New York. Member: Women Painters of Washington. Exh: Palace of the Legion of Honor, San Francisco; solo show, Seattle Art Museum, 1947, (part of their permanent collection).

HUMES, JESSIE N. (MRS.) Artist. Lived in Seattle, Washington, 1923.

HUMPHREY, JACK WELDON (1901–) Painter. Pupil: Museum of Fine Arts, Boston; National Academy of Design; Tiffany Foundation, Long Island. Worked in Vancouver, B.C., 1933.

HUMPHREY, JAY S. Commercial artist. Lived in Spokane, Washington, 1943.

HUMPHREY, SIDNEY J. Artist. Lived in Seattle, Washington, 1943. Member: Puget Sound Group of Northwest Men Painters, 1945.

HUNT, EDITH WARD China painter. Lived in Yakima, Washington, 1914.

HUNT, JOSEPHINE Artist. Lived in Seattle, Washington, 1907.

HUNTINGTON, DANIEL RIGGS (1871–) Painter, oil, watercolor, distemper. Architect. Lived in Metaline Falls, Washington, 1941. Pupil: Eustace Ziegler, Seattle. Exh: New York Watercolor Club; Fine Arts Guild, New York; solo show, Spokane Art Museum, 1938; New York Watercolor Club; New York Fine Arts Guild.

HUNTINGTON, MARGARET JEAN Artist. Lived in Castle Rock, Washington, 1934. Member: Women Painters of Washington. Exh: Seattle Art Museum, 1934.

HUNTLEY, DENNIS R. Painter, oil. Lived in Seattle, Washington, 1947. Exh: Seattle Art Museum, 1947.

HUSEBY, HERMAN (1912–) Painter, tempera, black & white. Printmaker, block print. Drawing, crayola, pencil, charcoal. Muralist. Born in Seattle, Washington. Lived in Tacoma, Washington. Pupil: Art Student League, New York. Instructor: Clover Park Education Center, Lakewood, Washington. Work: Seattle and Tacoma.

HUSTON, FLORENCE GARDINER (1893–1977) Commercial artist. Draftsman. Born in Oregon. She settled in San Francisco in 1927 where she remained.

HUSTON, KATHLEEN AGNEW Painter, oil, gouache. Lived in Seattle,

Washington, 1973. Member: Women Painters of Washington. Exh: Seattle Art Museum, 1945–47; Henry Gallery, University of Washington, Seattle, 1951.

HUTCHINS, SHELDON F. (1886–) Painter, oil, watercolor. Lived in Kirkland, Washington, 1941. Pupil: Ziegler; Fokko; Tadama; Hazelwood. Exh: first prize, Western Washington Fair, Puyallup, 1932; Annual Exhibit of Northwest Artists, 1932.

HYDE, BEULAH L. (1887–1983) Painter, oil, watercolor. Lived in Tacoma, Washington. Pupil: Mark To-bey. Member: Women Painters of Washington. Exh: Seattle Art Museum, 1940–47; solo show, Tacoma Art League, 1940, 1951.

HYDE, DONALD J. Artist. Lived in Ellensburg, Washington, 1948.

HYDE, HELEN (1868–1919) Painter. Illustrator. Etcher. Printmaker. Primarily a California artist. Exh: Alaska-Yukon Pacific Expo, Seattle, 1909.

HYDE, JULIA A. Artist. Lived in Seattle, Washington, 1914.

HYSLOP, JEAN Artist. Lived in Vancouver, B.C. 1930's.

—I—

IGLEHART, ROBERT L. (1912–) Designer. Teacher. Commercial Industrial Designer, advertising, publishing, typography, textile design. Lived in Seattle, Washington, 1941. Pupil: Art Students League, New York; Associate School of Art, University of Washington, Seattle; scholarship for travel and study in Europe, 1934. Member: Puget Sound Group of Northwest Men Painters. Teacher: School of Art, University of Washington.

IHDE, ADELAIDE Painter, oil, pastel, landscapes in the primitive style. Lived in Oregon around 1920. Painted in the Parrott/Barchus tradition.

IHRIG, HARRIETTE H. Artist. Lived in Tacoma, Washington, 1914.

IKARD, VIRGINIA (1871–) Painter, oil, pastel. Drawing: modeling in clay. Lived in Jerome, Idaho. Studied in France. Teacher: Gooding College, Wesleyan, Idaho, (7 years).

IMMEL, PAUL J. (1896–1964) Painter, watercolor, portraits, floral still lifes. Commercial artist. Teacher. Lived in Seattle, Washington. Pupil: Otis Art Institute, Los Angeles. Member: Puget Sound Group of Northwest Men Painters; Northwest Watercolor Society. Exh: Seattle Art Museum, 1935–40's; Frye Museum, Seattle. Worked as an artist for the *Seattle Post-Intelligencer*. Art instructor in the public schools.

IMPELMANS, LELA Painter, oil. Ceramist. Lived in Spokane, Washington, 1950. Member: Washington Art Association, 1950.

INGERSOLL, ENID V. Painter. Lived in Tacoma, Washington, 1925. Exh: Tacoma Fine Art Association, 1922, 1923.

INGERSOLL, REX E. Painter, oil. Commercial artist. Lived in Seattle, Washington, 1951. Exh: Seattle Art Museum, 1946.

INGRAHAM, LILLIAN M. Artist. Lived in Seattle, Washington, 1918.

INNES, JOHN (1863–) Painter, oil, watercolor, Western Canada. Printmaker, etching. Drawing, pen & ink. Cartoonist. Lived in Vancouver, B.C., 1940. Known as a historical artist. Worked with the survey party of the Canadian Pacific Railroad. Executed cartoons of his life as a cowboy for the *Calgary Herald* and *Canadian Magazine*. Went to Vancouver, B.C. by pack train around 1905 painting along the way. In New York City between 1903 and 1913 as a Hearst Publishing artist illustrating the lore of Western Canada. Work: "Herding in Canada", presented to the United States. Exh: solo show, "Epic of Western Canada", in Vancouver, Montreal, Leipzig & London.

INVERARITY, ROBERT BRUCE (1909–) Painter, oil, pastel, watercolor. Printmaker. Craftsman, puppetry. Born and lived in Seattle. Washington. Study: University of Washington; Mark Tobey; K. Yamagishi. Member: Fellow of the Royal Society of Arts London; WPA. Exh: solo show, Gumps, San Francisco; Weston Studio, Carmel Calif; Vancouver Art Gallery B.C.; Seattle Art Museum and extensively throughout the country and abroad. One of Seattle's youngest artists. Art Associate at the University of Washington, 1933–37.

INVERARITY, WALLACE D. (1904–) Painter, watercolor. Printmaker, wood block. Lived in Seattle, Washington, 1941. Pupil: Frank Binn, A. G. Snider. Member: Northwest Printmakers. Exh: Printmakers Society of California; Northwest Printmakers, 1935–37.

INVERTIARY, D. C. Photographer on board steamship *George W. Elder* to Alaska, at the turn of the century.

IRVINE, J. A. Artist. Lived in Seattle, Washington, 1907.

IRWIN, MARIE ISABELLA DUFFIELD (IRVIN) (1863–1932) Painter. Lived in Boise, Idaho. Pupil: Robert Reid; Metcalf.

ISAACS, JOSEPHINE A. Painter, oil, watercolor, china. Lived in Tacoma, Washington, 1913. Exh: Alaska-Yukon Pacific Expo, Seattle, 1909; Tacoma Art League, 1915.

ISAACS, MILDRED (1886–) Painter. Wife of artist, Walter F. Isaacs. Lived in Seattle, Washington.

ISAACS, WALTER F. (1886–1964) Painter. oil, watercolor, portraits. Teacher. Born in Illinois. Moved to Seattle, Washington in 1923. Pupil: Chase; Dumond; Friesz; Guerin; Art Students League, New York. Member: Group of Twelve; Puget Sound Group of Northwest Men Painters. Award: First prize for modern painting, Seattle Art Museum, 1928; Rockefeller Center, New York. Exh: Autumn and Spring salons in Paris. Professor of Art, Director of the School of Art, University of Washington, Seattle. Director of the Henry Art Gallery, University of Washington.

ISHIL, KOWHOO (1897–) Painter, oil, landscapes. Lived in Seattle, Washington, 1924–26.

ITO, TOZABURO C. Artist. Lived in Seattle, Washington, 1909.

ITTER, JULIAN E. Painter, oil, landscapes. Conservationist. Born in Canada. Lived in Seattle, Washington, 1912. Studied in Toronto, New York and Paris. As a part-time resident of Seattle at the beginning of the century, he painted the Northwest mountains, becoming an active conservationist. He is credited with the being the first strong advocate for the establishment of a North Cascades National Park. Exh: Butler Hotel, Seattle, 1906.

IVERSON, Los Angeles Artist. Lived in Seattle, Washington, 1910.

IVEY, JOHN JOSEPH (1842–1910) Painter, watercolor. Teacher. Writer: *A Plain Guide to Landscape Painting and Sketching From Nature in Watercolor.* Lecturer at art organizations in San Jose and Pacific Grove California, Portland and Seattle. He specialized in watercolor landscapes of Northern California, Oregon and Washington mountains, lakes, etc. which he sent to the East coast and England for sale. Exh: Washington State Arts & Crafts Show, Seattle, 1908; Oakland Museum.

IVEY, WILLIAM (1919–) Painter, abstract, large canvases. Pupil: Cornish Art School, Seattle; Mark Rothko; Clyfford Still, San Francisco, California. Exh: Seattle Art Museum.

IVY, JOHN Artist. Lived in Seattle, Washington, 1910.

IZQUIERDO, MANUEL (1925–) Sculptor, metal, bronze, clay. Painter. Printmaker. Teacher. Born in Spain. Pupil: Beaux Arts School, France; Portland Museum Art School; Fred Littman. Currently Chairman of the Sculpture Department, Pacific Northwest College of Art since 1956. Member: Metropolitan Arts Commission.

— J —

JACKSON, A. L. (MRS.) Artist. Lived in Tacoma, Washington, 1915. Member: Tacoma Art League, 1891. Exh: Western Washington Industrial Exposition, 1891; Washington State Commission of Fine Arts, 1914.

JACKSON, ALEXANDER YOUNG (1882–) Painter, oil. Original Member of the Canadian Group of Seven, 1920, Vancouver. Pupil: Julian Academie, Paris; Chicago Art Institute. Painted the Alaska Highway, 1943, the Arctic, British Columbia.

JACKSON, DAVID E. (1874–) Painter, oil, watercolor. Born in Canada. Lived in Olympia, Washington, 1941. Self-taught.

JACKSON, HEWETT (1914–) Painter, watercolor, mixed media. Illustrator. Printmaker. Lived in Bellevue, Washington, 1981. His specialty is sailing ships in Puget Sound from the turn of the century. Work: (on permanent display) Oregon Historical Society; Columbia River Maritime Museum, Astoria Washington.

JACKSON, JACQUELINE BOWEN Painter, watercolor. Lived in Wenatchee, Washington, 1946. Exh: Seattle Art Museum, 1946.

JACKSON, JAMES Painter. Member: Puget Sound Group of Northwest Men Painters, 1947.

JACKSON, JOSEPH R. (1898–1979) Painter, oils, landscapes. Photographer, portraits. Born in Ogden, Utah. Moved to Emmett, Idaho in 1936 where he maintained a photography studio and art gallery until his death in 1979. Exh: Idaho State Fair in Boise and locally.

JACKSON, MARTIN JACOB (1871–1955) Painter, portraits, landscapes, marines. Pupil: Cooper Union, New York; Paris; London; Brussels. Primarily a Calfornia artist. Exh: Alaska-Yukon Pacific Expo, Seattle, 1909.

JACKSON, ROY (1892–) Painter, landscapes. Lived in Seattle, Washington, 1924–26. Studied abroad. Member: Seattle Fine Art Society.

JACKSON, W. C. (19TH CENT.) Painter, oil. Lived in Oregon.

JACKSON, WILLIAM HENRY (1843–1942) Painter, watercolor. Photographer. After the Civil War he traveled by wagon to California from 1870–78 sketching the area and taking the first photographs of Yellowstone National Park with the Hayden Survey Expeditions. At the age of 81 he became Secretary of the Oregon Trail Memorial Association and was commissioned to paint historical scenes of the Trail's history. One of the nation's pioneer photographers of the West as well as a fine painter.

JACOBS, E. F. (MRS.) Painter, watercolor. Teacher. Lived in Tacoma, Washington, 1895. Member: Tacoma Art League, 1891. Exh: Western Washington Industrial Exposition, 1891; Tacoma Art League, 1896.

JACOBS, FRANK Painter. Lived in Seattle, Washington, 1924.

JACOBS, LEONEBEL Painter, oil, watercolor, portraits. Sculptor. Writer. Born in Tacoma, Washington. Lived in New York City, 1953. Study: University of Oregon. Pupil: Brush; Hawthorne. Member: American Watercolor Society; National Association of Women Artists; New York Watercolor Society. Work: portraits of Mrs. Calvin Coolege and Mrs. Herbert Hoover.

JACOBSEN, FERDINAND G. Painter, landscapes. Lived in Tacoma, Washington, 1932. Exh: Tacoma Civic Art Association, 1932.

JACOBSEN, JOHN T. Painter, murals. Architect. Lived in Seattle, Washington, 1941. Work: murals in the Northwest history room, University of Washington, Seattle.

JACOBSON, OSWALD BEYER (–1912) Painter, oil, marines. Lived in Tacoma, Washington, 1895–1898. Pupil: Max Mayer. First husband of Ruth Clark, a Tacoma painter. Died on the ocean liner *Titanic* when it sank.

JACOBY, ALICE B. Painter. Lived in Seattle, Washington, 1916–21.

JACQUES, RACHEL E. Painter. Lived in Tacoma, Washington, 1891. Member: Tacoma Art League, 1892.

JAEGER, HENRY Artist. Lived in Spokane, Washington, 1909.

JAENICKE, BEULAH. (1918–) Painter, oil. Lived in Vancouver, B.C., 1940. Pupil: James MacDonald; Canadian Institute of Associate Arts, Vancouver, B.C. Exh: B.C. Artists Exhibition, Vancouver; Montreal Art Association.

JAMES, HAZEL B. Artist. Lived in Seattle, Washington, 1912.

JAMES, JIMMIE (1894–) Painter, oil. Drawing, charcoal. Printmaker, etching. Lived in Portland, Oregon, 1940. Pupil: John T. Nolf; Otto Schneider, Chicago. Exh: Metropolitan Art Institute. Member: American Artists Professional League; Silver Palette Club.

JAMESON, DEMETRIUS GEORGE (1919–) Painter. Printmaker. Lived in Corvallis, Oregon. Work: Portland Art Museum; Seattle Art Museum; Corcoran Print Show, Washington, D.C. Many awards.

JAMIESON, AGNES D. Painter. Lived in Portland, Oregon, 1915.

JAMIESON, MITCHELL Painter. Member: Artists Equity Association, Seattle, Washington, 1952. Exh: Henry Gallery, University of Washington, 1951.

JANEL, EMIL G. (1897–1981) Wood sculptor. Born in Sweden. Study: California School of Fine Art, was active there from 1930–60's. Work: Carnegie Museum, Vancouver, B.C.

JANSSON, ARTHUR AUGUST (1890–1941) Painter. Pupil: W. R. Leigh; William Chase. Designed cover for *Natural History Magazine*. Criticized for his rendition of the Northwest Indians in kilts.

JARDON, L. E. Painter, portraits. Lived in Portland, Oregon during the late 1880's in the French academic style.

JARRETT, MARY (1913–) Painter, oil, watercolor, portraits, landscapes. Printmaker, wood and linoleum block. Lived in Seattle, Washington, 1941, though mostly lived in Los Angeles. Pupil: University of Washington, Seattle. Studied in England & Paris. Member: Women Painters of Washington; American Artists Professional League; Northwest Printmakers; British Watercolor Society; Société Libre des Artistes Français. Exh: Seattle Art Museum, 1938; San Francisco Art Association, 1938; British Watercolor Society 1935–38; Western Washington Fair, Puyallup, 1933; Grant Gallery, New York, 1937–38. Teacher: Seattle Public Schools.

JARVIS, DONALD Artist. Vancouver, B.C. Art School, 1945. Figurative, genre painter he painted pictures of empty men in the crowded streets of Vancouver.

JEDLICK, EDWARD J. Painter, scenic. Lived in Tacoma, Washington, 1940. Work: Edison Theater, 1905. Owner and artist for the Jedlick Sign Company, Tacoma.

JEFFERSON, C. L. (MRS.) Painter, watercolor. Lived in Chelan County, Washington, 1909. Exh: Alaska-Yukon Pacific Expo, Seattle, 1909.

JEFFERYS, CHARLES WILLIAM (1869–1951) Painter, historical, landscapes. Illustrator. Teacher. Writer. Born in England. Lived in Toronto. Work: Royal Ontario Museum. Primarily an Eastern artist his best-known subjects are of the prairies of Western Canada. Illustrated the classic book "The Chronicles of Canada".

JEFFRIES, WILMA Artist. Lived in Spokane, Washington, 1931.

JELACIE, JACK Painter. Commercial artist. Engineer. Member: Founder, The Attic Studio, Portland Oregon, 1929. Turned over the reigns of the Studio to Clyde and Ethyl Archibald in 1939 because of illness.

JENKINS, HANNAH TEMPEST (1865–1927) Painter. Primarily a California artist she studied all over the world and taught at Pomona College in 1905. She traveled widely around California and the Northwest. Exh: Alaska-Yukon Pacific Expo, Seattle, 1909.

JENKINS, LOUISA MEYER (1898–) Painter. Mosaicist. Born in Montana, spent her childhood in Seattle Washington. Studied in France while a nurse during WWI. She specialized in religious, liturgical works. Work: mosaic in Mt. Angel Abbey, Portland, Oregon.

JENKINS, MARY E. Artist. Lived in Monroe, Washington, 1906.

JENKS, JANE ELLEN (WARRACK) (1912–) Painter, watercolor. Craftsperson, jewelry, weaving. Printmaker, block print. Commercial Artist. Lived in Seattle, Washington, 1941. Pupil: Cornish Art School, Seattle; California School of Fine Arts, San Francisco. Exh: Seattle Art Museum; Frederick & Nelson, Seattle.

JENKYNS, JEAN Artist. Lived in Seattle, Washington, 1909.

JENNER, ERNEST C. Artist. Lived in Seattle, Washington, 1928.

JENNINGS, GEORGE R. Commercial artist. Lived in Seattle, Washington, 1929.

JENNINGS, JACQUELINE Painter, watercolor. Lived in Seattle, Washington, 1945. Exh: Seattle Art Museum, 1945.

JENNINGS, MARTHA Artist. Lived in Bellingham, Washington, 1913.

JENSEN, ARNE ROUDOLPH (1906–) Painter, oil, watercolor, marines. Lived in Everett, Washington, 1961. Pupil: Seattle Art School; Chicago Academy of Fine Arts; Eustace Ziegler. Member: Puget Sound Group of Northwest Men Painters. Exh: honorable mention, Seattle Art Museum, 1938; Portland Art Museum; College of the Puget Sound, Tacoma; Boise Art Association.

JENSEN, DOROTHY DOLPH (1895–1977) Painter, oil, watercolor. Printmaker, etching. Teacher. Born in Forest Grove, Oregon. Lived in Seattle, Washington. Pupil: Museum Art School, Portland; Julien Academy, Paris; Sydney Bell, Portland. Member: Women Painters of Washington (founder); Northwest Printmakers; Pacific Coast Painters, Sculptures & Writers; National League of American Pen Women, Seattle. Awards: first prize, Women Painters of Washington, 1936; Seattle Art Club, 1936, National League of American Pen Women, 1937–39. Works in Seattle Art Museum, Portland Art Museum.

JENSEN, EMMA Artist. Lived in Seattle, Washington, 1929.

JENSEN, HOWARD (1913–) Painter, gouache. Drawing, pen & ink. Born in Bellingham, Washington.

Lived in New York City, 1941. Study: Cornish Art School, Seattle, Washington.

JENSEN, LLOYD E. Painter, oil. Lived in Seattle, Washington, 1967. Exh: Seattle Art Museum, 1949.

JENSEN, MARTHA Painter, watercolor. Lived in Seattle, Washington, 1927.

JOHANSON, ERIK (1874–1969) Painter, oil, watercolor, landscapes, seascapes. Woodcarver. Lived in Seattle, Washington. Born in and studied in Sweden. Member: Northwest Puget Sound Group of Men Painters, 1933. Exh: Seattle Art Museum, 1935, 1945, 1946.

JOHANSON, GEORGE (1928–) Painter, oil, abstract. Pupil: Portland Museum Art School. Teacher at the school. Widely known for his etchings and collages.

JOHANSON, JEAN L. (1911–) Painter, oil. Sculptor. Craftsperson, ceramics. Lived in Seattle, Washington, 1941. Pupil: University of Washington, Seattle. Exh: Seattle Art Museum 1936–38; National Exhibition of American Art, New York, 1936; New York World's Fair, 1936.

JOHANSON, PERRY B. (1910–) Painter, watercolor. Architect. Lived in Bellevue, Washington, 1951. Pupil: University of Washington, Seattle. Member: American Institute of Architects. Exh: Seattle Art Museum, architectural exhibit, 1939; Henry Gallery, University of Washington, Seattle, 1932.

JOHANSON, WALDEMAR ALEXANDER (1888–1957) Painter, landscapes. Commercial artist. Set Designer. Born in Sweden. Teacher: Stanford University, California; California College of Arts and Crafts. He traveled widely around California and

the Northwest painting the mountains and local scenery.

JOHN, MARGARET SAWYER Painter, oil. watercolor. Lived in Corvallis, Oregon, 1940. Pupil: Chicago Art Institute. Member: Oregon Society of Artists. Award: first prize, American Artists Professional League, Portland. Exh: Seattle Art Museum; Oregon State Fair; Multnomah County Fair; solo show, Art Center, Corvallis, 1938.

JOHNSON, CATHERINE C. (1883–) Painter, oil, watercolor, black & white. Lived in Seattle, Washington, 1941. Pupil: F. Tadama; Dumi Kwei. Studied in San Francisco. Member: Women Painters of Washington. Exh: Seattle Art Museum, 1932–47. Award: Chinese Zeal, Dumi Kwei, 1929.

JOHNSON, D. W. (MRS.) Painter, watercolor. Lived in Parkland, Washington, 1906. Exh: award winner, Western Washington Fair, Puyallup, 1906.

JOHNSON, DAVID Painter, oil. Lived in Seattle, Washington, 1947. Exh: Seattle Art Museum, 1947.

JOHNSON, GWEN BALMER Painter, oil. Lived in Everett, Washington, 1939. Member: Women Painters Washington, 1949–58. Exh: Seattle Museum, 1949, 1952.

JOHNSON, H. A. (MRS.) Artist. Lived in Seattle, Washington, 1901.

JOHNSON, HAL O. (1908–1989) Painter, oil, watercolor, oil, and monotype. Born in North Dakota. Moved to Portland, Oregon, 1936. Exh: Portland Art Museum, 1955; Seattle Art Museum, 1964. Worked for Disney Studios in the 1930's; For J. K. Gill as Director of Advertising. Maintained his studio at Cannon Beach, Oregon. Member: Artists of Oregon.

JOHNSON, JEANNETTE D. (1909–) Painter, oil, watercolor.

Printmaker, etching. Craftsman, wood carving. Lived in Portland, Oregon, 1940. Pupil: scholarship to the Museum Art School, Portland, Oregon. Exh: first prize, Portland Art Museum; second prize, Oregon State Fair, Salem, 1935.

JOHNSON, KENN ELMER (1914–) Painter, oil, watercolor, Mt. Rainier and local landmarks. Consultant. Born in Seattle, Washington. Lived in Gig Harbor Washington, 1973. Pupil: Art Institute of Chicago; Abel Warshawsky; Rex Brandt. Work: Tacoma Public Library; Washington State Historical Society Museum, Tacoma; State Capitol Museum, Olympia, Washington. Painted abstracts and signed them Hjalmar Slominski.

JOHNSON, LILLIAN Painter. Lived in Tacoma, Washington, 1906.

JOHNSON, MARGARET MARY (1904–) Painter, oil. Printmaker, wood block, etcher. Drawing, pencil. Born and lived in Lewiston, Idaho, 1940. Pupil: University of Oregon, Eugene; Montana State College, Bozeman; Washington State College, Pullman. Head of the Art Department, Lewiston Public Schools, Lewiston Idaho.

JOHNSON, MARIE LABES (1906–) Painter, oil, watercolor, pastel, animal portraits. Sculptor. Printmaker. Teacher. Born in Chicago. Lived in Bellevue, Washington, 1960. Member: Women Painters of Washington. Exh: Seattle Art Museum, 1932–40; Grant Gallery, New York, 1936–38; Henry Gallery, University of Washington, Seattle, 1951.

JOHNSON, PAULINE B. Painter, watercolor. Teacher. Printmaker. Lived in Yakima, Washington, 1941. Study: University of Washington. Exh: Seattle Art Museum, 1936, 1937. Teacher: Central Washington College, Ellensburg, 1937.

JOHNSON, RICHARD VERNON (1905–) Painter. Mosaicist. Lived in Brookings, Oregon. Pupil: Chouinard Art School, Los Angeles. Teacher of oils and watercolors, Orange Coast College, California.

JOHNSON, RUBIE C. PEDERSON (1896–1980) Painter, watercolor, pen & ink. Pupil: University of the Puget Sound. Exh: Tacoma Civic Art Association, 1932; Seattle Art Museum, 1953.

JOHNSON, T. A. (MRS.) Artist. Lived in Seattle, Washington, 1902.

JOHNSTON, BRUCE E. Painter, oil. Lived in Seattle, Washington, 1951. Exh: Seattle Art Museum, 1949.

JOHNSTON, MARY A. (1816–1911) Painter, miniatures, portraits. Born in England. Lived in Tacoma, Washington. Daughter of Thomas Wheeler, court artist of London, 1820–30's. At ll years old, she was the youngest exhibitor in the history of the Royal Academy, London, 1911.

JOICE, DON K. (1914–) Sculptor. Born in Idaho Falls. Pupil: University of Idaho, Moscow; Royal Academy of Sweden, Stockholm; Carnegie Scholarship, University of Oregon, Eugene. Work: sandstone fountain, Administration Building, University of Idaho. Instructor: Moscow Public Schools.

JONES, ANNA M. Artist. Lived in Port Townsend, Washington, 1893.

JONES, ARISTINE, M. P. Painter, miniatures. Lived in Seattle, Washington, 1927.

JONES, CHARLES F. Painter. Lived in Tacoma, Washington, 1941.

JONES, CORRINE B. Artist. Lived in Tacoma, Washington, 1930–62. Exh: Tacoma Art League, 1930.

JONES, GRACE C. Artist. Decorator. Lived in Spokane, Washington, 1969. Owned an interior decorating business for 40 years.

JONES, IDA STONE (1867–1944) Painter, watercolor. Lived in Tacoma, Washington, 1904. Exh: Washington State Historical Society, 1904.

JONES, JESSE S. (MRS.) Painter, watercolor. Lived in Tacoma, Washington, 1932. Exh: Tacoma Civic Art Association, 1932.

JONES, MABEL Artist. Lived in Seattle, Washington, 1916.

JONES, OLA Artist. Member: Tacoma Art League. Exh: Washington State Historical Society, 1945.

JONES, SIDNEY E. (1908–) Painter, oil. Drawing, charcoal. Born in England. Lived in Burke, Idaho, 1940. Pupil: Chicago Art Institute. Exh: Chicago Art Institute, 1937–39; first prize, Boise Art Association, 1939.

JONNES, WILLIAM Artist. Lived in Seattle, Washington, 1919.

JONNEVOLD, CARL HENRIK (1856–1930) Painter, landscapes. Born in Norway. Migrated to the United States in the 1880's. He is known to have painted in the Northwest before moving to California in 1887, maintaining a studio in San Francisco. Exh: Alaska-Yukon Pacific Expo, Seattle, 1909, bronze medal.

JONSON, RAYMOND (1891–1976) Painter, western transcendentalist. Teacher. Gallery director. Pupil: Portland Art School, 1909–10. Work: Museum of Modern Art, New York. Professor: University of New Mexico, 1934–54.

JOSLING, STANLEY Painter, miniatures. Born in England. He worked in Los Angeles in 1907–1908 before departing north to Canada.

JOURDAN, ALBERT (1885–1936) Photographer. Lived in Portland, Ore-

gon with his artist wife, Alda. He was a leader in the school of realistic photography and numbered among his friends Edward Weston, Edward Steichen and the late Alfred Stighitz. Contributed articles to *American Photography*, *Camera Craft* and *The Camera*. Exh: around the world.

JOURDON, ALDA (1889–1962) Painter, watercolor. Photographer. Writer. Teacher. Born in Salem, Oregon. Lived in Portland, Oregon. Pupil: Chicago Art Institute. Member: Oregon Society of Artists. Exh: Los Angeles Museum of Art; Portland Art Museum, 1935; San Francisco Art Association; international salons of England, Scotland, France. She was known for her naturalistic expressionism. Her portraits were exhibited in New York and Paris. She was married to Albert Jourdan, a leader in realistic photography.

JOYNER, MARGARET PEARSON Painter, portraits. Commercial artist. Pupil: Tadama, Seattle. Moved to San Francisco in 1921 where she worked in advertising art. She returned to Los Angeles and taught commercial art at the University of Southern California through 1940.

JUDGE, GRACE Painter, watercolor, landscapes, in the style of the English illustrators such as Arthur Rackham and Edmond Dulac. Her paintings depicted the British Columbian forests around 1919. Member: Founding member, Vancouver, B.C. Fine Art Society, 1919.

JUDGE, SPENCER PERCIVAL Painter. Founding member of the Vancouver, B.C. Society Fine Arts, 1919.

JUETTNER, OTTO A. Painter. Sculptor. Lived in Seattle, Washington, 1926. President, Universal Art Association, Seattle, 1924.

JUHLIN, CHARLES R. Commercial artist. Lived in Seattle, Washington, 1944. Member: Puget Sound Group of Northwest Men Painters, 1945.

JULEEN, JOHN A. Painter, portraits. Photographer. Studio in Everett, Washington, 1925–31.

JULEEN, LEE D. (1891–) Painter. Photographer. Lived in Everett, Washington, 1941. Pupil: Chicago Academy of Fine Arts; Chouinard Art Institute, Los Angeles; University of Washington. Exh: Everett Drama League, 1930.

JURGINS, ANTONE Artist. Lived in Seattle, Washington, 1916.

JUSTEMA, WILLIAM (1909–1987) Painter. Designer. Commercial arist. Spent several years as a monk in a monastery in Oregon. Pupil: Martinez and MacDonald-Wright. He designed wallpapers and fabrics for the home furnishing industry. A modernist, he called his art magic realism.

JUVONEN, HELMI D. (1903–1985) Painter, watercolor, tempera, Northwest coast Indians & birds. Printmaker. Illustrator of children's books. Pupil: E. Ziegler; Walter Reese; Emilio Amero. Study: Cornish Art School, Seattle. Exh: Seattle Art Museum, 1946; Frye Museum, 1976. Signed her works: Helmi.

— **K** —

KAFOURY, ELEANOR PATTEN (1909–) Painter, oil, watercolor. Lived in Portland, Oregon. Pupil: University of Oregon, Eugene. Exh: Portland Art Museum, 1933–38.

KALLBERG, JOHN A. Artist. Lived in Everett, Washington, 1915–37.

KANE, ELISHA KENT Illustrator. Medical doctor. Illustrated an account of the Grinnell Expedition of 1850–60's to the American Arctic. He was the ship's surgeon.

KANE, PAUL (1810–1871) Painter, oil, watercolor, landscapes, Indian genre. One of the most important pioneering artists of the early Northwest. Pupil: Thomas Drury; Upper Canada College, where he painted some portraits, some not signed. He traveled to Europe from 1841–43, learning to paint by copying masterpieces. In London he met Catlin and became interested in Canadian Indians returning there in 1845. For the next three years Kane traveled to Vancouver by boat, horseback and snowshoes, sketching in oil and watercolor, recording Indian life, rituals and the spectacular scenery. Back in Toronto in 1848 he completed 100 canvases by 1856, also writing *Wanderings of an Artist among the Indians of North America*, published in 1859. Unfortunately, while still very successful he lost his sight in 1866.

KATAYAMA, TADIHIRA D. Painter, oil, watercolor, portraits, wall paintings. Studio in Seattle, Washington, 1918.

KEAGLE, GEORGE WADE Painter, impressionistic style. Born in Seattle, Washington around 1900. Retired from banking in 1957 and began serious study in Scotland and Ireland. Lived and exhibited in British Columbia.

KEAL, JOHN J. (1920–) Painter, oil, watercolor, tempera. Lived in Ellensburg, Washington, 1941. Study: Whitman College, Walla Walla, Washington. Exh: Seattle Art Museum, 1937, 1939; solo exhibition, Central Washington College, 1939.

KEATINGE, ELIZABETH (1885–1987) Painter, plein-air. Born in Corvallis Oregon. Active in Portland before moving to California in 1907 where most of her work depicts the Big Sur area. Member: Society of Western Artists.

KEE, BUE (1893–) Painter, oil, watercolor, pastel. Craftsman, ceramics. Lived in Portland, Oregon, 1940. Pupil: Museum Art School, Portland; Arts and Crafts Society, Portland. Exh: Portland Art Museum, 1930–33. WPA artist.

KEEFOVER, FRANK A. Painter. Lived in Tacoma, Washington, 1916. Exh: Tacoma Fine Arts Association, 1916. High school teacher.

KEEGAN, MELVIN AURELIUS (1903–) Sculptor, wood, metal. Born in Olequa, Washington. Lived in Portland, Oregon, 1940. Pupil: Museum Art School, Portland. Exh: Portland Art Museum. Work: metal repousse at St. Martin's College, Lacey, Washington; Timberline Lodge, Mount Hood Oregon; Gresham High School; St. Lawrence Church, Portland.

KEELER, CHARLES BUTLER (1882–1964) Painter. Etcher. Pupil: Chicago Art Institute; Harvard University. He traveled throughout Europe in 1909–1912 before coming to the West where he roamed the mountainous terrains on a donkey. He settled in Southern California in 1932.

KEELER, HAROLD E. Painter, watercolor. Printmaker, serigraphs. Lived in Seattle, Washington, 1956. Exh: Seattle Art Msueum, 1945; Henry Gallery, University of Washington, Seattle, 1953; Northwest Printmakers, 1955, 1956.

KEEN, HELEN B. (1894–) Painter, oil, watercolor, mixed media. Born and raised in the Tacoma, Washington area. Moved to New York in the 1940's. Pupil: Annie Wright Seminary; Alice Beck; Mark Tobey; California School Fine Arts: Arts Students League, New York. Exh: Seattle Art Museum and Tacoma Art League, 1938–45; Paris, 1956, 1957; widely in the Northwest.

KEENEY, ANNA (1898–) Sculptor. Born in Falls City, Oregon. Lived in Eugene, Oregon, 1929. Pupil: A. Fairbanks; H. P. Camden. Work: First National Bank, Condon, Oregon; University of Oregon. Member: San Francisco Society of Women Artists.

KEGG, WILLIAM (1838–1911) Painter, landscapes. Primarily a California artist he worked some in the Northwest. Exh: Alaska-Yukon Pacific Expo, Seattle, 1909.

KEIFER, DOUGLAS Painter. Member: Northwest Puget Sound Group of Men Painters, 1945.

KEITH, WILLIAM (1838–1911) Painter, monumental mountain landscapes, portraits. Craftsman, wood engraver. Born in Scotland. Studied in Europe. Arrived in New York in 1850 and visited California for *Harper's* in 1858. Accompanied naturalist John Muir throughout Northern California and Oregon, (1868–88). Primarily a Northern California artist he maintained a studio in San Francisco painting 4000 works, losing 2000 in the earthquake and fire of 1906. Work: Corcoran Art Gallery, Washington, D.C.; Crocker Art Museum, Sacramento; Los Angeles County Art Museum; National Gallery of Art, Washington DC.

KELCHNER, LOYD M. Artist. Lived in Seattle, Washington, 1926–44.

KELEZ, MARION (1907–) Painter, watercolor. Sculptor, wood, stone. Printmaker, woodcut. Draftsperson. Lived in Seattle, Washington, 1942. Pupil: University of Washington; Cornish Art School, Seattle. Exh: Seattle Art Museum with Northwest Printmakers, 1929–30.

KELLAR, ELMA Painter, oil. Lived in Spokane, Washington, 1909. Exh: Alaska-Yukon Pacific Expo, Seattle, 1909.

KELLER, CLYDE LEON (1872– 1962) Painter, oil, watercolor. Teacher. Born in Salem, Oregon. Lived in Portland, Oregon, 1940. Pupil: Bridges, Munich; Knowles, Boston; E.W. Christmas, London. Study: Williamette University, Salem. Lived in San Francisco from 1896–1906 where he lost many of his early works in the 1906 earthquake. Settled in Portland, 1906. Member: Oregon Society of Artists. Exh: solo show, Grand Central Palace, New York, 1924; Meier & Frank, Portland, 1937; Seattle Fine Arts Society; American Artists Professional League, Portland; Oregon-California Artists, 1946–47. Over 250 Awards. Works commissioned by: Presidents Hoover and F. D. Roosevelt; Oregon Governor Charles Sprague. His later works faltered considerably because of his alcoholic tendencies.

KELLER, PAUL (1902–) Painter, oil, watercolor. Illustrator. Lived in Portland, Oregon, 1940. Pupil: Oregon State College, Corvallis; Chicago Academy of Fine Arts; American Academy of Art, Chicago. Member:

Portland Artists Group. Exh: Portland Art Museum. Staff artist for the Oregon Journal in Portland.

KELLOGG, LYDIA MAY Painter, watercolor. Lived in Alaska, 1942.

KELLY, BELLA A. Artist. Studio in Seattle, Washington, 1922.

KELLY, CORRINE (1897–1988) Painter, oil, landscapes, coastal scenes. A Portland, Oregon artist.

KELLY, LEE (1932–) Sculptor, abstract, welded steel. Founded the New Gallery of Contemporary Art in Portland, which closed in 1962. Pupil: Portland Museum Art School.

KELLY, MARY BETH Painter, oil. Lived in Seattle, Washington, 1947. Exh: Seattle Art Museum, 1947.

KELLY, NILES E., JR. Painter, oil, watercolor, portraits. Lived in Seattle, Washington, 1947. Member: Puget Sound Group of Northwest Men Painters, 1945; Chicago Art Institute; Society of Art Directors. Exh: Seattle Art Museum, 1947.

KELSO, WALDO ELSWORTH Artist. Lived in Seattle, Washington, 1951.

KEMP, DR. ELMORE G. (1898–) Sculptor. Lived in New Westminster, B.C., 1940. Pupil: Vancouver School of Art; School of Associate Arts, Vancouver. Award: bronze medal, B.C. Artists Exhibit, 1937; solo show, Vancouver Art Gallery, 1939.

KEMPER, CHARLES (1876–1948) Painter. Settled in Sacramento in 1893. Worked for many years as a conductor for the Southern Pacific Railroad while painting the landscapes of the West.

KEMPER, MINNIE ELIZABETH KLEINSORGE (1875–1960) Painter, oil, portraits. Wife of artist Charles Kemper.

KEMPTON, R. Painter, oil, landscapes. Active in the Northwest in 1895. Painted in the style of Barchus and Parrott.

KENDALL, WINIFRED MULKEY (1872–1946) Painter, landscapes, floral still lifes. Born in England. Lived in Albany, Oregon. Mainly self-taught.

KENNEDY, DAWN S. Painter, oil, watercolor. Pupil: Pratt Institute, Brooklyn, New York; Columbia University Teachers College. Head of Art Department, Central Washington College of Education, Ellensburg. Exh: solo show, Denver Art Museum before 1941.

KENNEDY, LETA MARIETTA (1895–) Painter, watercolor. Printmaker. Designer. Craftsperson, pottery, weaving. Born near Pendleton, Oregon. Lived in Portland, Oregon, 1940. Pupil: Museum Art School; Wesley Dow; Hans Hofmann. Exh: Portland Art Museum; Seattle Art Museum. Exh: Northwest Printmakers, 1938. Instructor in design, children's drawing and painting, Museum Art School, Portland.

KENNEDY, MURIEL MENARD (1910–) Painter, oil. Printmaker. Lived in Seattle, Washington, 1937. Pupil: University of Washington, Seattle; scholarships, Art Students League, New York. Exh: Seattle Art Museum; Art Students League, New York; San Diego Expo, 1935; Henry Gallery, University of Washington, Seattle, 1936.

KENNEDY, RICHARD (1917–) Painter, oil, landscapes, still lifes, genre, impressionistic style. Born in Portland, Oregon. Began painting while working on a dude ranch in Eastern Oregon. Pupil: Peter Sheffers, New York, 1939; Art Students League, New York; National Academy of Design; Clyde Leon Keller, Oregon; Portland Art Museum School;

University of Oregon; University of Washington. Still working from his studio in Milwaukee, Oregon, 1992.

KENNEY, LEO (1925–) Painter, oil, tempera, ink on paper. Born in Spokane, Washington. Lived in Seattle, Washington, 1946. Moved to California in 1949. Exh: solo show, Seattle Art Museum, 1949; retrospective exhibition, Seattle Art Museum, 1973.

KENNY, BETTIE ILENE CRUTS (1931–) Painter, writer. Pupil: George Roskos, Pacific Luthern University; University of Washington. Work: commemorative portrait of President John F. Kennedy on glass, Smithsonian Institute; Henry Gallery, University of Washington, Seattle; Corning Museum of Glass; Frye Art Museum, Seattle; many public works in the state of Washington.

KENT, CHARLES (MRS.) Artist. Exh: Society of Seattle Artists. Seattle Fine Art Society, 1908.

KENT, ROCKWELL (1882–1971) Painter. Printmaker. Lithographer. Author. Illustrator of "Wilderness & Voyager". Exh: Metropolitan Museum and Brooklyn Museum, New York; Knoedler Gallery, New York.

KENTON, JOHN W. Artist. Lived in Seattle, Washington, 1914.

KEON, GEORGE Painter, oil, tempera. Lived in Seattle, Washington, 1951. Exh: Seattle Art Museum, 1947; Henry Gallery, University of Washington, Seattle, 1951.

KERFOOT, MARGARET (1901–) Painter. Pupil: Chicago Art Institute; Paris Atelier of Parson's School of Art; Grant Wood, Harvard University; University of Oregon; Carnegie Grant, 1941.

KERN, EDWARD MEYER (1823–1863) Painter, watercolor. Survey artist. He served as topographer on John Frement's third expedition in 1846. He later served on other expeditions into the Northwest. Work: Smithsonian Institute.

KERN, NINA D. Artist. Lived in Seattle, Washington, 1934.

KERNS, MAUDE IRVINE (1876–1965) Painter, oil, watercolor, modernist, landscapes. Printmaker. Teacher. Lived in Eugene, Oregon, 1941. Pupil: Hopkins Art Institute; Hans Hofmann; Alexander Archipenko; University of Oregon. Studied in Paris and Japan. Member: California Watercolor Society; Oregon Society of Artists; American Artists Professional League. Exh: Alaska-Yukon Pacific Expo, Seattle, 1909. Head of Department of Art Education, University of Oregon, Eugene.

KERSWILL, ROY (1925–) Painter, oil, watercolor, murals, traditional western paintings. Pupil: Plymouth College of Art, England. Spent the year 1947 in the Yukon and Alaska then took a 7000 mile canoe trip from British Columbia to New Orleans. Artist for the Hudson Bay Company around 1949. Moved to Wyoming in 1960.

KESTER, LENART (1917–) Painter, oil, watercolor. Member: National Academy Design, New York; American Watercolor Society; California Watercolor Society. Commissioned by Louis Comfort Tiffany Foundation Fellowship to paint a pictorial record of the Pacific Northwest, 1949.

KETCHAM, GRACE L (1856–) Painter, oil, watercolor, pen & ink. Sculptor. Born in Helena, Montana. Lived in Seattle, Washington, 1941. Pupil: F. Tadema, Eustace Ziegler, Seattle. Supervisor of Art and Museumic, Renton Washington Public Schools, 1930's.

KEYS, HERMAN A. Painter, water-color, tempera. Teacher. Lived in Spokane, Washington, 1988. Art Director, Whitworth College, Spokane, Washington. Owner: Herman Studio. Exh: Seattle Art Museum, 1949; Washington Art Association, 1950.

KIDWELL, VIVIAN (1908–) Painter, oil, tempera. Printmaker. Lived in Pullman, Washington, 1941. Study: Carnegie scholarships to the University of Oregon; Washington State University. Exh: Seattle Art Museum, 1937, 1939. Supervisor of Art, Pullman Washington Public Schools.

KIENHOLZ, EDWAYF (ED) (1927–) Painter, watercolor. Sculptor. Compositions. Assemblagist. Lived in Hope, Idaho.

KIHN, WILLIAM LANGDON (1898–1957) Painter. Illustrator. Work: Royal Ontario Museum. Pupil: Art Students League, New York; Winfold Reiss who took him on a field trip to Montana and New Mexico to paint Indians. Canadian Pacific Railroad sent him to Banff and Vancouver, B.C. and the Northwest to paint Totem Pole Indians. Painted the American Indian for the *National Geographic*. He was a noted authority on Indian lore of the Canadian West Coast.

KILLAM, EDITH H. Painter. Member: Founding member, Vancouver, B.C. Fine Art Society, 1919.

KILLEN, BRUCE (1937–) Sculptor, bronze, silver, gold, wild life (predominantly birds). Self-taught. Works from his studio on Klamath Marsh in Medford, Oregon, (1992). Exh: Los Angeles Museum of Art; 5 Best of Shows, National Wildlife Art Show, Kansas City, Missouri; Favell Museum, Klamath Falls, Oregon; National Audubon Society; Museum of Native American Culture, Spokane, Washington; Museum of Natural History, California; Northwest Wildlife Art Festival, Seattle, Washington, (Best of Show). Work: Numerous celebrity collections nationally; Daughter of the Confederacy, Tennessee.

KIMBALL, ELIZABETH O. Painter, oil. Known only from an oil painting of Olympia dated 1871 in the collection of the Washington State Capitol Museum. (primitive style)

KIMBALL, FRANK (1902–1990) Painter, oil, miniatures, landscapes. A house painter by trade received later commercial success as an artist. Only signed some of his later work. Died in Tacoma, Washington.

KIMBALL, NELLIE ELIZABETH (1869–1946) Painter, oil, landscapes. Teacher, private. Arrived in Tacoma, Washington in 1885 where she became a bookkeeper and studied art. Apparently gave up painting in 1908–11 with the arrival of her children. Member: Tacoma Art League, 1891–92.

KIMMEL, JOSEPH Painter, water-color. Lived in Spokane, Washington, 1943. Exh: Seattle Art Museum, 1940.

KIMURA, WILLIAM YUSABURO (1920–) Painter. Printmaker. Born in Seattle, Washington. Pupil: Cornish Art School, Seattle, 1940. Work: Anchorage Fine Arts Museum, Alaska. Exh: Northwest Artists, Seattle, 1953, 1958, 1962 & 1963; Smithsonian Traveling Exhibition, USA and Europe, 1962. Member: Alaska Council of the Arts. Awards: All-Alaska Juried Art.

KINDRICK, RODNEY Commercial artist. Lived in Seattle, Washington, 1931.

KING, JUNE E. (1917–) Painter, oil. Sculptor, clay. Lived in Seattle, Washington, 1941. Pupil: University of Washington, Seattle; Alexander Archipenko. Exh: Annual Exhibition of Northwest Artists, 1937–39; Seattle Art Museum, 1937–40.

KING, KENNETH L. (1891–) Painter. Commercial artist. Teacher. Born in Michigan. Active in Portland, Oregon. Pupil: Chicago Academy of Fine Arts. Art instructor: Lincoln County Art Center, Delake, Oregon.

KING, MOLLIE (1885–) Sculptor. Lived in Portland, Oregon, 1940. Pupil: Arts and Crafts Society, Portland; Alexander Archipenko, University of Washington; Studied in Germany. Exh: J. K. Gill, Portland 1937; National Art Exhibition, New York, 1938; Oregon Ceramic Studio, Portland, 1940; Portland Art Museum, 1940.

KING, MURIEL Painter, watercolor. Designer. Born in Bayview, Washington. Pupil: University of Washington, Seattle; Cornish Art School, Seattle; New York School of Fine and Applied Arts; J. Platt; T. Benton; Maude Kerns; studied in Paris. Movie costume designer for Katherine Hepburn, among others.

KINNEY, MAUDE (1874–) Sculptor. Lived in Seattle, Washington, 1940. Pupil: Dudley Pratt. Exh: Seattle Art Museum; Western Washington Fair, Puyallup.

KIRK, COMOS A. Commercial artist. Studio in Vancouver, Washington, 1936.

KIRK, PAUL HAYDEN (1914–) Painter, watercolor, pencils. Architect. Award: American Institute of Architects. Exh: Seattle Art Museum; Frederick & Nelson, Seattle.

KIRKWOOD, MARY (1904–) Painter, oil, watercolor. Printmaker, lithography. Lived in Moscow, Idaho, 1940. Pupil: University of Oregon, Eugene; Art Students League, New York. Exh: Royal Academy of Art, Stockholm, 1934; Denver Art Museum; Palace of the Legion of Honor, San Francisco, 1932; Boise Art Museum, 1938. Instructor, University of Idaho, Moscow.

KIRSCH, AGATHA B. (1897–1953) Painter. Graphic Artist. Teacher. Lived in Seattle, Washington. Pupil: University of Washington. Member: Women Painters of Washington. Exh: Seattle Art Museum, 1940. Commercial artist for the Bon Marche, 1916. WPA artist.

KIRSHBAUM, ANNIE R. Artist. Lived in Seattle, Washington, 1918.

KIRSTEN, RICHARD CHARLES (1920–) Painter, watercolor. Designer. Lived in Seattle, Washington, 1947. Pupil: University of Washington; Chicago Art Institute. Member: Artists Equity Association, Seattle; Northwest Puget Sound Group of Men Painters. Exh: Seattle Art Museum, 1945–50's, solo show, 1943; Northwest Watercolor Society, 1960.

KIRWAN, ANNA MAE Painter, oil, impressionistic landscapes and flowers. Active in Portland, Oregon in the 1950's. Exh: Portland Art Museum, 1944, 1946, 1948; Oregon Society of Artists, 1945–50.

KIRWIN, J. P. (MRS.) Painter, oil, impressionistic landscapes. Lived in Portland, Oregon, 1954. Painting, "Cowlitz River Canyon", dated October 1954.

KITTO, MARGARET Painter. Member of the Victoria Island Arts and Crafts Society, around 1910.

KIYOOKA, ROY (1926–) Painter. Lived in Vancouver, B.C. Exh: Biennial of Canadian Painting 1955. Instructor: Vancouver, B.C. School of Art, 1959.

KLAMM, WILLIAM J.C. (1888–1976) Painter, oil, watercolor. Printmaker. Moved to Seattle in 1909. Worked as an engraver until moving to Chicago in 1926 for more study. Re-

turned to Seattle in 1927 as a freelance commercial artist. Klamm, along with Norling, Ziegler & Sheckles formed the Northwest Puget Sound Group of Men Painters. Exh: Alaska-Yukon Pacific Expo, Seattle,1909; Seattle Art Museum, 1935, 1936. Pupil: Chicago Art Institute.

KLEIN, LILLIE V. O'RYAN Painter, miniatures. Pupil: Chase; Metcalf. Lived in San Francisco, 1900. Pupil: William M. Chase; George DeForest Brush. Exh: gold medal, Alaska-Yukon Pacific Expo, Seattle, 1909; Panama Pacific International Expo, San Francisco. Worked in the Northwest and Canada till 1924.

KLEMM, GERMANY (1900–) Printmaker. Designer. Teacher. Craftsman. Pupil: University of Oregon, Eugene. Member: Northwest Printmakers.

KLEY, THEODORE H. Commercial artist. Lived in Seattle, Washington, 1934. Member: Puget Sound Group of Northwest Men Painters, 1934.

KLIEMAND, ANNA MARIE LARSON Painter, oil, still lifes. Lived in Port Townsend, Washington, 1909. Exh: Alaska-Yukon Pacific Expo, Seattle, 1909.

KLINGE, NELLIE KILLGORE Painter, oil. Lived in Preston, Idaho, 1940. Pupil: Chicago Art Institute; Pratt Institute, Brooklyn. Awards for works which are in many Idaho public buildings. Exh: Boise Art Association, 1933, 1937, 1938. Instructor of Art, Colorado State College.

KLINGELHOFER, LOUIS K. (1861–1947) Painter, watercolor, landscapes. Born in Germany. Immigrated to the United States in 1894, settling in Oakland, California in 1904. He painted the Northern Sierras of California and into Oregon.

KLINGENPEEL Painter, watercolor, still life.

KNAB, IRA EUGENE (1900–1968) Painter. Muralist. Lived in Toledo, Washington. Traveled throughout the Northwest. Painted backdrops for Walt Disney. Died in Monterey, California.

KNABEL, WILLIAM U. Painter, watercolor. Commercial sign painter. Lived in Tacoma, Washington, 1969. Owner of Knabel Sign Company. Exh: Tacoma Art League, 1915, 1916; Brush & Palette Club, Tacoma, 1921.

KNAPP, NELLIE Artist. Member: Tacoma Art League, 1891.

KNITCH, THOMAS Painter, oil, tempera. Lived in Raymond, Washington in 1949. Exh: Seattle Art Museum, 1949; Henry Gallery, University of Washington, Seattle, 1951.

KNOBLE, WILLIAM B. Artist. Lived in Tacoma, Washington, 1916. Exh: Tacoma Fine Arts Association, 1916.

KNOPF, NELLIE AUGUSTA (1875–1962) Painter. Raised in Chicago. Study: Chicago Art Institute, with honors. Professor of Art: Illinois State Women's College, for 43 years. Her summers and holidays were spent on painting trips to the West coast and mountains sketching and painting landscapes, pueblo scenes and seascapes.

KNOWLES, JOSEPH "JOE" (1869–1942) Painter, oil, watercolor. Etcher. Adventurer. Sailor. Lived in Seaview, Washington. Known as the original nature man by Mr. Hearst and the *San Francisco Examiner* for staying in the Oregon Siskiyou Mountains with only his wits to survive. Authored and illustrated *Alone in the Wilderness* in 1917. He reportedly used the juice of roots and berries for his colors and a well chewed twig for

his brush. In 1917 he settled in Sea-view, Washington where he wrote his book. 46 of his paintings were commissioned by the Monticello Hotel in Longview, Washington in 1925.

KNOWLES, WILLIAM L. EVERET Painter, mixed media, watercolor, landscapes. Not much is personally known about W. L. E. Knowles except that his paintings are found in Washington and Oregon. He remains somewhat of a mystery among early Northwest artists. He lived in the Tacoma area in the late 19th century to early 20th century. Paintings are somewhat small in size, painted on inexpensive cut cardboard.

KNOX, MARVIN S. (1913–) Painter, watercolor. Architectural draftsman. Drawing, ink. Lived in Moscow, Idaho, 1940. Pupil: University of Idaho, Moscow; Chouinard Art Institute, Los Angeles. Member: Maya Fraternity, honorary member, University of Idaho. Did scale model buildings.

KNUST, BETTY Artist. Lived in Seattle, Washington, 1932. Member: Women Painters of Washington, 1932.

KOBER, ALFRED L. (1937–) Artist. Teacher: Art Department, Boise State University, Idaho.

KOCH, KARL F. (1888–) Painter, oil, watercolor. Lived in Portland, Oregon, 1940. Pupil: New York School of Art. Member: Oregon Society of Artists. Exh: Portland Art Museum, 1934–36; Seattle Art Museum, 1938; Oregon Society of Artists, 1932–34. Art Director, Foster and Kleiser Company, Portland.

KOEHLER, JOHN G. Painter, oil, tempera, landscapes. Lived in Spokane, Washington, 1949. Pupil: University of Washington. Chairman of the Art Department, Whitman College. Exh: Seattle Art Museum, 1949.

KOHLER, MELVIN OTTO (1911–) Painter, oil. Engraver. Born in Canada. Lived in Tacoma, Washington 1940. Pupil: University of Washington. Director of the Art Department, University of the Puget Sound, 1940. Member: Tacoma Art League.

KOIRANSKY, ALEXANDER (1884–) Painter. Teacher. Born in Russia. Lived in Seattle, Washington, 1938. Pupil: V. Seroff. Exh: Seattle Art Museum, 1934. Teacher: Cornish Art School, Seattle, Washington.

KOLESAR, HELENE Painter, watercolor, landscapes, port scenes. Works found in and about Oregon and Washington. Approximate date, 1950's.

KORN, ALPHA B. Artist. Lived in Tacoma, Washington, 1909.

KORNER, JOHN Painter. Lived in Vancouver, B.C., 1947. Exh: the World Youth Festival in Prague. Commissioned to paint the 'Favourite Harbour' series of Vancouver.

KOSTER, HARRY (MRS.) Artist. Lived in Seattle, Washington, 1910.

KOSTKA, PAULA Painter, oil. Lived in Seattle, Washington, 1947. Exh: Seattle Art Museum, 1947.

KOTTLER, HOWARD WILLIAM (1930–) Sculptor. Teacher. Study: Ohio State University, PhD. Work: Victoria & Albert Museum, London; National Museum of Modern Art; Smithsonian Institute; Seattle Art Museum. Professor of Art History, Ohio State University; Professor of Ceramics, University of Washington.

KOVAC, RUDY Artist. Vancouver, B.C. Art School, 1945-.

KRAUSE, LA VERNE ERICKSON (1924–1987) Painter. Graphics. Printmaker. Teacher. Pupil: University of Oregon; Pratt Graphic Art Center, New York; Portland Art Museum

School. Awards: Northwest Print-makers, 1954. Works: Henry Gallery, University of Washington, Seattle. Member: Oregon Governor's Award for the Arts; Governor's Planning Council for the Arts in Oregon. Art Instructor: Portland Museum Art School; School of Architecture and Allied Art, University of Oregon, 1966–86; Mt. Angel College, Oregon.

KREPS, HELEN TRAYLE (1917–) Painter, oil. Born in Portland, Oregon. Pupil: Portland Art Museum School; Albert Patecky & Peter Sheffers in Oregon; Van Nuys, Kentwood in Los Angeles. Art instructor; Lincoln County Art Center, Delake Oregon.

KREPS, RUTH M. (1900–) Painter, oil, watercolor, portraits. Printmaker, wood block. Lived in Seattle, Washington, 1935. Pupil: Cornish Art School, Seattle. Charter member: Women Painters of Washington; Northwest Printmakers. Exh: Seattle Art Museum, 1932–35; Oakland Art Gallery; Whitney Museum, New York, 1940.

KROMER, D. E. (MRS.) Artist. Lived in Spokane, Washington, 1926.

KROTTER, JOSEPH Painter, landscapes. Born in Austria. Settled in Portland, Oregon. Exh: Meier and Frank group, 1930's.

KRUSE, MAX (1854–) Painter, landscapes. Born in Berlin, Germany, Kruse was active in Northern California and the Northwest around the turn of the century.

KRUSKAMP, JANET (1934–) Painter, oil, tempera. Born in Grants Pass, Oregon. Pupil: Chouinard Art Institute, Los Angeles. Exh: Frye Art Museum, Seattle, Washington; American Artists Professional League Grand National; Society of Western Artists; Grand Gallery Art Competition, Seattle; many solo shows nationally.

KUCHEL (AND DRESEL) Artists. Lithographers. They traveled as a team in Oregon in the 1850's. They were pioneer artists and lithographers. They also published 'Fifty Views of Mining Towns in California and The West.'

KUHL, NUSSRALLAH M. Painter, oil. Lived in Seattle, Washington, 1947. Exh: Seattle Art Museum, 1947.

KUHN, ROBERT F. (1920–) Painter. Illustrator, wildlife and western art. Pupil: Pratt Institute, New York. Work: National Cowboy Hall of Fame. Has traveled extensively in Western Canada, Alaska and the American West. Currently specializing in African game animals.

KULLBERG, JULE H. (1905–1976) Painter, watercolor. Teacher. Moved to Seattle, Washington as a child. Pupil: University of Washington; University of Oregon; Doug Kingman. Head of the Art Department, Edison Technical School, Seattle. Member: Women Painters of Washington. Exh: Seattle Art Museum, 1946; Northwest Watercolor Society, 1960.

KUNISHIGI, ASAKICHI Artist. Lived in Seattle, Washington, 1920.

KUNZ, JAN (1920–) Painter, watercolor. Author. Teacher. Born in Portland, Oregon. Began as a commercial artist. Authored: *Painting Watercolor Portraits That Glow*, *Painting Children's Portraits*, and *Painting Still Lifes*, for Northlight Books. She moved to Newport, Oregon from Los Angeles where she and her husband owned and operated Kunz Billboards for many years. Member: Watercolor Society of Oregon.

KUTKA, ANNE (1900–) Painter, oil. Printmaker, lithography. Lived in Eugene, Oregon, 1940. Pupil: Art Stu-

dents League, New York. Awarded
Louis Comfort Tiffany Fellowship,
1928. Exh: New York World's Fair,
1939; Portland Art Museum, 1935–38;
Seattle Art Museum, 1936–38; Chi-
cago Art Institute, 1936; Denver Art
Museum, 1938; Pennsylvania Acad-
emy of Fine Arts, 1932–34. Married to
artist David McCosh.

KUVSHINOFF, BERTHA HORNE
Painter. Sculptor. Work: Tacoma Art
Museum; Phoenix Art Museum. Exh:
Washington State Capital Museum,
Olympia, 1965; Seattle Russian Cen-
ter, 1966; Edmonds Art Gallery.
Award: *Seattle Times*.

KUVSHINOFF, NICOLAI Painter.
Sculptor. Work: Seattle Art Museum;
Santa Fe Art Museum; Tacoma Art
Museum Exh: Novikoff Foundation of
Fine Arts, Seattle; Tacoma Allied
Arts; Seattle Russian Center; Tacoma
Art Museum; as well as Europe and
South America.

KYES, DOUGLAS Painter, water-
color. Born in Everett, Washington.
Lived in Renton, Washington, 1961.
Pupil: Art Center School, Los An-
geles. Member: Puget Sound Group of
Northwest Men Painters. Exh: widely
in the Northwest. Technical illustrator
and artist for Boeing Aircraft Com-
pany.

KYLE, JOHN Painter. Member:
Founding member, Vancouver, B.C.
Society of Fine Arts, 1919.

KYLE, MARY E. Artist. Lived in
Spokane, Washington, 1918.

—L—

**LABES, MARIE ELIZABETH
(1906–) (Mrs. David McCosh)**
Painter, oil, watercolor, pastel. Sculp-
tor. Printmaker, Teacher. Lived in
Bellevue, Washington, 1940. Pupil:
Chicago Art Institute. Member:
Women Painters of Washington; Art
Students League of Chicago; Pacific
Coast Painters and Sculptors. Exh:
Grant Galleries, New York, 1936–38;
Seattle Art Museum.

LACASSE, A. B. Painter, oil, land-
scapes. Known works in Portland,
Oregon.

LACEY, HARRIET E. (MRS. FRED)
Artist. Lived in Tacoma, Washington,
1891–94. Member: Tacoma Art
League, 1891–92. Exh: Western
Washington Industrial Exhibition,
1891.

LADD, HELEN L. Painter, water-
color. Lived in Seattle, Washington,
1962. Member of and exhibited with:
Women Painters Washington, 1937–
58.

LAGRILLE, WILLIAM (1913–)
Painter, oil, watercolor. Printmaker,
wood block, monotype. Sculptor.
Teacher. Lived in Seattle, Washing-
ton, 1941. Pupil: California School of
Fine Arts, San Francisco. Member:
Carmel Art Association. Exh: Seattle
Art Museum, 1940. Primarily a Cali-
fornia artist.

LAIDLAW, CORA M. (1863–)
Painter, oil. Printmaker, etchings.
Lived in San Diego, California, 1940.
Pupil: Otto Schneider, Alfred Mit-
chell. Member: Art Guild of San Di-
ego, Oregon Society of Artists.

LAING, JOHN WOOD (1871–) Painter, oil, watercolor. Born in Glasgow, Scotland. Lived in Vancouver, B.C., 1940. Pupil: Thomas William Fripp, Vancouver.

LAIRD, SARAH C. Artist. Lived in Spokane, Washington, 1918–1926.

LAISNER, GEORGE ALOIS F. (1914–) Painter, oil, watercolor. Sculptor. Printmaker. Born in Czechoslovakia. Lived in Pullman, Washington, 1947. Pupil: Chicago Art Institute. Member: Washington Creative Artists; Art Students League, Chicago. Exh: Chicago Art Institute; Seattle Art Museum; San Francisco Museum of Art, 1939. Professor of Art, Washington State College, Pullman.

LAMADE, ERICH (1894–) Painter, oil, watercolor, tempera, fresco, murals. Sculptor. Born in Germany. Lived in Portland, Oregon, 1940. Pupil: Art Students League of New York; Grand Central School of Art, New York; Museum Art School, Portland. Exh: solo show, University of Portland, 1939; Corcoran Art Gallery, Washington, D.C.; Palace of the Legion of Honor, San Francisco, 1934; Portland Art Museum, 1932–38; Timberline Lodge, Mt. Hood, Oregon, over the mantel carvings. Many Oregon murals.

LAMADE, THOMAS (1904–) Painter. Sculptor. Pupil: Portland Art Assocication; California School of Fine Arts; Oregon WPA. Exh: Portland Art Museum.

LAMAN, THOMAS (1904–1964) Painter. Sculptor. Pupil: Portland Art Association. Served as art administrator for four Northwestern states for WPA program.

LAMB, HAROLD MORTIMER (1872–1970) Painter. Photographer. Lived in Vancouver, B.C. Friend of Alfred Stieglitz in New York. Canadian correspondent for the leading English art journal *The Studio*.

LAMB, MOLLY Painter. Illustrator. Lived in Vancouver, B.C. Worked for the Allied Arts War Service Council becoming a war artist during World War II.

LAMONT, GWEN KORTRIGHT. (1909–) Painter, oil, watercolor. Illustrator. Drawing, brush, pencils. Lived in Vancouver, B.C., 1940. Pupil: scholarship, Ontario College of Art, Toronto with Arthur Lismer, James W.G. Macdonald. Exh: solo show, Vancouver Art Gallery, 1938.

LAMONT, J. A. Artist. Lived in Seattle, Washington, 1927.

LANDCASTER, KATHERINE E. Artist, landscapes. Lived in Tacoma, Washington, 1925. Member: Tacoma Art League, 1891, 1892. Exh: Western Washington Industrial Exhibition, 1891.

LANDIS, MARGUERITE A. Painter. Teacher. Lived in Seattle, Washington, 1920–23.

LANDIS, SADIE ELMAE Artist. Lived in Tacoma, Washington, 1926.

LANE, NORMA Painter, watercolor, landscapes. Teacher. Pupil: Boise State University; Famous Artists course. Living in Spokane, Washington, (1992).

LANE, STEPHEN (1911–) Painter, watercolor. Printmaker, etchings. Born in New York. Pupil: Cornell University College of Architecture; Ringling Bros. School of Art, Florida; Art Students League of New York. Exh: Henry Gallery, University of Washington, Seattle, 1936; New York Watercolor Club, 1938; Vassar College, 1939.

LANG, EDWARD Artist. Lived in Spokane, Washington, 1907.

LANGDON, CHARLES D. Artist. Lived in Tacoma, Washington. 1907–18.

LANGE, EDWARD Artist. Arrived in Olympia, Washington in 1889 where he possibly produced a panoramic map of the area. Lived in Olympia, 1910.

LANGWORTHY, MADELINE Painter. Lived in Spokane, Washington, 1935. Exh: Spokane Art Festival, 1928.

LANSDOWN, ELIZABETH (1903–) Painter, watercolor. Printmaker, linoleum, block prints. Commercial artist. Born in Everett, Washington. Lived in Seattle, Washington, 1941. Pupil: University of Washington, Seattle. Exh: Northwest Printmakers, 1930–31.

LANSING, MRS. E. Painter. Lived in Portland, Oregon in 1910. Painted from the Barchus, Parrott school.

LA RACQUE Painter, watercolor, contemporary. Coastal Oregon artist. Signature: slr.

LARGE, VIRGINIA (1914–) Painter, Western landscapes and genre, Portland, Oregon to Wyoming. Pupil: Chicago Art Institute.

LARKIN, J. S. Artist. Lived in Hadlock, Washington, 1921.

LARKIN, NORENE Painter, watercolor. Exh: Seattle Art Museum, 1945.

LARSEN, BEN (1892–) Painter, oil, watercolor, pastel. Decorator. Printmaker, etching. Lived in Portland, Oregon, 1940. Pupil: Chicago Academy of Fine Arts. Member: Oregon Society of Artists. Exh: solo show, Meier and Frank, Portland, 1931, 1933; Plaza Hotel, New York, 1930.

LASH, LEE (1864–) Painter, landscapes. Born in Vancouver, B.C. he began his art career in San Francisco before moving to New York.

LATIMER, LORENZO PALMER (1857–1941) Painter. Study: School of Design, San Francisco, later becoming an instructor there. He lost many works in the earthquake of 1906 when he moved across the bay to Berkeley, California. Exh: silver medal, Portland Expo, 1905; silver medal, Alaska-Yukon Pacific Expo, Seattle, 1909. Work: many museums in California and Nevada.

LATSHAW, ALICE Painter, oil. Lived in Tacoma, Washington, 1910. Pupil: University of Puget Sound, Tacoma, Washington, 1910. Exh: Alaska-Yukon Pacific Expo, Seattle, 1909.

L'AUBINIERE, de C.A. French painter. Student of Corot and Gerome who exhibited in England. Arrived in Victoria late in 1886 after a tour of the United States with his wife, who was also an artist. They took Victoria by storm, being commissioned by the provincial government to paint a series of fourteen oils for royal presentation.

L'AUBINIERE, GEORGINA STEEPLE Painter, watercolor. Wife of C. A. L'Aubiniere. A very successful husband and wife team in Victoria in the late 1886's. (see above)

LAURENCE, SYDNEY MORTIMER (1865–1940) Painter, oil, watercolor. Photographer. Journalist. Born in New York. Lived in Anchorage, Alaska. One of Alaska's most celebrated artists. Pupil: National Academy of Design, New York; Ecole des Beaux Arts, Paris. Member: 'Alaska Group of Four'; (founder) Western Academy of Beaux Arts, Seattle; Royal Society of British Artists. Work: Smithsonian Institute, Washington, D.C. Was lured to Alaska by the gold rush in 1903. He was very well schooled, an accomplished artist as well as somewhat of an adventurer.

Settled in England for several years before acquiring great fame in Alaska.

LAURITZ, PAUL (1889–1975) Painter, oil, landscapes, seascapes. Born in Norway. Worked as commercial artist in Vancouver, B.C. and Portland, Oregon where he also painted landscapes and portraits. Followed the Gold Rush to Alaska and painted and exhibited with Sydney Laurence, settling in Los Angeles in 1919. Work: many museums.

LAVARE, GABRIEL. Sculptor, marble and wood. Work: Oregon State Library, Salem, Oregon; iron gates, Mount Hood Lodge, Oregon; Federal Building and Washington Park Zoo, Portland, Oregon.

LAVON, LUCAS Painter, oil, watercolor. Drawing, pen & ink. An Oregon artist, mid 20th century. Exh: Portland Museum of Art, 1961.

LAWGAW, ROSE (1901–) Painter. Illustrator. Craftsperson. Born in Portland, Oregon. Lived in Seattle, 1931. Member: Seattle Fine Arts Society, 1931.

LAWLOR, RICHARD (1901–) Painter, landscapes. Illustrator, Western genres. Lived in Portland, Oregon, 1990. Member: The Attic Sketch Group, Portland.

LAWRENCE, ANDREW L. Painter. Lived in Seattle, Washington, 1930.

LAWRENCE, GARY Sculptor, bronze, steel, brass and copper. Founder of the Lawrence Galleries in Oregon. Currently living in Friday Harbor, Washington. Work: many private and corporate collections throughout the Northwest.

LAWRENCE, H. ABBOTT (1906–) Painter, watercolor. Architect. Designer. Lived in Portland, Oregon, 1940. Pupil: Museum Art School; University of Oregon, Eugene; Massa-

chusetts Institute of Technology, Boston. Member: American Institute of Architects. Exh: Portland Art Museum, 1933; University of Oregon, 1933–34.

LAWRENCE, JACOB (1917–) Painter, figurative abstractionist. Teacher. Pupil: Harlem Art Workshop, 1934–39. Work: Metropolitan Museum of Art, New York; Museum of Modern Art, New York; Whitney Museum; Seattle Art Museum. Professor of painting, University of Washington. Member: Washington State Arts Commission; National Endowment for the Arts Commission.

LAWRENCE, PAUL Painter. Illustrator. Lived in Tacoma, Washington, 1932. Exh: Tacoma Civic Art Association, 1932.

LAWSON, GERTRUDE (1892–) Painter, oil, watercolor. Lived in Vancouver, B.C., 1940. Member: West Vancouver Sketch Club. Exh: Vancouver Art Gallery, 1932–38.

LAWSON, NAN CHENEY (See CHENEY)

LAZARUS, EDGAR M. (-1939) Architect. Printmaker, etching. Lived in Portland, Oregon. Pupil: Maryland Institute of Arts, Baltimore, Maryland. Exh: 10th International Printmakers Exhibition, Los Angeles, 1929. Designer: Vista House, Columbia River Highway, Oregon.

LEADBETTER, NOBLE W. (1875–) Painter, oil. Drawing, pen & ink. Lived in Portland, Oregon, 1940. Pupil: Oregon State College, Corvallis, 1897. Exh: Portland Art Museum, 1938.

LEDWICH, RUTH E. China painter. Lived in Yakima, Washington, 1926.

LEE, ALAN Painter. Exh: The Society of Seattle Artists, 1912.

LEE, BERTHA E. STRINGER (1873–1937) Painter, landscapes. Primarily a prolific San Francisco artist. Exh: Alaska-Yukon Pacific Expo, Seattle, 1909.

LEE, BEULAH M. Painter, oil, landscapes.

LEE, FRED (1863–) Painter, watercolor, miniatures, landscapes. Born in London. Settled in Chilliwack, B.C. Pupil: Royal Academy; South Kensington Art School.

LEE, PERCY MYRON (1903–) Painter, watercolor, pastel, portraits, murals. Born in Tacoma, Washington. Moved to New York City in 1923, returning frequently to Tacoma. Magazine illustrator, covers for *Liberty Magazine*, 1937. Pupil: University of Washington; Paris. Member: American Watercolor Society.

LEE, ROBERT CRANSTON (1900–) Painter, oil, watercolor. Printmaker, etching. Teacher. Lived in Seattle, Washington, 1940. Pupil: University of Washington, Seattle; California School of Fine Arts, San Francisco; Leon Derbyshire; Edgar Forkner; Eustace Ziegler. Member: Puget Sound Group of Northwest Men Painters; Seattle Artists League. Exh: Alaska Fair, Nome, 1939, Frederick & Nelson, Seattle, 1935; Seattle Art Museum; Chinese Art Club, Seattle; Henry Gallery, University of Washington, Seattle, 1937.

LEE, ROBERT ORMOND (1921–) Painter, oil. Printmaker, linoleum, block print. Lived in Seattle, Washington, 1941. Pupil: University of Washington; Robert Cranston Lee; Mark Tobey. Exh: Seattle Art Museum 1940; Portland Art Museum, 1940; Albright Art Gallery, Buffalo, New York, 1940.

LEECH, EDWARD Artist. Lived in Seattle, Washington, 1907.

LEEDOM, JOHN Painter, watercolor, landscapes. Lived in Spanaway, Washington, 1951. Exh: Seattle Art Museum, 1949–50; Tacoma Art League, 1951; many solo shows nationally.

LEEK, EARL WILBER Painter, oil. Lived in Tacoma, Washington, 1938. Pupil: Cornish Art School, Seattle. Exh: Tacoma Fine Arts Association, 1941, solo show; American Art Company, 1940.

LEFEVER, BIRD (MRS. O. L.) Painter. Lived in Portland, Oregon, 1940. Member: Oregon Society of Artists.

LE GAULT, CATHERINE Painter, watercolor. Lived in Spokane, Washington, 1945. Exh: Seattle Art Museum, 1945.

LEGGENHAGER, WERNER Painter, oil. Lived in Seattle, Washington, 1951. Exh: Seattle Art Museum, 1945.

LEGGETT, MABEL. (1878–) Painter, oil, watercolor. Craftsperson. Lived in Portland, Oregon, 1940. Pupil: Chicago Art Institute; Metropolitan Art School, New York. Member: Art Students League, New York. Exh: Central Library, Portland; Meier and Frank, Portland.

LEHMAN, ROBERT B. (MRS.) Painter, watercolor. Lived in Tacoma, Washington, 1898. Member: Tacoma Art League, 1892; Annie Wright Seminary Art Club, 1889. Exh: Tacoma Art League, 1896.

LEHMAN, THELMA G. Painter, oil. Lived in Seattle, Washington, 1945. Art critic for the *Seattle Post Intelligence*, 1962. Member: Artist Equity Association. Exh: Seattle Art Museum; Henry Gallery, University of Washington, Seattle; Frederick & Nelson, Seattle, Seligman Gallery, 1945–56.

LEIGHTON, ALFRED CROCKER (1901–1965) Painter, oil, watercolor, pastel. Illustrator. Teacher. Art Director. Member: Royal Society British Artists, 1929. Work: Vancouver, B.C. Art Gallery; Edmonton Museum. Commissioned by the Canadian Pacific Railroad to paint the prairies and the Rockies of Western Canada. Teacher: Calgary Institute of Technology. Founder: Banff Art Society.

LEINDECKER, ALBERT Painter, oil. Born in Germany. Lived in Steilacoom, Washington, 1953. Painted the "City of Steilacoom" series for *Ford Times*. Exh: Tacoma Art League, 1951; Frye Museum, Seattle. Pupil: Chicago Art Institute; Omaha Art Institute.

LEINES, ROWENA N. Painter, oil, landscapes. Lived in Seattle, Washington, 1907–14. Exh: Alaska-Yukon Pacific Expo, Seattle, 1909.

LEMASTER, HARRIET (1883–) Painter, western, Indians, landscapes, Mexican. Lived in Seattle, Washington, 1941. Pupil: Western Reserve University. Exh: Idaho State Fair; National Exhibition, Portland, 1927.

LEMBKE, HALFORD (1889–) Sculptor, stone, wood, ivory. Lived in Seattle, Washington, 1940. Pupil: Los Angeles School of Art and Design; F. Tadama, Seattle. Exh: Cleveland Art Museum; Chicago Art Institute; Seattle Art Museum; Annual Exhibition of Northwest Artist, Seattle, 1932.

LEMERY, C.E. Painter. Member: The Attic Studio, Portland, Oregon, 1929–67.

LEMLEY, DEANNE (1940–) Painter, oil, watercolor, impressionistic landscapes, figures, genre. Teacher. Born in Spokane, Washington. Lived in Redmond, Washington, 1992. Pupil: Sergei Bongart, (scholarship); Rex Brandt; Joan Irving. Member: Northwest Watercolor Society ; Watercolor West; Women Artists of the West. Exh: Catherine Lorrilard Wolf Women's Exhibit, New York; San Diego International Watercolor Show. Many awards in shows in the United States and abroad.

LENFEST, FRANK Commercial artist. Lived in Seattle, Washington, 1940. Member: Puget Sound Group of Northwest Men Painters, Seattle Washington, 1940.

LENNIE, BEATRICE EDITH (1906–) Painter, oil, black & white. Sculptor. Designer, stage, masks, marionettes. Teacher. Lived in Vancouver, B.C., 1940. Pupil: Vancouver School of Decorative and Applied Arts; California School of Fine Arts, San Francisco; Frederick H. Varley; Harry Tauber. Member: B.C. Society of Fine Arts. Exh: National Gallery of Canada, Ottawa; Montreal Art Association; Royal Canadian Academy; Toronto Sculptors Society of Canada, Toronto; Seattle Art Museum.

LENON, JAMES Painter. Illustrator. Active in Oregon in the 1950's. Exh: Lincoln County Art Center, Delake, Oregon.

LENZE, MARIE Artist. Lived in Spokane, Washington, 1947.

LEONARD, CLAYTON W. (1899–1961) Painter, oil, landscapes. Commercial artist. Photographer. Lived in Tacoma, Washington, 1961. Display designer for J. C. Penney Company, 1930. Exh: Tacoma Civic Art Association, 1932.

LEONARD, CONSTANCE (1913–) Sculptor, ceramic, bronze. Drawing, pen & ink. Lived in Seattle, Washington, 1940. Pupil: School of Fine Arts, Boston; Alexander Archipenko. Exh: Seattle Art Museum, 1933–38; New York World's Fair, 1939; Annual Exhi-

bition of Northwest Artists, Seattle, first and second honorable mention.

LEONARD, MABEL Artist. Lived in Seattle, Washington, 1920.

LEPPICH, ELSA L. Artist. Lived in Seattle, Washington, 1938.

LETTICE, MAUDE Painter. Member of the Victoria (B.C.) Island Arts and Crafts Society around 1910.

LEVESQUE, HAYDON THOMAS (1910–) Painter, oil, watercolor. Born in Spokane, Washington. Pupil: Chicago Art Institute. Member: Montana Artists. Artist-designer, Yellowstone Park Museums.

LEVINE, DAVID PHILLIP (1910–) Painter. Designer. Resident of Los Angeles. Exh: Portland Museum, 1930.

LEVINE, REEVA (ANNA MILLER) (1912–) Painter. Teacher. Pupil: Emil Bistrom & Alex Rosenfild. Work: Temple De Hirsch Sinai, Seattle; Beth Sholom Temple, Richland, Washington; Temple Beth Israel, Aberdeen, Washington. Exh: Jewish Community Center, Mercer Island, Washington. Award: Artist of the Year, Museumic & Art Foundation, Seattle.

LEVINE, SHEPARD (1922) Painter. Teacher. Pupil: University of New Mexico; University of Toulouse, France. Exh: Portland Art Museum; Henry Gallery, University of Washington, Seattle; Spokane Art Museum. Professor of Art, Oregon State University, Corvallis.

LEVINO, HENRE Painter, musician. Lived in Tacoma, Washington, 1892–98. Studio in Tacoma, 1895.

LEVY, NAT (1896–1984) Painter, watercolor. Pupil: California School Fine Arts; Mark Hopkins Art Institute, San Francisco. Member: president, Society of Western Artists. Worked extensively in the Northwest and Alaska.

LEWIS, ALONZO VICTOR (1886–1946) Painter, oil, landscapes, portraits. Sculptor. Lived in Spokane and Seattle, Washington. Pupil: Chicago Art Institute. Created a WWI Victory Memorial statue for the Washington State Capitol. Washington State Sculptor Laureate, 1939. Also executed portraits of famous people.

LEWIS, ANNA B. Artist. Lived in Spokane, Washington, 1931.

LEWIS, BETTY Artist. Member: Tacoma Art League, Tacoma, Washington, 1945.

LEWIS, MARY (1926) Illustrator, ink & watercolor. Sculptor. Pupil: University of Oregon, 1945–50. Work: many public and private commissions nationally. Exh: Portland Art Museum Artists of Oregon.

LIBBY, CHARLES A. Artist. Studio in Spokane, Washington, 1918.

LIBERMAN, LORETTA Painter, watercolor. Lived in Seattle, Washington, 1945. Exh: Seattle Art Museum, 1945.

LIBERTY, DOROTHY B. Painter, watercolor. Lived in Seattle, Washington, 1951. Exh: Seattle Art Museum, 1949; Henry Gallery, University of Washington, Seattle, 1951.

LIDDELL, ANNA F. Artist. Lived in Tacoma, Washington, 1917.

LIEBMAN, ALLNE MEYER Painter. Exh: solo show, Portland Art Museum, 1939.

LILJESTROM, GUSTAVE F. (1882–1958) Painter, murals, landscapes, Chinese art. Member of the Group of Eight during the 1930's along with F. T. Johnson, E. Payne, A. Hansen, H. Wagner, A. Hill, William Wendt, William Ritschell. Work: Fifth Avenue Theater, Seattle Washington (Oriental interior). Traveled widely into the mountains and deserts of the West.

LINDALL, MATILDA Painter, oil, landscapes. Lived in Whatcom County, Washington, 1909. Exh: Alaska-Yukon Pacific Expo, Seattle, 1909.

LINDSAY, ANDREW JACKSON (1820–1895) Painter. Illustrator. Military topographical artist who traveled overland to Oregon in 1849 with the Mounted Rifle Regiment. Educated at West Point. Sketched the 1849 expedition of the military Regiment from Fort Leavenworth to Oregon. Joined the Confederate Army during the Civil War, 1861. Authored *In the Far Northwest*, in 1849–51. Also *Fort Hall on the Oregon Trail*.

LINGENBRINK, ARTHUR W. Artist. Sign painter. Lived in Seattle, Washington, 1941.

LINKHART, LUTHER J. Painter, watercolor. Lived in Spokane, Washington, 1948. Exh: Pacific Northwest Artists Annual Exhibition, 1948.

LINNELL, LILIAN B. (1894–) Painter, oil, watercolor. Lived in Medina, Washington, 1941. Pupil: Lucy Wells, Seattle.

LISLE, MABEL E. Artist. Lived in Seattle, Washington, 1919.

LISMER, ARTHUR Painter. Lived in Vancouver, B.C. Member: Canadian Group of Painters, 1936.

LITCHFIELD, DONALD (1896–) Painter, watercolor. Born in London. Lived in Seattle, Washington, 1942. Pupil: University College, London; Art Students League, New York. Member: Puget Sound Group of Northwest Men Painters. Exh: Pennsylvania Academy of Fine Arts, 1937; New York Watercolor Society; Salmagundi Club, New York; De-Young Museum, New York, 1940. Commercial artist for the *Seattle Post-Intelligencer*.

LITTAU, BERTHA Artist. Lived in Seattle, Washington. 1912.

LITTLE, GERTRUDE L. Painter, miniatures. Lived in Seattle, Washington, 1914. Pupil: Ella Bush, Seattle. Studio in Seattle, 1880's. Moved to Los Angeles, 1923.

LITTON, (LITT) Painter. Active in Oregon the late 1890's to early 20th century. Barchus school.

LITZENBURG, DOLA M. Painter, oil, portraits. Lived in Seattle, Washington, 1910. Work: Washington State Historical Society, Seattle, Washington, 1910.

LIVESLEY, LORNA (1915–) Painter, watercolor. Illustrator. Drawing, black & white, crayon. Lived in Portland, Oregon, 1940. Pupil: Cornish Art School, Seattle. Work: illustrations for *Paul Bunyan swings his Axe* and *Tall Timber Tales* by Dell McCormick.

LIVINGSTON, GRACE M. (1908–) Painter, pastel, watercolor. Lived in Milwaukie, Oregon. Pupil: State Teacher's College, Milwaukee; Bernard Hinshaw, Portland. Member: American Artists Professional League. Exh: Portland Art Museum, 1937.

LIVINGSTONE, CORALIE Artist. Lived in Seattle, Washington, 1929.

LLEWELLYN, MILES Painter, tempera. Lived in Seattle, Washington, 1949. Exh: Seattle Art Museum, 1949.

LOCHOW, CURT F. Painter. Lived in Seattle, Washington, 1931.

LOCHRIE, ELIZABETH DAVEY (1890–) Painter, oil, fresco. Sculptor. Illustrator. Writer. Pupil: Pratt Institute, Brooklyn; Winold Reiss, New York. Many frescos on public buildings in the west. Exh: Spokane Art Association, 1937; Portland Art Museum, 1937; American Fine Arts

Society, New York, 1938. Mural in the Post Office, Burley, Idaho.

LOCKWOOD, I. J. (MRS.) Artist. Lived in Bellingham, Washington, 1910.

LOEMANS, ALEXANDER F. Painter, oil, mountain landscapes, Indian portraits. Lived in Vancouver, B.C. in 1894.

LOEW, MICHAEL (1907–) Painter. Born in New York. Study: Art Students League, New York; Paris. Teacher: Portland Oregon Museum School, 1956–57; University of California, Berkeley, 1960–61; School of Visual Arts, New York, 1958. Member: Abstract Artists; Federation of Modern Painters and Sculptors. Work: murals in the Hall of Man & Pharmacy, New York World's Fair, 1939. Exh: throughout the United States (Museum of Modern Art, New York) and Europe.

LOFGREN, NELS P. Artist. Studio in Seattle, Washington, 1933. Worked at the Puget Sound Art Company, Seattle, Washington, 1933.

LOGAN, MAURICE GEORGE (1886–1977) Painter, oil, watercolor, landscapes. Study: San Francisco Institute of Art; Chicago Art Institute. Teacher: California College of Arts & Crafts, Oakland, until 1943. During the 20's he was active with the Society of Six. Work: Frye Museum, Seattle, Washington; many others.

LOGAN, THAYNE J. (1900–1990) Painter, oil, watercolor, pastel, landscapes. Architect. Lived in Portland, Oregon, 1940. Pupil: University of Oregon; Clyde Leon Keller and Sidney Bell, Portland. Member: Oregon Society of Artists, 1937; American Institute of Architects. Award: Oregon State Fair, 1927–34. Critic: art and sculpture projects, City of Portland. His widow still lives in the house he designed and built for her. Painted extensively all over the Pacific Northwest, and into Nevada and Utah. His paintings are all well documented regional landscapes.

LOGGIE, HELEN A. (–1976) Printmaker, etching. Drawing. Lived in Bellingham, Washington. Pupil: Art Students League of New York. Member: Society of American Etchers; Southern Printmakers; Northwest Printmakers. Exh: National Museum, Stockholm; Art Museum, Houston; University of Nebraska; Library of Congress, Washington, D.C.; Seattle Art Museum, 1939; Grand Central Gallery 1932–38; National Academy of Design, New York, 1934–38; Kennedy Gallery, New York, 1936; New York World's Fair, 1939. Received many awards.

LONEY, DORIS H. (1902–) Painter. Pupil: University of Washington; Art Students League, New York; Kuniyoshi. Exh: Seattle Art Museum, 1950.

LONEY, ELEANOR Painter, oil, watercolor. Lived in Spokane, Washington, 1946. Exh: Seattle Art Museum, 1945, 1946.

LONG, PETE Painter, watercolor, landscapes. Commercial artist. Lived in Spokane, Washington, 1950. Member: Washington Art Association, 1948.

LONG, VICTOR Painter. Died at his home in Vancouver, B.C. in 1939.

LONGDEN, MARGARET Painter. Member: Founding member, Vancouver, B.C. Fine Art Society, 1919.

LOOMIS, BIRDIE B. Painter, oil. Studio in Spokane, Washington 1930.

LOOMIS, CLYDE E. Painter, oil. Spokane, Washington, 1932.

LOOSE, D. A. (MRS.) Artist. Lived in Tacoma, Washington, 1891. Member: Tacoma Art League, 1892.

LOPP, HARRY LEONARD (1888–1966) Painter, oil, landscapes. Illustrator. Staff artist in Glacier National Park 1936–41. Pupil: University of Washington with Updyke. A depression artist he could produce a painting in a few minutes for tourists. Although he was living in Glacier Park, Montana, many of his works can be found in the Northwest.

LORENTZEN, HARRIET B. (– 1958) Painter, oil. Teacher. Lived in Seattle, Washington. Study: University of Washington. Member: Women Painters of Washington, 1940–58. Exh: Seattle Art Museum, 1940–58.

LORRAINE, ALMA ROYER (1858–1952) Painter, oil, landscapes, portraits, animals. Teacher. Lived in Seattle, Washington. Pupil: California Art Institute and in Europe. Exh: Washington State Arts & Crafts, 1909; Pan Pacific International Expo, 1915.

LORT, ROSS (1890–1968) Artist. Architect. Book designer. Illustrator. Member: Royal Art Institute of Canada; life governor of the Vancouver Art Gallery; president, B.C. Society of Artists, 1945–48.

LORY, JESSIE C. Painter, oil, watercolor, landscapes. Lived in Seattle, Washington, 1909. Exh: Washington State Arts & Crafts, 1909.

LOSEY, BLANCH L. (MORGAN) (1912–) Painter. Lithographer. Interior decorator. Lived in Seattle, Washington, 1980. Pupil: University of Washington. Member: Women Painters of Washington, 1935. Exh: Seattle Art Museum, 1935–47, under the names, Morgan, Losey & Mrs. Luther.

LOUGHEED, MARGARET Painter, landscapes. Lived in Vancouver, B.C.

in the 1930's. She painted the hills of the Cariboo.

LOUGHVAN Painter, oil, polar bears, Eskimos.

LOUIE, ALBERT Painter, oil, watercolor. Lived in Boise, Idaho, 1940. Pupil: Paul Dalzell and Conan Mathews. Exh: Idaho Artists Exhibition, 1939; Young America Paints, New York, 1939.

LOVEJOY, LETTIE A. Painter, oil, watercolor, landscapes. Teacher. Lived in Seattle, Washington, 1942. Exh: Washington State Arts & Crafts, 1909.

LOVETT, WENDELL H. Painter, watercolor. Draftsman. Lived in Bellevue, Washington, 1946. Exh: Seattle Art Museum, 1946.

LOWENTHAL, DAVID T. Painter, oil. Lived in Seattle, Washington, 1944. Exh: Seattle Art Museum, 1940.

LOWNSDALE, GERTRUDE G. (1853–1927) Painter, watercolors, Alaskan scenes.

LOWRY, ELEANOR (1875–1955) Painter, oil, watercolor. Lived in Seattle, Washington, 1940. Pupil: Minneapolis Art Institute. Member: Women Painters of Washington. Exh: solo show, Frederick & Nelson, Seattle; Seattle Art Museum; Portland Art Museum.

LOWRY, HAZEL Painter, impressionistic landscapes. Active in the early 20th century in Portland, Oregon.

LOWRY, LORNA ALIDA Painter, oil. Teacher. Lived in Seattle, Washington, 1967. Pupil: University of Washington. Exh: Seattle Art Museum, 1936, 1937; solo show, Frederick & Nelson, 1938.

LOYD, HARRY H. Artist. Lived in Tacoma, Washington, 1907.

LUCAS, CARTER H. Painter, oil. Lived in Seattle, Washington, 1945. Member: Puget Sound Group of Northwest Men Painters. Exh: Seattle Art Museum, 1945.

LUCAS, LA VON C. SALMELA Painter, oil. Lithographer. Sculptor, clay. Active in Portland, Oregon in the 1930's. Lived in Vancouver, Washington, 1954. Pupil: H. Wentz; L. Bunce. Exh: Southwest Washington Fine Arts, Vancouver, 1949; Seattle Art Museum, 1953. Specialized in painting mothers and children in the style of Kathe Kollwitz, as well as American Indians, suppressed working classes and minorities. Former wife of Jack Lucas. Currently living in Santa Barbara, California.

LUCAS, LAUREN M. Painter, watercolor.

LUCIAN, MAY Artist. Lived in Tacoma, Washington, 1899.

LUELL, WILLIAM Artist. Lived in Tacoma, Washington, 1930. Exh: Tacoma Art League, 1930.

LUNDBERG, ERVEN R. Commercial artist. Lived in Spokane, Washington, 1935.

LUNDBERG, HENRY J. Artist. Studio in Seattle, Washington, 1901–24.

LUNDEEN, DELPHINE C. Painter. Studio in Seattle, Washington, 1932. Also lived in Yakima, 1917.

LUNDIN, EMELIA A. (1884–) Painter. Born in Sweden. Lived in Seattle, Washington, 1929. Pupil: F. Tadema. Member: Seattle Fine Arts Society.

LUNDINE, CECILE L. Painter, oil. Lived in Seattle, Washington, 1944. Exh: Seattle Art Museum, 1934.

LUNG, ROWENA CLEMENT (See ALCORN)

LUNGER, BERNICE Artist. Studio in Seattle, Washington, 1927.

LUSSIER, CHARLES W. (1920–) Painter, watercolor. Lived in Seattle, Washington, 1960. Member: Puget Sound Group of Northwest Men Painters; Northwest Watercolor Society. Exh: Seattle Art Museum, 1940–45.

LYALL, EMILY Painter, pastel. Lived in Jefferson County, Washington, 1909. Exh: Alaska-Yukon Pacific Expo, Seattle, 1909.

LYLE, JEANNETTE E. (1883–) Painter, oil, watercolor. Drawing, pen & ink. Lived in Seattle, Washington, 1951. Pupil: Peter Camfferman; Langley.

LYNCH, DOUGLAS (1913–) Painter, oil, watercolor. Illustrator, black & white. Lived in Portland, Oregon, 1940. Pupil: Museum Art School, Portland; Chouinard Art Institute, Los Angeles. Member: Portland Advertising Artists. Muralist for Timberline Lodge.

LYNCH, JO (MARILYN BLANCHE) (1928–) Painter. Illustrator. Pupil: Iowa State College; Chicago Art Institute. Work: National Bank Commission, Seattle. Exh: Northwest Watercolor Exhibition; Seattle Art Museum; Society Western Artists; Frye Museum, Seattle, 1974. Member: Northwest Watercolor Society; Society Professional Graphic Artists.

LYON, EMMA L. (1900–1974) Painter, watercolor. Teacher. Lived in Seattle, Washington. Exh: Smithsonian Institute for a USA Traveling Exhibition. Donated more than 100 paintings to the Seattle Public Schools. Member: Women Painters of Washington.

LYON, GLADYS Artist. Lived in Seattle, Washington, 1914.

LYONS, DAVE W. Painter. Lived in Tacoma, Washington, 1945. Exh: Tacoma Fine Arts Association, 1943.

LYTLE, JEANETTE L. Painter, watercolor.

——M——

MAC, GEORGE D. Painter, watercolor. Lived in Seattle, Washington, 1941. Exh: Seattle Art Museum, 1939.

McALLISTER, PARKER (1903–1970) Painter, watercolor. Illustrator. Lived in Edmonds, Washington, 1964. Illustrator & staff artist for *Seattle Times*; two books, *Washington's Yesterdays*, 1953 & *Search for the Northwest Passage*, 1958. Member: Puget Sound Group of Men Painters. Exh: solo show, Washington State Historical Society, 1949. Paintings depicted pioneer life in the area.

McARTHUR, ALICE Artist. Lived in Seattle, Washington, 1917.

McARTHUR, WILLIAM C. Painter, watercolor. Lived in Pullam, Washington, 1946. Exh: Seattle Art Museum, 1946.

McAULEY, MILDRED E. Artist. Lived in Spokane, Washington, 1923.

McBAIN, ADDIE L. Painter, oil. Lived in Everett, Washington, 1926–44.

McBRIDE, DELBERT J. (1920–) Painter, oil, watercolor, ceramic tile. Historian. Lived in Olympia, Washington, 1991. From a pioneer family. Study: University of Washington; Cornish Art School, Seattle; Art Center, Los Angeles. Head Curator: State Capitol Museum, Olympia, Washington. Author of many historical publications on local native American art & Ethnology. Work: mural, Boy Scout headquarters, Seattle. Exh: Tacoma Art League, 1945; solo show, Tacoma, 1949.

McBRIDE, GEORGE M. Painter, portraits, landscapes, marines. Active in Portland, Oregon in the 1940's. Exh: Portland Art Museum.

McCAFFREY, FRANK Painter, oil. Lived in Seattle, Washington, 1926–53. Pupil: Cornish Art School, Seattle. Member: Puget Sound Group of Northwest Men Painters, 1937.

McCALL, ALICE HOWE (1882–1956) Painter, oil, watercolor. Born in England. Lived in Portland, Oregon until 1956. Pupil: University of Oregon, Eugene. Member: Oregon Society of Artists. Exh: Portland Art Museum; Oregon State Fair, Salem.

McCANN, ISABEL (–1955) Painter, oil, watercolor. Lived in Seattle, Washington. Pupil: Leon Derbyshire; Edgar Forkner; Peter Camfferman. Exh: Western Washington Fair; Frederick & Nelson, Seattle; Women Painters of Washington, 1940–55; Seattle Art Museum.

McCANN, UNA (1913–) Painter, murals. Born in California. Study: California and Paris. Assisted Diego Rivera on murals for Golden Gate International Expo, 1939. In 1940 she married Jack Wilkinson and moved to Eugene, Oregon.

MacCANNELL, EARLE E. (1885–) Painter, oil, pastel, murals. Sculptor. Lived in Olympia, Washington, 1941.

Pupil: Boston Watercolor Club; Boston Architectural Club. Muralist for Sacajawea State Park Museum, Pasco, Washington; Outdoor Art Club, Mill Valley, California, 1910.

McCARTHY, FRANK P. Artist. Studio in Seattle, Washington, 1916.

McCLAIRE, GEROLD ARMSTRONG (1897–) Painter, landscapes. Illustrator. Lived in Seattle, Washington, 1924–26.

McCLEARY, HARRY Artist. Studio in Spokane, Washington, 1923.

McCLOSKEY, WILLIAM J. (1859–) Painter, oil, watercolor, portraits. Lived in Ashland, Oregon, 1940. Pupil: Pennsylvania Academy of Fine Arts; Thomas Eakins. Exh: Paris Salon; Royal Academy of British Artists.

McCLURE, THOMAS F. Painter, gouache. Draftsman. Lived in Seattle, Washington, 1945. Exh: Seattle Art Museum, 1945.

McCOMAS, FRANCIS, JOHN (1875–1938) Painter, watercolor. Well known, important California landscape artist. Exh: Portland Art Museum; Lewis & Clark Expo, Portland, 1905; Alaska-Yukon Pacific Expo, Seattle, 1909. Member: American Watercolor Society. Settled in Carmel, California in 1912.

McCONIHE, MARGUERITE C. Artist. Lived in Tacoma, Washington, 1917. Teacher: University of Puget Sound, 1917. Exh: Tacoma Fine Arts Association, 1916.

McCONKEY, WILTON Painter, oil, watercolor, pastel. Drawing, pen & ink. Illustrator. Cartoonist. Lived in Olympia, Washington, 1941. Pupil: Cornish Art School, Seattle. Awards: three medals, W. D. Boyce, Chicago, 1926, 1927.

McCORMACK, ADELINE C. WILLOUGHBY (1871–1954) Painter, oil, watercolor. Lived in Port Townsend, Washington. Daughter of artist Sarah Cheney Willoughby. Award: gold & silver medal, Alaska-Yukon Pacific Expo, Seattle, 1909. Signed later works: A.W.Mc.

McCORMICK, OMEGA Painter, oil, still lifes. Lived in Jefferson County, Washington, 1909. Exh: Alaska-Yukon Pacific Expo, Seattle, 1909.

McCORMICK, S. K. Artist. Lived in Seattle, Washington, 1910.

McCOSH, DAVID J. (1903–) Painter, oil, watercolor. Printmaker, lithography. Lived in Eugene, Oregon, 1940. Pupil: Chicago Art Institute. Award: Chicago Art Institute; Tiffany Fellowship; West Seattle Art Club. Exh: Whitney Museum, New York; Seattle Art Museum; Pennsylvania Academy of Fine Arts; Portland Art Museum; University of Oregon, Eugene.

McCOSH, MRS. DAVID J. (See KUTKA)

McCRACKEN, PHILIP (1928–) Sculptor. Pupil: University of Washington; Henry Moore, England. Work: Detroit Institute of Art; Museum of Art, Victoria, B.C. Exh: Seattle Art Museum; Corcoran Art Gallery, Washington, D.C.; Whitney Museum of American Art, New York; many others.

McCRACKEN, W. L. (MRS.) Painter, watercolor. Lived in Yakima County, Washington, 1909. Exh: Alaska-Yukon Pacific Expo, Seattle, 1909.

McCREERY, OLLIE A. Artist. Lived in Seattle, Washington, 1901.

McCULLOCH, FAY Painter, oil, impressionist landscapes. Early 20th

century artist. Known work dated 1924, of an Oregon landscape.

McCULLOCH, M. L. Artist. Lived in Seattle, Washington, 1901.

McCULLY, WEYGANT (MRS.) Artist. Lived in Spokane, Washington, 1914.

McDERMITT, WILLIAM THOMAS (1884–1961) Painter, landscapes. Printmaker. Teacher. Lived in Spokane, Washington, 1928. Teacher: Washington State University, Pullman, 1925. He moved to Los Angeles in the early 1930's. Pasco, Washington; Outdoor Art Club, Mill Valley, California, 1910.

MacDONALD, J. A. S. Painter, modernist. Lived in Vancouver, B.C., 1940's.

MacDONALD, JAMES EDWARD HARVEY (1873–1932) Painter. Teacher. Muralist. Poet. Important Canadian artist. Original member of the Group of Seven, 1920. Work: National Gallery of Canada.

MacDONALD, JAMES W. G. (1897–) Painter, oil. Teacher. Lived in Vancouver, B.C., 1940. Pupil: College of Art, Edinburgh. Member: Canadian Group of Painters; B.C. Society of Fine Arts. Exh: National Gallery of Canada; Royal Canadian Academy, 1924–34; Tate Gallery, London, 1939; Golden Gate Expo, San Francisco, 1939.

McDONALD, JEWELL Painter, oil. Teacher. Studio in Spokane, Washington, 1918. Teacher of oil paintings, 25 cents per lesson.

McDONALD, M. J. Artist. Lived in Seattle, Washington, 1901.

MACE, JEAN DEUBEL Painter, oil, watercolor, pastels, landscapes, genre. Born in Northern Idaho. Living in Bonners Ferry, Idaho, (1992). Member: Idaho Watercolor Society; Midwest Watercolor Society.

McEVOY, BERNARD Painter. Member: Founding member B.C. Society of Fine Arts, 1919. Lived in Vancouver, 1933.

McFARLAND, J. M. (MRS.) Painter, oil. Lived in Chelan County, Washington, 1909. Exh: Alaska-Yukon Pacific Expo, Seattle, 1909.

McFARLAND, LOIS (1920–) Painter, oil, watercolor, landscapes, portraits, still lifes. Teacher, in her own school. Born in Washington, D.C. Moved to Mercer Island, Washington in 1945. Pupil: Sergei Bongart (she arranged his workshops in Seattle until his death in 1985); Delbert Gish; Ramon Kelly; R. Schmidt; B. Steinke. She has painted in Hawaii, Alaska, Spain, Italy, Mexico as well as Russia. Exh: solo show, Frye Museum, Seattle; Anchorage Fine Arts Museum; Puget Sound Art League.

McFEE, JUNE KING Painter, oil, tempera. Lived in Bellevue, Washington, 1946. Exh: Seattle Art Museum, 1946.

McGARRELL, JAMES (1930–) Painter. Born in Indiana. Pupil: Indiana University; UCLA; Academy of Fine Arts, Stuttgart. Exh: Portland Art Museum, 1959, 1962. Work: Portland Art Museum.

MacGOWAN, CLARA (1895–) Painter, oil, landscapes. Lived in Seattle, Washington, 1944. Pupil: University of Washington; L'Hote, Paris. Member: Chicago Women's Salon; Chicago Art Institute. Teacher: Northwestern University, 1935. Exh: Vienna; Paris; Chicago.

McGRATH, LENORE K. Artist. Lived in Seattle, Washington, 1908. Exh: Seattle Fine Art Society, 1908.

McGRATH, JAMES ARTHUR (1928–) Painter, Native Americans. Sculptor. Administrator. Pupil: Central Washington State College; University of Oregon. Work: Museum of New Mexico; Institute of American Indian Arts, Santa Fe; Bureau of Indian Affairs, Washington, D.C. Exh: Seattle Art Museum; many private and public collections.

MacGREGOR, EMMA L. DAVIS (1906–) Painter. Sculptor. Craftsperson, ceramics. Lived in Portland, Oregon, 1940. Pupil: Vassar College; Pennsylvania Academy of Fine Art. Member: American Artists Congress. Exh: Whitney Museum; Institute of Fine Art, Peking China, 1936; Paris International Expo, 1930. Portland Art Museum, 1939.

McGUIRE, MYRTLE (1897–) Painter, oil. Lived in Portland, Oregon, 1940. Member: Oregon Society of Artists. Exh: Portland Art Museum, 1936; Meier and Frank, Portland, 1937, 1938. Award: Oregon State Fair, Salem, 1935–1937.

McGURDY, CLARA HOWELLS Artist. Lived in Port Townsend, Washington, 1893.

MACHETANZ, FREDRICK KARL (1908–) Painter, oil. Graphic artist, lithographic crayon and pen & ink combination. Illustrator. Writer. Important Alaskan artist, specializes in Alaskan genre & landscapes. Pupil: Chicago Art Institute. Author & Illustrator: *Panuck, Eskimo Sled Dog*, 1939; among others.

MACHETTE, F. E. Artist. Lived in Seattle, Washington, 1909.

McHUGH, IRENE MUIR (1891–1955) Painter, oil, portraits. Sculptor. Lived in Tacoma and Seattle, Washington. Study: Annie Wright Seminary, Tacoma. Exh: Seattle Art Museum, 1938. Work: Washington State Capital; University of Washington.

McILVAIN, DOROTHY S. (1901–) Painter, oil, watercolor. Printmaker, block print. Teacher. Lived in Seattle & Spokane, Washington, 1935, 1950. Pupil: University of Washington, Seattle. Member: Northwest Printmakers. Exh: Seattle Art Museum, 1935–37; Los Angeles Museum of Art, 1935.

McILVAIN, ELVERDA B. Artist. Lived in Seattle, Washington, 1910.

McILWRAITH, WILLIAM FORSYTH (1867–1940) Painter. Illustrator, scenes of Willamette River & Valley and the Columbia River. Lived in Hood River City and Portland, Oregon. Study: Art Students League, New York. Illustrator in New York, 15 years. Published art calendars and several books.

MacINTOSH-GOW, J. Painter. Member: Founding member, Vancouver, B.C. Fine Art Society, 1919.

MacINTYRE, EMILE K. Painter, oil, watercolor, tempera. Printmaker. Sculptor. Lived in Seattle, Washington, 1940–44. Pupil: L. Derbyshire; M. Tobey. Member: Women Painters of Washington; Northwest Printmakers; Buffalo Print Club. Exh: Seattle Art Museum, 1937–49; Portland Museum; Oakland Art Gallery.

MACK, SVERRE Artist. Lived in Seattle, Washington, 1918.

McKAY, ARTHUR Painter, abstractist. Canadian. Painted with the Regina Group of artists.

McKAY, BERNICE Artist. Lived in Seattle, Washington, 1926.

McKECHNIE, CALVERT Painter, oil, still lifes. Lived in Spokane, Washington, 1935. Exh: Pacific Coast Painters, 1935.

MACKENLEY, MARY (1887–) Painter, oil, watercolor, portraits,

miniatures. Lived in Spokane, Washington, 1941. Pupil: Pennsylvania Academy of Fine Arts. Exh: Seattle Fine Arts Society, 1927; Spokane Fine Arts Festival, 1928.

MacKENLAY, GWYNETH, (1902–) Painter, watercolor, floral painting. Designer. Lived in Lewiston, Idaho. Pupil: University of California, Berkley. Exh: Clarkston Washington City Library, 1936; Decorators Club Gallery, New York, 1937.

McKIERNAN, DUNCAN YVES Painter, oil. Lived in Port Angeles, Washington, 1949. Exh: Seattle Art Museum, 1949.

McKIM CHARLES C. (1872–1939) Painter. Teacher. Lived in Oregon. Pupil: Winslow Homer.

McKINNEY, GEORGE Painter, tempera. Lived in Puyallup, Washington, 1945. Exh: Seattle Art Museum, 1945.

McKINNEY, W. A. Painter, landscapes. Active in Northern California and Oregon, 1910.

MACKLIN, LIDA ALLEN (1872–) Painter, oil, watercolor. Lived in Portland, Oregon, 1940. Pupil: University of Oregon Museum Art School; Clyde Keller. Member: Oregon Society of Artists.

McLANE, BLANCHE HELEN (MRS. HARRY COOK) (1901–) Painter, oil, still lifes, portraits. Drawing, charcoal. Teacher. Lived in Yakima, Washington, 1947–82. Pupil: Philadelphia School of Design. Member: Women Painters of Washington. Exh: Western Washington Fair, Puyallup, 1930, 1931; Seattle Art Museum, 1945.

MACLAREN, FREDRICK Artist. Lived in Eastsound, Washington, 1932.

McLARTY, WILLIAM JAMES (JACK) (1919–) Painter. Teacher.

Muralist. Pupil: Museum Art School, Portland, Oregon. Exh: Northwest Printmakers, 1943–45; Portland Art Museum, 1945. Teacher: Portland Art Museum.

McLAUGHAN, EBBA RAPP (See RAPP)

McLEOD, GRIETA Artist. Lived in Seattle, Washington, 1927.

MacLEOD, LAURETTA ANDREWS Painter, portraits. Lived in Lakota Beach, Washington, 1945. Pupil: Harvey Dunn, New York. Wife of artist Robert MacLeod. Painted portraits of American serviceman during World War II.

McLEOD, MAMIE WILLIAMS (1880–1980) Painter, oil, watercolor. China painter. Teacher. Moved to Tacoma, Washington, in 1885. Pupil: Franz Bishoff & Harriet Clark. Did not participate in local art exhibitions & associations, so her works remained obscure though she maintained a studio in Tacoma.

MacLEOD, PEGI NICOL (1904–1949) Painter, Canadian modernist. Painted among the Skeena River Indians, 1928. She accompanied the ethnologist Marius Barbeau to the Skeena River area in British Columbia as an Eastern painter. Won the Willingdon Prize for her landscape "The Log Run". Her work is included in *Canadian Paintings in the Thirties*.

MacLEOD, ROBERT P. (1908–) Painter, watercolor, marines. Etcher. Lived in Lakota Beach, Washington, 1945. Pupil: Sam Armstrong; Victor A. Lewis; Ed Warde; Karl Illave; Troy Kinney. Exh: Tacoma Art League, 1940; many eastern galleries and museums.

MACLURE, MARGARET CATHERINE (1869–1930) Painter, oil, watercolor, Coastal Indians, Chinese portraits, Vancouver Island. Lived in

Victoria, B.C. Self-taught. Member: Island Arts & Crafts Society.

MACLURE, S. Founding member: B.C. Society of Fine Arts, Vancouver, B.C., 1933.

MACLURE, SAMUEL Painter. Architect. Born in British Columbia in the 1890's. Landscape painting was a relaxing hobby, being unable to venture into the wilderness because of a heart condition.

McMAHON, HAROLDE A. (1889–) Painter, oil, watercolor. Drawing, crayon & pencil. Lived in Portland, Oregon, 1940. Pupil: University of Oregon; Clyde Leon Keller. Member: Oregon Society of Artists. Exh: Portland Art Museum: Meier & Frank, Portland.

McMEEKIN, JOSEPH PATRICK (1857–1936) Painter, oil, tempera, still lifes, landscapes, western genre. Born in Ireland. Moved to Idaho around 1875. Finally settled in Napa County California. Exh: World Columbian Expo, Chicago, 1893; Boise Idaho Fair, 1896; San Francisco Palace of Fine Arts, 1916.

McMICKEN, HELEN PARKER (1856–1942) Painter, watercolor, pencil. Lived in Olympia, Washington. Self-taught. Daughter of steamboat captain operating in the Puget Sound. Painted in watercolor in and around Washington State. Work: University of Washington.

McMURTRIE, WILLIAM BIRCH Painter, watercolor. Cartographer. In the Northwest circa 1850. Made numerous watercolor expeditions to Oregon. Topographical draftsman for the Pacific Coast Survey. Worked in California for 10 years from 1849. Exh: Oregon Historical Society Quarterly, September 1959.

McNEA, ALBERT T. Painter. Sculptor. Illustrator, gouache, landscapes. Many awards.

McNEA, JUDITH KAY Painter, watercolor. Pupil: Cleveland Institute of Art. Many awards.

McNEALEY, JAMES Sculptor. Painter. Teacher. Lived in Eugene, Oregon, 1992. Pupil: University of Wyoming, BA & MA. Art instructor: Laramie, Wyoming; Eugene, Oregon. Taught sculpting; University of Wyoming; Lane Community College, Oregon. Exh: bronze, Smithsonian Institute, Washington, D.C.; widely throughout the United States.

MacNEIL, NEIL T. Artist. Lived in Seattle, Washington, 1953. Member: Puget Sound Group of Northwest Men Painters, 1941.

McNEILL, KALIDA RYAN Painter, watercolor, winter genre.

McNIRN, IAN Painter. Teacher: Fine Arts Department, University of B.C., 1940's.

McNULTY, WILLIAM Artist. Lived in Seattle, Washington, 1914.

MacPHERSON, J. C. B. Artist. Lived in Seattle, Washington, 1907.

MacSOUND, NICOLAS S. (1884–1929) Painter, Alaskan scenes. Pupil: National Academy Design, New York.

MADDEN, DANIEL C. Artist. Lived in Seattle, Washington, 1944. Member: Puget Sound Group of Northwest Men Painters, 1940.

MADDEN, IRENE O. Painter, tempera. Lived in Seattle, Washington, 1980. Member: Women Painters of Washington, 1954. Exh: Seattle Art Museum. 1947.

MADDOX, TERRY Painter, watercolor. Drawing, pencil, pen & ink. Printmaker, hand-colored lithographs. Teacher. Grew up on a ranch

in Rogue Valley, Oregon. Lived in Eugene, Oregon. Pupil: University of Oregon. Teacher: Oregon Public Schools for many years.

MADSEN, JILL Painter, oil. Lived in Seattle, Washington, 1945. Exh: Seattle Art Museum, 1945.

MAGRATH, LENORE K. Painter, miniatures. Lived in Seattle, Washington. Member: Watercolor Society, 1910.

MAHAFFIE, BERTHA Artist. Studio in Seattle, Washington, 1917.

MAIN, CLARA AGNES (1899–1984) Painter, watercolor. Teacher. Born in Kent, Washington. Study: University of Washington. Teacher: Stanwood, Washington, 1923–25. Settled in Vallejo, California. Work: Vallejo Historical Museum.

MAKI, ROBERT (1938–) Sculptor, abstract. Teacher: University of Washington, Seattle 1966–68. Work: Seattle-Tacoma Airport; Henry Gallery, University of Washington, Seattle; Stanford University, California; National Collection of Fine Arts, Washington, D.C. Exh: Portland Art Museum; Seattle Art Museum Pavillion; De Young Museum, San Francisco; Denver Art Museum. Award: National Endowment Individual Artist Award, 1968.

MALLOY, MARGARET (1900–) Painter, oil, watercolor, large watercolors of flowers. Lived in Seattle, Washington, 1982. Pupil: M. Tobey. Member: president, Women Painters of Washington, 1949. Exh: Henry Gallery, University of Washington, Seattle; Seattle Art Museum.

MANGUS, MARVIN D. Painter, oil, watercolor, impressionist landscapes of Alaska and Canada. Pupil: Eliot O'Hara; William F. Walter; Roger Rittase; Penn State University. Exh: Smithsonian Museum Area Show; Alaska Juried Art Show; All-Alaska Representational Show.

MANKENBERG, KAROLA (1919–) Painter, oil, watercolor. Drawing, crayon. Lived in Monroe, Washington, 1940. Pupil: University of Washington, Seattle; Winold Reiss Art School, Glacier Park Montana. Exh: Denver Art Club, 1938.

MANN, MARGARET STROUSE (1906–) Printmaker, wood & linoleum block. Lived in Seattle, Washington, 1940. Pupil: University of Washington. Member: Lambda Rho. Exh: Northwest Printmakers.

MANSER, PERCY L. (1886–) Painter, oil. Born in England. Lived in Hood River, Oregon, 1940. Member: Oregon Society of Artists; American Artists Professional League. Work: murals in many public buildings. Exh: National Exhibition, New York, 1936–39; Seattle Art Museum; Boise Art Association.

MARCELLA, B. Painter, oil, still lifes. Works to be found in and about Portland, Oregon. (Grand Central Gallery sticker on back)

MARCH, HARRY S. JR. Painter, oil. Teacher. Lived in Seattle, Washington, 1951. Exh: Seattle Art Museum, 1946.

MARCHAND, PAUL (1870–) Painter, marine. Lived in Mount Vernon, Washington, 1924. Pupil: W. M. Hunt; C. Bennett.

MAREGA, C. Painter. Member: Founding member, Vancouver, B.C. Fine Art Society, 1919.

MAREGA, CHARLES (–1939) Sculptor. Born in Italy. Lived in Vancouver, B.C. Studied in Vienna. Member: B.C. Society of Fine Arts; Palette and Chisel Club. Exh: Royal Canadian Academy; BC Artists Annual Exhibition. Work: many in public places. Teacher: Vancouver School of Art.

MARING, C. C. Engraver. Designer. Died in Seattle, Washington prior to 1940. Designed the State Seal of Washington.

MARKELL, ISABELLA BANKS Graphic Artist. Pupil: Ecole des Beaux-Arts, Paris. Work: Northwest Printmakers.

MARKS, A. L. Painter. Lived in Spokane, Washington, 1927. Exh: Seattle Fine Arts Association, 1927.

MARSH, DAVID FOSTER (1926–) Painter. Teacher. Pupil: Central Washington University; University of Oregon. Exh: Northwest Annual Exhibition, 1963 & 1966; Northwest Watercolor Society Exhibition, 1958. Member: National Art Education Association.

MARSH, ELSIE Artist. Lived in Seattle, Washington, 1942.

MARSH, HAROLD DICKSON (1899–) Painter. Work: Oregon State Art Museum Association, Salem; La Grande Public Library.

MARSH, LEON D. (1906–) Painter, oil. Lived in Seattle, Washington, 1940. Pupil: Chicago Art Institute; University of Washington; Mark Tobey. Member: Washington Artists Union. Exh: Seattle Art Museum, 1936, 1937.

MARSH, RUTH BASSETT (MRS. LEON MARSH) (1908–) Painter, oil, watercolor. Craftsman, ceramics. Lived in Seattle, Washington, 1940. Pupil: Chicago Art Institute; Mark Tobey. Exh: Seattle Art Museum, 1936–38.

MARSHALL, ALBERT G. Artist. Lived in Seattle, Washington, 1916.

MARSHALL, FRED BRUCE (1904–1979) Painter, oil, watercolor. Illustrator. Cartoonist. Teacher. Lived in Seattle, Washington. Study: Washington State University. Member: Puget Sound Group of Northwest Men Painters. Exh: Seattle Art Museum. Staff artist, *Seattle Post Intelligencer* and *Seattle Daily Times*, 38 years.

MARSHALL, MAY WARNER (MRS. FRED MARSHALL) (1902–) Painter, oil, watercolor, acrylic, casein. Drawing, pen & ink. Teacher. Lived in Seattle, Washington. Pupil: Cornish Art School, Seattle; Walter Reese; Peter Camfferman. Member: Women Painters of Washington. Fashion artist, *Seattle Daily Times*, 20 years.

MARSTERS, EDA Painter, oil, landscapes. Many works found in and about Beaverton, Oregon, some dated 1930's-40's.

MARTIN, ANDREW G. Painter, oil. Lived in Seattle, Washington, 1946. Exh: Seattle Art Museum, 1946; Henry Gallery, University of Washington, Seattle, 1951.

MARTIN, DORA E. Artist. Lived in Seattle, Washington, 1928.

MARTIN, FLETCHER (1904–) Painter, fresco, tempera, modern Western scenes. Muralist. Printmaker, lithography. Illustrator. Lithographer. Teacher. Born in Clarkston, Washington. The son of a newspaperman he became a printer at the age of 12. Self taught as a painter. Teacher: Art Center School, Los Angeles, 1938–39; Artist-in-residence at the University of Iowa, 1940–41; several other teaching positions.

MARTIN, HATTIE C. Artist. Lived in Spokane, Washington, 1942.

MARTIN, JENNIE Artist. Studio in Spokane, Washington, 1902.

MARTIN, JO G. (1886–) Painter, oil, watercolor, wash, equestrian subjects. Drawing, pen & ink. Printmaker, linoleum block prints. Born in Idaho Falls, Idaho. Pupil: Chicago Art

Institute. Illustrator: *Red Heroines of the Northwest*, 1929, plus other western books.

MARTIN, THOMAS MOWER (1838–1934) Painter, watercolor landscapes. Illustrator. Teacher. Important early Western Canadian railway survey artist. He was the first full-time artist in Toronto. Founder of the Ontario Art Union and the Royal Canadian Art Academy. Followed the course of the Canadian Pacific Railway, illustrating 76 water colors for a book *Canada*, by W. W. Campbell. Almost made Vancouver his home. In the late 1860's Martin led a group of painters into the Canadian West along the proposed Canadian Pacific railway. Ten more trips took him through the Pacific Coast, Vancouver Islands and Washington State.

MARULIS, ATHAN G. Painter, oil, portraits, landscapes, seascapes. Teacher. Lived in Seattle, Washington, 1926. Member: Seattle Fine Arts Society. Exh: Seattle Art Directors Society, 1925.

MARUMACHI, F. Painter, oil. Lived in Seattle, Washington, 1934. Exh: Seattle Art Museum, 1934.

MASON, ALDEN C. (1919–) Abstract painter, mixed media. Teacher: University of Washington, Seattle. Work: Seattle Art Museum; Denver Art Museum; Portland Center Visual Art.

MASON, DORA EATON (1896–) Painter, oil, watercolor, pastel. Sculptor, clay, marble, wood, stone, plaster. Lived in Iowa City, Iowa, 1940. Pupil: University of Idaho, Moscow. Work: bronze memorial tablet, Congregational Church, Mountain Home, Idaho. Exh: solo show, Muncipal Art Gallery, Davenport Iowa; University of Iowa, 1938; American Municpal Art Committee Show, New York, 1937.

MASON, DORIS BELLE (1896–) Sculptor. Pupil: University of Idaho. Work: Spokane Art Association.

MASON, J. Q. (MRS.) Artist. Lived in Tacoma, Washington, 1905. Member: Tacoma Art League, 1905.

MATHENY, LU ANN Painter, oil, watercolor. Lived in Bellevue, Washington, 1956. Pupil: Marie Labes. Exh: Seattle Art Museum, 1945; Frederick & Nelson, Seattle.

MATHES, E. T. (MRS.) Painter, watercolor. Lived in Whatcom County, 1909. Exh: Alaska-Yukon Pacific Expo, Seattle, 1909.

MATHESON, JOHANNA E. Artist. Lived in Seattle, Washington, 1923. Exh: Seattle Fine Arts Society, 1922.

MATHEWS, CONAN E. (1905–) Painter, oil, watercolor. Muralist. Teacher. Writer. Lived in Boise, Idaho, 1940. Pupil: California School of Fine Arts, San Francisco; University of California; Hans Hofmann. Member: Idaho Art Association. Exh: Golden Gate International Expo, San Francisco, 1940. Head of the Art Department, Boise Junior College.

MATHIS, GOLDA E. Artist. Lived in Spokane, Washington, 1921.

MATHY, JEAN SMITH Painter, oil, tempera. Lived in Seattle, Washington, 1945. Exh: Seattle Art Museum, 1945.

MATSEN, IDA M. Painter, oil, watercolor, still lifes. Printmaker, wood block. Lived in Corvallis, Oregon, 1941. Associate Professor, Oregon State University, 1941. Study: Washington State University; University of Washington; University of Oregon. Member: Northwest Printmakers; American Artists Professional League; Oregon Society of Artists. Exh: Seattle Fine Art Society, 1921, 1922; Seattle Art Museum, 1934.

MATSEN, JOSEPHINE Painter, oil. Lived in Seattle, Washington, 1946. Exh: Seattle Art Museum, 1946.

MATSON, REA BLAMER (1913–) Painter, oil, landscapes. Born in Everett, Washington. Pupil: E. Forkner; Mary Allen. Member: Women Painters of Washington, 1946. Exh: Seattle Art Museum, 1932, 1934.

MATSUDAIRA, JOHN T. Painter, oil, tempera. Lived in Seattle, Washington, 1959. Exh: Seattle Art Museum, 1949; Henry Gallery, University of Washington, Seattle, 1951, 1959.

MATTHEWS, MARMADUKE (1837–1913) Painter, watercolor, landscapes. Born in England. Arrived in Toronto, Canada in 1860. Painted the Pacific Northwest coast and the Canadian Rockies after 1888. Founding member and secretary of the Royal Canadian Academy of Art, 1879. Worked in the traditional English watercolor style of grand landscapes with great detail.

MATTHEWS, ROSS R. Artist. Lived in Seattle, 1917.

MATTHIESEN, ROBERT (1915–) Painter, watercolor. Lived in Seattle, Washington, 1945. Member: Seattle Art Director Society, 1945; Puget Sound Group of Northwest Men Painters, 1934.

MATTISON, LEOTA RUTH Painter, oil. Lived in Seattle, Washington, 1937. Exh: Seattle Art Museum, 1934–35.

MATTOCKS, MARGARET COPLEN (1898–) Painter, oil, watercolor, ink, acrylic. Lived in Seattle, Washington, 1982. Pupil: Rex Brant; Helen Everett; May Marshall; F. E. O'Hara; George Post. Organized & served as President & Director, Artists Gallery of the Northwest. Exh: Frye Museum, Seattle; Henry Gallery, University of Washington, Seattle.

MAURICE, EVA E. Artist. Lived in Spokane, Washington, 1901.

MAXWELL, E. S. (MRS.) Artist. Lived in Walla Walla, Washington, 1902.

MAYBELLE, CLAUDE S. (1872–) Cartoonist, watercolor, pen & ink. Born and worked in Portland, Oregon. Cartoonist for the *San Francisco Chronicle* and *Examiner*, 1891–93.

MAYHEW, ELZA Sculptor. Lived in Vancouver, B.C., 1950's.

MAYNARD, MAX Painter, modernist landscapes in the style of Emily Carr. Pupil: Vancouver, B.C. Art School. Teacher: University of B.C.

MAYNARD, PRISCILLA Painter, sumi watercolors, Oriental-style florals, still lifes. Teacher. Pupil: Art Students League, New York, MFA Degree; University of Iowa; Wesleyan Conservatory, BFA. Member: Northwest Watercolor Society; Women Painters of Washington, Sumi Award; Puget Sound Sumi Artists, Sumi-e Society of America.

MAYRS, FRANK Painter. Vancouver, B.C. Art School, 1945.

MEAD, ELLA L. Painter, watercolor, china. Lived in Tacoma, Washington, 1920. Member: Tacoma Art League, 1933. Exh: Tacoma Fine Art Association, 1915.

MEAD, RAY Painter. Vancouver, B.C. Exh: Biennial Canadian Painters, 1955.

MEARES, JOHN (1756–1809) Came to the Northwestern coast in 1786. Commander in the English Navy. Illustrator, *China to the Northwest Coast of America*.

MEDCALF, JOHN Painter, oil. Lived in Eugene, Oregon, 1940. Exh: Seattle Art Museum, 1938.

MEEHAN, K. D. (MRS.) Artist. Lived in Seattle, Washington, 1909.

MEERES, GEORGE A. (1878–) Painter, watercolor. Born in England. Lived in Vernon, B.C., 1940. Exh: Vancouver Art Gallery, 1935; New Westminster Art Gallery, 1929.

MEINHARDT, JOHN Painter. Lived in Spokane, Washington, 1927. Exh: Seattle Fine Art Association, 1927.

MEINZER, DOROTHY 'MOMNO' Painter, acrylic. genre. Portland artist. Active around 1960.

MELLON, GEORGE Artist. Lived in Seattle, Washington, 1914.

MELVIN, GRACE W. Painter, watercolor, black & white. Craftsperson, illumination, ceramics, embroidery. Teacher. Lived in Vancouver, B.C., 1940. Study: London and Paris. Member: Glasgow Society of Lady Artists. Exh: Royal Scottish Academy, Edinburgh; Royal Canadian Academy, Montreal 1929; Vancouver Art Gallery, 1931–37. Was recruited to the staff of the Vancouver School of Art and Design to nourish the new form of landscape painting which was to become one with nature.

MENARD, MURIAL (See KENNEDY)

MENARD, PHILLIP J. Artist. Lived in Seattle, Washington, 1930.

MENELAWS, WILL Painter, oil, watercolor, pastel, tempera. Drawing, pen & ink. Born in Scotland. Lived in Victoria, B.C., 1940. Teacher. Member: Victoria Sketch Club; Arts and Crafts Society. Exh: Seattle Art Museum; Vancouver Art Gallery, Victoria.

MERCIER, FRANCIS X. Artist. Lived in Seattle, Washington, 1921.

MERITT, MARGARET (1912–) Painter, oils, watercolors, landscapes, portraits, florals. Born in Clackamas,

Oregon. Moved to Bend Oregon in 1949 and opened a gallery she built herself. Known in Central Oregon as the "Mistress of the Juniper". Self-taught she is currently painting and showing her work, (1992). Margaret builds many of the frames for her paintings from old weathered wood she gathers on walks through the woods. Member: Sagebrushers Art Society, Bend. Exh: Oregon State Fairs, from the 1950's, Salem.

MERO, DAVID S. Artist. Lived in Seattle, Washington, 1927.

MERO, JACK R. Painter, oil. Lived in Seattle, Washington, 1944. Exh: Seattle Art Museum, 1938.

MERRIAM, IRMA S. Painter. Lived in Seattle, Washington, 1924–26. Member: Seattle Fine Arts Association. Exh: Seattle Art Directors Society, 1921, 1925.

MERRILL, ANNE E. Artist. Lived in Spokane, Washington, 1917.

MERRITT, D. (MRS. W. C.) Painter. Exhibited in the only show presented by the Tacoma Art League in March 1891. One of the area's earliest significant exhibitions.

MERRITT, INGEBORG JOHNSON (1888–) Painter, oil, watercolor, Indian paintings. Drawing, conte. Born in Norway. Pupil: Chicago Art Institute; Winold Reiss; Alphonse Mucha. Exh: Seattle Art Museum, 1938. His Indian painting was presented to the Crown Prince of Sweden, 1938.

MERSFELDER, JULES (1865–1937) Painter, landscapes. Born in Stockton, California. Study: School of Design, San Francisco. Exh: Chicago; Boston; Philadelphia; New York; Boston; Baltimore. Award: bronze medal, St. Louis Expo, 1904. Maintained a studio in Portland, Oregon in 1889 before re-

turning to San Francisco in 1891. Work: Oakland Museum, California.

MEYER, ESTER, C. (1897–) Painter. Etcher. Born in Coos Bay, Oregon where she worked before settling in the San Francisco Bay area. Primarily a California artist.

MEYER, HAZEL (early 20th century) Painter, oil, impressionist mountain and landscapes. Oregon artist. Student of Maude Wanker in the 1930's.

MEYER, LOUIS RICHARD "MAX" (1856–1912) Painter, oil, watercolor, landscapes, portraits. Teacher. Photographer. Born in Germany. Lived in Tacoma, Washington and Portland, Oregon. Pupil: Royal School of Arts, Berlin; Munich; Dresden. Principal of Art & Design, College of Puget Sound. Exh: Western Washington Industrial Exposition, 1891, 1892. Important Northwest artist.

MEYER, MYRTLE (1889–) Painter, oil, watercolor. Lived in Portland, Oregon, 1940. Pupil: Maude Wanker; WPA art classes, Portland. Member: Oregon Society of Artists. Exh: Meier & Frank, Portland, 1939.

MEYER, SUSAN Painter, watercolor. Lived in Seattle, Washington, 1945. Exh: Seattle Art Museum, 1945.

MEYER, WILLIAM Painter, watercolor. Lived in Seattle, Washington, 1937–40. Exh: Seattle Art Museum, 1937.

MEYERS, PERRY S. Painter, landscapes, ships in the tight luminist style. Active in Portland, Oregon in the 1920's, 30's.

MICHAELS, PAUL S. Painter, watercolor. Lived in Spokane, Washington, 1948. Exh: Pacific Northwest Artists Annual, 1948.

MICHALOV, ANN W. (1904–) Painter, oil, watercolor, tempera, mu-

rals. Printmaker, lithography. Lived in Spokane, Washington, 1941. Pupil: Chicago Art Institute. Member: Chicago Society of Artists. Exh: New York World's Fair, 1939; Golden Gate International Expo, San Francisco, 1939. WPA artist.

MICHETTI, OTHELLO (1895–1981) Painter, watercolor, landscapes, farms, mining camps. Commercial artist. Born in Italy. Immigrated to New York at age ten. Study: Art Students League, New York. At 21 he settled in San Francisco and became a world traveler making several sketching trips to Europe, Alaska and the Orient.

MIGNOT, I. R. Painter. Lived in Washington.

MIKKELSON, FLORENCE Artist. Lived in Seattle, Washington, 1917.

MILES, MARY A. Painter. Teacher. Lived in Tacoma, Washington, 1912. Member: Tacoma Art League, 1916. Teacher: Ferry Museum Art School, 1895.

MILLAR, CLARA L. (1893–) Painter, oil, watercolor. Craftsperson, porcelain and pottery decoration. Lived in Vancouver, B.C., 1940. Pupil: University of Washington, Seattle; Paris. Exh: bronze medal, Vancouver Art Gallery, 1934; Royal Canadian Academy; B.C. Artists Exhibition.

MILLER, CORA J. Painter, china. Lived in Tacoma, Washington, 1910.

MILLER, DEAN (MRS.) Painter, oil. Lived in Seattle, Washington, 1907.

MILLER, E. D. (MRS.) Artist. Lived in Seattle, Washington, 1910.

MILLER, ELIDA (1907–) Painter, watercolor. Designer. Lived in Union, Oregon, 1940. Pupil: University of Oregon, Eugene; University of Washington, Seattle; New York School of Fine and Applied Art; Mark Tobey. Cos-

tume Designer for Northwest Opera Repertory Theater. Teacher: St. Helen's Hall Junior College, Portland.

MILLER, MYRON C. Painter. Lived in Seattle, Washington, 1951. Member: Puget Sound Group of Northwest Men Painters, 1941.

MILLER, REX ASHBY (1901–1967) Painter. Teacher. Born in Oregon. Later moved to Glendale, California and taught at Franklin High School.

MILLER, SUSAN ELIZABETH Painter, oil, black & white. Printmaker, dry point, wood engraving. Designer, jewelry. Lived in Seattle, Washington, 1941. Pupil: College of Puget Sound; Rowena Clement Lung Studio, Tacoma; Paul Bornet, Paris. Member: Tacoma Fine Arts Association.

MILLS, ALICE TAYLOR Painter, oil. Lived in Tacoma, Washington, 1907–09. Teacher: Annie Wright Seminary, 1907–09. Exh: Alaska-Yukon Pacifc Expo, Seattle, 1909.

MILLS, W. ALEXANDER Artist. Lived in Everett, Washington, 1912.

MINCHEON, BEATRICE Artist. Lived in Seattle, Washington, 1919.

MINOR, JULIA (1895–) Craftsperson, wood worker. Lived in Seattle, Washington, 1940.

MINUTOLI, ANGELA Painter, tempera. Lived in Seattle, Washington, 1946. Exh: Seattle Art Museum, 1946.

MIRZA, PRINCE K. Artist. Lived in Seattle, Washington, 1926.

MISH, CHARLOTTE ROBERTS. (1909–1974) Painter, oil, watercolor, pastel, marine, landscapes and portraits. Sculptor. Writer. Teacher. Poet. Born in Pennsylvania. Active in Washington, 1920; Oregon, 1930–1974. Pupil: University of Southern California;

Sidney Bell; F. Tadama; H. Wentz; Art Students League, New York; Paris; Mexico. Member: Portland Art Association; Oregon Society of Artists. Illustrator for national magazines and the *Portland Oregonian*, 1940. Exh: Seattle Art Museum, 1925.

MITCHELL, HARRY O'DANIAL Artist. Lived in Seattle, Washington, 1951. Member: Puget Sound Group of Northwest Men Painters, 1945.

MITCHELL, MABEL KRIEBEL (1897–) Painter, oil, watercolor. Lived in Seattle, Washington, 1941. Pupil: Eustace Ziegler; Leon Derbyshire; Seattle. Exh: Northwest Gallery, 1931; Western Washington Fair, Puyallup, 1935.

MITCHELL, MARGARET GRIFFITHS Painter, miniatures. Lived in Seattle, Washington, 1924. Pupil: Ella Bush. Exh: Seattle Fine Arts Society, 1915.

MITCHELL, MICHAEL Painter. Commercial artist. Member: The Attic Studio, Portland, Oregon, 1929–67.

MITCHELL, PATRICIA CARTER Painter, watercolor. Born in Oakland, California. Lived in Portland, Oregon, 1940. Pupil: Museum Art School, Portland.

MIYAZAKI, SHIRO (1910–) Painter, oil, watercolor. Printmaker, block prints. Lived in Seattle, Washington, 1941. Pupil: California School of Fine Arts, San Francisco. Many awards. Member: Northwest Printmakers, 1939; Seattle Art Museum, 1939.

MIZUNO, SADAO Painter, oil, watercolor. Photographer. Lived in Portland, Oregon, 1940. Pupil: Museum Art School.

MOBBS, ALFRED Artist. Lived in Seattle, Washington, 1914.

MOBERLY, W. M. Artist. Lived in Walla Walla, Washington, 1902.

MOCINE, EMILY MARY RUTHER-FORD (1884–1957) Wood Carver. Born in New Zealand. Study: Sydney, Australia; UCLA. Exh: Alaska-Yukon Pacific Expo, Seattle, 1909.

MOCINE, RALPH FULLERTON (1875–1953) Painter. Commercial artist. Born in Gardiner, Oregon where he studied and worked before moving to Los Angeles in 1903.

MOIR, MARION Painter, watercolor, landscapes, marines, genre. Teacher. Pupil: Oregon State University; George & Satsuko Hamilton; Jan Kunz; Masonori Kimurs, Japan. Member: Watercolor Society of Oregon; Yaquina Art Association. Exh: extensively in Oregon, California, Alaska and the United States. Teacher: Japanese fis rubbings, Coos Art Museum, Coos Bay, Oregon.

MOLINARI, GUIDO (1933–) Painter, abstract expressionist. Canadian. Exh: Vancouver, B.C. Art Gallery, 1964.

MOLLER, OLAF (1903–) Painter, oil, tempera. Muralist. Born in Copenhagen. Lived in Rupert, Idaho, 1940. Pupil: Pennsylvania Academy of Fine Arts; Daniel Garber. Member: Washington Landscape Club; Teton Artists Association; Rocky Mountain Artists Association. Many awards and public commissions in the Northwest.

MOMENT, JEANNE (1901–1984) Painter, watercolor, Drawing, charcoal. Lived in Oregon.

MONAGHAN, KEITH (1921–) Painter, semi-abstract. Teacher. Pupil: University of California, Berkeley, BA, MA. Work: Washington State University; plus many corporations and private collections. Exh: Vancouver Art Gallery, B.C.; Cheney Cowles Museum, Spokane; Seattle World's Fair. Professor of Art, Washington State University. Member: Northwest Watercolor Society, 1951.

MONROE, MILTON (1898–1986) Commercial and newspaper artist. Born in Monrovia, California, the city his grandfather, James Monroe, founded in 1886. Study: UCLA. Teacher: Chouinard Art School in 1928. Became head of the Art Department at the *Seattle Post-Intelligencer* before settling in San Francisco as Art Director for the *San Francisco Chronicle*.

MONTEIRO, H. THEODORE Artist. Lived in Everett, Washington, 1912.

MONTGOMERY, LORAIN Painter, ceramics. Teacher. Lived in Spokane, Washington, 1950. Member: Washington Art Association, 1950.

MOONEY, C. G. Artist. Lived in Seattle, Washington, 1909.

MOORE, AGNES RANDALL (1906–) Painter, watercolor. Illustrator. Living in Moscow, Idaho, 1940. Pupil: Chicago Art Institute. Book Illustrator.

MOORE, BERNICE STARR (1903–) Painter, oil. Sculptor. Teacher. Writer. Lived in Seattle, Washington, 1940–62. Pupil: Schaeffer School of Design, San Francisco; Alexander Archipenko; University of Washington, Seattle. Member: Women Painters of Washington; National League of American Pen Women. Exh: Seattle Art Museum; Grant Galleries, New York.

MOORE, C. McDONALD (MRS.) Artist. Lived in Spokane, Washington, 1913.

MOORE, DAVID Artist. Lived in Tacoma, Washington, 1940. Exh: Tacoma Fine Arts Association, 1940.

MOORE, ELBRIDGE WILLIS (1857–1938) Portrait Painter. Photogra-

pher. Captain of the First Regiment, Oregon, National Guard and a resident of Portland since 1883. Very well known portrait artist, photographer in Portland having the largest gallery in the area.

MOORE, HIRAM (MRS.) Painter, oil, landscapes, still lifes. Lived in Pierce County, Washington, 1909. Exh: Alaska Yukon Pacific Expo, Seattle, 1909.

MOORE, MARY E. Painter, oil. Lived in Tacoma, Washington, 1921. Exh: Tacoma Art League, 1915.

MOORE, RUTH L. Artist. Lived in Tacoma, Washington, 1951. Teacher: Tacoma Public Schools. Member: Tacoma Fine Art Association, 1919.

MOORE, TOM J. (1892–) Painter, oil, watercolor. Printmaker, lithography, etching. Muralist. Pupil: Cincinnati Art Academy; Frank Duveneck; George Luks; John Sloan. Member: American Federation of Art; American Artists Professional League. Exh: Brooklyn Art Museum, 1932; Chicago Art Institute, 1931; Montross Galleries, New York, 1930; New York World's Fair, 1939.

MORA, JOSEPH JACINTO (1876– 1947) Painter. Sculptor. Illustrator. Etcher. Important California artist. Exh: Alaska-Yukon Pacific Expo, Seattle, 1909.

MORETTI, VICTOR Artist. Lived in Tacoma, Washington, 1891. Member: Tacoma Art League, 1892.

MORGAN, BLANCHE LUZADER (1912–) Painter, watercolor. Decorator. Born in Los Angeles, California. Lived in Seattle, Washington, 1940. Pupil: University of Washington, Seattle. Member: Women Painters of Washington. Exh: Seattle Art Museum; Frederick & Nelson, Seattle; College of Puget Sound, Tacoma.

MORGAN, DARLENE Painter, ink and oil. Pupil: Merle Olson. Work: Pacific Northwest Indian Center; Pacific Northwest Indian Center Art Auction Annual, (best in show); Charles Russell Exhibition & Auction; National Parks Centennial Exhibition, Glacier Park, Montana.

MORGAN, EFFIE Painter, oil, watercolor, landscapes. Oregon artist. Not much is known about Effie's career as an artist except that when she passed away in Albany, Oregon the heirs to her estate distributed a large collection of her works. The reverse of one of these paintings speaks of a solo show held in 1908 in Salem, Oregon.

MORGAN, MARION L. (1875–) Printmaker, linoleum block print, wood engraving, monoprints. Brush drawing. Lived in Queen Charlotte Islands, B.C., 1940. Exh: Southern Printmakers Rotary Exhibition, Atlanta, Georgia, 1939.

MORGAN, MARY A. (1880–1975) Painter, oil, watercolor, crayon, pen & ink, portrait silhouettes. Lived in Burton on Vashon Island, Washington, 1940. Pupil: Smith College; University of Washington: Chicago Art Institute. Exh: Western Washington Fair, 1937, 1938.

MORGAN, MINA QUEVLI Painter, oil. Lived in Tacoma, Washington, 1934. Exh: Seattle Art Museum, 1934.

MORGAN, P. A. Painter, oil. Work: "Early Seattle Waterfront at Foot of Washington St." in the Seattle Museum of History & Industry, 1986.

MORGAN, ROSE Commercial artist. Lived in Seattle, Washington, 1923.

MORGAN, W. VAUGHAN Artist. Lived in Seattle, Washington, 1928.

MORHAM, MARION A. (1902–) Painter, watercolor. Craftsperson.

Born in London, England. Lived in Vancouver, B.C., 1940. Pupil: University of London. Exh: Vancouver Art Gallery, 1938; and in England.

MORIMOTO, SAM Painter, oil. Lived in Spokane, Washington, 1948. Exh: Pacific Northwest Artists Annual, 1948.

MORPHEY, MARY Painter, watercolor. Lived in Kennewick, Washington, 1947. Exh: Seattle Art Museum, 1947.

MORRIS, CARL A. (1911–) Painter, oil, watercolor. Lived in Seattle, Washington, 1947. Pupil: Chicago Art Institute; Vienna. Exh: Oakland Art Museum, 1937; Chicago Art Institute, 1938; Seattle Art Museum, 1939–52. WPA artist.

MORRIS, ETTA A. Artist. Lived in Tacoma, Washington, 1938. Member: Tacoma Art League, 1938.

MORRIS, HILDA (1911–) (MRS. CARL A.) Painter. Sculptor. Lived in Seattle, Washington, 1947. Pupil: Cooper Union School; Art Students League, New York. Exh: solo show, Portland Art Museum, 1946 & 1955; nationally. Important sculpture commissions, including the Seattle Opera House.

MORRIS, WILLIAM CHARLES Painter. Lived in Spokane, Washington, 1913.

MORRISON, LOUISE GERTRUDE (1873–1948) Painter, oil, watercolor. Printmaker, etching. Sculptor. Lived in Seattle, Washington. Pupil: Couwles Art School, Boston. Member: Women Painters of Washington; American Federation of Arts. Exh: Salon des Artistes Francais, Paris, 1908; Baltimore Watercolor Club; Philadelphia Art Alliance, 1936.

MORRISON, MALCOLM M. Painter, oil, landscapes. Lived in Seat-

tle, Washington, 1921; Tacoma Washington, 1933. Exh: Tacoma Civic Art Assocication, 1932.

MORRISON, NELSON J. (1891–1963) Painter, watercolor, pen & ink. Architect. Lived in Fircrest, Washington. Member: Tacoma Fine Art Association, 1922. Exh: solo show, American Art Gallery, Tacoma.

MORRISON, NORMAN R. Painter. Lived in Tacoma, Washington, 1916. Award: Western Washington Fair, Puyallup, 1906.

MORSE, EMILY HALL (1906–1988) Painter, collages, murals. Lived in Seattle, Washington. Pupil: Art Students League, New York; Radcliff College School of Fine Art. Established the Emily Hall Morse Scholorship of Art, Cornish Art School, Seattle. Work: mural, Seattle Public Library.

MOSELEY, SPENCER ALTEMONT (1925–) Painter, oil, gouache. Teacher. Lived in Olympia, Washington, late 1940's. Pupil: University of Washington; F. Leger, Paris. Work: Seattle Art Museum, 1945–49; Henry Gallery, University of Washington, Seattle; San Francisco Museum of Art; Denver Art Museum. Award: Pacific Northwest Arts & Crafts Fair; many others.

MOSES, THOMAS G. (1865–1934) Painter, oil, landscapes. Born in England. Work: theater scenery for the Old Tacoma Theater in 1889; Scottish Rite Cathedral Theater, Tacoma; landscapes of Mt. Rainier and local scenery.

MOSIER, W. A. (MRS.) Painter, oil. Lived in Whitman County, Washington, 1909. Exh: Alaska-Yukon Pacific Expo, Seattle, 1909.

MOSSMAN, S. V. (MRS.) Painter, oil. Lived in Seattle, Washington,

1910. Exh: Pan Pacific International Expo, 1915.

MOULTON, M. LYONE (MRS.) Painter. Lived in Tacoma, Washington, 1902. Member: Tacoma Art League, 1892.

MOULTON, NELLIE GAIL (1878–1972) Painter. Teacher. Lived in Seattle, Washington at turn of century. Member: Women Painters of the West; founder, Laguna Beach Artists Association; Laguna School of Art.

MOUNTFORT, MABEL Painter. Lived in Tacoma, Washington, 1894. Member: Tacoma Art League, 1892.

MUEHLENBECK, HERBERT P. (1886–1947) Painter, oil, watercolor, portraits, landscapes. Lived in Seattle, Washington, 1940. Pupil: Chicago Art Institute. Member: Northwest Puget Sound Group of Northwest Men Painters. Exh: Seattle Art Museum. Work: portraits of 2 governors, the Capitol building, Olympia, Washington.

MUELLER, MICHAEL J. (1893–1931) Painter, Oregon countryside landscapes. Pupil: Yale School of Fine Art; fellowship, the American Academy in Rome, 1930. Teacher: University of Oregon. Award: first prize, Northwest Annual, Seattle.

MUELLER, NED (1940–) Painter, impressionistic landscapes, figural, genre. Illustrator. Lived in Renton, Washington, 1992. Pupil: Montana State College; Art Center School, Los Angeles, California, (scholarship); with Sergei Bongart; Betina Steinke; among others. Art instructor: Art Center School, Los Angeles; Art Institute of Seattle; Puget Sound Art League; Scottsdale Art Institute; Fechin Institute, New Mexico. Member: San Francisco Society of Illustrators; Northwest Watercolor Society; Northwest Pastel Society; founder,

Puget Sound Group of Northwest Men Painters; Northwest Rendez-vous Group. Exh: Frye Museum, Seattle; National Academy of Western Art; many galleries in the United States. Important Northwest artist.

MUIR, WILLIAM M. Painter, impressionistic landscapes. Active in the early 20th century (1920's) in Washington.

MULTNER, ARDIS (1899–) Painter, oil, landscapes, air brush. Commercial artist, illumination, lettering. Neon sign painter. Lived in Seattle, Washington, 1940. Pupil: Denver Art Institute.

MULVEY, CHARLES (1918–) Painter, watercolor, seascapes, harbors, landscapes. Teacher. Studio in Long Beach, Washington, 1955. Pupil: Art Center School, Los Angeles; Cornish Art School, Seattle. Exh: many galleries in Northwest; public and private collections.

MUNCY, MILTON A. Painter, oil, landscapes. Art Dealer. Lived in Seattle, Washington, 1924–26. Exh: Washington State Arts & Crafts, 1909.

MUNGER, GILBERT (1837–1903) Painter, landscapes. Engraver. At 14, was an engraver at the Smithsonian Institute, Washington, D.C. Established the Bureau of Lithography in Washington, D.C. After serving in the Civil War, traveled West where his magnificent landscapes of the mountains of Washington and Oregon brought him a fortune from English collectors. He was in Oregon from the 1860's. Moved to Europe for 17 years, returning to the United States in 1893.

MUNOZ, RIE (MARIE ANGELINA) Painter. Printmaker. Pupil: Washington & Lee University of Alaska. Work: Alaska State Museum; Anchorage Historical & Fine Arts Museum; Governor's Office; many others.

MURFREE, ANNE Painter, oil, landscapes. Many works found in and about Portland, Oregon dated around the 1930's.

MURPHY, CHESTER GLENN (1907–) Painter, oil, Northwest landscapes. Teacher. Lived in West Linn, Oregon, 1992. Pupil: Clyde L. Keller, Portland, Oregon, essentially self-taught. Work: many public murals in Oregon, Washington & British Columbia. Member: American Artists Professional League; The Oregon Society of Artists; Lake Area Artists; Council of American Artist Societies. Exh: extensively in the Northwest, California and New Mexico.

MURPHY, HARRY DANIELS (1880–) Illustrator. Lived in Portland, Oregon. Work: *The Oregonian* newspaper.

MURPHY, LAURA M. Artist. Studio in Spokane, Washington, 1902.

MURRAY, DOUGLAS A. Painter, watercolor. Lived in Seattle, Washington, 1951. Pupil & Teacher: Cornish Art School. Member: Puget Sound Group of Northwest Men Painters; American Academy of Art; Northwest Watercolor Society. Exh: Seattle Art Museum, 1948, 1949; Henry Gallery, University of Washington, Seattle, 1951.

MURTON, CLARENCE C. (1901–) Painter. Commercial Illustrator.

Teacher. Designer. Lived in Seattle, Washington, 1956. Work: Art Manager, *Seattle Post-Intelligencer*, 1947; Teacher, University of Washington, Seattle.

MUSHKIN, ALEX M. Painter. Lived in Seattle, Washington, 1953. Member: Puget Sound Group of Northwest Men Painters, 1949.

MUTCH, WILLIAM Painter, oil. Lived in Seattle, Washington, 1949. Exh: Seattle Art Museum, 1947.

MYERS, DATUS E. (1879–1960) Painter, Indians and their ceremonies, mountain landscapes. Born in Jefferson, Oregon. Pupil: Chouinard School of Art, Los Angeles; Chicago Art Institute. Primarily a Santa Fe artist for 30 years. He spent his remaining years in Northern California and Southern Oregon painting mountain landscapes.

MYERS, DAVID J. (–1936) Painter. Architect. Lived in Seattle, Washington, 1920's-36.

MYRAH, NEWMAN Painter, oils, watercolors. Western genre, landscapes. Born in Canada, spent his early years in Montana before settling in Oregon. Charter member, past president: The Northwest Rendezvous Group. Commissioned to do a series on the Salmon fishing industry in Alaska, 30 large works. Exh: Frye Museum of Art, Seattle, Wash.

—**N**—

NAGELVOORT, BETTY (1909–) Painter, watercolor. Printmaker, block print. Designer, textiles. Lived in Seattle, Washington, 1940. Pupil: University of Washington, Seattle; Art Center School, Los Angeles. Member: International Printmakers; Northwest Printmakers; California Watercolor Society.

NAHL, PERHAM WILHEIM (1869–1935) Painter. Lithographer. Illustrator. Etcher. Important California artist working mainly in the northern part of the state. Exh: Alaska-Yukon Pacific Expo, Seattle, 1909.

NALDER, NAN (1938–) Painter, acrylic and mixed medium. Designer. Born in Spokane, Washington. Pupil: Washington State University BFA (with honors). Work: Haseltine Collection of Northwestern Art; University of Oregon Museum of Art, Eugene; Crocker Collection, Sacramento California. Work: many public buildings in the West. Exh: Northwest Annual, 1967; Portland Art Museum Annual; Frye Museum Annual, Seattle; Tacoma Art Museum; Portland Art Museum.

NALLY, BOB Painter, oil, coastal scene.

NAPIER, DOROTHY Painter, oil. Lived in Seattle, Washington, 1946. Exh: Seattle Art Museum, 1946.

NAPIER, GEORGE Painter. Pupil of Emily Carr. Arrived in Victoria, B.C. in 1928.

NASH, ANNA M. Painter, still lifes, figures. Lived in Seattle, Washington, 1933. Member: Women Painters of Washington; Seattle Fine Arts Society. Exh: Women Painters of Washington, 1931, 1932.

NASH, P. C. Artist. Lived in Seattle, Washington, 1907.

NASH, RUTH B. Painter, oil, still lifes, china. Lived in Tacoma, Washington, 1911. Exh: Alaska-Yukon Pacific Expo, Seattle, 1909.

NASH, WALLIS (1837–1926) Painter. Illustrator. Oregon artist.

NEILSEN, VALBORG NIELS (1900–)(MRS.) Painter, oil, watercolor. Born in Denmark. Lived in Seattle, Washington, 1941–51. Study: Sweden; Denmark; Myra Wiggins; Alma R. Lorraine. Exh: Seattle Art Museum, 1933.

NEILSON T. R. Teacher. Lived in Pocatello, Idaho, 1940. Professor of Art, University of Idaho, Southern Branch, Pocatello, 1940's. Pupil: American Conservatory; Metropolitan Art School.

NELLOR, WILLIAM L. Painter, watercolor. Lived in Bothell, Washington, 1949. Member: Puget Sound Group of Northwest Painters, 1952. Exh: Seattle Art Museum, 1949.

NELMS, RICHARD A. Painter, oil, watercolor. Commercial artist. Lived in Seattle, Washington, 1953. Member: Puget Sound Group of Northwest Men Painters, 1949. Exh: Seattle Art Museum, 1947; Henry Gallery, University of Washington, Seattle, 1951.

NELSON, BETTY KUNST (1911–) Painter, oil, watercolor. Printmaker, block print. Lived in Seattle, Washington, 1950. Pupil: Edgar Forkner, Seattle; University of Washington. Member: Women Painters of Washington. Exh: Bon Marche, Seattle, 1930; Henry Gallery, University of Washington, Seattle.

NELSON, EMMA J. Artist. Studio in Spokane, Washington, 1903.

NELSON, ERNEST Painter, tempera. Lived in Seattle, Washington, 1947. Exh: Seattle Art Museum, 1947.

NELSON, FRANCIS B. Painter, watercolor. Lived in Everett, Washington, 1940. Exh: Seattle Art Museum, 1940.

NELSON, KATHERINE Artist. Lived in Tacoma, Washington, 1940. Exh: Tacoma Fine Arts Association, 1940.

NELSON, LUCRETIA (1912–) Painter. Educator. Pupil: University California, BA & MA; California Insti-

tute of Technology. Exh: solo show, Seattle Art Museum, 1947; Pennsylvania Academy of Fine Arts, 1938.

NELSON, PAT Painter. Member: Tacoma Art League. Exh: Washington State Historical Society, 1945.

NESBIT, FLORENCE HARRISON (1910–) Painter, oil, watercolor. Lived in Seattle, Washington, 1990. Pupil: University of Washington; Cornish Art School, Seattle. Member: Women Painters of Washington; Northwest Watercolor Society. Exh: Frederick & Nelson, Seattle; Seattle Art Museum; Women Painters of Washington, 1934–47; many solo and juried shows. Teacher: Charette School of Costume Design, Seattle.

NESMITH, Painter, oil. Modernist. Works to be found in and about Central Washington dated 1960.

NESTOR, BARNEY D. (1903–) Painter, oil. Lived in Seattle, Washington, 1940. Pupil: University of Washington, Seattle; Academy Moderne, Paris; Emile Renard; Leger; Ozenfant. Exh: Seattle Art Museum, 1931, 1934, 1935.

NEUHAUS, KARL EUGEN (1879– 1963) Painter. Author. Important California Impressionist. Exh: Alaska-Yukon Pacific Expo, Seattle, 1909.

NEVITT, MARTHA Artist. Member: Women Painters of Washington. Exh: Larson Museum, Yakima, Washington, 1954.

NEWBERRY, CLARE TURLEY Painter, watercolor, cats. Drawing, pencils, pen & ink, Printmaker, dry point. Illustrator. Author. Born in Enterprise Oregon. Pupil: Museum Art School, Portland, Oregon; California School of Fine Arts, San Francisco; Academy de la Grande Chaumiere, Paris; University of Oregon; Univer-

sity of Washington. Author and illustrator of many books.

NEWELL, GORDON B. (1905–) Sculptor. Primarily a California artist. Work: Honeyman State Park, Oregon.

NEWHAUSER, MAY Painter. Lived in Tacoma, Washington, 1915. Exh: Washington State Commission of Fine Arts, 1914.

NEWMAN, ADOLPH Painter, oil, landscapes. Studio in Seattle, Washington, 1937.

NEWMAN, ALEXANDER H. Artist. Studio in Tacoma, Washington, 1927.

NEWMAN, BARNETT (1905–) Painter, abstract, surrealistic artist. Exh: widely in the United States; Seattle World's Fair, 1962.

NEWMAN, UNA BLIGH Artist. Member: Art in Living Group, Vancouver, Canada B.C.

NEWSHAM, NORMAN Artist. Lived in Spokane. Washington, 1947.

NEWTON, EDITH (1878–) Lithographer. Work: Whitney Museum of American Art; Metropolitan Museum of Art, New York; Seattle Art Museum. Award: Northwest Printmakers.

NEWTON, HARRY C. Artist. Studio in Seattle, Washington, 1921.

NEWTON, LILIAS TORRANCE (1896–) Painter, oil, portraits. Canadian artist. Exh: Tate Museum, University of Washington, Seattle.

NICE, CAROLINE J. Artist. Lived in Tacoma, Washington, 1891. Member: Tacoma Art League, 1891.

NICHOLL, THOMAS JEFFS (1851– 1931) Painter, oil, watercolor, cowboys, indians, western scenes. Illustrator. Cartoonist, syndicated newspapers. Teacher. Stone cutter. Poet.

Song writer. Born in Ireland. Moved to Tacoma, Washington, 1924. Exh: Washington State Historical Society.

NICHOLS, E. J. Artist. Lived Spokane, Washington, 1912.

NICHOLS, GRACE Painter, oil, watercolor. Lived in Spokane, Washington, 1946. Exh: Seattle Art Museum, 1946.

NICHOLS, JANK Painter. Lived in Vancouver B.C. Exh: Biennial Canadian Painters, 1955.

NICHOLS, KEITH R. Painter, oil. Lived in Easton, Washington, 1946. Exh: Seattle Art Museum, 1946.

NICHOLSON, JENNIE M. (1885–) Painter, oil, watercolor, pastel. Teacher. Lived in Filer, Idaho, 1940. Member: Idaho Art Association. Exh: University of Idaho, 1933. Art reproduced on calenders.

NICHOLSON, PATRICIA (1900–1978) Painter, oil, tempera, religious, Northwest coast indian, european and oriental themes. Lived in Seattle and Yakima, Washington. Pupil: Peter Camfferman; Mark Tobey; Franz Baum. Member: Women Painters of Washington. Exh: Seattle Art Museum, 1939–55; Henry Gallery, University of Washington, Seattle, 1951, 1959.

NIEMEYER, ARTHUR F. Painter, oil. Commercial artist. Lived in Seattle, Washington, 1924. Pupil: Renault. Member: Puget Sound Group of Northwest Men Painters.

NILSEN, ERNEST Painter, tempera. Lived in Seattle, Washington, 1947. Exh: Seattle Art Museum, 1947.

NISHII, KOO Painter, still lifes. Lived in Seattle, Washington, 1928. Exh: Painters of the Pacific Northwest, 1928.

NOBLES, ORRE NELSON (1895–1967) Designer, cloisonne, silver, Chinese rugs. Illustrator. Photographer. Printmaker. Lived in Seattle, Washington. Pupil: Pratt Institute Brooklyn; Art Students League of New York. Art teacher in local high schools for 30 years.

NOGLEBERG, JOHN A. (1861–1935) Painter, oil, portraits, landscapes. Born in Norway. Lived in Seattle, Washington. Pupil: Sorbonne, Paris; Cornish Art School, Seattle. Painted extensively throughout the Northwest. However, few of his paintings are accounted for. In 1966 his painting "City of Tacoma", an 8′ × 18′ canvas, was discovered after 45 years in the Washington Historical Society. Dated 1893, commissioned by the City of Tacoma, it was a major discovery.

NOMURA KENJIRO (1896–1956) Painter, oil, watercolor, seascapes, landscapes. Lived in Seattle, Washington. Member: Group of Twelve. Exh: solo exhibition, Seattle Art Museum, 1933; Museum of Modern Art (MOMA) New York; Washington, D.C.; San Francisco.

NORBERG, RUSSELL Painter, oil, landscapes. Works to be found in and about Portland, Oregon are dated in the 1930's.

NORDMARK, ANDREW Painter. Lived in Seattle, Washington 1917.

NORDSTROM, EVERETT W. Painter. Lived in Seattle, Washington, 1924.

NORLING, ERNEST (1892–1974) Painter, oil, watercolor. Drawing, pen & ink. Printmaker. Teacher. Author. Lived in Seattle, Washington. Pupil: Whitman College, Washington; Chicago Art Institute; Chicago Academy of Fine Arts; F. Tadama. Member: Puget Sound Group of Northwest Men Painters. Exh: Seattle Art Museum, 1934, 1935; Anderson Galleries, New York.

NORLING, JOSEPHINE STEARNS (1895–) Writer. Lived in Seattle, Washington. Illustrator of *Pogo* series of books for children.

NORMAN, ALICE Painter, oil, portraits, landscapes. Studio in Tacoma, Washington, 1890. Member: Annie Wright Seminary Art Club, Tacoma, Washington, 1889.

NORMAN, G. N. Artist. Studio in Tacoma, Washington, 1895.

NORMAN, JOHN Artist. Lived in Seattle, Washington, 1921.

NORRIS, FRANCES HEDGES Painter, watercolor. Sculptor, stone, metal work. Born in Everett, Washington. Lived in California, 1941. Pupil: University of Washington; M. Steiger; Berlin; Alexander Archipenko; Cornish Art School, Seattle. Exh: Seattle Art Museum.

NORRIS, MABEL (1902–) Painter, oil, tempera. Drawing, crayon, charcoal, pencil. Sculptor, clay. Teacher. Pupil: University of Washington, Seattle; Winold Reiss. Exh: Glathead County High School, Kalispell, Montana. Instructor of Art, Central Junior High, Kalispell.

NORRIS, MARIE DE JARNETT Painter. Teacher. Lived at Whitworth College, Washington, 1904, 1905. Pupil: Whistler, Paris. Art Director, Whitworth College, Washington.

NORRIS, WILLIAM (MRS.) Artist. Lived in Dayton, Washington, 1902.

NORTH, WILLIAM (MRS.) Artist. Lived in Seattle, Washington, 1917.

NOVA, GARY LEE Painter, landscapes. Modernist. Lived in Vancouver, B.C., 1960's.

NUNNELEY, VERA Painter. Lived in Tacoma, Washington, 1945. Member: Tacoma Art League, 1945. Exh: Washington State Historical Society, 1945.

NUTLEY, CHARLES A. Commercial artist. Lived in Seattle, Washington, 1927.

NYE, JUNE Painter, oil, watercolor. Lived in Seattle, Washington, 1961. Pupil: Mark Tobey. Exh: Seattle Art Museum, 1947; Henry Gallery, University of Washington, Seattle, 1951, 1959; Frye Museum, Seattle, 1961.

NYSTROM, RUTH Printmaker. Teacher. Lived in Seattle, Washington, 1940. Teacher: Monroe Junior High School, Seattle, Washington.

—O—

OBERG, IDA Artist. Lived in Seattle, Washington, 1930.

O'BRIEN, LUCIUS RICHARD (1832–1899) Painter. Civil engineer. A prominent native Canadian artist he was one of the first to paint Western Canada in the early days of the Canadian Pacific Railway. He travelled from Chicago to the Canadian Rockies on horseback with his missionary brother. Trained as an architect and civil engineer he became a professional artist in the 1870's.

ODEGAARDE, KARL E. Painter, landscapes. Lived in Tacoma, Washington, 1932. Exh: Tacoma Civic Art Association, 1932.

ODENRIDER, ADA BRIDGMAN Artist. Lived in Seattle, Washington, 1951. Member: Women Painters of Washington 1943–49.

OECHSLI, KELLY Artist. Lived in Seattle, Washington, 1941. Member: Puget Sound Group of Northwest Men Painters, 1941.

OESTERMANN, MILDRED CAROLINE (1899–) Painter. Etcher. Portraits and scenes of the Mother Lode area & Oregon.

OGURA, RYOZO Painter, oil. Lived in Seattle, Washington, 1934. Exh: Seattle Art Museum, 1934, 1936, 1937.

O'HARA, ELIOT Painter. Writer. Teacher. World traveler. Major expedition to Alaska in 1940 was produced in watercolors.

OJA, ALEXANDER (1903–) Painter, oil, watercolor. Teacher. Lived in Clarkson, Washington, 1935. Exh: Seattle Art Museum, 1935, 1936.

OLAINE, LOLITA ALICE. (1905–) Painter, oil, opaque watercolor. Printmaker, linoleum block. Commercial artist. Lived in Seattle, Washington, 1941. Exh: Downtown Gallery Seattle, 1937–38.

OLDEN, W. T. (MRS.) Painter, watercolor. Lived in Skagit County, Washington, 1909.

OLDFIELD, FREDRICK Painter, oil, watercolor. Washington landscapist.

OLDHAM, THOMAS Engraver. Washington.

OLDRIGHT, ALICE L. Painter, oil, watercolor, landscapes. Lived in Tacoma, Washington, 1917. Exh: Washington State Arts & Crafts, 1909; Tacoma Art League, 1916.

OLDWIN, MILDRED S. Artist. Lived in Bellingham, Washington, 1910.

OLINGER, GERALDINE (1917–) Painter, oil. Drawing, black & white wash, pen & ink, newspaper reproduction. Lived in Everett, Washington, 1940. Pupil: Cornish Art School. Work: Advertising Departments, Frederick & Nelson; Art Director, I. Magnin, San Francisco. Exh: Washington Athletic Club, Seattle.

OLIVER, LILLIAN B. Painter, oil. Lived in Snohomish County Washington, 1909. Exh: Alaska-Yukon Pacific Expo, Seattle, 1909.

OLIVER, PEARL Artist. Lived in Bellingham, Washington, 1910.

OLSEN, KRISTOFFER Artist. Lived in Tacoma, Washington, 1906.

OLSEN, LOUISE Artist. Lived in Tacoma, Washington, 1913.

OLSON, CHELNESHA M. Painter, watercolor. Lived in Whatcom County, Washington, 1909. Exh: Alaska-Yukon Pacific Expo, Seattle, 1909.

OLSON, ESTER L. Painter, pastel. Lived in Jefferson County, Washington, 1909. Exh: Alaska-Yukon Pacific Expo, Seattle, 1909.

OLSON, JOSEPH OLIVER Painter. Lived in Seattle, Washington, 1915.

OLSSON, RALPH P. Painter, watercolor. Lived in Seattle, Washington, 1937. Pupil: Art Center School, Los Angeles. Member: Puget Sound Group of Northwest Men Painters, 1937.

ONLEY, TONI Painter, modernist. Vancouver, B.C., 1950's-. One of the most accomplished artists in the city in the 50's and 60's. An abstract collagist earlier in the decade later introducing landscape images into his pictures.

OPERTI, A. J. L. R. (ALBERTO) (1852–) Painter. Sculptor. An Italian artist, he traveled to Alaska and the Canadian Northwest.

ORAVEZ, DAVID L. (1935–) Artist. Teacher: Art Department, Boise State University, Idaho.

ORDAYNE, NEALE (1890–1950) Painter, oil, portraits. Lived in Seattle, Washington. Pupil: Cornish Art School, Seattle; Julian Academy, Paris. Member: Puget Sound Group of Northwest Men Painters, 1940. Exh: Paris Salon, 1923.

ORTON, VIRGINIA KEATING Painter. Lecturer. Writer. Lived in Sumner, Washington, 1942. Member: American Federation of Arts; American Society of Modern Art; International Art Guild; National League of American Pen Women; Governors Advisory Art Committee, State of Washington 1934; founder, director of Pacific Coast Painters, Sculptors and Writers Guild.

ORUM, CAROLYN NUESSLE Painter, oil, watercolors. Printmaker. Pottery sculptor. Teacher. Moved to the Pacific Northwest in 1952. Pupil: M.F.A. Tyler School of Fine Arts; Temple University, Philadelphia Pennsylvania; University of Oregon, metal work and weaving; Lane Community College, sculpture. Exh: Pacific Northwest Art Annuals; Watercolor Society of Oregon, Juried Awards; Coos Bay Art Museum; Womens Visions Show, Corvallis Oregon; Northwest Watercolor Society; among many others.

O'RYAN, LILLIE V. Painter, miniatures, portraits. Sculptor. Born in Canada. Pupil: William M. Chase; George DeForrest Brush; Dennis Bunker. Lived in New York before moving to San Francisco in the later 1890's where she established a studio next to William Keith. She worked in Portland, Oregon and Canada until 1924. Upon returning to San Francisco she sculpted figurines and became well known as a miniature painter and portraitist. Exh: gold medal, Alaska-Yukon Pacific Expo, Seattle, 1909. Work: Oakland Art Museum.

OSBORNE, EMMY LOU (1910–) Painter, oil, watercolor. Lived in Bothel, Washington, 1941. Pupil: Cornish Art School, Seattle. Charter member: Women Painters of Washington. Exh: Seattle Art Museum, 1931, 1932.

OSBORNE, HELEN R. Artist. Lived in Tacoma, Washington, 1945. Member: Tacoma Art League. Exh: Washington State Historical Society, 1945.

OSTNER, CHARLES Sculptor. Born in Germany. Moved to Garden Valley, Idaho in 1864. Carved wood statue of George Washington mounted on horseback for the Idaho Territory.

O'SULLIVAN, TIMOTHY Photographer. Worked for the government. Official geographical surveyor around the time of the Civil War. Recorded on film the American West from the Rockies to the Coast.

OTHELLO, MICHETTI (1895– 1981) Painter, watercolor. Pupil: Art Students League, New York; Academy of Art, New York; Mark Hopkins Institute, San Francisco. Member: Society Western Artists. A California artist who painted extensively in Alaska.

OTTINGER, GEORGE MARTIN (1833–1917) He began in Utah painting stage scenery and signs and the history of Mexico. Oil sketching trips to Oregon, Idaho, Wyoming and Utah.

OVERMAN, FRED K. (MRS.) Artist. Lived in Tacoma, Washington, 1906.

OVERMAN, MARGARET Painter, watercolor. Lived in Everett, Washington, 1916. Exh: Alaska-Yukon Pacific Expo, Seattle, 1909.

OVERSTREET, EDWARD, B. E.
(1901–1991) Painter, oil, watercolor.
Sculptor, wood. Art Director. Born in
Louisiana, was light heavyweight
boxing champion of the South. Moved
to California in 1929 to work for Para-
mount Pictures and headed the Art
Department there from 1935–44.
Moved to Grants Pass, Oregon in
1952–1968. Owned a large cattle
ranch in Southern Colorado and
painted with Gerald Farm in New
Mexico. Close friends to evangelist

Billy Graham he published three
books on theology.

OVERTURF, JO (1910–) Painter,
oil. Sculptor, ceramic, stone. Draw-
ing, chalk. Born in Walla Walla, Wash-
ington. Lived in Corvallis, Oregon,
1940. Pupil: University of Washing-
ton; University of Oregon. Exh: Port-
land Art Museum, 1938. Teacher: Ore-
gon State College, Corvallis, Oregon.

OWENS, HEZEKIAH S. Artist. Stu-
dio in Tacoma, Washington, 1891.

——P——

PABST, CATHERINE J. Painter, wa-
tercolor. Lived in Seattle, Washing-
ton, 1938. Exh: Seattle Art Museum,
1938.

PACIFIC, GERTRUDE (1942–)
Painter, acrylic. Designer. Study: Uni-
versity of Washington, BA & MFA;
with Alden Mason, 1965. Work: City
of Seattle; National Capitol Commis-
sion, Ottawa, Canada; Smithsonian
Institute, Washington, D.C.; Seattle
Art Museum; Art Gallery of Greater
Victoria, B.C.

PADDEN, ELLA H. Artist. Art
Teacher. Lived in Seattle, Washing-
ton, 1932.

PADELFORD, MORGAN C.
(1902–) Painter, oil, watercolor.
Sculptor. Teacher. Born in Seattle,
Washington. Pupil: John Butler, Bos-
ton; André L'Hote; Hans Hofmann,
Paris; University of Washington, 1925.
Member: The Fifteen Gallery, New
York; Seattle Fine Arts Society, 1923;
Northwest Printmakers. Work: por-
traits, University of Washington.

PAILTHORPE, DR. GRACE
Psychologist. Introduced and adopted

automatic expressional art to psychia-
try. She felt Surrealism and psycho-
analysis had the same goal, liberation
of the individual from internal conflict.

PAINE, IRMA L. (1908–1976)
Painter. Teacher. Author. Lived in
Tacoma, Washington since 1911.
Study: Western Washington State Col-
lege. Director: Tacoma Public Schools
art curriculum, 1950–1966.

PAINE, MARGARET WALKER
(1896–) Sculptor. Lived in Ev-
erett, Washington, 1940. Pupil: Dud-
ley Pratt. Exh: Henry Gallery, Univer-
sity of Washington, Seattle; North
Pacific Fair; Western Washington Fair,
Payallup.

PAINE, SALLY Commercial Artist.
Lived in Spokane, Washington, 1950.
Member: Washington Art Associa-
tion, Spokane 1950.

PALLADO, D. J. (MRS.) Artist.
Lived in Everett, Washington, 1905.

PALMER, CHARLES W. Painter,
oil. Study: Fort Wright College,
Spokane, Washington, MFA. Many
awards.

PALMER, E. S. (MISS) Painter, oil, still lifes. Lived in Tacoma, Washington, 1889. Member: Annie Wright Seminary, Tacoma, Washington.

PALMER, JESSIE W. Artist. Studio in Spokane, Washington, 1903.

PALMER, LEROY A. Artist. Lived in Tacoma, Washington, 1894. Exh: Interstate Fair, Tacoma, 1894.

PALMER, MABEL (EVELYN) 1903–) Painter, acrylic, watercolor. Work: Frye Museum, Seattle, Washington; All Western Art Show, Ellensburg, Washington; many others.

PALMER, MARGARET B. Artist. Lived in Seattle, Washington, 1917.

PAPAS, WILLIAM (1927–) Painter, modernist.

PARENT, SANGLIER Commercial artist. Lived in Spokane, Washington, 1922.

PARISH, ANNABELLA HUTCHINSON (MRS.) Painter. Lived in Portland, Oregon, 1906.

PARKER, ARTHUR HENRY 1874–) Painter, watercolor. Born in England. Lived in Victoria, B.C., 1940. Studied in England. Member: Island Arts and Crafts Society, Victoria, B.C. Exh: solo show, Empress Hotel, Victoria; Vancouver, B.C. Art Gallery; Frederick & Nelson, Seattle; Royal Canadian Academy, 1924.

PARKER, BEN Painter, oil. Lived in Seattle, Washington, 1937. Exh: Seattle Art Museum, 1937.

PARKER, LUCINDA (1942–) Painter, modernist.

PARKER, PATSEE Painter, oil, coastal landscapes, seascapes. Born in Oregon. Lived on the coast in Waldport, Oregon since the early 1960's. Exh: many shows along the West Coast and Oregon.

PARKER, PHOEBE (1886–1986) Painter, watercolor, oil, still lifes, portraits. Studio in Tacoma, Washington.

PARKHURST, ELSIE (1905–) Painter, oil, watercolor, pastel. Lived in Caldwell, Idaho, 1940. Pupil: Walla Walla College, Washington; School of Applied Art, Chicago. Teacher: Government Vocational College, Weiser, Idaho.

PARKS, MINNIE E. Artist. Lived in Seattle, Washington, 1916–19.

PARMENTER, O. S. Artist. Lived in Spokane, Washington, 1913.

PARRISH, ANNABELLE, HUTCHINSON Painter, tapestry. Enamelist.

PARROTT, WILLIAM SAMUEL (1844–1915) Painter, oil, landscapes. One of the most important scenic artists of the Pacific Northwest. Opened his first studio in Portland 1867–87. After twenty years there he closed his studio and spent several years in the wilds of Oregon, Washington, and California. In 1906 he maintained a studio in Oakland, California for six years before returning to the Klickatat, Washington area. A picture of Mt. Hood sold for $10,000 in New York. Received the same amount for a landscape painted while in Switzerland. Parrott reportedly never signed a painting he donated. A painting of the Modoc Indian War in 1874 brought him national recognition. Exh: Paris, London. Closed Portland studio and moved back to Goldendale and spent the rest of his life painting the beautiful scenery of the Pacific Northwest. He died in Goldendale, Washington.

PARSE, JOSEPHINE L. (BUHR) (1896–1987) Painter, watercolor. Lived in Tacoma, Washington. Member: Tacoma Art League.

PARSONS, THEODORE H. Commercial artist. Lived in Seattle, Washington, 1940. Member: Puget Sound

Group of Northwest Men Painters, 1937.

PARTRIDGE, ESTER E. (1875–) Painter, oil, watercolor, pastel. Lived in Spokane, Washington, 1940. Pupil: Chicago Art Institute; S.S. Nicolini, San Francisco; Art Center, Los Angeles. Member: Spokane Art Association. Exh: Spokane Museum of Art, 1928. Award: Eastern Washington Fair, Yakima, 1921.

PARTRIDGE, IMOGENE (IMOGENE CUNNINGHAM) (1883–1976) Photographer. Wife of artist Roi Partridge. Studied art in Europe but turned to photography. Member: Seattle Fine Arts Society.

PARTRIDGE, ROI (1888–1984) Printmaker, etching. Painter. Photographer. Writer. Spent his early years working and studying in Seattle, Washington. He moved to San Francisco in 1917. Pupil: National Academy of Design, New York; Europe. Member: Chicago Society of Etchers; Northwest Printmakers; Alaska-Yukon Pacific Expo, Seattle, 1909. Professor of Art, Mills College, Oakland, California, 1919.

PASCO, DUANE (1932–) Painter. Sculptor. Wood Carver, traditional Northwest Coast Indian Art Stylist. Born in Seattle, Washington. Work: Seattle Tacoma Airport Carvings; many private and corporate collections. Exh: Richard White Gallery, Seattle; Boston Museum of Fine Art; Washington State Historical Museum; University of British Columbia; Alaska State Museum; The Heys Foundation Museum of the American Indian, New York; all over the world.

PASCUAL, NEMESIO A. (1908–) Painter, oil, watercolor. Lived in Seattle, Washington, 1940. Pupil: Cornish Art School, Seattle. Exh: Seattle Art Museum, 1936, 1937.

PATECKY, ALBERT (1906–) Painter, oil, watercolor, still lifes, landscapes. Drawing, pen & ink. Sculptor. Born in Michigan. Lived in Portland Oregon, 1940–1990. Pupil: Chicago Academy of Fine Art; University of Oregon; Museum Art School, Portland; Sidney Bell. Member: Oregon Society of Artists. Exh: widely in the United States and Europe.

PATECKY, BLANCHE (MRS. ALBERT) (1904–) Painter, watercolor florals. An active Portland artist since the 1920's.

PATERSON, ALEXANDER (1887–) Painter, watercolor. Born in Scotland. Lived in Vancouver, B.C., 1940. Pupil: McCulloch, Scotland. Exh: solo show, Vancouver Art Gallery 1935, B.C. Society of Fine Arts, 1935–39.

PATIGIAN, HAIG (1876–1950) One of the most famous sculptors on the West Coast maintaining a studio in San Francisco. Work: Alden J. Blethen Memorial, Seattle, Washington.

PATRICK, RANSOM R. Painter, watercolor. Sign painter. Lived in Seattle, Washington, 1940. Member: Puget Sound Group of Northwest Men Painters. Exh: Seattle Art Museum, 1939.

PATTEN, KATHARINE (1866–) Painter, watercolor. Born in Bangor, Maine. Lived in Portland, Oregon, 1940. Exh: Minneapolis Institute of Art. Pupil: Museum of Fine Arts, Boston.

PATTERSON, AMBROSE (1877–1966) Painter, oil, watercolor, fresco. Printmaker. Teacher. Born in Australia. Lived in the San Francisco Bay Area before settling down in Seattle Washington in 1918, already an accomplished international art figure. Pupil: National Gallery Art School, Melbourne; Julien Academy, Paris.

Member: Seattle Group of Twelve. Exh: Salon d'Automne, Paris; Seattle Art Museum; Royal Academy, London; Northwest Printers. Professor of Painting, University of Washington, Seattle, until 1947. Chairman, Artists Council of Washington. Exh: widely in the United States and abroad.

PATTERSON, F. W. (MRS.) Artist. Member: Tacoma Art League, 1891, 1892. Exh: Western Washington Industrial Exposition, 1891.

PATTERSON, J. M. (MRS.) Artist. Lived in Tacoma, Washington, 1892. Member: Tacoma Art League, 1891, 1892.

PATTERSON, RUTH (1910–) Painter, watercolor, oil. Teacher. Born in Seattle. Lived in Portland, Oregon, 1940. Pupil: Art Students League of New York; Mills College, Oakland; Celestini, Florence, Italy; Honolulu Academy of Art, 1934. Exh: Seattle Art Museum, 1935, 1936; Portland Art Museum, 1935, 1936. Art Instructor, Riverdale School, Portland.

PATTERSON, VIOLA H. (MRS. AMBROSE) (1898–) Painter, oil. Sculptor. Printmaker. Teacher. Born in Seattle Washington, 1940. Pupil: University of Washington; André L'Hote Academy, Paris; Archipenko. Member: Seattle 'Group of Twelve': Women Painters of Washington; Northwest Printmakers. Exh: solo show, Seattle Art Museum, 1935; Architectural League, New York, 1938. Award: Katherine B. Baker, Memorial Purchase Prize, West Seattle Art Club, 1928. Work: "Oak, Victoria", Phoenix Arizona. Art instructor, University of Washington, 1940–47.

PATTISON, EVELYN Painter. Lived in Enumclaw, Washington, 1941. Charter member: Women Painters of Washington, 1931.

PATZOLD, OSWALD E. Sculptor, plaster. Lived in Seattle, Washington, 1940. Exh: Seattle Art Museum, 1939.

PAUL, ETHEL STRAUSER (1900–) Painter, oil, watercolor. Lived in Driggs, Idaho, 1940. Teaching scholarship, Brigham Young University, 1936–39. Worked mainly in the Utah region.

PAUL, KEN (HUGH) (1938–) Painter. Printmaker. Work: Tasmania; Hobsart; Australia; University of Oregon Museum, Eugene; Portland Art Museum; Denver Art Museum; Cheney Cowles Museum, Spokane, Washington. Member: "The Attic Group", Portland. Many awards.

PAULSON, GEORGE H. Painter. Lived in Tacoma, Washington, 1917–24. Exh: Tacoma Art League, 1915.

PAYETTE, MEDELINE (See FERRARA)

PAYNE, MILFORD D. Commercial artist. Lived in Tacoma, Washington, 1936.

PEARCE, JOHN Artist. Lived in Seattle, Washington, 1932.

PEARCE, LENORA (1872–1961) Painter. Lived in Tacoma, Washington. Exh: solo show, Washington State Historical Society, 1954.

PEARSON, CHARLES J. Etcher, drypoint. A mid 20th century artist. A known work titled "Lewis County Washington".

PEARSON, JOHN H. Artist. Lived in Seattle, Washington, 1920. Member: Watercolor Society, 1914.

PEASE, LUCIUS CURTIS (LUTE) (1869–1963) Painter, oil. Cartoonist. Worked for the *Oregonian* in 1890. From 1897–1901 was covering the Gold Rush of Alaska for Portland and Seattle papers. Editor of *Pacific Monthly* till 1914. Won the Pulitzer

prize for catooning at the age of 80. Executed many oils of the Northwest from the turn of the century till 1915.

PEASE, NELL MCMILLAN (WIFE OF LUCIUS) Painter. Illustrator. Studied in Chicago. Made cover paintings and illustrations for the old *Pacific Monthly*. Maintained a long career in art in Oregon and Washington.

PEBBLES, FRANK M. Painter, portraits. A portrait of Judge M. P. Deady of Portland is dated 1877. A portrait of Mayor Newbury of Portland is dated 1878.

PECK, JAMES EDWARD (1907–) Painter, oil, watercolor, tempera. Designer. Lived in Seattle, 1953. Pupil: Cleveland Institute of Art. Work: American Academy Arts & Letters, New York; Seattle Art Museum Washington. Exh: American Watercolor Society, New York; Seattle Art Museum; Northwest Annual; Metropolitan Museum of Art, New York. Teaching; Head of the Art Department, Cornish Art School, Seattle, 1947–52.

PECK, LOUIS (1922–) Artist. Department Chairman (retired), Art Department, Boise State University, Idaho.

PECK, ROZELIA S. Artist. Lived in Everett, Washington, 1932–44.

PECKHAM, ANITA (1917–1984) Painter. Weaver. Lived in Seattle, Washington. Member: Women Painters of Washington, 1948.

PEDERSEN, CONRAD G. (1887–) Painter, oil, watercolor, pastel. Born in Denmark. Lived in Portland, Oregon, 1940. Charter member: Oregon Society of Artists. Work: many public buildings in Oregon. Exh: Portland Art Museum, 1911–32; Corcoran Gallery Washington, D.C.; Christensen Gallery, Portland.

PEDROSE, MARGARET BJORNSON (1893–) Painter, oil. Drawing, crayons. Writer. Lived in Seattle, Washington, 1940. Exh: Art Institute of Seattle; Western Washington Fair, Puyallup, 1932. Wrote children's books.

PEEL, PAUL (1860–1891) Painter, oil, portraits. Exh: Vancouver (B.C.) Art Gallery

PEIRCE, REX BARTON (1902–1982) Painter, oil, watercolor, tempera. Paper collage. Wood carver. Lived in Tacoma, Washington. Member: Puget Gallery Artists. Exh: Frye Museum, Seattle, Washington; State Historical Society.

PEMBERTON, JOSEPH DESPARD Surveryor. Sketcher around British Columbia in the 1880's working for the Island Colony.

PEMBERTON, SOPHIE TERESA (1869–1959) Painter. Born in Victoria, B.C. Study: in London at the Slade in 1894; the Julian, Paris, 1896. Exh: Vancouver studio of James Blomfield.

PENDELL, C. B. (MRS.) Painter, ceramics. Lived in Spokane. Washington, 1950. Member: Washington Art Association, 1950.

PENFRO, ALFRED T. Artist. Lived in Seattle, Washington, 1917.

PENINGTON, RUTH ESTER (1905–) Painter, oil, portraits. Printmaker, block prints. Craftsperson, metal, jewelry. Lived in Seattle, Washington, 1951. Pupil: University of Washington; University of Oregon; College of Arts and Crafts, Oakland. Member: Northwest Printmakers. Award: Lambda Rho. Exh: Seattle Art Museum, 1934. Professor of Art, University of Washington, 1941.

PEREIRA, I. RICE (1901–) Painter. Born in Boston. Study: Art Students League, New York. Traveled widely in Europe, North Africa. Re-

sided in London, Paris. Exh: Portland, Oregon Art Museum, 1950; many awards and exhibitions.

PEREZ, TONY (RALPH AUSTIN) Painter, oil. Printmaker. Lived in Seattle, Washington, 1941. Exh: Seattle Art Museum, 1935.

PERFIELD, JOHN Painter. Member: Puget Sound Group of Northwest Men Painters, 1933.

PERKINS, WALTER Painter, oil. The back of one of his paintings reads "Ennaville, IDAHO".

PERRIN, DOROTHY M. Painter, oil. Lived in Seattle, Washington, 1949. Exh: Seattle Art Museum, 1949.

PERRY, ANNIE E. Artist. Studio in Tacoma, Washington, 1905.

PERRY, CLIFFORD Member: Puget Sound Group of Northwest Men Painters, 1946.

PERRY, HATTIE A. Artist. Lived in Tacoma, Washington, 1906.

PERRY, JEROME R. Artist. Lived in Seattle, 1951. Member: Puget Sound Group of Northwest Men Painters, 1945. Artist for the Sterling Theaters, 1951.

PETERS, CHARLES ROLLO (1862– 1928) Painter. Important California Impressionist. Exh: Alaska-Yukon Pacific Expo, Seattle, 1909.

PETERS, J. M. (MRS.) Artist. Lived in Spokane, Washington, 1905.

PETERS, VERDA V. Painter, watercolor. Lived in Seattle, Washington, 1940. Exh: Seattle Art Museum, 1939.

PETERSEN, ELNAR CORTSEN (1885–1986) Painter, murals. Born in Denmark. Studied in Paris, Rome and Munich. Immigrated to United States in 1912 where he worked in Nebraska, Oregon and Washington before settling in Los Angeles in 1916.

PETERSON, JOHN L. Artist. Lived in Seattle, Washington, 1919.

PETERSON, JOHN M. Artist. Studio in Spokane, Washington, 1918.

PETERSON, MARGARET (1902–) Painter. Illustrator. Teacher. Born in Seattle, Washington. Moved to Berkeley California. Study: University of California, MA degree; Hans Hofmann; André L'Hote, Paris. Work: the Art Department at University of California, 1928–1950. Moved to Victoria, B.C. to paint the Northwest Indians. Member: American Abstract Artists. Exh: solo show, University of British Columbia, 1961; San Francisco Women Artists, 1936.

PETERSON, RUBIE Painter, "Old Steilacoom Jail", 1858 (Washington).

PETERSON, RUTH JORDON (1901–) Sculptor, wood. Craftsperson. Lived in Seattle, Washington, 1940. Pupil: University of Washington. Member: Women Painters of Washington, 1938–43. Exh: New York World's Fair, 1939; Annual Exhibition of Northwest Artists, 1935; Washington State Arts & Crafts, 1935. Designed State seal for Washington State Building.

PETERSON, SIGVARD J. Painter. Photographer. Lived in Tacoma, Washington, 1900.

PETITE, JEAN WOLVERTON (1892– 1974) Painter, watercolor. Illustrator, wildlife, birds. Lived in Seattle, Washington. Pupil: Reed College, Portland Oregon; Central Washington College. Her bird paintings have been made into slides for public schools.

PETRIC, LUBIN (–1978) Painter, oil. Lived in Seattle, Washington. Immensely talented but obscure artist of the Northwest. In 1930's became an important member of the Northwest School of Painters with Callahan, Tobey, Graves, that were to be called the

Group of Twelve. Reclusive, he sold mostly to private collectors. Exh: Seattle Art Museum, 1934.

PETTINGILL, LILLIAN ANNIN Painter, oil, watercolor, landscapes. Teacher. Lived in Seattle, Washington, 1907. Charter member: The Society of Seattle Artists, 1904. One of 11 charter members.

PFLANZ, GEORGE M. Artist. Lived in Seattle, Washington, 1920–26.

PHAIR, RUTHE (1898–) Painter, oil. Born in Buffalo, New York. Lived in Spokane, Washington, 1940. Pupil: Spokane Art Center. Exh: Seattle Art Museum, 1934; Spokane Art Association, 1935; Portland Art Museum, 1935.

PHILLIPPI, FRANK Painter, oil, impressionistic landscapes, still lifes. Photographer. Lived in Portland, Oregon from 1909–1920.

PHILLIPS, JESSIE W. Painter. Lived in Seattle, Washington, 1924.

PHILLIPS, TRUMAN (1902–1989) Painter, watercolor, Oregon landscapes, Southwest works. Architect. Study: architecture at the University of Oregon, the early 1920's. He traveled widely to the Mediterranean, Middle East and South America, painting all the time. He did not sell his volume of works during his lifetime. Phillips died at the age of 86 leaving behind the home he had designed himself.

PHILLIPS, WALTER J. Painter, in the English traditional sense. He painted the mountains and the West Coast Indians in British Columbia in the 1920's.

PHILLIPS, WALTER S. Artist. Lived in Seattle, Washington, 1919.

PHILLIPS, WILLIAM ARTHUR (1916–1989) Painter, watercolor.

Teacher. Writer. Lived in Seattle, Washington. Study: University of Washington, graduate studies. Member: Puget Sound Group of Northwest Men Painters. Teacher, Tacoma School system for 30 years.

PHOUTRIDES, EVAN Painter, oil. Lived in Seattle, Washington, 1949. Exh: Seattle Art Museum, 1949; Henry Gallery, University of Washington, Seattle, 1950.

PICKENS, ALTON (1917–) Painter, oil, watercolor. Drawing, pen & ink. Printmaker, wood engraving, block print. Lived in Portland, Oregon, 1940. Pupil: Seattle Art Institute; Museum Art School, Portland.

PICKERING, EMMA L. Artist. Lived in Seattle, Washington, 1909.

PICKETT, JAMES TILTON (1857–1889) Painter, oil. Photographer. Born in Billingham, Washington Territory. Lived in Portland, Oregon. Son of George Edward Pickett, the Confederate General who led "Pickett's Charge" at Gettysburg. Began to draw using charcoal on the sides of a barn and berry juices for colors. Work: *Seattle Post Intelligencer*; *Portland Oregonian*; Tacoma Historical Society. Exh: Festival of the Arts Expo, State Capitol Museum, Olympia, Washington, 1971.

PIERCE, DANNY (1920–) Painter, Graphic Designer, Printmaker, Sculptor, Hand-Crafted Books, University Instructor, (established the first Art Department at the University of Alaska, 1960.) Student of Art Center School and Chouinard Art Institute in Los Angeles. Exh: Corcoran Gallery: Los Angeles Art Museum: Library of Congress: Butler Art Institute: Brooklyn Museum: Seattle Art Museum: Smithsonian: National Library of Paris: National Museum of Sweden.

PIERCE, ELIZABETH C. Artist. Lived in Seattle, Washington, 1929.

PIERCE, PEARL B. Artist. Lived in Spokane, Washington, 1909.

PIERCE, WILLIAM Painter. Member: The Attic Studio, Portland, Oregon, 1929–50. Moved to San Francisco to become an art director.

PIKE, VIRGINIA (1914–) Commercial artist. Drawing, pen & ink line, wash. Designer. Born in Bellingham, Washington. Lived in Everett, 1940. Work: Everett Printing Company. Award: honorable mention, Latham Foundation Contest, Stanford University, 1936.

PILKINGTON, ADELA Painter. Lived in Vancouver, B.C. in the 1930's.

PINKHAM, GEORGE W. Artist. Lived in Seattle, Washington, 1920, 1921.

PINKHAM, MARJORIE STAFFORD (1909–) Painter. Teacher. Printmaker. Teacher: Cordova Indian School, Seward, Alaska, 1940.

PINNOCK, D. Lithographer. Lived in Portland, Oregon, 1950.

PIPER, F. S. Artist. Lived in Bellingham, Washington, 1913.

PITCHER, GRACE Painter, oil. Lived in Seattle, Washington, 1901–10. Possibly from New York. Pupil: Harriet Foster Beecher.

PITTWOOD, ANN (1895–) Painter, oil, watercolor. Graphic artist, pen & ink. Sculptor. Lived in Seattle, Washington, 1940. Pupil: National Academy of Design; Art Students League, New York; Otis Art Institute, Los Angeles; Cornish Art School, Seattle; studied in Europe. Member: Womens Professional League. She specialized in books entirely of pictures, (pen and ink) and shell sculpture.

PIXLEY, EMMA CATHERINE O'REILLY (1836–1911) Painter, the Olympic Range. Lived in Seattle, 1910. Pupil: Matthews in San Francisco & Cooper Union, New York. Member: San Francisco Art Association.

PLANTA, LESLIE Artist. Pupil: F. H. Varley; Vancouver, B.C. Art School, 1930's.

PLASKETT, JOSEPH (1918–) Artist. Lived in Vancouver, B.C., 1930's. Winner: Emily Carr Scholarship.

PLATH, HERBERT A. Commercial artist. Studio in Seattle, Washington, 1927.

PLUMMER, EVELYN G. Artist. Lived in Seattle, Washington, 1931, 1932.

PLYMPTON, HAZEL JEAN (1894–) Craftsperson, ceramics. Teacher. Born in Portland, Oregon. Lived in Bellingham, Washington, 1940. Pupil: Museum Art School, Portland; University of Chicago. Exh: Portland Art Museum, 1923, 1926. Chairman of the Art Department, Western Washington College of Education, Bellingham.

POINT, NICOLAS (1799–1868) (Reverend, Father, S.J.) Painter. Architect. Lived in Idaho and Oregon 1841–47. A skillful architect, Father Point drew up the plans for the Coeur d'Aloene Mission and also illustrated the book, *Oregon Missions and Travels Over The Rocky Mountains* in 1845–46.

POKISER, FRANK Painter, fresco. Lived in Tacoma, Washington, 1923.

POLLACK, JAMES (JIMMY) Artist. Pupil: F. H. Varley; Vancouver, B.C. Art School, 1930's. Head of Visual Arts Department, Vancouver, B.C. Art School.

POLLARD, JOHN H. Painter, watercolor. Lived in Seattle, Washington, 1938. Exh: Seattle Art Museum, 1937.

POND, E. PERCY Photographer, Native Alaskan life 1893–1910. Exh: "Images from the Inside Passage", 100 photos of Tlingit Indians.

POND, ELIZABETH PARROTT **(1849–1936)** Painter, oil, landscapes. Lived in Seattle, Washington. Sister of renowned artist, William Samuel Pond.

POND, WILLIE BAZE (MRS.) **(1896–)** Painter. Teacher. Writer. Muralist. Exh: Denver Art Museum; Colorado Springs Fine Art Center. Director, Indian A. Anadarko Reservation, 1922–27. Member: Creative Arts Womens Club, Spokane, 1944–45.

POOR, HENRY VARNUM (1888– **1970)** Painter. Potter. Architect. Study: graduated PhiBetaKappa, Stanford University. Chief of the Army's Art Unit for the Alaskan Theater. Founder, the California School of Fine Arts. Work: murals for the Department of Justice in Washington, D.C. Author: *An Artist Sees Alaska*.

POORE, TAYLOR Painter. Member: The Attic Studio, Portland, Oregon 1929–67. Moved to Chicago in 1953 to become an art director.

POORMAN, KERMIT C. Artist. Studio in Spokane, Washington, 1935.

POPE, FRANKLIN L. Illustrator. Brought from New York to Victoria, B.C. by the Collins Telegraph in the 1880's.

PORTAL JOSEPH M (1908–) Painter, oil, watercolor, pastel. Illustrator. Writer. Born in Chicago. Lived in Salem, Oregon, 1940. Pupil: Chicago Art Institute; studied in Europe, Africa, Canada, Mexico. Member: American Artists Professional League; Oregon Society of Artists. Exh: Federal Art Center, Salem 1937, 1938; Sacred Heart Academy; St. Benedict's Abbey, Mt. Angel, Oregon, 1937; Young's Gallery, Chicago, 1926. Award: first and second place, Oregon State Fair, 1935–38. Work: St. Joseph Church, Salem. Contributor to Benedictine Press of stories, illustrations, cover designs.

PORTER, CASSIE C. Painter. Lived in Seattle, Washington, 1916. Exh: Washington State Commission of Fine Arts, 1914.

PORTER, RUSSELL WILLIAM **(1871–1949)** Painter. Traveled with Peary, Fiala and Cook to Greenland & Alaska.

PORTLOCK, NATHANIEL (1748– **1817)** Illustrator. Author. Captain in the English Navy. Illustrated, *A Voyage Round the World*, in 1786 to 1788. Maps were also made by Portlock.

PORTMANN, FRIEDA BERTHA **ANNE** Painter, oil, watercolor. Sculptor. Printmaker. Craftsman. Teacher. Born in Tacoma, Washington. Lived in Seattle, Washington, 1940. Pupil: Chicago Art Institute; California College of Arts and Crafts; Cornish Art School, Seattle; Peter Camfferman; Mark Tobey. Member: National Association of Women Painters and Sculptors, New York; Northwest Printmakers; Women Painters of Washington: Seattle Art Teachers Association. Exh: Seattle Art Museum; Henry Gallery, University of Washington, Seattle; Oakland Art Museum, 1937; New York Watercolor Club; Oakland Art Museum, 1937; Chicago Art Institute; Four Arts Gallery, Palm Beach. Art Instructor: Seattle Public Schools.

POST, CHARLES W. Painter, oil, landscapes, Columbia River scenes.

Active in Corbett, Oregon in the mid 20th century.

POST, GEORGE BOOTH (1906–) Painter, watercolor. Teacher. Primarily a California artist. Work: Seattle Art Museum.

POSTELS, ALEKSANDR Artist on board the Russian *Seniavin* in 1826. Specialized in botanical, ornithological and mineralogical lithographic depictions.

POTTER, LOUIS MCCLELLAN (1873–1912) Etcher. Sculptor, American & Alaskan Indian groups. Lived in Seattle, Washington.

POTTS, MARY G. (1921–1986) Painter. Lived in Tacoma, Washington, 1941–1986. Study: Pacific Lutheran College.

POTVIN, LORA REMINGTON (1880–) Painter, oil. Sculptor, wax, clay. Born in Silverton, Oregon. Lived in Lewiston, Idaho, 1940. Pupil: Art Students League of New York; Chase Art School, New York. Exh: Federated Clubs of Idaho; Nez Perce County Expo, 1939.

POWELL, ASA L. (ACE) (1912–) Painter, oil, western landscapes & genre. Important Western genre artist. Painted mainly in Montana, but maintained a studio in Yakima, Washington in 1946.

POWELL, CORRINE Painter, watercolor. Known work of Yokum Falls.

POWER, STELLA Painter, watercolor. Lived in Whatcom County, Washington, 1909. Exh: Alaska-Yukon Pacific Expo, Seattle, 1909.

POWERS, MARION Painter. Studied in London and Paris. Work: mural, Canadian Pacific Railway and Hotel Vancouver, B.C.

PRACZUKOWSKI, EDWARD LEON (1930–) Painter. Teacher. Pupil:

Boston Museum School. Associate Professor of Painting, University of Washington 1965. Member: Allied Artists, Seattle.

PRASCH, RICHARD JOHN JR. (1918–1986) Painter, watercolor. Teacher. Lived in Tacoma, Washington. Pupil: University Washington. Exh: Seattle Art Museum; Portland Art Museum. Member: Tacoma Art League, 1955. Teacher: University of Oregon, 1949.

PRATT, DUDLEY (1897–1975) Sculptor. Teacher. Writer. Painter. Born in Paris, France. Lived in Seattle, Washington, 1940. Pupil: School of the Museum of Fine Arts, Boston; Ecole de la Grande Chaumiere, Paris; Massachusetts Institute of Technology: Pennsylvania Academy of Fine Arts; University of Washington; Archipenko. Member: Craftsmen's Guild of Washington; Governors Advisory Art Committee, Washington. Exh: Seattle Art Museum, 1937; New York World's Fair, 1939. Professor of Art, University of Washington, Seattle. Many award and commissions in public buildings in the Northwest.

PRATT, NORMA W. (Circa 1900) Painter. Lived in Walla Walla, Washington, 1940; the Portland area, 1992. Member: Women Painters of Washington, 1938–56.

PRATT, VIRGINIA CLAFLIN (MRS. DUDLEY) (1902–) Sculptor. Teacher. Lived in Seattle, Washington. Pupil: School of Museum of Fine Arts, Boston; studied in Paris. Exh: Seattle Art Museum, 1937.

PRENICH, FRANK Artist. Lived in Tacoma, Washington, 1892.

PREUSS, CHARLES Map maker. Painter. Came with Fremont to Oregon in 1843–44. Published a report of the Exploring Expedition to The

Rocky Mountains and to Oregon and North California.

PRICE, CLARA J. Artist. Lived in Tacoma, Washington, 1902.

PRICE, CLAYTON S. **(1874–1950)** Painter, oil. Illustrator. Muralist. Lived in Portland, Oregon, 1940. Exh: Portland Art Museum (retrospective). Award: Seattle Art Museum. Los Angeles Art Museum; Baltimore Museum of Art; Palace of Legion of Honor, San Francisco; Santa Barbara Museum of Art. Work: Los Angeles Museum of Art; Museum of Modern Art. Member: Oregon Society of Artists, Portland, 1929.

PRICE, HAROLD (1912–) Painter. Lithographer. Illustrator for Binsford and Mort, Publishers, Portland, Oregon. Pupil: University of Oregon; Art Students League, New York. Moved to Carmel in the 1960's.

PRICHARD, EDNA O. Artist. Lived in Seattle, Washington, 1929.

PRICHARD, THEODORE JAN (1902–) Painter, watercolor. Teacher. Lived in Moscow, Idaho, 1940. Pupil: Harvard University; University of Washington. Exh: Seattle Art Museum; Palace of the Legion of Honor, San Francisco; Boise Art Museum.

PRIEBE, ELIZABETH Painter, oil, watercolor, landscapes. Exh: Washington State Arts & Crafts, 1909.

PRIES, LIONEL H. (1897–1968) Painter, oil, watercolor. Architect. Printmaker, dry print. Teacher. Lived in Seattle, Washington. Associate professor of Architecture at the University of Washington at Seattle. Pupil: University of California, Berkeley. Exh: Bohemian Club, San Francisco; Architectural League, New York, 1923; Seattle Art Museum, 1935.

PRINCE, BERTHA Painter. Teacher. Lived in Tacoma, Washington, 1909.

PRIOR, MELTON (1845–1910) Painter. Illustrator. Born in England. He was a pupil of his father William Henry Prior, a landscape painter. Worked for *Illustrated London News* for whom he took many trips to the West. His third trip was in 1888 painting Indian life across Canada. Was world renowned in his day.

PRITCHARD, WALTER Sculptor. Teacher. Lived in Pullman, Washington, 1940. Pupil: University of Oregon; Art Students League, New York; William Zorach; Thomas Tenton. Exh: Seattle Art Museum, 1939.

PROCTOR, ALEXANDER PHIMIS-TER (1862–1950) Painter, watercolor. Sculptor. Lived in Seattle, Washington. Pupil: National School of Design; Art Students League, New York. Exh: Paris Expo, 1900. Works displayed nationally. Was commissioned by Thodore Roosevelt to paint the Bison Heads which hung over the mantel in the State Dining Room of the White House. Spent his summers in the Northwest painting and hunting.

PROCTOR, E. (EARLY 20TH CENTURY) Painter, oil, landscapes, architectural. Commercial artist. Lived in Portland, Oregon, 1934. Member: Founding member, The Attic Studio, Portland.

PROSE, GERMANY KLEMM Painter. Lived in Vancouver, Washington, 1950. Pupil: University of Oregon; Rhode Island School of Design.

PUCCIO, GASPARE L. Artist. Studio in Seattle, Washington, 1927. Member: Puget Sound Group of Northwest Men Painters, 1930.

PUGH, GRACE J. Painter. Lived in Tacoma, Washington, 1937. Exh: Tacoma Art League, 1915.

PURCELL, MARIE F. (1917–)
Sculptor, clay, figures, portraits. Self-taught. Lived in Salem, Oregon. In private collections nationally.

PUTMAN, DONALD (1927–)
Painter, traditional western genre. Born in Washington. Designed and painted background scenery for MGM studios. Considers himself an illusionist.

—Q—

QUIGLEY, EDWARD B. (1895–)
Painter, oil, watercolor. Woodcarving. Lived in Portland, Oregon, 1940. Pupil: Chicago Art Institute. Member: Oregon Society of Artists; American Artists Professional League. Exh: Meier & Frank, Portland, Oregon. Traveled and painted extensively in Northern Washington where he sketched ranch life, Yakima Indians and wild horses and cowboy genre.

QUINAN, HENRY BREWERTON (1876–) Art Director. Lived in Sitka, Alaska. Pupil: Laurens, Paris.

—R—

RABORG, BENJAMIN Painter, oil. Painted an indian burial in oil, 19th century.

RABUT, PAUL (1914–) Painter. Illustrator. Teacher. Expert in American Indian culture with emphasis on the Northwest. Work: USA Medical Museum in Washington. Won a medal for a historical stockade scene. Designed a six cent postage stamp as a Haida Ceremonial Canoe and the eleven cent airmail commemorative stamp.

RACINE, ALBERT (a.k.a. APOW-MUCKCON RUNNING WEASEL) (1907–) Painter. Wood Carver. Gallery owner. Lived in Seattle, Washington, 1940–42. Pupil: Winold Reiss; Edward Everett Hale, Jr.; College of Puget Sound. Work: Museum of the Plains Indians. A Blackfoot Indian. After WWII he painted signs and carved on the West Coast.

RADER, VIRGINIA BAKER (1906–) Painter. Sculptor. Born in Denver, Colorado. Lived in Seattle, Washington, 1940. Pupil: Museum Art School, Portland. Exh: Seattle Art Museum. Member: Lambda Rho. Award: scholarship, Portland Art Museum, 1924–25; Louis Comfort Tiffany Foundation, 1927; Museum and Art Foundation, Seattle, 1927. Work: bronze portrait plaque of Marcus Whitman, M. Whitman Hotel, Walla Walla, Washington.

RADFORD, ZILPHA (1885–1948) Painter, oil. Born in Auburn, California. Lived in Seattle, Washington, 1940. Pupil: University of Washington. Exh: Seattle Art Museum, 1934–38.

RALEIGH, HENRY (1880–) Printmaker. Illustrator. Lived in Portland, Oregon. Member: Alliance Artists Guild. Illustrator for the *Saturday Evening Post*; *Cosmopolitan*, 1940.

RALSTON, J. KENNETH (1896–) Painter, oil, dry brush. Illustrator. Drawing, ink. Pupil: Chicago Art Institute. Commercial artist in Washington for 7 years. Work: "Surrender of Chief Joseph".

RAMSAY, COLIN CAMERON (1891–) Painter, oil, pastel. Born in Scotland. Lived in Vancouver, B.C., 1940. Studied in Rome and Florence. Exh: Vancouver, B.C. Art Gallery; Royal Scottish Academy; Walker Art Gallery, Liverpool; Royal Glasgow Art Institute.

RAND, PAUL Painter who developed a refined landscape style which was consistant with the wilderness perception. Founding member: British Columbia Society of Artists, Vancouver 1930.

RANDALL, ANNE W. Painter, watercolor. Illustrator. Lived in Seattle, Washington, 1944. Exh: Seattle Art Museum, 1940.

RANDALL, ARNE Painter, oil. Lived in Seattle, Washington, 1941. Exh: Seattle Art Museum, 1940.

RANDALL, BYRON (1918–) Painter. Engraver. Teacher. Born in Tacoma, Washington. Lived in Salem, Oregon before moving to Seattle, Washington, 1944. Exh: solo show: Seattle Art Museum, 1940. Most of his memberships and exhibitions were in California.

RANDALL, GEORGE C. Painter, oil. Lived in Ellensburg, Washington, 1938. Exh: Seattle Art Museum, 1938.

RANDOLPH, GLADYS C. Painter. Pupil: Portland Oregon Art Museum School. Award: National League of American Pen Women; American Artists Professional League.

RANFT, NANCY Artist. Lived in Tacoma, Washington, 1900.

RANKUM, CHARLES E. (–1935) Commercial artist. Painter. Born in Vancouver, B.C. He worked for the Schmidt Lithograph Company in the 1920's returning to his home in 1928.

RANSON, W. H. Painter, pen & ink. Lived in Seattle, Washington, 1902.

RAPHAEL, WILLIAM (1833–1914) Painter. Pupil: Berlin Academy. Founding member: Society Canadian Artists. Exh: Vancouver, B.C. Art Gallery.

RAPP, EBBA Painter, oil, watercolor. Printmaker, lithography, block print. Sculptor, terra cotta. Teacher. Lived in Seattle, Washington, 1941. Pupil: Cornish Art School. Member: Women Painters of Washington. Exh: Seattle Art Museum; Frederick & Nelson, Seattle, 1937; New York World's Fair, 1939; Northwest Printmakers, 1937–40; Grant Galleries, New York. Ceramics instructor: Cornish Art School, Seattle.

RASCHEN, HENRY (1854–1937) Painter, landscapes, Indians. Born in Germany. Lived in Oakland, California. Study: School of Design, San Francisco; Munich, for 8 years. Studio in San Francisco, 1883. Made many working trips North and to Arizona as a volunteer scout and sketch artist with the United States Army in pursuit of Geronimo. He painted several portraits of him. Award: Lewis & Clark Expo, Portland, 1905; gold medal, Alaska-Yukon Expo, Seattle, 1909. Work: Frye Museum, Seattle; Bohemian Club.

RASCOVICH, FRANCIS (MRS. ROBERT) Artist. Teacher. Lived in Tacoma, Washington, 1909.

RASCOVITCH, ROBERT BENJAMIN (1857–1905) Painter, oil, watercolor, landscapes. Born in Austria. Lived in Tacoma, Washington. Two paintings are in the Tacoma Public Library.

RATTENBUTY, F. M. Artist. Architect. Designed the Legislative Building, Victoria, B.C.

RATTRAY, ANNIE L. Artist. Lived in Tacoma, Washington, 1896.

RATTRAY, FLORENCE H. Artist. Lived in Tacoma, Washington, 1898.

RAY, GEORGE C. Commercial artist. Studio in Tacoma, Washington, 1933.

RAYMOND, BESSIE Painter, oil, lumber camps, redwoods. Active in Northern California and Oregon in the 1870's.

RAYMOND, KATE CORDON. **(1888–)** Painter, oil, watercolor. Born in Texas. Lived in Portland, Oregon, 1940. Pupil: C. C. McKim. Member: Oregon Society of Artists, 1938. Exh: Oregon State Fair, Salem, 1938, 1938.

RAYNER, HERBERT (1888–) Woodcarver. Born in England. Lived in Portland, Oregon, 1940. Exh: Portland Library; Reed College, Portland. Exh: Calgary Alberta, 1913; Housing Show, Portland, 1935; Seattle, Washington, 1938.

READ, FRANK E. (1862–1927) Painter. Teacher. Writer. Lived in Seattle, Washington. Member: Seattle Fine Arts Society, 1925.

READ, MILDRED L. (1911–) Painter, watercolor. Printmaker, linoleum, wood block, lithography, monotype. Born in Aberdeen, Washington. Lived in Anacon, Canal Zone, 1940. Pupil: University of Washington. Member: Lambda Rho; Northwest Printmakers; Seattle Art Museum. Exh: Henry Gallery, University of Washington, Seattle, 1935; Annual Exhibition of Watercolors, Oakland, California, 1938.

REAGEN, PAMELA Artist. Lived in Vancouver, B.C., 1930's.

REAVIS, B. Painter, oil, post-impressionistic landscapes. Lived in Beaverton, Oregon in the 1960's.

REBONDORF, M. Artist. Lived in Walla Walla, Washington, 1902.

REDBERG, RUTH Artist. Studio in Seattle, Washington, 1928.

REDFERN, HELEN E. Artist. Lived in Spokane, Washington, 1921.

REDINGTON, N. M. (MRS.) Painter, oil, watercolor. Lived in Tacoma, Washington, 1909. Exh: Alaska-Yukon Pacific Expo, Seattle, 1909.

REDMAN, MARY CATHERINE **(1872–1968)** Painter, oil, watercolor, landscapes. China painter. Studio in Victoria, B.C. for 25 years. Lived on Vashon Island, Washington. Known mostly for her China painting.

REDMANN, RALPH R. Painter. Lived in Everett, Washington, 1950–63. Sport Center Artist, 1950.

REDMOND, GRANVILLE RICHARD SEYMOUR (1871–1935) Painter. Important California plein-air artist. Exh: silver medal, Alaska-Yukon Pacific Expo, Seattle, 1909.

REDWOOD, ALLEN C. (1844–1922) Painter. Illustrator. Writer. Magazine illustrator of the Civil War, the Spanish American War, and the West for *Leslie's Weekly*, *Harper's Weekly*, *Harper's Magazine* and *Century*. Served as a Major in the Civil War. In 1882 he traveled West through Idaho to the State of Washington. By the 1890's he was known as a Western Illustrator.

REED, ADDIE M. Portrait painter. Commercial artist. Lived in Seattle, Washington, 1931. Charter Member: Women Painters of Washington, 1931. Artist for Western Engraving & Colortype Company, Seattle.

REED, ELOISE Artist. Lived in Seattle, Washington, 1907.

REED, GENEVIEVE Artist. Lived in Seattle, Washington, 1907.

REESE, COLONEL C.A. Referring to an article published in the *Oregonian* August of 1873: "The 'Panorama' of Oregon and Washington Territory which Colonel C.A. Reed has painted will be exhibited for the first time. Reese's panorama, a magnificent representation of the unrivalled scenic beauties of the Great Northwest will be travelling east."

REESE, WALTER O. (1889–1943) Painter, watercolor. Sculptor, stone, wood. Illustrator. Teacher. Lived in Seattle, Washington. Pupil: Chicago Academy of Fine Arts. Member: Puget Sound Group of Northwest Men Painters; Seattle Artists League. Illustration: Many cover designs for magazines. Exh: New York World's Fair, 1939; Seattle Art Museum. Art Director, Cornish Art School, Seattle.

REESE, WILLIAM FOSTER (1938–) Painter. Pupil: Washington State University, Art Center; School of Design, Los Angeles. Work: Frye Art Museum, Seattle. Exh: Allied Artists of America; National Academy Galleries, New York; Cowboy Hall of Fame, Oklahoma City. Many awards in the Northwest. Member: Puget Sound Group Northwest Painters; Northwest Watercolor Society; National Academy Western Art; Pastel Society of America; Society of Animal Artists. Currently residing in Washington, (1992)

REEVE, DONOVAN W. Artist. Lived in Cinebar, Washington, 1940. Exh: Tacoma Art League, 1940.

REEVE, GORDON Painter. Ceramist. Lived in Vancouver, B.C. 1950's.

REGAT, MARY E. Sculptor. Muralist. Pupil: University of Alaska. Work: Anchorage Fine Arts Museum, Alaska; many public buildings in Alaska. Exh: solo shows, Alaska State Museum, Juneau. Many awards.

REHBOCK, LILLIAN FITCH (1907–) Painter, oil, watercolor. Printmaker, linoleum block. Lived in Seattle, Washington, 1940. Pupil: Chicago Art Institute; University of Washington; studied in Paris. Member: Women Painters of Washington. Exh: Seattle Art Museum; Grant Studios, New York; Chicago Art Institute, 1924.

REID, IRENE HOFFAR (1908–) Painter, oil. Lived in in Vancouver, B.C., 1940. Pupil: Vancouver School of Art: Royal Academy School, London. Exh: National Gallery Ottawa, 1931, 1932; Seattle Art Museum, 1930–34; B.C. Artists Exhibition, 1932–38.

REID, MARSHALL Painter, oil, portraits. Studio in Tacoma, Washington, 1942.

REINDAL, CARL Artist. Lived in Spokane, Washington, 1925.

REISDORFF, MARY E. MILLER (1900–) Painter, oil, watercolor. Illustrator. Drawing, pen and ink. Writer. Born in Nebraska. Lived in Seattle, 1940. Pupil: Cornish Art School, Seattle.

REITZE, FLORENCE BROWN Painter, oil. Lived in Seattle, Washington, 1937. Exh: Alaska-Yukon Pacific Expo, Seattle, 1909.

RELF, CLYDE EUGENIA Painter. Lived in Seattle, Washington, 1924.

REMINGTON, FREDERIC SACKRIDER (1871–1909) Painter. Illustrator. World-renowned. Spent most of his life painting the life of the Western genre. He was to bequest to the world an extraordinary legacy of art and literature on life on the American frontier from 1880–1909. At the age of 19 he abandoned his education at Yale

and headed West. His first important break came through *Harper's Weekly* who published his sketches and stories for many years. He maintained his studio in New York but spent many years traveling and painting all over the West. He illustrated Francis Parkman's *Oregon Trail* in 1900.

REMINGTON, S. J. (MRS.) Painter, oil, watercolor. Lived in Tacoma, Washington, 1895. Exh: Tacoma Art League, 1895. Her painting of Mount Hood and Mountainous Landscape with a Cataract sold in 1972 at auction for $375.

RENFRO, ALFRED T. PLASKETT Cartoonist. Lived in Seattle, Washington, 1912. Wrote & illustrated book, *History of the 13th Session of the Washington, Legislature, 1912.*

RENSTROM, GLORIA R. Artist. Lived in Tacoma, Washington, 1935.

REPPETO, JOHN D. Painter, oil. Lived in Kirkland, Washington, 1946, 1947. Member: Puget Sound Group of Northwest Men Painters, 1946. Exh: Seattle Art Museum, 1946, 1947.

RESNICK, MILTON (1917–) Painter. Born in Russia. Lived in Paris, 1946–48. Taught: University of California at Berkeley, 1955–56. Important American Artist. Exh: Seattle World's Fair, 1962.

REYNOLDS, CHARLES F. Painter, oil, post-impressionist in the Cezanne style. Active in the early 20th century in Portland Oregon. Member: The Attic Sketch Group, Portland. Used a monogram signature.

REYNOLDS, LLOYD J. (1902–) Printmaker, wood engravings. Illustrator. Teacher. Lived in Portland, Oregon, 1940. Pupil: Sidney Bell; Portland University of Art. Member: American Artists Congress; Northwest Printmakers, 1938. Exh: Seattle

Art Museum; Portland Art Museum. Instructor: Reed College, Portland.

RHIND, MARJORIE WOLF Illustrator. Lived in Tacoma, Washington, 1940. Pupil: University Washington; Cornish Art School, Seattle. Exh: Tacoma Art League, 1940. Fashion illustrator; children's book illustrator.

RHODEHAMEL, RUTH Artist. Lived in Spokane, Washington, 1903.

RHODES, GEORGE W. (1850–1937) Painter, oil, landscapes, portraits, indians. Lived in Seattle, Washington. Worked in a primitive style often destroying his work upon completion. He & his brother apparently died in a Washington State mental hospital for manic depressives. Exh: Washington State Historical Society.

RHODES, HELEN NEILSON (1875–1938) Painter, watercolor. Printmaker, wood block, lithography. Teacher. Born in Wisconsin. Lived in Seattle, Washington, 1940. Pupil: National Academy of Design, New York; Cowles Art School, Boston. Member: Northwest Printmakers (Northwest Printmakers Exhibit dedicated to her prints); Pacific Arts Association. Exh: Seattle Art Museum; Henry Gallery, University of Washington, Seattle. Author of many articles on art education. Associate Professor of Design, University of Washington, Seattle.

RICE, CHARLES Painter, oil, pastels, landscapes. Lived in Everett, Washington, 1931.

RICE, MARGARET A. (1901–) Painter, oil. Born in Canada. Lived in Seattle, Washington, 1940. Pupil: Leon Derbyshire. Work: Head of Christ, Laurel Presbyterian Church. Exh: Western Washington Fair, Puyallup, 1936.

RICEN, STANLEY (1909–) Painter, oil, watercolor, tempera. Drawing, pen & ink. Commercial art-

ist. Lived in Portland, Oregon, 1940. Pupil: Museum Art School, Portland. Exh: Portland Art Museum.

RICH, FRANCES (1910–) Sculptor. Lived in Spokane, Washington. Work: Mt. Angel Abbey, Oregon.

RICHARDS, EDYTHE Artist. Lived in Tacoma, Washington, 1931. Pupil: University of Washington. Exh: first prize, Cooper Union Art Institute, New York, 1931.

RICHARDS, H. SARGEANT Painter, oil, mountain landscapes.

RICHARDSON, E. M. Painter. Surveyor. Studied at the Royal Academy, London. Famous for his sketches in the Cariboo, 1880's.

RICHARDSON, ERNEST Painter. Member: Founding member, finance manager . . . The Attic Studio, Portland, Oregon, 1929–67.

RICHARDSON, THEODORE J. (1855–1914) Painter. Lived in and painted Alaskan scenery for four years. Studied abroad from 1896–1902.

RICHMOND, LEONARD Painter, landscapes, figures. Art critic. Lived in London, England, 1934. Worked extensively in California, Canada and the West. His "Western Landscapes" sold from $200 to $800 in 1971.

RICHTER, ALBERT B. (1845–1898) Painter. Illustrator, big-game hunting. Pupil: the Dresden Academy. Became Special Artist for *Illustrierte Zeitung*, traveling to the United States in 1878 to paint horses for battle murals in St. Paul and Chicago. His western illustrations were published in Germany in the 1890's including Indian and pioneer life in the Northwest where he sketched extensively.

RIEPE, DONALD J. Painter, oil. Lived in Seattle, Washington, 1951. Exh: Seattle Art Museum, 1945, 1946;

Henry Gallery, University of Washington, Seattle, 1950, 1951.

RIES, ENRYP Painter, oil. Lived in Seattle, Washington, 1934. Exh: Seattle Art Museum, 1934.

RIESENBERG, SIDNEY H. (1885–) Painter. Illustrator, Western subjects. Teacher. Pupil: Chicago Art Institute. Made two trips West between 1905–1909 doing several covers for *Pacific Monthly*, *The Saturday Evening Post*, *Harper's*, *Collier's* and *Scribner's*. Exhibited his impressionist paintings at the National Academy of Design in 1930.

RIGGS, KATHERINE G. Painter. Teacher. Lived in Tacoma, Washington, 1901. Teacher of drawing and painting at the Ferry Museum, Tacoma, 1899–1901.

RILEY, LILLIAN IRENE Painter, oil. Lived in Seattle, Washington, 1946. Exh: Seattle Art Museum, 1946; Henry Gallery, University of Washington, Seattle, 1951.

RINDISBACHER, PETER (RINDESBERGER) (1806–1834) Painter, watercolor, Indians, frontier life in Canada and the United States. The first pioneer artist recording genre of Western Indians. His painting, "Two of the Companie's Officers Traveling in a Canoe", sold at auction in 1973 for $10,000. Died at the age of 28 just as he was achieving national recognition.

RIOPELLE, JEAN-PAUL Painter, abstract. Lived in Vancouver, B.C., 1956. Exh: Smithsonian Institute, Washington, D.C.

RIPLEY, THOMAS EMERSON (1865–1956) Painter. Writer. Lived in Tacoma, Washington. Study: Yale University. Began his career as a writer and painter after losing everything in the Stock Market Crash of 1929. Exh: Santa Barbara Museum.

RISING, DOROTHY JEAN (see DAR-IOTIS) Painter, oil. Born in Seattle, Washington. Member: Women Painters of Washington. Exh: Seattle Art Museum., 1938; first sweepstakes, Western Washington Fair, Puyallup, 1938.

RISING, DOROTHY MILNE (1895–1990) Painter, oil, watercolor. Printmaker, block print. Teacher. Writer. Lived in Seattle, Washington. Study: University of Washington, BA & MFA degrees; Ambrose Patterson; Walter Izaacs; Helen Rhodes; Henry Keller. Teacher: University of Puget Sound; Western Washington State University; Seattle School System. Member: Women Painters of Washington; Northwest Watercolor Society; Royal Society of Artists, London. Exh: Seattle Art Museum.

RISING, RUTH Artist. Lived in Tacoma, Washington, 1945. Member: Tacoma Art League; Washington State Historical Society, 1945.

ROATS, TATIANA M. Painter, oil. Lived on Bainbridge Island, Washington, 1982. Member: Women Painters of Washington. Exh: Seattle Art Museum, 1945.

ROBBINS, FRANCIS Commercial artist. Lived in Yakima, Washington, 1939.

ROBERG, PATRICIA Painter, oil. Exh: Seattle Art Museum, 1945.

ROBERTS, H. TOMTU Painter. Arrived in Vancouver, B.C. in 1886 from Wales already a successful artist. He was enthralled with the misty forests and grandiose mountains.

ROBERTS, HERMINE Painter, watercolor. Printmaker, lithography. Teacher. Writer. Born in Cleveland, Ohio, a Montana artist, in 1940. Pupil: University of Oregon. Exh: Seattle Art Museum, 1937.

ROBERTS, MALCOLM M. Painter, tempera, surrealist. Lived in Seattle, Washington, 1941. Pupil: University of Washington, Seattle; Chicago Art Institute; studied in Europe. Exh: Annual Exhibition of Northwest Artists, 1939; Seattle Art Museum, 1934; Northwest Artists, 1939.

ROBERTS, MAURINE HIATT (1898–) Painter. Illustrator. Teacher. Lived in Seattle, Washington, 1923. Member: Seattle Fine Arts Society, 1925.

ROBERTS, MILNORA deB. Painter. Lived in Seattle, Washington, 1951.

ROBERTS, MYRTLE G. Artist. Lived in Seattle, Washington, 1912.

ROBERTS, P. GIGBY Painter, oil. Lived in Seattle, Washington, 1945. Exh: Seattle Art Museum, 1945.

ROBERTS, S. M. Artist. Lived in Ballard, Washington, 1901.

ROBERTSON, CLIFFORD Artist. Lived in Vancouver, B.C., 1940's.

ROBERTSON, HARRIET C. Painter, oil. Lived in Seattle, Washington, 1951. Exh: Seattle Art Museum, 1945.

ROBERTSON, LUCILLE Painter, oils, watercolor. Member: The Attic Studio, Portland, Oregon, 1929–67.

ROBERTSON, MAISIE (1910–) Painter, oil, watercolor, black & white. Sculptor, Teacher. Lived in Vancouver, B.C., 1940. Pupil: Vancouver School of Decorative and Applied Arts. Many awards and scholarships in Canada. Member: B.C. Society of Fine Arts, 1936. Exh: National Gallery of Canada, Toronto.

ROBINSON, CHARLES DORMAN (1847–1933) Painter, landscapes, marine, the Yosemite Valley and the High Sierras. Illustrator. He settled in San Francisco where he became

known as the "Dean of Pacific Coast Artists".

ROBINSON, HERBERT Artist. Lived in Seattle, Washington, 1951. Member: Puget Sound Group of Northwest Men Painters, 1951.

ROBINSON, IONE (1910–) Painter. Writer. Illustrator. Pupil: Otis Art Institute. Exh: Los Angeles Art Museum, 1929; National Palace, Mexico.

ROBISON, LAURA LEE (1914–) Painter, oil, watercolor. Drawing, charcoal, chalk. Teacher. Lived in Walla Walla, Washington, 1941. Pupil: Pratt Institute Brooklyn; Art Students League of New York.

ROBITIZER, J. P. Artist. Lived in Seattle, Washington, 1907.

ROCHE, RENA M. Painter, watercolor. Lived in Seattle, Washington, 1909. Exh: Alaska-Yukon Pacific Expo, Seattle, 1909.

ROCKWELL, CLEVELAND (1837–1907) Painter, oil, watercolor. Work: Flavel Museum, Astoria, Oregon. Position: U.S. Geodetic Department as a Survey artist and mapmaker, surveying the Oregon Coast from 1868 as Chief of the Northwest section personally surveying the Columbia and Willamette Rivers. He also painted ship portraits on commission. Retired from the Coast Survey in 1892 and was active as an artist in Portland, Oregon until his death. Member: Oregon Art Association; Sketch Club of Portland. Exh: Portland Art Museum; Flavel Museum; Stenzel Collection.

RODE, CORA (1898–) Painter, oil, watercolor. Born in Chicago. Lived in Seattle, Washington, 1940.

RODE, CORAL ANN (1923–) Painter, watercolor. Lived in Seattle, Washington, 1940.

ROGERS, ANNAH BARKLEY WRIGHT Painter, oil, watercolor, portraits. Drawing, pen & ink, pencil, crayon. Lived in Seattle, Washington, 1926. Pupil: Chicago Art Institute. Exh: Annual Exhibition of Northwest Artists, 1929, 1932; Harry Hartman's, Seattle.

ROGERS, CHARLES ALBERT (1848–1918) Painter. Lived and studied in New York, Rome, Munich and Paris. Became well known in California. Exh: Alaska-Yukon Pacific Expo, Seattle, 1909.

ROGERS, LAURA Painter, oil. Exh: Washington State Arts & Crafts, 1931.

ROGERS, MARY LUPEN Painter, oil, pastel. Lived in Everett, Washington, 1931. Exh: Everett Drama League, 1931.

ROGERS, ROY D. Painter, watercolor, landscapes. Lived in Seattle, Washington, 1924.

ROGERS, WILLIAM ALLEN (1854–1931) Cartoonist. Teacher. Illustrator. Important Western Artist-Correspondent for *Harper's Weekly*. Traveled extensively all over the country as an illustrator. In 1898 he covered the "Omaha Exposition" including the Indian congress continuing on to Eastern Oregon and California where he painted extensively before returning home via the Southwest.

ROHR, DORIS ESTELLE (1896–1987) Painter. Study: Western Washington, College. Settled in Carmel, California in 1925 where she remained until her death.

ROLLEFSON, J. WARREN Artist. Lived in Seattle, Washington, 1926.

ROLLINS, WARREN ELIPHALET (1861–1962) Painter, oil, watercolor, mixed media, landscapes, indians. Teacher. Study: Virgil Williams; California School of Design. In 1890, he

owned and operated an art school in Tacoma, Washington. Exh: 1st Annual Western Washington Industrial Exposition, 1891. Member: Tacoma Art League, 1892. Eventually returned to California where he became "Dean of Taos and Santa Fe Art Colonies".

RONALD, WILLIAM Painter, abstract. Lived in Vancouver, B.C., 1950's. Exh: Smithsonian Institute, Washington, D.C.

ROOZEBOOM, AUGUST Painter. Dutch-born student of the Vancouver, B.C. School of Art. Died while serving with the Dutch airborne commandoes during World War II.

ROPER, EDWARD Painter. Came to British Columbia in 1887 to chronicle his journey painting landscapes for his book. He settled on Vancouver Island.

ROSATI, JAMES (1912–) Painter. Musician. Born in the United States. Violinist with the Pittsburgh Symphony. Teacher: Cooper Union; Pratt Institute; Yale University, 1960. Exh: Seattle World's Fair, 1962.

ROSELLINI, LILLIAN Painter, oil, pastel. Lived in Tacoma, Washington, 1957. Self-taught. Exh: Western Washington Fair, Payullup, 1930's. Exh: solo show, Handforth Gallery, Tacoma, Washington, 1955.

ROSENBERG, LOUIS CONRAD. (1890–) Printmaker. Illustrator. Architect. Lived in Portland, Oregon. Pupil: American Academy, Rome. Belonged to numerous organizations.

ROSENQUIST, WILLARD VIRGIL (1910–) Painter, oil, watercolor. Born in Mt. Vernon, Washington. Lived in Seattle, Washington, 1941. Pupil: University of Washington; Columbia University. Exh: Seattle Art Museum, 1937–39. Teacher: Garfield High School, Seattle, Washington.

ROSS, A. J. (MRS.) Painter, oil. Lived in Pierce County, Washington, 1909. Exh: Alaska-Yukon Pacific Expo, Seattle, 1909.

ROSS, DAN C. Painter. Studio in Spokane, Washington, 1911. Exh: Seattle Fine Art Society, 1927.

ROSS, HENRY C. Painter, watercolor, landscapes. Lived in Seattle, Washington, 1951. Pupil: L. Derbyshire; Paul Immel; Dorothy Rising. Member: Puget Sound Group of Northwest Men Painters, 1944. Exh: Vancouver, B.C. Art Museum; Denver Art Museum; Seattle Art Museum, 1945.

ROSS, L. (1877–1957) Commercial artist. Lived on Vashon Island. Washington, 1883.

ROSS, LEINA D. Commercial artist. Lived in Tacoma, Washington, 1888.

ROSS, NANCY J. Art teacher, oil, watercolor, china decoration. Studio in Tacoma, Washington, 1907.

ROSSBACH, ED Painter, casein, still Life. Exh: Henry Gallery, University of Washington, Seattle, 1950.

ROSSITER, T. P. Painter. Washington.

ROTH, HENRY (1874–1961) Painter, oil, watercolor. Illustrator. Lived in Seattle, Washington. Staff artist, *Seattle Post Intelligencer*, 1933–57.

ROTH, JOSEPH Artist. Lived in Seattle, Washington, 1920.

ROTHSTEIN, THERESA M. (1893–) Painter, oil. Lived in Vancouver, Washington, 1955. Pupil: University of Oregon; Museum Art School, Portland; Clyde Leon Keller. Member: Oregon Society of Artists; American Artists Professional League. Exh: Portland Art Museum; Portland, Oregon Womens Club.

ROWLEY, LOTTIE B. Artist. Lived in Tacoma, Washington, 1916.

ROY, JOSEPH Artist. Lived in Seattle, Washington, 1902.

RUBEN, THOMAS (1916–) Artist. Teacher. Professor of Art, Oregon State University, Corvallis.

RUDD, W. H. Artist. Lived in Seattle, Washington, 1902.

RUDE, LILLIAN A. Artist. Studio in Seattle, Washington, 1933.

RUFF, CORNELIA W. Artist. Lived in Seattle, Washington, 1933. Member: Women Painters of Washington, 1934.

RUNGIUS, CARL CLEMENS (1869–1959) Painter. Etcher. Illustrator, Western American big game subjects. Study: educated in Germany. Emigrated to the United States in 1894 and established a studio in New York City, maintaining a summer studio in Banff Canada from which he made many hunting, sketching, painting trips into Western Canada and the Northwest, down to Arizona, and North to Alaska.

RUNQUIST, ALBERT C. (1894–) Painter, oil, tempera. Printmaker, etching. Muralist. Lived in Portland, Oregon, 1940. Pupil: Museum Art School, Portland; Art Students League, New York. Member: American Artists Congress. Work: mural, Library, University of Oregon, Eugene; Pendleton High School. Exh: New York World's Fair, 1939; Golden Gate International Expo, San Francisco, 1939; Portland Art Museum.

RUNQUIST, ARTHUR (1891–) Painter, oil, watercolor, tempera. Born in South Bend, Washington. Lived in Portland, 1940. Pupil: University of Oregon: Art Students League of New York. Exh: New York World's Fair, 1939; Golden Gate International Expo, San Francisco. Member: American Artists Congress Annual, New York, 1940. WPA artist.

RUSH, CLARA E. Painter. Lived in Seattle, Washington, 1944.

RUSHMORE, MELVINA Artist. Lived in Selah, Washington, 1918.

RUSSELL, AMBROSE JAMES Art teacher. Architect. Study: art schools in London. Teacher, Tacoma Art League, 1895; Ferry Museum, 1899. President: Tacoma Art League, 1895.

RUSSELL, ASHLEY Painter, oil, landscapes. Works found in and about Portland, Oregon executed from 1910–1940's.

RUSSELL, CARRIE F. Artist. Lived in Spokane, Washington, 1914.

RUSSELL, GLADYS L. Commercial artist. Lived in Seattle, Washington, 1925.

RUSSELL, JAMES K. (1937–) Artist. Teacher: Art Department, Boise State University, Idaho.

RUSSO, MICHELLE (1909–) Painter, abstract figurative. Teacher. Pupil: B. Robinson; George Biddle. Teacher: Portland Museum Art School.

RUTLEDGE, MINNIE AURELIA Commercial artist. Lived in Seattle, Washington, 1934.

RUTT, ANNA HELGA HONG (1894–1984) Painter, oil, watercolor, landscapes. Teacher. Pupil: Otis Art Institute, Los Angeles; Cornish Art School, Seattle; UCLA. Professor of Art, Northwestern University, 1926–32.

RYAN, ANGELA S. Painter, watercolor. Lived in Pullman, Washington, 1936. Exh: Seattle Art Museum, 1936; Tacoma Civic Art Association, 1937.

RYAN, N. H. Artist. Lived in Seattle, Washington, 1912.

RYAN, WILLIAM FORTUNE Artist. Lived in Pullman, Washington, 1937. Exh: Seattle Art Museum, 1937.

RYERSON, MARGERY AUSTEN
Painter, oil, watercolor. Etcher. Pupil:
Vassar College; Art Students League,
New York; Robert Henri; Charles
Hawthorne. Exh: Frye Museum, Seattle Washington.

— S —

SAARI, HELMI Painter, oil. Lived
in Spokane, Washington, 1948. Exh:
Pacific Northwest Artists Annual Exhibition, 1948.

SAARI, SIGNE Painter. Oregon artist. Lived in Northern California,
1930's.

SAGER, PETER (1920–) Sculptor. Printmaker, linoleum block.
Lived in Vancouver, B.C., 1940. Pupil: B.C. College of Art. Member:
Northwest Printmakers. Exh: Vancouver Art Gallery, 1937; Toronto Art
Gallery, 1939; Seattle Art Museum,
1937; Northwest Printmakers, 1939;
Canadian Society of Graphic Arts.

SALE, C. C. (MRS.) Artist. Lived in
Seattle, Washington, 1909.

SALMON, LIONEL E.(1885–1945)
Painter, oil, watercolor, portraits,
landscapes. Born in London. Son of
artist, Charles William Salmon. Traveled in the Northwest before settling in
Tacoma in 1913. Exh: Tacoma Art
League, 1916, 1923. Unofficial painter
of Mt. Rainier, painting the mountain
over 2,000 times.

**SALMON, ROBERT W. (1775–
1845)** Painter, English marine. Traveled to the Arctic in 1800. Work: Boston Museum; Spanierman Gallery,
New York.

SALTER, NANCY Painter, oil.
Lived in Clarkston, Washington, 1948.
Exh: Pacific Northwest Artists Annual
Exhibtion, 1948.

SALVINI, ARTHUR Artist. Lived in
Seattle, Washington, 1901.

SALZBRENNER, ALBERT Painter.
Itinerant artist of Portland, Oregon
from 1911–14, and again in 1920.

SAMPSON, S. ANDREA (1891–)
Painter, oil, watercolor. Printmaker,
linoleum, woodblock. Lived in Everett, Washington, 1962. Pupil: Ambrose Patterson; Eustace Ziegler;
Leon Marsh. Member: Women
Painters of Washington. Exh: Grant
Galleries, New York, 1937; Seattle Art
Museum, 1938; Western Washington
Fair, Puyallup, 1935.

SAMSON, ALICE Painter, oil,
genre. Lived in Tacoma, Washington,
early 20th century. Self-taught. Husband owned the Samson Hotel, Tacoma. Exh: Regional Painters of the
Puget Sound.

SANDBERG, RAYMOND (1939–)
Painter, Alaskan landscapes.

SANDEN ARTHUR G. (1893–)
Painter, watercolor, oil, tempera.
Teacher. Printmaker, lithography.
Sculptor. Born in Colorado Springs.
Lived in Bellingham, Washington,
1940. Pupil: University of Washington, Seattle; University of Oregon,
Eugene; Western Washington College
of Education, Bellingham; Cornish
Art School, Seattle, with Walter
Reese. Teacher of Art, Bellingham
High School. Author: *How to Draw
the Human Head.*

SANDERS, FRANK Artist. Lived in Seattle, Washington, 1912.

SANDHAM, HENRY J. (1842–1912) Painter. Illustrator, Western historical, marine subjects. He traveled to the West from Boston in 1882 for *Century Magazine* and also illustrated Roosevelt's *Hunting Trips of a Ranchman*.

SANDS, JERRY Painter, tempera. Lived in Seattle, Washington, 1947. Member: Puget Sound Group of Northwest Men Painters. Exh: Seattle Art Museum, 1947; Henry Gallery, University of Washington, Seattle, 1951.

SANGREN, ERNEST NELSON (1917) Painter. Printmaker. Pupil: University of Oregon; Chicago Institute of Design. Work: Portland Art Museum; Victoria & Albert Museum, London; many public murals. Art Instructor, University of Oregon, Eugene, 1947.

SARGENT, JOHN SINGER Painted briefly in the Rockies in 1916.

SAUDERS, E. J. (MRS.) Painter, oil. Lived in Kittitas County, Washington, 1909. Exh: Alaska-Yukon Pacific Expo, Seattle, 1909.

SAUL, LAUREL Painter, oil. Lived in Seattle, Washington, 1947. Exh: Seattle Art Museum, 1947; Henry Gallery, University of Washington, Seattle, 1951.

SAURBRUNN, C. F. Artist. Lived in Spokane, Washington, 1912.

SAVAGE, ANNIE DOUGLAS (1896– 1971) Painter, western. Illustrator. Teacher. Member: Canadian Group of Painters. Teacher, Montreal Public Schools. Illustrator of Canadian West Coast Indian lore featuring a landscape of the Upper Skeena River.

SAVAGE, BESSIE I. Painter, oil, landscapes. Exh: Washington State Arts & Crafts, 1909.

SAVAGE, LILLA D. (–1909) Painter, oil, watercolor. China painter. Craftsperson, tapestry, leather, wood. Teacher. Member: Tacoma Art League. 1896. Exh: Western Washington Industrial Exposition, 1891; Tacoma Art League, 1896.

SAVERY, ROBERT, HUBERT (1902–) Painter, oil, watercolor, black & white, animals, plants. Wood carving. Teacher. Born in England. Lived in Duncan, B.C., 1940. Pupil: Museum of Natural History, London, 6 years. Exh: Vancouver Art Gallery, 1937–39; B.C. Artists Exhibition, Vancouver, 1936–38; Vancouver, B.C. Art Gallery, 1936. Instructor of Art and Applied Art, B.C. Department of Education.

SAVIDGE, ELSIE Painter, oil. Lived in Seattle, Washington, 1939. Member: Women Painters of Washington. Exh: Seattle Art Museum 1937, 1939; Fredrick & Nelson, Seattle, 1943.

SAVITT, SAMUAL Illustrator. Writer, specializing in horses. Lived in New York, 1975. Work: Over 90 magazines and books. Western illustrator of cowboy genre. Pupil: Pratt Institute, Brooklyn New York. Worked as a ranch hand throughout the West painting and sketching.

SAWADA, IKUNE (1936–) Painter. Teacher. Pupil: Auburn University, Alpha Delta Pi Scholar. Exh: National Academy Galleries, New York. Exh: Annual Exhibition of Northwest Artists; Seattle Art Museum; Public High Schools, Japan.

SAWARD, VIRGINIA M. Painter, watercolor. Lived in Portland, Oregon, 1952. Exh: Southwest Washington Fair, Vancouver, 1949.

SAWCHUCK, GEORGE Painter. Sculptor. Lived in Vancouver, B.C., 1960's. Pupil: Iain Baxter. Worked with mixed mediums to form abstract landscapes.

SAWYER, EDMUND JOSEPH (1880–1971) Painter, watercolor, murals. Illustrator. Writer. Lived in Bellingham, Washington. Member: Northwest Bird & Mammal Society. Exh: Cornell Rockefeller Center. Work: New York State Museum; Yellowstone Park Museum; Bellingham Museum. Illustrator, writer: *Game Birds & Others of the Northwest.* WPA artist.

SAXON, WILLIAM Painter. Lived in Tacoma, Washington, 1930. Exh: Womens Club Annual Art Show, Tacoma, Washington, 1930.

SCHABERG, N. Painter, oil, expressionist style, Oregon coastal scenes. Painted in the late 20th century.

SCHAFER, FREDERICK (SCHAEFFER) (1839–1927) Painter, oil, landscapes. Born in Germany. He painted extensively after 1878 throughout Northern California, Washington, Oregon, Montana and Idaho painting mainly mountain landscapes. Some include figures (Indians and men on horseback). The bulk of his work was done prior to 1890 at which time he settled in San Francisco where he exhibited regularly with the San Francisco Art Association. Exh: Seattle Art Museum; Oakland Museum, Stenzel Collection; Shasta State Historical Monument.

SCHAFFER, DON (1904–1986) Painter, oil, watercolor, still life, figures, landscapes, seascapes, desert scenes. Before moving to Beaverton, Oregon from California he worked as designer and layout artist for the cartoon departments of Warner Brothers Studios, Metro-Goldwyn-Mayer and the Disney Studios. Study: Taxco Art School; Otis Art Institute; Chouinard Art Institute; University of California. Loved to paint the Oregon coast and sea. His celluloid paintings have been sold at Christie's in New York. Signed his work mostly "Shaffer".

SCHECHERT, DOROTHEA (1888–) Painter, watercolor, pastel. Lived in Poulsbo, Washington, 1941. Pupil: Tillie Piper, Seattle. Exh: Seattle Art Museum.

SCHECKLES, GLENN Artist. Member: Puget Sound Group of Northwest Men Painters, 1928.

SCHELLENBERGER, OTTO (1896–) Painter, oil, watercolor. Lived in Vancouver, B.C., 1940. Pupil: Vancouver School of Art (B.C.); Frederick H. Varley. Member: B.C. Society of Fine Arts. Exh: Vancouver Art Gallery, 1937.

SCHIMMEL, WILLIAM BERRY (1906–) Painter, traditional western. Illustrator. Teacher. Writer. Pupil: Rutgers University; National Academy of Design. Art Director of a major advertising agency in New York City. Teacher in Arizona, Wyoming, Colorado, Texas and Washington. In 1958 he wrote, *Watercolor, The Happy Medium.*

SCHLEY, ROBERT (1902–) Painter, oil, watercolor. Decorator. Born in Michigan. Lived in Portland, Oregon, 1940. Pupil: Chicago Art Institute; Pennsylvania Academy of Fine Arts; National Adademy of Design, New York. Exh: Portland Art Museum, 1936–39.

SCHLOTFELDT, ALMA E. (See DANIELS)

SCHMIDT, THEODOR B. W. (1869–) Painter, oil. Printmaker, wood block. Born in Germany. Lived in Monroe, Washington, 1940. Pupil: Chicago Art Institute; studied in Germany.

SCHMIDTMAN, MILDRED DEMP-STER (1900–) Painter, oil, water-color, indians of the Northwest. Print-maker, dry point. Lived in Seattle, Washington, 1982. Pupil: Edgar Fork-ner; Eustace Ziegler; Seattle. Mem-ber: American Artists Professional League; Women Painters of Washing-ton; Pacific Coast Painters. Exh: Seat-tle Art Museum, 1934; Seattle YWCA; Grant Galleries, New York, 1936–38; Portland Art Museum.

SCHMOHL, FRED C. (1847–1922) Sculptor. Born in Germany. Active in California during the expositions in San Francisco and San Diego of 1915. Exh: Alaska-Yukon Pacific Expo, Seattle, 1909.

SCHNEIDER, ALFRED E. Artist. Lived in Seattle, Washington, 1910.

SCHOLLE, CHARLES F. (1891–1987) Painter, oil, watercolor. Illus-trator. Commercial artist. Pupil: Coo-per Union, New York City; Art Stu-dents League, New York City. Painted extensively in the East Coast with stu-dios in New York City & Connecticut. In Portland, Oregon he painted land & seascapes for 30 years from his studio in Lake Oswego. Most well-known work: "Tillamook Burning" (Oregon).

SCHOLLE, LOUIS (1829–1911) Painter.

SCHOTT, CLIFFORD, F. Artist. Studio in Yakima, Washington, 1934.

SCHRAM, CHARLES Artist. Lived in Seattle, Washington, 1909.

SCHROEDER, GEORGE EUGENE (1865–1934) Painter, landscapes. Born in Illinois. Lived in Burley, Idaho. Studied in Europe. Member: American Federation of Arts. Exh: Idaho Artists Exhibition, Boise, 1926.

SCHROFF, ALFRED HERMANN (1863–1939) Painter, oil, watercolor. Printmaker. Stained glass designer.

Teacher. Lived in Eugene, Oregon. Studied: Cowles Art School. Main-tained a home in Carmel California where was a Professor at University of California's Summer School. Mem-ber: Oregon Society of Artists; Carmel Art Association; Oakland Art League; Professor of Art, University of Ore-gon, Eugene.

SCHROFF, LOUISE BARROWS (MRS. ALFRED) Painter. Teacher. Pupil: School of the Boston Museum of Fine Arts; Harvard University, Summer Session. Teacher of Drawing and Painting, University of Oregon, Eugene.

SCHUETT, MARGARET T. Artist. Studio in Seattle, Washington, 1932.

SCHULZ, WILLIAM GALLAGHER (1920) Sculptor. Painter. Studied and exhibited widely in Europe; Museum of Modern Art, New York.

SCHULZE, MABEL Painter, land-scapes. Lived in Spokane, Washing-ton, 1950. Member: Washington Art Association, 1950.

SCHUNKE, ADELE R. (1915–) Painter, oil, watercolor, tempera. Lived in Seattle, Washington, 1940. Pupil: University of Washington, Seat-tle. Exh: Seattle Art Museum, 1939. Teacher: Clover Junior-Senior High School, Tacoma.

SCHURMAN, WILLIAM J. Painter, oil, landscapes, genre. "Lumber Trucked, Sub Zero", genre scene found in Central Oregon dated 1960.

SCHUYLER, PHILLIP GRIFFIN (1910–1981) Painter, oil, portraits. Grew up in Tacoma, Washington. Pu-pil: Art Students League, New York; Oregon State University. Artist for the Boston Herald. War Artist in Vietnam.

SCHWIDDER, ERNST CARL (1931–) Sculptor, Designer. Pupil: University of Washington. Work:

wood and stone sculpture and furniture for churches nationally; St. Matthew's Lutheran Church, Portland, Oregon; Demaray Hall, Seattle Pacific University; Our Saviour Lutheran Church, Everett Washington. Exh: Portland Art Museum.

SCOBIE, NELLEMARY Painter. Lived in Eureka in Far Northern California Coast.

SCOTT, CHARLES HEPBURN (1886–) Painter, oil, watercolor, black & white, pastel. Printmaker, etching. Lecturer. Lived in Vancouver, B.C., 1940. Studied widely in Europe. Member: Canadian Group of Painters; Founding member, Vancouver, B.C. Society of Fine Arts, 1919; Canadian Society of Graphic Arts. Exh: Vancouver Art Gallery, 1933; Canadian Coronation Exhibition, London. Director: Vancouver School of Art. He settled in Vancouver in 1912 as art supervisor in the school system.

SCOTT, CYNTHIA W. Artist. Lived in Everett, Washington, 1931.

SCOTT, ESTHER E. (1906–) Painter, oil, watercolor. Printmaker, block print. Born in Yakima, Washington. Lived in Toppenish, Washington, 1940. Pupil: Martha Bolman Nevitt. Exh: Washington State Federated Clubs, Fine Arts Festival, Walla Walla, 1938; Public Library, Toppenish; Whitman College, Walla Walla, 1938; Eastern Washington Fair, Yakima, 1938.

SCOTT, GEORGE M. Commercial artist. Lived in Seattle, Washington, 1938.

SCOTT, HENRY ELIOT (1909–) Painter, oil, watercolor. Printmaker, woodcut. Born in Grants Pass, Oregon. Lived in Los Angeles, 1940. Pupil: Harvard University; University of Munich; University of Oregon, Eugene; Mills College, Oakland; Art Center, Los Angeles. Exh: Oakland Municipal Gallery, 1937; Chamber of Commerce, Portland, Oregon, 1936; Reed College, 1936.

SCOTT, JOHN Artist. Lived in Tacoma, Washington, 1906.

SCOTT, MAMMIE Artist. Lived in Seattle, Washington, 1910.

SCOTT, PAUL M. (1910–) Painter, oil, watercolor. Born in Puyallup, Washington. Pupil: Armstrong School of Art, Tacoma; Derbyshire School of Art, Seattle. Exh: Tacoma Art League, 1940.

SCOTT, QUINCY (1882–) Painter, wash, tempera, oil. Cartoonist. Drawing, pen & ink, brush, crayon. Born in Ohio. Lived in Portland, Oregon, 1940. Pupil: Art Students League of New York. Editorial cartoonist, *The Oregonian*, Portland. Represented by cartoons in Columbus Gallery of Fine Arts; Huntington Gallery; Medill School of Journalism; others.

SCOTT, RETTA E. Painter, oil, watercolor. Born in Omak, Washington. Pupil: Cornish Art School, Seattle; Chouinard Art Institute, Los Angeles. Artist for Walt Disney Productions. Exh: Northwest Artist, 1939; Seattle Art Museum, 1937, 39; solo show, Sunset Club, Seattle, 1939.

SCOTT, STUART, R. (1904–) Painter, watercolor. Born in Nanaimo, B.C. Lived in Vancouver, 1940. Pupil: Vancouver School of Art; Federal School, Chicago. Exh: Vancouver Art Gallery, 1936; Canadian Society of Watercolor Artists; Royal Canadian Society of Artists.

SCRAM, EGBERT Artist. Lived in Seattle, Washington, 1920.

SEAL, MABEL Painter. Member: Founding member, Vancouver, B.C. Fine Art Society, 1919.

SEAQUEST, CHARLES L. (1864–1938) Painter, oil, watercolor. Lived in Portland, Oregon. Pupil: Clyde Leon Keller. Member: Oregon Society of Artists.

SEARLESS, QUENTEN L. Painter, oils. Lived in Yakima, Washington, 1947. Exh: Seattle Art Museum, 1947.

SECREST, EDITH E. Artist. Lived in Seattle, Washington, 1901.

SEDGWICK, FRANCIS MINTURN (1904–) Primarily a California Sculptor of Western monuments, he has a major piece in Washington.

SEGESMAN, JOHN F. (1899–) Painter, oil, watercolor, tempera. Illustrator. Born in Spokane Washington. Lived in Seattle, 1940. Pupil: University of Washington, Seattle; Cornish Art School, Seattle; American Academy of Art, Chicago. Member: Puget Sound Group of Northwest Men Painters. Illustrator, Scripps league of newspapers.

SEIDLER, DORIS (1912–) Painter. Born in London. Awards: National Association of Women Artists; Washington Watercolor Club; Chicago Society of Etchers. Work: Seattle Art Museum; Library of Congress; Philadelphia Museum of Art.

SELANDER, ARTHUR A. (1884–1978) Painter, oil, watercolor, landscapes of Washington and Oregon scenery. Drawing, pencil, charcoal. Born in Marshfield, Oregon, now Coos Bay. At one time he worked as a cartoonist for the *Oregonion*. Member: Oregon Society of Artists, president for three terms; League of Oregon Artists, honorary membership; The Society of Western Artists, San Francisco California; The League of Professional Artists, New York. Prolific artist, painted with Clyde Leon Keller from the 1920's.

SELANDER, MENALKAS Painter, watercolor, seascapes, landscapes of the Northwest. Son of artist, Arthur A. Selander. Born in Portland, Oregon, active in the 1950–70's.

SEMEYN, JACOBUS H. Artist. Lived in Seattle, Washington, 1917.

SERGEANT, JUDSON T. Artist. Lived in Seattle, Washington, 1907.

SERISAWA, SUEO (1910–) Painter. Teacher. Born in Japan. Immigrated to Seattle, Washington in 1918, moving to Long Beach, California. Member: past president, California Watercolor Society.

SERISAWA, YOICHI (1874–1927) Painter, oil, landscapes. Born in Japan. Immigrated to Seattle, Washington in 1915, settling in Southern California in 1924. Painting of Mt. Rainier.

SERSEN, FRED M. (1890–1962) Painter. While studying art in Portland, Oregon He was commissioned by the Canadian Government to paint a mural for Pan Pacific International Expo, 1915. Spent most of his life in California as head of special effects for 20th Century Fox where he was nominated for nine Academy Awards and received two Oscars.

SEWALL, HOWARD STOYELL (1899–) Painter, oil. Muralist. Teacher. Active mainly in Portland, Oregon. Member: American Artists Council. Award: Architectural League of New York for mural, "Stone-cutter", 1938. Work: Oregon City High School; Timberline Lodge, Mt. Hood, Portland, Oregon; many public works. Exh: Portland Art Museum. WPA project.

SEWELL, ADA Artist. Studio in Spokane, Washington, 1912.

SEWELL, ALICE (EARLY 20TH CENTURY) Sculptor. Painter. Printmaker. Teacher. Lived in Portland, Or-

egon. Pupil: Art Students League of New York City; Portland Museum Art School. Member: Oregon Society of Artists. Many public works.

SEWELL, EDWARD (1905–) Painter, watercolor, oil. Lived in Portland, Oregon, 1940. Pupil: Museum Art School, Portland; Art Students League of New York. Member: Oregon Ceramic Studio. Work: many public buildings. Exh: Los Angeles Museum of Art, 1933–37; Chicago Art Institute; Seattle Art Museum, 1934–37; San Francisco Museum of Art, 1940; Riverside Museum, New York, 1940.

SHADBOLT, JACK LEONARD (1909–) Painter, oil, watercolor. Modernist, Northwest Coast Indian scenes, surreal floral abstracts. Teacher. Lived in Vancouver, B.C., 1940. Pupil: Vancouver, B.C. School of Art; New York; London; Paris; Frederick H. Varley, Vancouver. Influenced greatly by Emily Carr. Instructor of Drawing and Painting, Vancouver School of Art. Writer of articles on contemporary Canadian art. Exh: Vancouver Art Gallery, 1936–38. Work: murals, Canadian public buildings.

SHADRACH, JEAN Painter, acrylic, watercolor and sumi'ink, landscapes, wildlife and flowers of Alaska. Born in Colorado. Pupil: University of Colorado; Alaska Pacific University; Alaska Community College. Work: Anchorage Fine Arts Museum. Exh: All-Alaska Art Exhibition, Anchorage, 1968; Governor's Award, Alaska, 1970.

SHANK, MAURITA (1916–) Painter, oil. Printmaker. Teacher. Born and lived in Tacoma, Washington, 1941. Pupil: University of Washington, Seattle. Exh: College of Puget Sound, 1940; Seattle Art Museum; Northwest Printmakers, 1937.

SHANKLIN, ETTIE Painter, oil. Lived in Tacoma, Washington, 1940. Pupil: Edgar Forkner, Seattle. Member: Tacoma Art Association. Exh: Seattle Art Museum, 1937–39.

SHANNON, IDA MAE GARMEYER (1890–1962) Painter, oil, lifesize Northwest Indians. Lived on Vashon Island, Washington. Known as a lightning artist completed paintings in minutes & sold them wet to the crowd. Painted on a variety of materials, such as elk and deer hides.

SHARP, F. C. (MISS) Artist. Lived in Tacoma, Washington, 1891. Member: Tacoma Art League, 1892.

SHARP, JOSEPH HENRY (1859–1953) Painter. Very Important Taos Painter of Indian Genre. At 24 he made a sketching trip to Santa Fe, New Mexico, California and the Columbia River sketching the Indian tribes in 1883.

SHARP, THORTON G. Painter. Member: Founding member, Vancouver, B.C. Society Fine Arts, 1919. Lived in Vancouver, 1933.

SHARPE, H. PERCY Painter. Lived in Seattle, Washington, 1921.

SHARPE, VERA M. (1905–) Painter, watercolor, pastel, miniatures. Drawing, pencil portraits. Clay modeling. Born and lived in Vernon, B.C. Pupil: University of British Columbia, Vancouver. Exh: Vancouver Art Gallery, 1935–37.

SHARPSTEIN, W. C. (MRS.) Painter. Lived in Tacoma, Washington, 1891–1896. Member: Tacoma Art League, 1892.

SHAUGHNESSY, ZORA C. Artist. Lived in Tacoma, Washington, 1942. Member: Tacoma Art League. Exh: Washington State Historical Society, 1945.

SHAW, AGNES Artist. Lived in Seattle, Washington, 1928.

SHAW, DICK (1916–) Illustrator. Born in and lived in Vancouver, Washington. Pupil: Cornish Art School, Seattle; Chicago Art Institute. Exh: *Saturday Evening Post*, *Collier's Weekly*.

SHAW, HARRIETT MCCREARY (1865–1934) Painter, oil, watercolor, portraits, landscapes. Ivory miniatures. Writer. Teacher. Award: silver medal for ivory miniatures, St. Louis Exposition, 1904; gold and silver for portraits, Seattle Fine Arts Society. Author, *Outlines of American Painting*.

SHAW, JACK (1898–) Painter, oil, watercolor, pastel. Lived in Kirkland, Washington, 1941. Pupil: Chicago Art Academy; Mark Tobey. Member: Washington Artists Union. Work: murals in many public buildings. Exh: Seattle Art Museum; Pennsylvania Academy of Fine Arts. WPA artist.

SHAWHAN, F. E. Artist. Lived in Walla Walla, Washington, 1902.

SHECKELS, GLENN (–1939) Commercial artist. Lived in Seattle, Washington. Pupil: Leon Derbyshire; Oliver Fiedeman. Exh: Seattle Art Museum, 1928–29. Art Director, Western Engraving and Colortype, Seattle. Shared a studio with William Klamm and Roy Terry.

SHEEHAN, EVELYN (1919) Painter, water based medium for painting, collage. Pupil: Scripps College; Phil Dike & Rex Brandt. Work: Museum of Art, University of Oregon, Eugene; National Academy of Design, New York; Cheney Cowles Museum, Spokane; Northwest Exhibition; Seattle Art Museum; San Francisco Museum of Art. Exh: Spokane Annual Art.

SHEETS, MILLARD OWEN (1907– 1989) Very important California watercolorist, his works are held at the Seattle Art Museum, among many others.

SHEFFERS, PETER WINTHROP (1893–) Painter. Teacher. Lived in Portland, Oregon. Studied in Germany; London. Member: American Artists Professional League; Oregon Society of Artists; Carmel Art Association.

SHELDEN, CLIFFORD GEORGE Painter, oil. Lived in Everett, Washington, 1926–37. Teacher: Everett Public Schools, Washington.

SHEPARD, ISABEL BENSON (1908–) Painter, watercolor. Printmaker. Craftsperson. Born in Spokane, Washington. Lived in Seattle, 1941. Study: University of Washington, Seattle; Art Center, Riverside California. Exh: Northwest Printmakers; Seattle Art Museum, 1937, 1938.

SHEPHERD, MARY E. Painter, oil, portraits. Lived in Seattle, Washington, 1917. Exh: Alaska-Yukon Pacific Expo, Seattle, 1909; Tacoma Art League, 1914.

SHEPARD, MELLIE E. Artist. Lived in Seattle, Washington, 1922.

SHEPARD, OLIVIA FAILING (1906–) Painter, oil, watercolor, tempera. Wood carving. Born and lived in Portland, Oregon. Pupil: Museum Art School, Portland; Art Students League of New York. Exh: Portland Art Museum, 1932–38; Seattle Art Museum.

SHERA, R. E. (MISS) Painter, oil, portraits. Lived in Tacoma, Washington, 1892. Member: Tacoma Art League, 1892.

SHERFEY, FLORENCE Painter, oil, landscapes. Lived in Spokane, Wash-

ington, 1948. Exh: Pacific Northwest Artists Annual Exhibition, 1948.

SHERIDAN, BERNARD LEROY (1904–) Display designer. Lived in Seattle, Washington, 1940. Pupil: Chicago Academy of Fine Arts; American Academy of Art. Member: Federal Art Project, WPA.

SHERIDAN, LILLIAN L. Artist. Lived in Seattle, Washington, 1924.

SHERMAN, MARTHA L. JOHNSTON (1909–) Printmaker. Sculptor. Born Roseberry, Idaho. Lived in Mount Vernon, Washington, 1940. Pupil: University of Washington; Alexander Archipenko. Exh: Northwest Printmakers, 1932–34.

SHERMAN, MAUD Painter. Lived in Vancouver, B.C., 1940. Secretary, Pasovas Arts Club.

SHERWOOD, J. (MISS) Artist. Lived in Tacoma, Washington, 1891. Member: Tacoma Art League, 1892.

SHIDE, MYRA R. Artist. Lived in Spokane, Washington, 1913.

SHINROCK, MAUD Artist. Lived in Spokane, Washington, 1909–28.

SHISLER, CLARE SHEPARD Painter, watercolor. Miniaturist. Lived in Seattle, Washington, 1924. Member: The Triad Group, 1909. Exh: Alaska-Yukon Pacific Expo, Seattle, 1909, (medal); Seattle Art Museum; Washington State Arts & Crafts, Seattle, 1908; Seattle Fine Arts Society, 1913; Golden Gate International Exposition, 1939.

SHKURKIN, VLADIMIR P. (1900– 1985) Painter, oil, murals, landscapes. Craftsman. Lived in Seattle, Washington, 1925–38. Murals for Seattle public buildings. Exh: Seattle & Golden Gate Expositions. Work: Russian Samovar, Seattle; Icons, St Spiridon's Russian Orthodox Church, Seattle.

SHOESMITH, MARK (1912–) Sculptor, stone, marble, granite, wood. Teacher. Born in Payette, Idaho. Lived in Salem, Oregon, 1940. Pupil: University of Oregon: Columbia University; scholarship, Roerich Museum, New York. Work: many public buildings in Oregon, New York. Exh: New York World's Fair, 1939. Many stone & wood works in public places.

SHORE, HENRIETTA (1880–1963) Painter, Lithographer, Muralist. Important California artist. After establishing a studio in Carmel she lived there the rest of her life. Work: University of Washington, Seattle.

SHORES, KENNETH (1928–) Painter, clay, mixed media. Abstracts. Pupil: University of Oregon, Eugene.

SHOREY, LIZZIE NENNISH (1852– 1955) Painter. Teacher. Lived in Puyallup, Washington. Mother of artist, Maude K. Shorey.

SHOREY, MAUDE KENNISH (1882–) Painter, oil, watercolor, portraits, landscapes. Teacher. Lived in Puyallup, Washington, 1962. Pupil: Central Washington College, Ellensburg. Teacher: Washington Public Schools, 17 years. Exh: sweepstakes winner, Western Washington Fair, 1929.

SHOUDY, JOHN (MRS.) Painter, oil. Lived in Kittitas County, Washington, 1909. Exh: Alaska-Yukon Pacific Expo, Seattle, 1909.

SHULTZ, RALPH T. Illustrator. Lived in Tacoma, Washington, 1897. Illustrator for Tacoma Sunday and Daily Ledgers. Member: Art Students League, New York; Ferry Museum, 1899.

SIBLEY, GLADYS M. (–1964) Painter, oil. Lived in Seattle, Washington. Exh: Seattle Art Museum; Frye Museum, Seattle.

SIDWELL, M. A. Painter, oil, landscapes. Lived in Seattle, Washington, 1907.

SIEGRIEST, LOUIS BASS (1899–) Painter. Important California artist. Member: San Francisco Society of Six. Exh: Oakland Art Gallery. Worked as a commercial artist in Seattle. Many awards.

SILSBY, WILSON (1883–1952) Painter. Born in Chicago. Work: Metropolitan Museum of Art; Library of Congress; Pennsylvania Academy of Fine Arts; Crocker Art Gallery; Seattle Art Museum. Primarily a California artist.

SILVER, ROSE RHANA (1902–) Painter, pastel. Illustrator. Lived in Seattle, Washington, 1934. Cover: *New Yorker* magazine. Member: University of Washington Art Club.

SIMMS, THEODORE FREELAND (1912–) Painter. Industrial designer. Teacher. Lived in Seattle, Washington, 1951. Pupil: D. Lutz; M. Elrod; A. Montgomery; A. Jones; H. Harvey; M. Gniesen; G. Lukens. Member: Southern California Watercolor Society. Exh: Denver Art Museum, 1934, 1937.

SIMPSON, NANCY GRISWOLD (1902–) Painter, portraits, charcoal, pastel. Lived in Seattle, Washington, 1941. Pupil: Art Students League, New York. Member: Women Painters of Washington. Exh: Seattle Fine Art Society, 1920–24; Seattle Art Museum, 1937; Peninsular Artists, Monterey California.

SIMPSON, ROBERTS (1897–) Printmaker, wood block. Designer. Lived in Portland, Oregon, 1940. Pupil: Museum Art School, Portland; California School of Fine Arts, San Francisco.

SIMPSON, WILLIAM E. (MRS.) Sketcher, pen & ink. Lived in Tacoma,

Washington, 1892. Pupil: J. E. Stuart. Member: Tacoma Art League, 1891, 1892.

SINCLAIR, ARCHIE (1890) Painter. Designer, stained glass. Lived in Portland, Oregon. Pupil: Clyde L. Keller.

SINCLAIR, FRANK E. Commercial artist. Lived in Olympia, Washington, 1949.

SINCLAIR, IRVING (1895–1969) Painter, portraits. Born in British Columbia. Settled in San Francisco in 1917 where he worked as a billboard artist for Foster & Kleiser. Well known for his celebrity portraits.

SINGERMAN, GERTRUDE STERN Painter. Lived in Seattle, Washington 1917–24.

SISSON NELLIE S. Painter, oil, watercolor. Lived in Bremerton, Washington, 1941. Pupil: Chicago Art Institute; studied in Europe. Exh: American Artists Professional League, Portland; Oregon Society of Artists. Advisory Art Committee, Portland. Exh: Washington State Arts & Crafts, 1909.

SISTER, MARY ROSINA (1888–) Painter, oil, watercolor. Teacher. Lived in Portland, Oregon, 1940. Pupil: Holy Names Academy, Seattle. Member: American Artists Professional League. Exh: Portland Art Museum, 1937–38; Meier & Frank, Portland, 1938.

SKILES, VIOLET Painter, watercolor. Exh: American Watercolor Society; Allied Artists of America; Pacific Northwest Arts & Crafts Fair; Women Painters of Washington; Eastern Washington Watercolor Society.

SKIRVING, JOHN Painter, marinescapes. Architectural Designer. Exh: "Skirving's Moving Panorama", "Colonel Fremont's Western Expedition, Pictorialized", Boston, 1849. He

used Fremont's sketches of scenes on the overland journey to Oregon and California plus published depictions of the West of others.

SKOV, ARNY R. (1938–) Artist. Teacher: Art Department, Boise State University, Idaho.

SLATER, EMMA Painter, landscapes. Active in the late 19th to early 20th century in Oregon and California. Pupil: S. Parrott (Washington); E. Barchus (Portland). Lived in Oakland, California from 1906–1911.

SLAUGHTER, JULIA CORNELIA WIDGERY (1850–1905) Painter, oil, watercolor, pastel, landscapes, portraits. Born in England. Lived in Tacoma, Washington, 1891–1904. From a renowned artistic family she helped establish The Tacoma Art League in late 1880's. Exh: National Academy Design; American Art Assocication. Member: only female board member, Ferry Museum, Tacoma.

SLOAN, LYDIA MARY (1890–) Painter, oil. Teacher. Lived in Lewiston, Idaho, 1940. Pupil: Chicago Art Institute; University of Washington. Exh: Boise Art Museum, 1936; Lewis-Clark Hotel, Lewiston, 1939.

SLOANE, SIDNEY E. Artist. Lived in Spokane, Washington, 1933.

SLY, FRANKLIN A. Painter. Lived in Seattle, Washington, 1926.

SMALL, ALICE JEAN Painter, oil, watercolor. Printmaker. Teacher, Tacoma Public Schools. Illustrator of children's books. Member: Northwest Printmakers; Northwest Watercolor Society. Exh: Seattle Art Museum; Washington State Historical Society, 1950.

SMEDLEY, WILLIAM THOMAS (1858–1920) Painter, watercolor, portraits. Drawing, pen & ink. Illustrator, Western Canada, New York

City. Study: Laurens, Paris. Returned to New York at 22 becoming an important illustrator of social life for the magazines. In 1882 he received a commission from the publishers of *Picturesque Canada*, traveling west for a series of illustrations.

SMILLIE, JAMES DAVID (1833–1909) Painter, mountain landscapes, Illustrator. Engraver. Writer. Became an important engraver working with his father, specializing in bank-note vignettes. After 1864 he began painting the mountain ranges of the American West traveling widely and exhibiting his engravings.

SMITH, C. C. (MRS.) Artist. Lived in Seattle, Washington, 1910.

SMITH, CECIL A. (1910–) Painter, oil, watercolor. Drawing, dry brush. Printmaker, lithography. Illustrator. Teacher. Lived in Cary, Idaho, 1940. Pupil: John Carroll; Max Weber; Kuniyoshi, New York. Member: American Artists Congress. Exh: Boise Art Gallery, 1939; Corcoran Art Gallery, Washington, D.C., 1934. Grew up on his family's cow ranch, the Bar Bell Land and Cattle Company in Idaho. He was a working cowboy and a realistic painter also an illustrator for *Sunset Magazine* and teacher.

SMITH, DAN (1865–1934) Painter. Illustrator. Etcher. Studied in Europe returning to New York City becoming a member of the art staff of *Leslie's Magazine* from 1890–1897. His sketches depict life in the West, including Alaska, based on his many excursions into the area. For more than twenty years his dry brush drawings appeared on the cover of *Sunday World Magazine*.

SMITH, DOROTHY E. Painter, oil, landscapes. Lived in Seattle, Washington, 1945. Exh: Seattle Art Museum, 1945.

SMITH, E.D. Artist. Lived in Pullman, Washington, 1910.

SMITH, EDWARD HAROLD Painter, oil. Lived in Seattle, Washington, 1934. Exh: Seattle Art Museum, 1934.

SMITH, ERWIN E. (1888–1947) Texas cowboy. Indian Sculptor. Sketch Artist. Photographer. Studied in Chicago and Boston. Spent 25 years in ranch life sketching cowboy and pioneer subjects and making thousands of photographs to illustrate George Patullo's Western stories. His sculpture includes "Nez Percé Indians of Oregon".

SMITH, F. E. Painter, watercolor, drawings, landscapes, figures, still lifes, genre. Active in Portland, Oregon from the 1930's to 1950's.

SMITH, FERN THATCHER (1908–) Painter, watercolor. Born in North Dakota. Lived in Salem, Oregon, 1992. Pupil: studied with her husband, Fred Smith. Together they helped to form the Oregon Watercolor Society in 1965. Exhibited widely in the Northwest winning many awards.

SMITH, FLORENCE Artist. Lived in Seattle, Washington, 1917.

SMITH, FRED (1903–) Painter, watercolorist. Teacher. Born in Salem, Oregon. He did not pursue his art until retiring in 1959. Married to artist Fern Thatcher. Together they helped form the Oregon Watercolor Society in 1965. Exhibited widely in the Northwest and has won many awards.

SMITH, FRED (MRS.) Artist. Lived in Tacoma, Washington, 1891. Member: Tacoma Art League, 1892.

SMITH, FREDERIC MARLETT-BELL (1846–) Premier painter who travelled the mountains of British Columbia on horseback depicting the new wilderness of the 1880's. He returned to paint the Rockies twenty times.

SMITH, GORDON Painter, Lived in Vancouver, B.C. Exh: Biennial Canadian Painters, 1955.

SMITH, HAROLD THOMAS FAULKNER (1893–) Painter, oil, watercolor, pastel, tempera. Printmaker, etching, lithography. Sculptor. Lived in Vancouver, B.C., 1940. Studied in England. Exh: Vancouver Art Gallery, 1934–37; Ontario Society of Artists, Toronto, 1921; Canadian Society of Painters, 1935. Owner: H. Faulkner Smith School of Applied and Fine Art, Vancouver, B.C.

SMITH, JEROME (JOSIAH) HOWARD (1861–1941) Illustrator. Cartoonist. Western Genre Painter. Lithographer. As a cartoonist he worked for the Chicago Rambler. By 1887 he was in New York City as a cartoonist for *Judge* which became *Leslie's Magazine*. He was sent to the Northwest as a correspondent at which time he did a series of illustrations of the Northwest on a wide range of genre: Indian troubles, cattlemen, the Chinese. In 1890 he spent two years studying in Paris. Returning he wandered through the West as a miner, cowboy, driver and finally married in British Columbia where he painted Western scenes for reproduction as lithographs.

SMITH, JULIA E. (1893–1966) Painter. Lived in Seattle, Washington, also Santa Barbara, California. Daughter of Tacoma pioneers.

SMITH, KATE A. Painter. Member: Founding member, Vancouver, B.C. Fine Art Society, 1919.

SMITH, KATHARINE CONLEY (1895–) Painter, watercolor. Drawing, pen & ink. Printmaker, linoleum block. Lived in Mt. Vernon,

Washington, 1941. Pupil: School of Applied Art, Chicago. Illustrator, "Dog of the Pioneer Trail".

SMITH, LANDGON (1870–1959) Painter, oil, watercolor. Illustrator, pen & ink. Commercial artist. Moved to Pasadena as a child he went east in 1895 to work for the *New York Herald*. After the turn of the century, his career as an illustrator zoomed and between 1907–1912 he produced 22 covers for *West Coast Magazine*, traveling to the Pacific Northwest. He died in the tiny gold town of Grass Valley in the Sierra Nevada Mountains.

SMITH, MARGERY HOFFMAN (1888–) Painter, oil, tempera. Designer, furniture, textile. Decorator. Craftsman. Lived in Portland, Oregon, 1940. Pupil: Art Students League, New York; Portland Art Association. Member: Arts and Crafts Society, Portland; Oregon State Director, Oregon Art Project. Designed furniture for Timberline Lodge, Mount Hood, Oregon.

SMITH, MARIE VAUGHAN (1892–1977) Painter. Leather Craftsperson. Bookbinder. Born in Tacoma, Washington. Study: Portland Oregon Museum Art School; University of Oregon; UCLA; Chouinard School of Art, Los Angeles.

SMITH, MARY LOUISE Artist. Lived in Tacoma, Washington, 1909. Member: Tacoma Art League, 1892.

SMITH, SHARON Painter, watercolorist. Graphic artist. Pupil: California State University at Long Beach. Primarily a California and Hawaiian artist, many of her works have been found in and about Portland, Oregon of Northwest subjects.

SMITH, TOM (1913–) Sketcher. Draftsman. Lived in Tacoma, Washington, 1935. Exh: Seattle Art Museum, 1935.

SMITH, W. THOMAS Painter, portraits. Lived in Spokane, Washington, 1909. Portraits of the local elite of Spokane.

SMITH, WILLIAM HAROLD Painter, oil. Drawing, pencil. Lived in Seattle, Washington, 1920. Exh: Seattle Art Museum, 1934–35.

SMITHSON, ELIZABETH A. Painter, watercolor. Lived in Seattle, Washington, 1951. Teacher: Helen Bush School, Seattle, Washington, 1944. Exh: Seattle Art Museum, 1940, 1946.

SMITHSTON, O. A. Artist. Lived in Seattle, Washington, 1909.

SMYLY, MRS. F. H. Painter. Lived in Vancouver, B.C., 1940.

SNELL, BERTHA DENTON (1872–1957) Painter, landscapes. Attorney. Lived in Tacoma, Washington. Pupil: Max Meyer. First woman admitted to the Washington State Bar, 1899.

SNIDER, ADOLPH G. Artist. Lived in Seattle, Washington, 1928.

SNIDER, MARGURITE E. Painter. Teacher. Interior Decorator. Lived in Seattle, Washington, 1930. Member: Tacoma Fine Arts Association, 1925.

SNIDER, P. M. Artist. Lived in Tacoma, Washington, 1951. Member: Tacoma Art League, 1951. Exh: Washington State Historical Society, 1945.

SNYDER, AMANDA TESTER (1894–1980) Painter, oil. Printmaker, woodcuts, linocuts. She was of the C. S. Price circle in Portland, Oregon.

SNYDER, E. F. (MRS.) Artist. Lived in Tacoma, Washington, 1899.

SNYDER, MAYBELLE Painter, oil, still lifes, landscapes. Exh: Washington State Arts & Crafts, 1909.

SOHON, GUSTAVUS (1825–1903) Painter, watercolor. Sketcher, pen &

ink, pencil, portraits, scenics. Topographer. Born in Prussia. Lived in the Northwest for 9 years. At age 17 Sohon enlisted in the army and helped blaze the trail across the Coeur d'Alene Mountains to Walla Walla, Washington. He recorded pictorially the treaty negotiations, maps and illustrations for government reports. In 1853 he was stationed in Fort Dallas in the Oregon Territory, then was sent with supplies for Major Stevens, the first governor of the Washington Territory and in charge of the exploration of the Northern Railway route from the Mississippi River to Puget Sound. He was assigned Lt. Mullans's party surveying the Rocky Mountain passes. He learned the Indian languages and made sketches for lithographs in the Steven's report. He drew the first panoramic view of the main chain of the Rockies. As a civilian, Sohon returned to the Northwest to help construct the wagon road over the Rockies. His Indian drawings are in the National Museum (Smithsonian). Many original sketches and paintings are in the Washington State Historical Society.

SOLDATKIN, PAUL (1910–) Painter, oil, pastel. Printmaker. Lived in Vancouver, B.C., 1940. Pupil: Russian Art Institute, Harbin, China. Exh: B.C. Artists, 1937.

SOLOMAN, MAUDE BEATRICE Painter. Sculptor. Seattle, Washington. Illustrated: *Aristocrats of the North*.

SOLTON, PEGGY Commercial artist. Studio in Yakima, Washington, 1941.

SOMERVELL, W. MARBURY Painter. Printmaker. Lived in Seattle, Washington, 1917.

SONDAG, LAURETTA (1900–1930) Painter, oil, watercolor. Teacher. Pupil: Chicago Art Institute; Art Students League, New York; Tiffany

Foundation Scholorship; John Horton; John Carroll. Exh: Seattle Art Museum, 1939; Frederick & Nelson, Seattle, 1939.

SONDERGARD, WILLIAM V. Artist. Lived in Spokane, Washington, 1930.

SONNICHSEN, YNGVAR (1873–1938) Painter, oil, landscapes, murals. Printmaker, etching. Lived in Seattle, Washington. Pupil: Royal Academy, Belgium; Julien Academy, Paris. Member: Seattle Fine Arts Society; Puget Sound Group of Northwest Men Painters, 1933; gold & silver medals, Alaska-Yukon Pacific Expo, Seattle, 1909. Best known for his portraits & landscapes of Southeastern Alaska.

SOREFF, HELEN Painter, acrylic. Pupil: Art Students League, New York. Work: Big Thing Show, Seattle, Washington Art Committee, 1969.

SORENSON, DONALD E. Painter, oil. Lived in Vancouver, Washington, 1949. Exh: Seattle Art Museum, 1949.

SORENSON, EVELYN (1908–) Painter, oil, watercolor, still lifes, flowers. Born in Everett, Washington. Lived in Bothell, Washington, 1940. Pupil: Normal School, Bellingham, but mainly self-taught.

SORKNER, E. Painter. Lived in Seattle, Washington, 1915. Member: Seattle Fine Arts Society, 1915.

SOTER, JOHN Painter. Lived in Seattle, Washington, 1922.

SOUTHER, GAIL (MISS) Painter, watercolor. Lived in Pacific County, Washington, 1909. Exh: Alaska-Yukon Pacific Expo, Seattle, 1909.

SOUTHILL, OLIVER Artist. Lived in Seattle, Washington, 1907.

SOUTHWORTH, DR. FRED W. (1860–1946) Painter, oil, watercolor,

landscapes, marines. Illustrator. Medical doctor. Born in Ontario, Canada. Lived in Tacoma, Washington. Mainly self taught. Member: Tacoma Art League. Exh: Seattle Art Museum; Physicians Art Club, New York. Covers, *Literary Digest Magazine*.

SPAFFORD, MICHAEL (1935–) Painter, mixed media, abstracts. Pupil: Harvard University; Tiffany grant, Rome. Teacher: University of Washington.

SPALDING, ELIZA HART (1807–1851) Painter. Oregon Territory. Protestant missionary. Came to Oregon in 1836.

SPARLING, MINNIE Painter. Teacher of the first class at the Territorial University of Washington in 1878 to 8 students. Commissioned to paint portraits of past governors which were hung in the State Capitol.

SPECKERT, C. M. (MRS.) Artist. Lived in Seattle, Washington, 1914.

SPENCER, DUANE JARARD (1909–1982) Painter, oil, watercolor, portraits. Commercial artist. Illustrator. Lived in Spokane, Washington, 1932. A resident of San Francisco by the late 1930's.

SPENCER, GRAHAM L. (1913–) Painter, collage. Lived in Seattle, Washington, 1953. Pupil: E. Norling. Commercial artist, J. C. Penney, 1951.

SPENCER, MYFANWY (1916–) Painter, oil, watercolor. Lived in Victoria, B.C., 1940. Pupil: Trueman Hicks, Boston; studied in London. Exh: Vancouver Art Gallery, 1938.

SPEROW, EVA M. Artist. Lived in Seattle, Washington, 1914.

SPICER, CATHERINE (1893–1929) Painter. Born in Washington. Study: Otis Art Institute, Los Angeles. Exh: California Watercolor Society, 1928.

SPIEGAL, RICHARD (1903–) Painter, oil, acrylic, impressionist, expressionist. Born in Germany. Lived in Portland, Oregon until the 1980's. Member: Portland Museum, artist member. Exh: Portland Art Museum, 1946 and 1966; widely in Oregon.

SPITZER, HUGO Artist. Lived in Seattle, Washington, 1910.

SPONENBURGH, MARK (1916) Sculptor. Pupil: Ecole Beaux-Arts, Paris; University of London; University of Cairo. Work: Portland Art Museum; Museum of Modern Art; Egypt and others. Exh: Pennsylvania Academy of Fine Arts; Durand-Ruel, Paris. Associate Professor, University of Oregon, 1946–56. Many awards and associations.

SPOTTS, NELL Commercial Artist. Lived in Seattle, Washington, 1926.

SPRAGUE, JULIA FRANCES (1826–1886) Painter. Member: Tacoma, Washington Fine Art Association. Wife of General John W. Sprague.

SPRENGLE, ENID A. Artist. Lived in Seattle, Washington, 1916.

SPROUL, J. R. Painter, watercolor. Lived in Seattle, Washington, 1935. Exh: Seattle Art Museum, 1935.

SPRUNGER, ELMER (1915–) Painter, wildlife scenes. An important Montana artist, he traveled and worked in Seattle, Washington until 1950.

SPURGEON, SARAH EDNA M. (1903–) Painter. Teacher. Pupil: Harvard University; Grand Central School of Art, New York; Grant Woods; Paul Sachs. Carnegie Fellowship, 1929–30. Member: Women Painters of Washington. Teacher: Central Washington College, Ellensburgh, 1939–42. Work: Seattle Art Museum; Henry Gallery, University of Washington, Seattle. Exh: Gumps, San Francisco; plus others.

SQUIRES, WARREN L. (1886–1938) Painter. Lived and worked in Idaho before settling in California in the 1930's. Member: Painters and Sculptors of Los Angeles.

STACKHOUSE, KATHERINE Artist. Studio in Spokane, Washington, 1902.

STACKPOLE, RALPH (1885–1973) Painter. Muralist. Sculptor. Etcher. Born in Williams, Oregon. Moved to San Francisco in 1901. Became a very important California artist.

STACY, MARY BURR Painter, still lifes. Lived in Tacoma, Washington, 1895. Member: Tacoma Art League, 1892.

STAHMER, ARNOLD J., JR. (1915–) Painter. Lived in Seattle, Washington, 1951. Member: Puget Sound Group of Northwest Men Painters. Exh: Seattle Art Museum, 1936.

STAHMER, ARNOLD J., SR. Painter. Commercial artist. Lived in Seattle, Washington, 1941. Member: Puget Sound Group of Northwest Men Painters, 1928. Exh: Tacoma Fine Art Association, 1922, 1923; Seattle Art Museum, 1936.

STAHUNN, MR. Painter. Member: Tacoma Fine Arts Association, 1925.

STALEY, KENNETH T. Painter, watercolor. Lived in Seattle, Washington, 1945. Exh: Seattle Art Museum, 1945.

STANDAERT, JERRY Painter, watercolor. Lived in Kent, Washington, 1947. Exh: Seattle Art Museum, 1947; Henry Gallery, University of Washington, Seattle, 1951.

STANFORD, AMANDA Artist. Lived in Spokane, Washington, 1902.

STANGLE, JACK WARREN (1928–1980) Painter, oil, watercolor, landscapes, still lifes, cityscapes. Lived in Seattle, Washington. Mostly self-taught. Lived & painted in Spain & Japan. Exh: Seattle Art Museum, 1949; other Northwest shows.

STANLEY, JOHN MIX (1814–1872) Painter, oil, watercolor, portraits, scenics. Sketcher, pen, pencil. Topographer. Explorer. Important Indian painter and survey artist. Mainly self-taught. In 1842 he began painting frontiersman and the Oklahoma Territory Indians living in the Indian country. In 1853 he joined Stevens' Survey of northern railway route from St. Paul to the Northwest coast. In 1847 he went to Oregon to paint portraits of Northwest Indians. He displayed his Indian Gallery in Eastern cities and in 1852 put his collection of 150 paintings on display at the Smithsonian in order to offer it to the Government for $19,200 in return for his ten years work and $12,000 in expenses. Congress refused and in 1865 the collection was destroyed by fire. By 1854 he had used his field sketches to prepare a huge panorama of 42 episodes of Western scenes. Like most of his original works the panorama has disppeared.

STANSELL, GUY E. Painter, oil, landscapes. Lived in Seattle, Washington, 1924. Exh: Washington State Arts & Crafts, 1909.

STANTON, WILLIAM Artist. Lived in Wenatchee, Washington, 1910.

STARCHER, HATTIE (1895–) Painter, oil, watercolor, Indian life. Printmaker. Craftsperson, wood carving. Teacher. Pupil: Vancouver Academy of Art; University of Washington; certificate of merit, Latham Foundation, Stanford University, 1934–36. Worked with the State Department of Indian Education, Olympia, Washington. Received many awards.

STARKEY, FLORA U. Artist. Lived in Seattle, Washington, 1901.

STARR NELLIE S. (1869–) Painter, oil, watercolor. Born in Illinois. Lived in Portland, Oregon, 1940. Member: Oregon Society of Artists. Exh: Oregon State Fair, Salem; Meier & Frank, Portland; Portland Art Museum.

STEEL, MARY E. Artist. Lived in Seattle, Washington, 1926.

STEELE, CLARENCE H. Painter, oil. Lived in Seattle, Washington, 1949. Member: Puget Sound Group of Northwest Painters, 1948. Exh: Seattle Art Museum, 1949.

STEELE, THEODORE CLEMENT (1847–) Painter. Pupil: Royal Academy, Munich. Member: National Academy, 1914. Exh: Paris Expo, 1900. Traveled west in 1902 painting the Oregon Coast.

STEEN, EDNA BARRELL (–1959) Artist. Lived in Seattle, Washington. Charter member: Women Painters of Washington, 1931.

STEEVES, L. R. Craftsperson, fiber, clay, metal. Exh: Northwest Craftsman Exhibition; Henry Gallery, University of Washington, Seattle, 1957–58, 1960.

STEGEMAN, CHARLES Painter, modernist. Lived in Vancouver, B.C., 1940's. Friend of Tobey.

STEIN, AARON (1835–1900) Lithographer. Drawing, pen & ink. His view of California and Oregon State was reproduced by Britton and Rey. Pen & Ink drawing "Across the Continent" widely shown at Golden Gate International Exposition, 1939; World's Columbian Expo.

STEINBREUCK, VICTOR Painter, watercolor. Architect. Lived in Seattle, Washington, 1938. Exh: Seattle Art Museum, 1934.

STENDER, FANNIE B. Artist. Lived in Seattle, Washington, 1901.

STEPHENS, ALICE W. (1926–) Painter. Affiliated with "The Gazebo", Lake Oswego, Oregon.

STEPHENS, CLARA JANE (1877–1952) Painter. Writer. Lived in Portland, Oregon. Pupil: Chase; Cox; Dumond, New York City. Moved to San Francisco in her teens. Active there until the late 1930's by then moving to Portland, Oregon. Member: Advisory Committee, the Panama-Pacific International Expo; Seattle Fine Arts Society, 1925. Exh: Oregon Historical Society Exhibition, 1990. One of Oregon's foremost impressionists.

STEPHEY, EVA LEE (1866–1943) Artist. Studio in Spokane, Washington, 1916.

STERLING, LEWIS MILTON (1879–) Painter, oil. colored pencil. Born in Illinois. Lived in Cashmere, Washington, 1940. Exh: Seattle Art Museum, 1935; Society of Seattle Artist, 1908.

STEUERNAGEL, HERMANN (1867–1956) Painter, oil, portraits. Cartoonist. Born and studied in Germany. Lived in Puyallup, Washington from 1936. Art Director, Pathe Pictures. Creator of the first animated cartoon. Exh: Tacoma Art League, 1940.

STEVENS, CHARLES (early 19th century) Primitive artist from Oregon. Sketches of local genre & landscapes.

STEVENS, HAZEL E. (1910–) Painter, oil, watercolor. Born in Denver. Lived in Portland, Oregon. Pupil: Museum Art School, Portland. Exh: Portland Art Museum, 1935.

STEVENS, MARJORIE (1902–) Painter, watercolor, collage. Mainly self-taught. Exh: solo shows, De Young Museum, San Francisco, 1955; Frye Museum, Seattle, Washington, 1960. Member: American Watercolor Society; West Coast Watercolor Society. Many awards.

STEVENS, NINA F. Artist. Lived in Tacoma, Washington, 1949. Member: Tacoma Art League. Exh: Washington State Historical Society, 1945.

STEVENS, RUTH TUNANDER (1897–) Painter, watercolor. Printmaker, linoleum block. Craftsperson. Teacher. Lived in Seattle, Washington, 1941. Pupil: University of Washington; Alexander Archipenko. Member: Northwest Printmakers, 1928–41. Exh: Seattle Art Museum. Art Teacher, Seattle Public Schools.

STEVENSON, BRANSON GRAVES (1901–) Painter, oil, watercolor, fresco. Printmaker, etching. Sculptor. Craftsman. Teacher. Work: Montana Institute of Arts, Helena; C. M. Russell Gallery, Great Falls; University of Oregon, Eugene. Raised in Panama he came to Montana where he was in the oil business with his brothers. He retired from Mobil Oil in 1960. He exhibited paintings and prints in Montana as early as 1936.

STEVENSON, CLARK Painter. Lived in Vancouver, B.C., 1940.

STEWART, ALEXANDER Painter, oil, watercolor. Lived in Tacoma, Washington, 1932. Exh: Rhodes Brothers Store Gallery, Tacoma, 1932; Tacoma Civic Art Association, 1932.

STEWART, JEANNIE M. Painter, watercolor, landscapes. Lived in Seattle, Washington, 1909. Exh: Society Seattle Artists, 1908; Alaska-Yukon Pacific Expo, Seattle, 1909.

STEWART, LE CONTE (1891–) Painter, landscapes. Printmaker. Teacher. Worked in Utah and Idaho Colleges and high schools until his retirement in 1956. Murals in LDS temples and Denver State House. Leaned toward the abstract.

STEWART, TISBA (MISS) Painter, watercolor. Drawing, crayon. Lived in Thurston County, Washington, 1909.

Exh: Alaska-Yukon Pacific Expo, Seattle, 1909.

STICKER, ROSAMOND (1910–) Painter, tempera. Craftsperson. Born in Grants Pass, Oregon. Lived in Portland from 1929–39, (except in 1938 when she was in San Francisco.) Settled in San Rafael, California. Exh: Portland Art Museum, 1935; San Francisco Art Association, 1938.

STILES, FLORENCE Painter, landscapes. Lived in Tacoma, Washington, 1892. Member: Tacoma Art League, 1891. Exh: Western Washington Industrial Exposition, 1891.

STILL, CLYFFORD E. (1904–1980) Painter, oil. Teacher. Important abstract expressionist. Lived in Pullman, Washington. Pupil: Art Students League, New York. Exh: San Francisco Museum of Art; Metropolitan Museum of Art, New York, 1979. Teacher: Washington State University, 1946–50.

STILLMAN, GEORGE (1921–) Painter. Administrator. Pupil: California School of Fine Arts, 1949. Work: Oakland Museum of Art; High Museum of Art, Atlanta; San Francisco Museum of Art. Work: murals commissioned by Washington Art Commission, Olympia; La Cross. Exh: Henry Gallery, University of Washington, Seattle, 1950.

STOCKBRIDGE, MARY G. (See ALLEN)

STODDARD, MARY I. Painter. Member: Founding member, Vancouver, B.C. Fine Art Society, 1919.

STOKES, FRANK WILBERT Painter, arctic landscapes. Sculptor. Pupil: Thomas Eakins; Ecole des Beaux-Arts, Paris. Member: Peary Greenland Expedition, 1892–94. Work: Museum of Natural History, New York. Many awards.

STONE, ANNA BELLE (1874–1950)
Painter, oil, watercolor, flower portraits, landscapes, portraits. Printmaker, block print. Lived in Seattle, Washington. Pupil: University of Washington, Seattle. Member: Northwest Watercolor Society; Women Painters of Washington; American Artists Professional League, Portland. Exh: Laguna Beach Art Museum; Seattle Art Museum; Henry Gallery, University of Washington, Seattle; many others.

STONE, FRANK FREDERICK (1860–1939) Sculptor. Born in London. He moved first to Canada then to Los Angeles because of his health. Award: gold medal, Alaska-Yukon Pacific Expo, Seattle, 1909.

STONE, MARGARET ANTHONY (1910–) Painter, oil, watercolor. Drawing, charcoal. Printmaker, lithography. Lived in Portland, Oregon, 1940. Pupil: Vassar College; Art Center School, Los Angeles. Member: American Artists Professional League, Portland. Exh: Rockefeller Center, New York, 1939; Seattle Art Museum; Spokane Art Museum. Rose queen portrait artist.

STOOPS, HERBERT MORTON (1887–1948) Painter. Illustrator, magazines and books, including school texts. Specialized in the Old West and military subjects. Raised on a ranch in Idaho's Rockies 60 miles from Yellowstone Park. Pupil: Chicago Art Institute. Staff artist for the *Chicago Tribune*; western illustrator for the *San Francisco Call*, 1910. After WWI he settled in New York City as an illustrator specializing in Western and historical scenes. An Important illustrator of the 20's.

STORCK, ABRAHAM (1625–1695) Dutch painter, arctic landscapes, genre.

STORM, ALFRIDA ANNA (1896–) Painter. Lived in Seattle, Washington, 1926. Teacher of Design, University of Washington 1924–26. Member: Seattle Fine Arts Society.

STORSETH, PETER (1898–1965) Painter. Born in Norway. Lived in Everett, Washington. Work: mural, First Lutheran Church, Port Orchard, Washington.

STOUT, ELLA J. (1877–) Painter, oil. Woodcarver. Born in Calistoga, California. Lived in Newberg, Oregon, 1940. Pupil: Museum Art School, Portland. Exh: Seattle Art Museum.

STOVER, ALLAN JAMES (1887–1967) Painter. Lived in Corvallis, Oregon. Illustrator, *Oregon's Commercial Forests*, 1940.

STOVER, RAY Artist. Lived in Tacoma, Washington, 19949. Exh: Tacoma Art League, 1940.

STOWITTS, HUBERT JULIAN (1892–1953) Painter, portraits, murals. Dancer with the Ballet Russe, the partner of Pavlova for five years. Left the stage in 1921 to paint in Paris and Venice. Settled in Southern California in 1931 where he was a set designer, lead dancer. Died in obscurity. Exh: solo show, Seattle Art Museum, 1931.

STRATTON, SUSAN B. (1875–1912) Painter, oil, watercolor. Teacher. Studio in Tacoma, Washington.

STRAUS, MEYER (1831–1905) Painter, oil, watercolor, landscapes, china. Born in Bavaria. Studio in San Francisco. A theater scenery artist until 1877. Made many trips to Oregon painting landscapes. An important Western artist.

STRAUSS, GERTRUDE Artist. Studio in Seattle, Washington, 1922.

STREETON, ARTHUR Famous Australian artist. Painted for a time in Victoria and the Rockies in 1923.

STRETCH, LILLIAN R. Painter. Lived in Seattle, Washington, 1928.

STRICKER, ROSAMUND Painter. Craftsperson. Lived in Portland, Oregon, 1929–39, except in 1938 when she was in San Francisco. Currently a resident of San Rafael, California. Exh: Portland Art Musuem, 1935; Seattle Fine Arts Association, 1938.

STRICKLAND, ELLA Artist. Lived in Seattle, Washington, 1917.

STRICKLAND, FREDRICK (1880–1956) Painter, oil, landscapes. Religious carvings. Settled in Portland, Oregon in 1914. Teacher, Benson Technical School for 27 years.

STRICKLAND, PHYLLIS ALBA (1915–) Painter. Born in Portland, Oregon. The daughter of artist Fred Strickland. Moved to San Francisco in 1940.

STRIKER, KENNETH LOUIS (1908–) Painter, watercolor. Drawing, pencil. Born in St. Louis. Lived in Portland, Oregon, 1940. Pupil: University of Washington, Seattle. Art Director, McCann-Erickson, Portland, Oregon

STROMBERG, JESSIE SMIT Painter, oil, still lifes, landscapes. Lived in Everett, Washington, 1931. Exh: Everett Drama League, 1931.

STRONACH, SHIRLEY Painter. Lived in Cheney, Washington, 1950. Member: Washington Art Association, 1950.

STRONG, PEGGY INTERLAAKEN (1912–1956) Painter, oil, portraits, murals. Born in Aberdeen, Washington. Lived in Tacoma. Pupil: University of Washington with Mark Tobey, Seattle. Exh: Seattle Art Museum, 1937; Portland Art Museum, 1936–38; San Francisco Museum of Art, 1937, 1938; Golden Gate International Expo, San Francisco, 1939. Member: West Seattle Art Club, 1938. Work: College of the Puget Sound, 1937; Museum of Modern Art, New York.

STRONG, RAY STANFORD (1905–) Painter, landscapes, murals. Lived in Corvallis, Oregon. Pupil: Clyde Keller, working from the Columbia to Mt. Hood. Teacher: Art Students League in New York. Founder: the Artists Cooperative Gallery. Artist in residence at the Santa Barbara Museum of Natural History.

STROUSE, MARGARET F. (See MANN)

STRYKER, F. R. Artist. Lived in Spokane, Washington, 1929.

STUART, (STEWART) FREDERICK (1816–) Survey Artist. Engraver. Illustrator, *Narrative of the United States Exploring Expedition*, 1844. He was in the Pacific Northwest as part of the government expedition before 1844. A member of another expedition in 1862.

STUART, JAMES EVERETT (1852–1941) Painter, oil, watercolor, landscapes, portraits. The grandson of famous portraitist, Gilbert Stuart. Moved to California as a child. Began painting at eight years old. Pupil: San Francisco School of Design. Maintained a studio in Portland, Oregon (1881), New York City (1886), Chicago for twenty years. Member: Society of Independent Artists, Bohemian Club, San Francisco Art Association. Work: Oakland Museum, White House Washington, D.C.; Crocker Museum, Sacramento; Washington State Historical Society; Oregon Historical Society. Painted over 5,000 landscapes, including many of the Pacific Northwest and Alaska. On the back of his canvases he listed the price, number, date, and geographical location of the painting. A very successful landscape artist.

STUART, RICHMOND NORMAN (1915–) Painter, oil, landscapes, portraits. Teacher. Illustrator. Studio in Tacoma, Washington, 1977. Pupil: Rowena Alcorn; Carl Brodin; Mary Jarrett; Leslie B. DeMille. Illustrator for the United States Army.

STYLES, WALTER B. Came to Alaska as a miner & missionary. Painted life among the Tlingit Indians around 1880.

SULLIVAN, JOHN JOSEPH (1914–1939) Painter, oil, watercolor. Born in Cedar Mills Oregon. Lived in Portland. Pupil: Museum Art School, Portland; American Artists School, New York. Member: Young Artists Congress. Award: scholarships, Portland Art Museum, 1934–37. Exh: Portland Art Museum.

SULLY, ALFRED (1820–1879) Painter, watercolors, Western forts, soldiers, Indian fighters. Son of premier portrait artist Thomas Sully. He fought during the Civil War ending as a major general on an expedition against the Indians in the Northwest. In 1870 he was transferred to Fort Vancouver as post commander where he devoted much time to his painting.

SULTON, MAUD Painter. Lived in Spokane, Washington, 1924.

SUMBARDO, MARTHA KUHN (1873–1961) Painter, oil, landscapes. Born in Germany. Studied in Germany and Italy. Worked in the Petti and Uffici galleries. Lived in Seattle, Washington. Established Sumbardo's School of Fine Art in Seattle, 1908. Noted for her copies of old masters.

SUMMERS, CLARA T. (late 19th century) Painter, oil, landscapes. Many canvases found in Portland, Oregon of Multnomah Falls, Mt. Hood dated 1886.

SUMMERS, LEO RAMON Painter, gouache. Lived in Seattle, Washington, 1947. Exh: Seattle Art Museum, 1947.

SUNBERG, ARTHUR Painter, watercolor. Lived in Seattle, Washington, 1945. Exh: Seattle Art Museum, 1945.

SUNDE, OLIVE "OLE" (MRS.) Artist. Lived in Tacoma, Washington, 1930. Exh: Women's Club, Tacoma, 1930.

SURIA, THOMAS de Artist-Engraver, at the Mexican mint. Employed by the Spanish government for the expedition of Alejandro Malaspinas in 1791 north from California.

SURREY, PHILIP (1910–) Painter. Pupil: Art Students League, New York, 1936. Friend of F. H. Varley in Vancouver, B.C. where he worked for seven years. Important Canadian artist.

SUTHERLAND, MINNIE Painter. Lived in Seattle, Washington, 1921.

SUTTON, FRANK (MRS.) Painter. Lived in Chelan County, Washington, 1909.

SWAIN, ADDIE P. Artist. Lived in Seattle, Washington, 1917.

SWAIN, ROBERT Artist. Lived in Seattle, Washington, 1918.

SWAIN, WILLIAM Painter. Member: Tacoma Fine Arts Association, 1925.

SWALWELL, ARLENE Painter, oil, pastels. Lived in Everett, Washington, 1931. Pupil: M. Tobey. Charter Member: Women Painters of Washington. Exh: Everett Drama League, 1931, 1932.

SWAN, JAMES GILCHRIST (1818–1900) Painter, watercolor. Drawing, crayon, pen & ink, pencil. Writer. Anthropolgist. Indian Agent. Cartographer. Lived in Port Townsend, Washington. Author, *The Northwest Coast*, 1857. Wrote and sketched the natives

of the Northwest, their ways of life, their homes and settlements, their natural history. Work: Smithsonian Institute; Washington State Historical Society. An important contributor to the history of the Northwest.

SWANBERG, CHARLES WILLARD (1923–) Painter, acrylic, tempera. Commercial artist. Lived in Seattle, Washington, 1962. Member: Puget Sound Group of Northwest Men Painters, 1946.

SWANSON, CHARLES Painter, oil, landscapes. Lived in Washington.

SWANSON, PATRICIA Painter, watercolor. Lived in Seattle, Washington, 1946. Exh: Seattle Art Museum, 1946.

SWANSON, VICTOR A. Artist. Lived in Tacoma, Washington, 1902.

SWARVA, ANNA L. Painter. Craftsperson. Lived in Seattle, Washington, 1931. Charter Member: Women Painters of Washington, 1931.

SWEETSER, C. K. (MRS.) (1862–) Painter, watercolor. Born in Massachusetts. Lived in Eugene, Oregon, 1940. Work: 350 Oregon wild flower botanical paintings (watercolor), Library, University of Oregon, Eugene.

SWENSON, STEWART (1909–) Painter, oil, watercolor. Commercial artist.Lived Snoqualmie Falls, Washington, 1941. Pupil: Cornish Art School, Seattle.

SWETT-GRAY, NOAMI (1889–) Painter, sepia. Drawing, crayon, pencil. Writer. Born in Portland, Oregon. Lived in Seattle, Washington, 1940. Pupil: Museum Art School, Portland. Member: Oregon Society of Artists.

SWEUM, MINNIE O. (1872–1962) Painter, oil, china, landscapes. Teacher. Lived in Tacoma, Washington, 1926.

SWIFT, FRANCES DUBOIS (1903–) Painter, oil, watercolor. Craftsperson, jewelry, metal work. Teacher. Born in Portland, Oregon. Lived in Seattle, Washington, 1940. Pupil: University of Washington. Member: Lambda Rho. Exh: Seattle Art Museum, crafts exhibtion, 1936–37. Art teacher, Seattle Public Schools.

SWIFT, JOHN T. (1893–1938) Painter, oil, watercolor. Born in Denver, Colorado. Lived in Boise, Idaho. Pupil: Henry Reed, Denver. Exh: Boise Art Museum. Primarily a commercial artist.

SWIGGETT, JEAN DONALD (1910–) Painter, murals. Teacher, Washington State College, 1941–42. Settled in Southern California.

SWORMSTEDT, EMILIE Artist. Lived in Seattle, Washington, 1901.

SYKES, JOHN (1773–1858) Illustrator. Topographical artist. Served with Captain George Vancouver on the Pacific Expedition, 1792–94. Author: *Voyage of Discovery to the North Pacific Ocean*, 1798, in three volumes.

SYLVESTER, RAYMOND F. (1912–) Painter, watercolor. Interior designer. Born in Wasco, Washington. Lived in Seattle, Washington, 1940. Pupil: University of Washington; Chicago Art Institute. Exh: Seattle Art Museum, 1939.

——T——

TABOR, FRANK A. (1855–1934)
Painter, oil, landscapes. Teacher. Lived in Seattle and Tacoma, Washington. Study: Paris; Germany. Commissioned by the United States Government to paint Pacific Northwest scenes for Chicago World's Fair, 1893. Exh: Alaska-Yukon Pacific Expo, Seattle, 1909.

TABOR, JULIA (–1935) Painter. Wife of Frank Tabor. Lived in Tacoma, Washington.

TADAMA, FOKKO (1871–1937)
Painter, oil, pastels. Teacher. Born in Banda, India. Lived in Seattle, Washington. Pupil: Academy of Fine Arts, Amsterdam; Paris; Dusseldorf; Antwerp. Exh: San Francisco Museum of Art; Washington State Art Association, 1912; extensively all over Europe and the United States. Director, owner, Tadama Art School, Seattle. Work: San Francisco Museum of Art; Royal Victoria Theatre, Victoria, B.C.; Press Club, Seattle.

TAFT, KATHERINE UPRON Painter, watercolor. Teacher. Studio in Spokane, Washington, 1935. Exh: Alaska-Yukon Pacific Expo, Seattle, 1909; Washington Commission of Fine Arts, 1914.

TAKEHARA, JOHN S. (1929–)
Artist. Teacher: Art Department, Boise State University, Idaho.

TALBOT, CATHERINE P. Painter. Lived in Portland, Oregon, 1898.

TALBOT, PAUL A. Artist. Lived in Seattle, Washington, 1907.

TALBOTT, KETHERINE (1908–)
Sculptor. Resident of Berkeley, California in the 1930's. Exh: first prize, Portland Art Museum, Portland, Oregon, 1932.

TALIAFERRO, JOHN (1895–)
Painter, oil. Born in Nebraska. Lived in Seattle, 1940. Pupil: Yale University, School of Fine Arts. Member: Puget Sound Group of Northwest Men Painters. Advertising artist for the *Seattle Post Intelligencer*.

TALLANT, RICHARD H. (1853–1934) Painter. Illustrator, mountain landscapes of Oregon, Washington. Self-taught. He lived in Colorado mining camps as a young man. Member: Denver Art Club, 1886–87. Lived for a time in Salt Lake City, Utah, moving back to Colorado where he lived for 31 years. He painted all over the West, The Rockies, The Tetons, The Grand Canyon, The Colorado peaks and Pueblo scenes with Indians.

TALMAGE, ALGERNON M. (1871–1939) Painter, oil, landscapes. Born in England. Member: Society of British Artists. His works are in museums all over the United States, England and Australia. He traveled and painted extensively all over the Western part of the United States in and around 1918.

TANABE, TAKAO (1926–)
Painter. Lived in Vancouver, B.C. Exh: Seven West Coast Painters, 1947. Won an Emily Carr scholarship in 1953 and a Canada Council fellowship 1959. Traveled in Europe and Japan.

TANAKA, YASHUSHI (1886–)
Painter. Teacher. Born in Tokyo, Japan. Lived in Seattle, Washington, 1901–20. Pupil: F. Tadama; mainly self-taught. Member: Societe Nationale; Societe des Independents, Paris. Exh: solo show, Seattle Fine Arts Society, 1920.

TAPPAN, WILLIAM HENRY (1821–1907) Painter. Engraver. Sketcher. Cartographer. Lived in the Washington Territory for 25 years. He traveled the overland route to Oregon in 1849 with the Mounted Rifles Regiment. Special artist for the Government in 1849. Fifty of his sketches produced along the way have survived and some are reproduced by the State Historical Society of Wisconsin in 1931. He settled in the State of Washington and served in the legislature. He designed and engraved the Seal of Washington Territory.

TARBO, F. A. Artist. Lived in Seattle, Washington, 1907.

TASAKOS, ELSIE EYERDAM (1889–) Painter, oil, watercolor. Designer. Craftsperson, tapestry. Teacher. Born in Willamina, Oregon. Lived in Seattle, 1940. Pupil: Otis Art Institute, Los Angeles. Exh: Annual Exhibition of Northwest Artists, 1924.

TASSELL, W. H. (1880–) Painter, watercolor. Born in England. Lived in Kelowna, B.C., 1940. Exh: Vancouver Art Gallery, 1936–39.

TATUM, ARMINTA J. (1881–1961) Painter, oil, landscapes, china. Studio in Tacoma, Washington. Teacher, ceramics. Exh: Tacoma Civic Art Association, 1932.

TAUBER, HARRY Designer, stage and costume, modernism, expressionist. Arrived in Vancouver, B.C. in 1932 from Vienna. Pupil: Josef Hoffman. He was one of the chief exponents of Vienna's expressionist theatre of the 1920's. He settled in Vancouver, B.C., bringing with him expressionism, constructivism and spiritualism.

TAUTAKAWA, EDWARD Painter, oil, landscapes. Lived in Spokane, Washington, 1950. Exh: Washington Art Association, 1950.

TAVERNIER, JULES (1844–1889) Painter, landscapes. Important California illustrator. Commissioned by *Harper's Magazine* to record the emigration west traveling extensively over the entire western frontier. Arrived in San Francisco in 1874 and was promptly elected to the Bohemian Club where he established a studio. He sold an Indian scene in 1879 for $2,000; however he evolved into an unpredictable character who was constantly avoiding the sheriff who came to collect his debts. He fled to Hawaii and became court painter to the King. He died from acute alcoholism and his fellow artists erected a granite stone over his grave in memory of their love.

TAYLOR, FREDRICK THOMAS (1848–1928) Painter, watercolor. Lived in Tacoma, Washington. Member: Tacoma Washington Historical Society; National Gallery, Canada. Accompanied artist John Anderson on painting excursions to Mt. Rainier and the Tacoma tidal marshes. Prominent historian of early Tacoma history. Lost his sight at 50 years of age.

TAYLOR, G. BENTLEY Painter, watercolor. Lived in Seattle, Washington, 1945. Exh: Seattle Art Museum, 1945.

TAYLOR, HENRY C. (1906–1987) Painter, watercolor, murals, historical Northwest landscapes, native peoples. Studio in Monesano, Washington. Member: Puget Sound Group of Northwest Men Painters.

TAYLOR, JOSEPH RICHARD. (1907–) Sculptor. Teacher. Exh: Annual Northwest Art Exhibit; Seattle Art Museum, grand award, 1932. Teacher: University of Oklahoma.

TAYLOR, KYLE (1906–) Painter, oil. Teacher. Born in Portland, Oregon, Lived in Lewiston, Idaho, 1940. Pupil: University of Washington, Seattle. Study: the United States; Mexico;

Carnegie School; University of Oregon, Eugene. Head of Art Department, Lewiston State Normal School, Lewiston, Idaho.

TAYLOR, MARY A. Artist. Lived in Spokane, Washington, 1902.

TAYLOR, W. F. Artist. Lived in Spokane, Washington, 1911.

TAYSON, WAYNE PENDELTON (1925) Sculptor. Teacher. Exh: Seattle World's Fair; many others. Member: Portland Art Association; Corvallis Art Association. Work: Portland Art Museum; many public and private commissions.

TEAGUE, DONALD (1897–1990) Painter. Illustrator. Nationally known artist, elected to the National Academy in 1948. Settled in California in 1938. Work: Frye Museum, Seattle, Washington.

TEATER, ARCHIE B. (1901–) Painter, oil. Born in Boise, Idaho. Lived in Wyoming, 1940. Pupil: Museum Art School, Portland, Oregon; Art Students League, New York; Robert Henri. Work: ten western murals, State Capitol, Cheyenne, Wyoming; "Indians", State Capitol, Boise, Idaho; "Pioneers", Hotel Utah, Salt Lake City.

TEICHERT, MINERVA KOHLHEPP (1899–) Painter. Lived on a ranch in Idaho and Wyoming. Pupil: Art Students League, New York; Chicago Art Institute, with Robert Henri. One of five Wyoming artists whose work was selected for the First National Exhibition of American Art at Rockefeller Center, 1936.

TEICHMA, ERWIN Painter. Member: Puget Sound Group of Northwest Men Painters, 1932.

TEIDEMANN, H. D. Civil engineer. Draughtsman. Sketcher. Produced a panoramic engraving of Victoria, 1880's.

TELLER, ETHYL M. Artist. Lived in Seattle, Washington, 1926.

TEMPLIN, JESSIE CARLETON Painter. Drawing. Teacher. Lived in Seattle, Washington, 1898–1901. Teacher: Annie Wright Seminary, Seattle, 1891–1901.

TENEAU, PETER V. (1929–) Painter, abstracts. Sculptor. Teacher: Everett, Washington Junior College.

TENNEY, VERA Painter, oil. Lived in Everett, Washington, 1948. Exh: Pacific Northwest Artists Annual, 1948.

TERRY, FLORENCE BEACH (1880–) Painter, oil, watercolor. Born in Kansas. Lived in Seattle, Washington, 1940. Pupil: New York School of Art; William Chase; Robert Henri; University of Washington, Seattle; Kansas City Art Institute. Exh: Seattle Art Museum, 1937. Formerly head of Art Department, Ottawa University, Ottawa Kansas.

TERRY, ROLAND (1917–) Painter, oil, watercolor. Commercial artist. Born in Seattle, Washington. Lived in Seattle, 1941. Member: Puget Sound Group of Northwest Men Painters. Exh: Seattle Art Museum, 1937, 1938.

TERRY, ROY H. Commercial artist. Lived in Seattle, Washington in 1940. Member: Puget Sound Group of Northwest Men Painters.

TESTER, JEFFERSON (1899–1972) Painter, portraits, landscapes, genre, interiors, expressionist. Born in Tennessee. Moved to Roseburg, Oregon in 1912. Lived in Portland in 1918 as a staff artist for the *Oregonian*. Pupil: Chicago Art Institute. Arrived in New York City in 1924 where he worked as a commercial artist for twenty years. In the late 1940's Tester turned to the fine arts, touring the world and giving one-man shows in Paris, Italy

and Mexico. During this time he created 7 covers for *Time* Magazine. He returned to Portland in 1963 and married his childhood sweetheart, remaining there until his death. Brother of artist Amanda Snyder.

THAYER, EMMA HOMAN (1842–1908) Painter. Illustrator, flora of the West. She wrote and illustrated *Wild Flowers of the Pacific Coast*. Settled in Colorado.

THAYER, MABEL R. (1882–1954) Art teacher. Born in Oregon City, Oregon. She settled in Banning, California by 1934 where she taught in the public schools. Died in Santa Barbara.

THEISS, JOHN WILLIAM (1863–1932) Painter, watercolor. Writer. Study: Concoria Theological Seminary, St. Louis, 1886. Was a Lutheran minister in Portland, Oregon 1889–93. Member: Springfield Art League, Oregon. Moved to Northern California and then to Los Angeles.

THIELE, MILDRED Painter, watercolor. Active in the 1960's in Roseburg, Oregon.

THOMAS, ALICE BLAIR Painter. Founding member, B.C. Society Fine Arts, Vancouver, 1933.

THOMAS, CARROLL K. Artist. Lived in Seattle, Washington, 1928.

THOMAS, DORIS HUNTSMAN (1907–) Painter, oil, watercolor. Sculptor, wood. Born in Spokane, Washington. Lived in Tacoma, 1940. Pupil: University of Washington, Seattle. Exh: solo show, Temple Theater, Tacoma, 1933; Western Washington Fair, Puyallup, 1937; College of the Puget Sound, 1939, 1940.

THOMAS, FLORENCE (1906–) Sculptor. Born in Chicago. Lived in Portland, Oregon, 1940. Pupil: Chicago Art Institute; studied in Europe on Ryerson Fellowship, 1931. Work:

Children's room, Portland Library; Vancouver Library; "Mountain Lion", Timberline Lodge, Mt. Hood, Oregon. Exh: New York World's Fair, 1939.

THOMAS, LIONEL Painter. Lived in Vancouver, B.C. Member: Labor Arts Guild, 1944.

THOMAS, W. S. Artist. Lived in Spokane, Washington, 1907.

THOMPSON, CAROL Painter, oil, watercolor, Northwest coastal seascapes, marine life along the shores. Printmaker. Moved to Washington State in 1969. Exh: State Capitol Museum, Olympia, Washington; nationally and internationally.

THOMPSON, DAN Painter, gouache. Lived in Spokane, Washington, 1945. Exh: Seattle Art Museum, 1945.

THOMPSON, DAVID Artist who drew the first known sketches of the Rocky Mountains and the Selkirks, for 4 years around 1811, executed mainly in ink washes.

THOMPSON, JANE C. Painter, oil. Lived in Seattle, Washington, 1945. Exh: Seattle Art Museum, 1945.

THOMPSON, MARTHA E. Painter. Studio in Seattle, Washington, 1934.

THOMPSON, NELL Artist. Lived in Blaine, Washington, 1902.

THOMPSON, PAUL L. (1911–) Painter, oil, watercolor, tempera. Born in Buffalo, Iowa. Lived in Bremerton, Washington, 1940. Pupil: California School of Fine Arts, San Francisco. Exh: Seattle Art Museum, 1937, 1939.

THOMPSON, THOMAS HIRAM (1876–) Painter, oil, watercolor, pastel. Lived in Spokane, Washington, 1902, 1903. Member: Spokane Art League. Exh: gold medals, Seattle

Fine Art Society, 1902; Spokane Art League, 1902, 1903.

THOMPSON, WILMER N. Painter, oil. Exh: Seattle Art Museum, 1945, 1946.

THOMSON, LOUISE A. M. Painter, oil, watercolor, landscapes, church interiors. Born in London, England. Lived in Portland, Oregon, 1940. Study: the South Kensington School of Art, London. Member: Oregon Society of Artists. Formerly head of Art Department, St. Helen's Hall, Portland.

THOMSON, THOMAS Painter. Worked with Varley and Phillips at Grip Limited, a commercial art firm in Toronto, Canada around 1912.

THORNDIKE, CHARLES J. Artist. Lived in Longmire, Washington, 1924.

THORNE, ANNA LOUISE Painter. Teacher, Spokane Art League School, Spokane, Washington, 1892.

THORNE, GORDON KIT (1896–) Painter, oil, watercolor, pastel. Printmaker, etching. Born in England. Lived in Vancouver, B.C., 1940. Pupil: Vancouver School of Applied Arts; H. Varley. Exh: Vancouver Art Gallery, 1936, 1939. Commercial artist, David Hall Signs, Vancouver, B.C.

THORNTON, MILDRED VALLEY Painter, oil, watercolor. Born in Dresden, Ontario. Lived in Vancouver, B.C., 1940. Pupil: Chicago Art Institute; Ontario College of Art. Exh: Canadian National Exhibition, Toronto, 1931, 1932; Royal Canadian Academy. Highly recognized for her paintings of Canadian Indians.

THORNTON, T. J., JR. (1886–) Sculptor, wood, white marble, sandstone, animal sculpture. Born near American Falls, Idaho. Self-taught. Member: Boise Art Association. Exh: solo show, Yellowstone National Park, 1931–32.

THORPE, ANDREW R. Artist. Lived in Seattle, Washington, 1932.

THORPE, EVERETT CLARK (1907– 1976) Painter, portraits. Muralist. Illustrator. Cartoonist. Teacher. Member: National Society of Mural Painters. Work: Seattle Art Museum; University of Colorado; Los Angeles County Art Museum. Professor of Art, Utah State University, since 1936.

THORSON, ALICE O. Painter, oil, landscapes. Lived in Tacoma, Washington, 1929.

THORTON, LOTTIE C. Artist. Lived in Arlington, Washington, 1907.

THORTON, MILDRED VALLEY Painter, Indian portraits. Lived in Vancouver, B.C., 1930– .

THORTON, NANCY Thought of as Oregon's first woman artist. In 1847 established the first art school in Oregon, in Oregon City.

THRAPP, ROSE S. Painter. Lived in Tacoma, Washington, 1909–12.

THRASHER, ELIZABETH ASENATH (1909–1989) Painter, oil, watercolor. Costume Designer. Lived in Puyallup, Washington. Exh: Western Washington Fair.

THROSSEL, RICHARD (1882– 1933) Painter. Photographer. Raised in Yelm, Washington.

TIBBETS, MARION Painter. Lived in Seattle, Washington, 1921. Member: Seattle Fine Arts Society, 1924.

TICKNER, F. J. Artist. Lived in Yakima, Washington, 1904.

TIDBALL, JOHN CALDWELL (1825–1906) Railway survey artist. Civil War general. Writer. Teacher. Study: West Point Academy, 1848. In 1853 was named artist for the railway surveys to establish a route to the Pacific, joining the ranks of such artists as John Mix Stanley, Sohon and

others. After the war Tidball was on the West Coast, in Alaska, and acted as aide-de-camp to Sherman. Work: Oklahoma Historical Society.

TIKHANOV, MIKHAIL Painter. Commissioned to sail to Alaska in 1817 on board the *Kamchatka* from St. Petersburg, Russia. Also on the *Moller* in 1827. He produced nineteen paintings.

TILDEN, DOUGLAS (1860–1935) Sculptor. Born in California into a pioneer family. A bout with scarlet fever as a child left him deaf. Recognized nationally as one of America's greatest sculptors he died in Berkeley a lonely, penniless old man. Exh: gold medal, Alaska-Yukon Pacific Expo, Seattle, 1909; many others. Work: Oregon Volunteers, Portland.

TIMM, HARRY Commercial artist. Lived in Spokane, Washington, 1930.

TITUS, FRANK J. B. Commercial artist. Lived in Seattle, Washington, 1926.

TJOSEVIG, DAGNY MARIE (1907–) Painter, oil, watercolor, pastel. Drawing, pen & ink, pencil, charcoal. Born in Valdez, Alaska. Lived in Seattle, 1941. Pupil: University of Washington; Ambrose Patterson.

TOBEY, MARK (1890–1976) Painter, oil, tempera, watercolor, portraits, abstracts. Musician. Poet. Teacher. Born in Wisconsin. Lived in Seattle, 1923–1960. Then moved permanently to Switzerland. Pupil: Chicago Art Institute; Henry Salem Hubbell; Kenneth Hayes Miller, New York. Traveled a great deal all over the world. He, along with Morris Graves and Kenneth Callahan dominate the modernist art scene of the Northwest. He was also an inspirational teacher wielding a strong influence on his many pupils. Work: Seattle Art Museum.

Exh: Museum of Modern Art, New York, 1929; Knoedlers, New York; Beaux Arts Gallery, London; Rose Gallery, Los Angeles; The Louvre, Paris; widely in the United States and Europe.

TODD, RUSSELL C. Painter, watercolor. Lived in Seattle, Washington, 1949. Exh: Seattle Art Museum, 1949; Henry Gallery, University of Washington, Seattle, 1951.

TOFFT, (TOFT, TOFFTS, TUFTS) PETER PETERSON (1825–1901) Painter, oil, watercolor. Illustrator. Born in Denmark. Arrived in California aboard the ship *Ohio* to pan for gold and sketch his surroundings. By 1852 Toft was in the Oregon Territory and traveled into British Columbia until 1866. His paintings cover Oregon, Washington, Idaho and Montana. He was also an illustrator for *Harper's*. He died in London. He sometimes signed his works with his monogram, the letter T with a circle drawn around the stem. Exh: Royal Academy, London. Works: Oakland Museum, Montana Historical Society. Painted mainly watercolors.

TOKITA, KAMEKICHI (1874–1948) Painter, oil, watercolor. Born in Japan. Lived in Seattle, Washington. Member: The least remembered member of the Group of Twelve. Mainly self taught he strived to find the 'basic truths' in his art through simple, rhythmic, expressive line. Exh: Seattle Art Museum, solo show, 1931–35.

TOKUYA, M. (NA) Artist. Studio in Seattle, Washington, 1917.

TOMKINS, MARGARET (1916–) Painter, oil, watercolor, tempera. Teacher. Lived on San Juan Islands, Washington, 1982. Pupil: D. Prendergast; Paul Sample; University of Southern California. Member: San Francisco Museum of Art. Exh: solo show, Seattle Art Museum, 1941;

Henry Gallery, University of Washington, Seattle. Teacher: School of Art, University of Washington, 1940.

TOMLINSON, HENRY M. (1875–) Painter, oil. Born in New Jersey. Lived in Portland, Oregon, 1940. Self-taught. Member: Oregon Society of Artists.

TONK, ERNEST A. (1889–1968) Painter, traditional western scenes. Muralist. Commercial artist. Illustrator. Writer. Work: Willis Carey Historical Museum, Cashmere, Washington. He was employed in the west as a cowhand and logger. He also ran a ranch in Cashmere, Washington, painting all winter, moving to California in the early 1920's to work for the movies. He continued to work both in California and Washington.

TONNANCOUR, JACQUES DE Painter. Lived in Vancouver, B.C. Exh: Biennial Canadian Painters, 1955.

TORVICK, HELEN Painter, watercolor. Lived in Seattle, Washington, 1951. Exh: Seattle Art Museum, 1946.

TORVICK, PAUL E. Painter, watercolor. Lived in Seattle, Washington, 1951. Exh: Seattle Art Museum, 1946.

TOWN, HAROLD Painter. Lived in Vancouver, B.C. Exh: Biennial Canadian Painters, 1955.

TOWNSEND, FRANCES. (1863–) Painter, landscapes. Teacher. Lived in Yakima, Washington, 1924. Pupil: Mary DeNeale Morgan; A. Patterson. Member: Seattle Fine Arts Society, 1924.

TOWNSEND, H. F. Artist. Studio in Tacoma, Washington, 1889. Member: Annie Wright Seminary Art Club, Tacoma, Washington, 1889.

TOWNSEND, HELEN Painter, oil. Lived in Seattle, Washington, 1951.

Exh: Henry Gallery, University of Washington, Seattle, 1950, 1951.

TOWSLEY Painter, western landscapes, mountains. Active in Oregon in 1940–1950.

TRANQUILLITSKY, VASILY GEORGIEVICH (1888–1951) Painter. Muralist. Seattle, Washington.

TRAVIS, EMILY L. (1872–1915) Painter. Born in California. A resident of San Francisco and active in the local art scene. Her painting subjects indicate travel to Vancouver and Belgium. Exh: Washington State Arts & Crafts, Seattle, 1908; San Francisco Art Association, 1911. Work: Golden Gate Park Memorial Museum, 1916.

TREZISE, MOLLIE Artist. Lived in Bellingham, Washington, 1913.

TROTTER, HORTENSE Artist. Lived in Seattle, Washington, 1901–16.

TROTTER, NEWBOLD HOUGH (1827–1898) Painter, animals, Alaska. Pupil: Philadelphia Academy of Fine Arts.

TROY, MINERVA ELIZABETH (1878–) Painter, oil, watercolor. Craftsperson, ceramics. Teacher. Born in Michigan. Lived in Port Angeles, Washington, 1940. Pupil: Bischoff; Gustave Kalling. Exh: Clallum County Fair, Washington, 1938. Teacher of Art, WPA. Chosen to design commemorative postage stamp for Olympia National Park.

TRULLINGER, JOHN (1870–) Painter, oil, watercolor, portraits. Born in Forest Grove, Oregon. Lived in Portland, 1940. Study: Colarossi Academy, Paris; and England. Exh: solo show, Portland Art Museum, 1910; Societe des Artistes Francais, Paris, 1909.

TSE, STEPHEN (1938–) Painter. Ceramics. Teacher. Study: University

Idaho, MFA. Work: public buildings in the Northwest. Many awards. Member: Washington Art Association.

TSHAIKOVSKY, ALEXANDER NICOLAIEF (1893–) Painter. Born in Russia. Lived in Vancouver, B.C., 1940. Exh: Vancouver, B.C. Art Gallery.

TSUTAKAWA, GEORGE (1910–) Painter, oil, watercolor, abstracts. Printmaker, block print. Sculptor. Craftsman, pottery. Born in and lived in Seattle, Washington, 1982. Pupil: University of Washington, Seattle. Member: Northwest Printmakers. Exh: Seattle Art Museum, 1934–39; all over the Northwest. Teacher: University of Washington, 1946. Work: Seattle Public Library; Renton Center; Lloyd Center, Portland, Oregon; St. Mark's Cathedral, Seattle; Seattle World's Fair, 1962. Seattle Art Museum Annuals, 1933; Portland Art Museum, 1955; Oakland Art Museum, 1951; Denver Art Museum; Santa Barbara Art Museum.

TUCKER, LUELLA Artist. Lived in Yakima, Washington, 1906.

TUPPER, GILBERT H. Artist. Owner, Tupper Art School, Seattle, Washington, 1932.

TURNER, ELLEN (LATE 19TH CENTURY) Painter, oil, landscapes. Teacher. Portland, Oregon artist in the 1880's.

TURNER, JANET E. (1914–) Painter. Award: Guggenheim fellowship. Exh: Northwest Printmakers; Seattle Art Museum.

TURNER, LENNY Painter. Active in Portland, Oregon in 1886.

TURNER, NELLIE C. Painter, oil, watercolor. Drawing. Teacher. First art instructor in Portland public schools, 1877–1891.

TURNER, RALPH JAMES (1935–) Painter. Sculptor, aeronautical & space sculptors. Study: Portland Art Museum School; University of Oregon, MFA. Exh: University of Oregon, 1962. Work: Smithsonian Institute, Washington, D.C.; many private & corporate commissions. Many awards.

TURNER, RICHARD (1936–) Sculptor. Resident of Vancouver, B.C. Study: Vancouver, B.C. School of Art 1958–62. Received a Canada Council scholarship for research in bronze casting, 1964.

TUTTLE, B. INEZ Artist. Lived in Walla Walla, Washington, 1932.

TUVE, ALDA Painter, oil, watercolor. Lived in Tacoma, Washington, 1932. Exh: Tacoma Civic Art Association, 1932.

TUXFORD, KENNETH A. (1903– 1986) Painter. Sculptor. Canadian. Study: Vancouver Art School; Detroit School of Fine Arts; Chouinard Art School, Los Angeles. By 1930 he had settled in Los Angeles.

TWISS, LIZZIE E. (1866–) Drawing, pen & ink, pencil. Teacher. Musician. Lived in Napavine, Washington Territory, 1887, 1888. Study: Annie Wright Seminary, Tacoma, Washington. Teacher, grade school. Exh: Washington State Historical Socity.

TWOHY, JULIUS "LAND ELK" Painter, oil, watercolor, art & life of the Indian. Born on the Ute Indian Reservation, Utah. Lived in Seattle, Washington, 1941. Mainly self taught. Member: Washington Artists Union. Exh: Seattle Art Museum; New York World's Fair, 1939. WPA artist.

TYLER, GERALD HALL (1897–) Painter, oil, watercolor, landscape and marine painter. Born in England. Lived in Vancouver, B.C., 1940.

Member: B.C. Society of Fine Arts. Exh: Vancouver Art Gallery; Montreal Art Association. Also specialized in the chemistry of painting and restoration work.

TYLER, MARIE Artist. Lived in Seattle, Washington, 1917.

TYLER, PHIL Painter. Oregon artist, active in Portland in the 1950's. Deceased.

TYTLER, STANLEY D. Painter. Member: Founding member B.C. Society Fine Arts, 1919. Lived in Vancouver, 1933

——U——

UERKVITZ, HERTA (1894–) Painter. Writer. Lived in Everett, Washington, 1921. Work: Seattle Fine Arts Association, 1921.

UGLAND, G. Sculptor, wood. Lived on Vashon Island, Washington, 1940.

UHL, KATE Painter. China decorator. Lived in Seattle, Washington, 1917.

UHTHOFF, INA D. D. CAMPBELL (1889–) Painter, oil, watercolor. Printmaker, etching, wood block. Drawing, dry brush. Teacher. Born in Scotland. Lived in Victoria, B.C., 1940. Pupil: Glasgow School of Art. Exh: Royal Glasgow Institute of Fine Arts, 1911–13; Canadian National Exhibition, Toronto, 1928. Principal, Victoria School of Art, 1926.

ULLMAN JULIUS (1866–1952) Painter, oil, watercolor, pastel, landscapes, murals. Born in Bavaria. Lived in Seattle, Washington. Study: Kunst Akademy, Germany. Member: Puget Sound Group Of Northwest Men Painters. Exh: Seattle Art Museum. Known for his painting, "El Dorado", of the Yukon gold rush.

ULLREN, WINOLA Artist. Lived in Seattle, Washington, 1918.

ULLRICH, BEATRICE (1907–) Painter. Lithographer. Photographer.

Active in California during the 1930's, by the 1950's she had returned to Chicago. Wife of artists J.D. Prendergast and Murray Zuckerman. Exh: Portland Art Museum, 1939.

ULMAN, ELINOR ELIZABETH (1909–) Painter, oil, watercolor. Born in and lived in Enumclaw, Washington. Pupil: Mills College, Oakland, California. Exh: Seattle Art Museum, 1934–36; Palace of the Legion of Honor, San Francisco, 1931–33; De Young Museum, 1933; Oakland Art Museum; College of Puget Sound, Tacoma, Washington; solo show, San Francisco Art Center, 1933, 1938.

ULMANN, JULIUS Painter. Northwest.

ULRICH, AMY G. (–1966) Painter, oil. Lived in Seattle, Washington. Member: Women Painters of Washington, 1946. Exh: Seattle Art Museum, 1945.

ULRICH, J. D. (MRS.) Painter. Lived in Spokane, Washington, 1950. Member: Washington Art Association, 1950.

UNDERWOOD, ELIZABETH H. Printmaker. Lived in Seattle, Washington, 1941. Exh: Northwest Printmakers, 1940.

UPDYKE, LEROY DAYTON (1876–1959) Painter, oil, landscapes, portraits, murals. Depression era native or primitive artist. Lived in Seattle, Washington. Traveled the fair circuit selling his art.

USAH, EDWARD Q. Painter, impressionistic landscapes. Active in Washington and Oregon, 1940.

USTINOW, PLATO V. (USTINOF) (1903–) Painter, oil, aquarell, black & white. Sculptor. Teacher. Born in Jerusalem, Palestine. Lived in Vancouver, B.C., 1940. Study: Royal Academy of Art, Stuttgart Germany; Paris. Member: B.C. Society of Fine Arts. Exh: Vancouver Art Gallery, 1933–39; Royal Canadian Academy, Toronto, 1938. Teacher, Vancouver, B.C. School of Art.

UTLEY, WINSOR (1920–1989) Painter, oil, watercolor. Musician. Teacher. Studio in Seattle, Washing-ton. Trained as a musician, he played with the Tacoma Symphony Orchestra, 1940's. He began painting with encouragement from artist, Mark Tobey. Head of Art Department, Cornish Art School, Seattle, 1953. Work: massive mural, "Tribute to Beethoven", Meany Hall, University of Washington. Member: Puget Sound Group of Northwest Men Painters, 1964. Exh: solo show, Seattle Art Museum, 1948, 1951, 1955; Henry Gallery, University of Washington, Seattle, 1950, 1951, 1959.

UTTERSTROM, JOHN Artist. Member: Puget Sound Group of Northwest Men Painters, 1941.

UZAFOVAGE, LOUISE A. (1862–1934) Painter, oil, portraits. Lived in Tacoma, Washington. Member: Tacoma Art League 1906. Exh: Western Washington Industrial Exposition, 1891, 1892.

— **V** —

VALLEE, WILLIAM OSCAR (1934–) Painter. Graphic Artist. Pupil: University of Alaska. Cofounder, Alaska-International Cultural Arts Center; Anchorage Commission Art Center. Member: American Artists Professional League.

VAN ARNAM, MARGARET NEWTON Painter, watercolor. Lived in Seattle, Washington, 1951. Exh: Seattle Art Museum, 1947.

VAN BERGEN, MINA GATENS Painter. Active in Oregon in the 1950's. Exh: Oregon Society of Artists.

VAN CISE, MONONA C. (1859–1933) Painter, oil, watercolor, pastel, landscapes. Born in Wisconsin. Painted the mountains of Wyoming and taught in Laramie from 1899–1911 when she and her husband moved to Idaho until his death in 1917. Died in California.

VAN COTT, SHERRILL Painter, oil. Sculptor, ditch clay. Lived in Sedro Woolley, Washington, 1941. Exh: Seattle Art Museum, 1935, 1939.

VAN DALEN, PIETER (1897–) Painter, oil. Commercial artist. Born in Amsterdam, Holland. Lived in Seattle, Washington, 1940. Study:

Paris; Brussells; mostly self-taught. Member: Puget Sound Group of Northwest Men Painters. Exh: Seattle Art Museum, 1936.

VANDERLOEFF, A. RUTGERS Painter. Lived in Spokane, Washington, 1926.

VANDERPANT, JOHN Painter. Pupil: Edinburgh College of Art with training in commercial design. Shared a studio with F. H. Varley, became one of the first two teachers of the new Vancouver, (B.C.) Art School of Decorative & Applied Arts in 1926. He quickly rediscovered his artist soul and evolved into a more abstract style. Left the school in 1933 to form with Varley, the B.C. College of Arts.

VAN DEWERKER, KATHLEEN Painter, oil. Lived in Spokane, Washington, 1950. Member: Washington Art Association. Exh: Seattle Art Museum, 1945; Henry Gallery, University of Washington, Seattle, 1951.

VANESS, MARGARET HELEN (1919–) Painter. Printmaker. Pupil: Francis Cellentano. Work: United States' Embassies in Athen, Bogata, Bierut; Cheney Cowles Museum, Spokane, Washington; Evergreen State College Library Collection, Olympia, Washington; plus many others. Exh: Washington State Capital, Olympia; Northwest Annual; Seattle Art Museum; Pacific Northwest Arts & Crafts Print invitational. Teacher of Printmaking, University of Washington.

VAN FREDENBURG, CAROLYN (1911–) Painter, oil, watercolor. Born in Coeur d'Alene, Idaho. Lived in Kellogg, Idaho, 1940. Member: Fireside Artists, Chicago. Exh: State House, Boise, Idaho, 1937; Civic Auditorium, Coeur d'Alene, Idaho, 1938.

VANN, ESSE BALL (1888–1955) Painter, oil, watercolor. Born in Indiana. Lived in Woodinville, Washington. Pupil: University of Southern California. Member: Women Painters of Washington; Laguna Beach Art Association; Women Painters of the West. Exh: solo show, Vancouver, B.C. Art Gallery; Seattle Art Museum.

NNINI, FREIDA (–1955) Painter, oil, watercolor. Lived in Yakima, Washington. Member: Women Painters of Washington, 1932–55. Exh: Seattle Art Museum.

VANSCOY, MYRTLE Painter, oil, pastel. Lived in Portland, Oregon, 1920's.

VAN RYDER, JACK (1898–) Painter, traditional western. Illustrator. Etcher. Writer. Born in Arizona. Pupil: Charles Russell. Travelled to Montana with a shipment of Mexican steers. He remained in the Northwest for years working as a cowboy and competing in rodeos.

VAN VEEN, PIETER, J.L. (1875–1961) Painter, oil, watercolor, plein-air Northwest landscapes, impressionist still lifes, genre. Drawing, pen & ink. Born in Holland. Lived for a time in Tacoma, Washington. Pupil: Royal Academy of the Arts, The Hague; In Paris with Henry Harpignies, Monet, Renoir, studied in Italy, France and Greece. Award: Knight of the Legion of Honor, France. Commissioned painting for the Queen of Belgium and by the Great Northern Railroad to paint the West. His first American exhibition was held in the state of Washington. His painting of Glacier National Park was exhibited in the National Gallery of Art, Smithsonian. Was associated for a time with the Old Lyme School of Impressionists including Chadwick, Crane, DeMond, Foot, Irvine and

Wiggins. Painted extensively in California, Montana, Washington. Mem: Salmagundi Club, New York. Died in Tacoma, Washington.

VAN ZANDT, ROSALIE Painter, children's subjects. Active in the early 20th century in Oregon. WPA artist.

VAN ZYLE, JON Painter, acrylic, Alaskan landscapes & wildlife. Award: Official Iditarod artist, 1979 (twice completed the Iditarod Trail Sled Dog Race); invited artist at Alaska's Artists in Washington, D.C., 1986, 1987.

VARLEY, FREDERICK HORSMAN (1881–) Painter, oil, watercolor. Muralist. Teacher. Born in Sheffield, England. Lived in Upper Lynn, British Columbia, 1940. Pupil: Royale des Beaux Arts, Antwerp. Member: Group of Seven (founder); Canadian Group of Painters (elected, 1933); associate of the Royal Canadian Academy (elected, 1919). Award: double medalist, L'Academy Royale des Beaux Arts, 1901–02. Exh: Canadian National Gallery, Ottawa; Vancouver Gallery. Appointed official war artist, 1914–18. Innovator of transcendental meditational painting.

VARNEY WALT (1908–) Painter, oil. Drawing. Sculptor. Born in Montana 1908. Lived in North Bend, Washington, 1940. Pupil: Donal Hord, San Diego. Exh: Seattle Art Museum.

VAUPELL, EDNA (1908–) Painter, oil, watercolor. Born in Kansas. Lived in Seattle, Washington, 1940. Pupil: University of Washington, Seattle; Edgar Forkner. Member: Women Painters of Washington. Exh: Seattle Art Museum, 1933–37; Grant Studios, New York; Oakland Art Museum, 1937–1938.

VENATTA, CARLOTTA BLAUROCK Painter, miniatures. Pupil: Whistler. Worked in Seattle at the turn of century.

VERLET, PAUL Painter, watercolor, landscapes. Known works in Portland, Oregon. Painting titled "Woodland Interior".

VERNER, FREDERICK ARTHUR (1836–1928) Painter who spent a lifetime depicting the Indians and buffalo of British Columbia in the 1870's. Founding member of the Ontario Society of Artists, Toronto 1872. Member: Royal British Artists, 1910. Made a number of sketching trips in the West devoting his life to western genre. He moved to England about 1890.

VERRAL, MINNIE OLIVE BELCHER (1873–) Painter, watercolor, flower paintings. Born in Michigan. Lived in North Vancouver, B.C., 1940. Pupil: Academy de la Grande Chaumiere, Paris. Member: British Columbia Society of Fine Arts. Exh: National Gallery of Canada, Ottawa, 1930–31; Seattle Art Museum, 1930.

VIANT, LATVINIA Artist. Sketcher. Lived in Tacoma, Washington, 1903.

VIKDAL, P. G. Painter. Photographer. Lived in Snohomish, Washington, 1927.

VILLENEUVE, NICHOLAS C. (1883–) Cartoonist, pen & ink. Born in Idaho. Lived in Boise, Idaho, 1940. Pupil: Chicago Art Institute. Work: Henry Huntington Library, San Marino, California. Cartoonist, *Idaho Daily Statesman*.

VILLIERS, FREDERICK (1852–1922) Artist-Correspondent. Born in England. Study: the British Museum; the Royal Academy, London; France. He covered 20 war campaigns up to World War I. In 1889 he accompanied Lord Stanley, the Canadian Governor

General, on a special train from Quebec to Vancouver, B.C. sketching all along the way. He repeated the trip in 1894 taking along a camera.

VINCENT, ANDREW MCDUFFIE (1898–) Painter, oil, watercolor. Born in Kansas. Lived in Eugene, Oregon, 1940. Pupil: Chicago Art Institute. Member: American Artists Professional League. Exh: Seattle Art Museum; Post Office in Salem, Oregon; Golden Gate International Exposition, San Francisco, 1939; Portland Art Museum; Palace of the Legion of Honor, San Francisco. Head of Art Department, University of Oregon, Eugene.

VINCENT, G. E. (MRS.) Painter, oil. Lived in Skagit County, Washington, 1909. Exh: Alaska-Yukon Pacific Expo, Seattle, 1909.

VINEYARD, HOWARD Painter. Elderly, lived in Vancouver, Washington, 1992.

VIRGIL, CARLOS Painter, watercolor. Commission artist. Lived in Spokane, Washington, 1988. Member: Annie Wright Seminary, Seattle.

VISSCHER, EMMA B. Painter, oil, china. Teacher. Lived in Tacoma, Washington, 1889.

VOGT, HELEN ELIZABETH (1910–) Painter, oil, watercolor, murals, flower paintings. Printmaker, linoleum block. Born in Seattle. Lived in Edmonds, Washington, 1940. Pupil: University of Washington, Seattle; Esse Ball Vann, Seattle.

VOIGHT, BOB (1920–) Painter. Moved to Oregon in 1937. Pupil: Willamette University, Salem, Oregon; C. Fowler; Carl Hall. Art instructor: Parrish Junior High School, Salem, Oregon. Exh: All-Oregon Show, Portland Art Museum.

VOISIN, ADRIEN ALEXANDER (1890–1979) Painter, watercolor.

Sculptor. Born in New York. Moved to San Francisco in 1932. Study: Yale School of Fine Arts; Colarossi Academy; Ecole des Beaux Arts; Ecole Nationale des Art; John La Farge. Award: Diplome d'Honneur, France, 1931. Exh: Bernheim-Jeune Galleries, Paris, 1930. Work: memorial head of Mr. B.F. Irvine, Oregon State College; Lewis & Clark Memorial, Portland, Oregon; memorial head of Governor Martin, State House, Salem, Oregon; architectural commission on the Hearst castle. He also lived among the Indians in Montana.

VOLLMER, GRACE LIBBY (1884–1977) Painter. Born in Massachusetts, the daughter of a successful Boston publisher. She moved with her parents to Clarkston, Idaho and in 1906 married Ralston Vollmer, a member of one of Idaho's wealthiest families. She moved to Southern California in the early 1920's and became a well-known California artist.

VOLSWINKLER, MAY BELLE (1900–) Painter, oil, watercolor. Born in Wisconsin. Lived in LaGrande, Oregon, 1940. Member: American Artists Professional League. Exh: Portland Art Museum, 1940.

VON GILSA, MAY Painter. Born in Chicago. Teacher: Spokane Art League School, 1900.

VON KEITH, JOHN H. Painter. landscapes. Studio home in Oakland, California, 1892, and in that year made a trip to Central Oregon to paint the Three Sisters, part of the Cascades mountain range. A resident of Los Angeles by 1884.

VON KITTLITZ, FRIEDRICH HEINRICH Painter on board the Russian vessel *Seniavin* in 1826, along the Alaskan and Pacific coast. His specialty was botanical, ornithological

and mineralogical lithographic depictions.

VON LUERZER, FEODOR (1851–) Painter, landscapes. Lived in Spokane, Washington at the turn of the century.

VON WEIGAND, CHARMION (1899–) Painter, modernist. Self-taught. Traveled in Europe and Mexico. Member: Abstract Artists. Work: Seattle Art Museum. American artist.

VOORHIES, CHARLES HOWARD (1901–1970) Painter, oil, watercolor. Teacher. Born in and lived in Portland, Oregon. Assistant to Diego Rivera. Exh: Santa Fe Museum, 1930; Portland Art Museum, 1936; Palace of the Legion of Honor, San Francisco; San Francisco Museum of Art; Chicago Art Institute, 1940. Teacher: Museum Art School, Portland, Oregon.

VOSEN, CHRISTINE Painter. Teacher. Lived in Spokane, Washington, 1950. Member: Washington Art Association, 1950.

VRADENBURG, LAURENCIA Artist. Lived in Seattle, Washington, 1917.

VROOMAN, RICHARD F. (1923–1976) Painter, watercolor. Commercial artist. Born and lived in Seattle, Washington. Also lived in San Francisco, California. Member: Bohemian Club, San Francisco; Puget Sound Group of Northwest Men Painters, 1946.

VROOMEN, JACK Artist. Member: Puget Sound Group of Northwest Men Painters, 1950.

VULLENT, G. E. (MRS.) Painter, oil. Lived in Skagit County, Washington, 1909. Exh: Alaska-Yukon Pacific Expo, Seattle, 1909.

—— W ——

WADDINGHAM, HELEN (1917–) Painter, watercolor. Sister of John Waddingham. Oregon artist.

WADDINGHAM, JOHN (1915–) Painter, watercolor. Printmaker. Illustrator. Born in London. Lived in India and Canada before coming to the United States. Lived in Portland, Oregon, 1992. Work: Portland Art Museum; Bush House, Salem, Oregon. Member: The Attic Studio, Portland, Oregon, 1929–67. Oregon Society of Artists; Oregon Watercolor Society; (Artist Member) Portland Art Museum; Past president, Portland Art Directors' Club. Exh: American Watercolor Society Travelling Exhibition; over 30 solo shows in the Northwest.

WADDINGHAM, STANLEY Painter, oil. Lived in Seattle, Washington, 1937. Exh: Seattle Art Museum, 1937.

WADE, DILLA M. (1883–1964) Painter, oil, landscapes. Drawing, charcoal. Lived in Seattle, Washington. Daughter of artist Sarah V. Wade. Member: Tacoma Art League, 1914–15. Exh: Tacoma Art League, 1914, 1915.

WADE, MURRAY (1876–) Painter, oil, Cartoonist. Born in and living in Salem, Oregon, 1940. Study: Mark Hopkins Art School, San Francisco. Pupil: William Keith. Cartoonist with *The Oregonian*, Portland;

The Post, San Francisco; *The Examiner*, San Francisco. Award: Oregon State Fairs, 1894, 1895, & 1900. Work: Oregon Historical Society.

WADE, ROBERT W. Artist. Studio in Spokane, Washington, 1928.

WADE, SARAH V. (1850–1937) Painter, watercolor, landscapes, china. Lived in Tacoma and Seattle, Washington. Her daughter was artist Dilla M. Wade. Member: Tacoma Art League, 1914–15.

WADSWORTH, WINIFRED W. Artist. Lived in Tacoma, Washington, 1906–10.

WAGNER, A. P. Painter, oil. Painted Coupeville Blockhouse in 1855 in oil. (Whidbey Island, Puget Sound).

WAGNER, ROBERT LEICESTER (1872–1942) Painter, portraits. Illustrator. Writer. California artist. Worked as an illustrator in New York. Studied in Paris. Taught at Manual Arts High School. As a writer he contributed to *Saturday Evening Post*, *Collier's*. After 1914 he worked as a writer for Paramount Studios. Exh: San Francisco Art Association, 1916. Award: silver medal, Alaska-Yukon Pacific Expo, Seattle, 1909.

WAHL, HAROLD (1898–) Painter, oil, abstracts, semi-abstracts. Cartoonist. Lived in Bellingham, Washington, 1903, 1953. Pupil: Chicago Academy of Fine Arts. Exh: Seattle Art Museum, 1953 & 1957; Governor's Art Show, 1966.

WAINRIGHT, ELIZABETH E. Painter. Lived in Tacoma, Washington, 1932. Exh: Tacoma Civic Art Association, 1932.

WAINWRIGHT, CHRISTINE A. Painter, oil, watercolor, pastel, landscapes. Lived in Seattle, Washington, 1921. Exh: Washington State Arts & Crafts, 1909.

WAKE, MARGARET Painter, British Columbian landscapes around 1910. Lived in Victoria on Vancouver Island. Member: Founding member, Vancouver, B.C. Fine Art Society, 1919.

WALBERG, LOUISE Painter, watercolor, landscapes. Lived in San Juan County, Washington, 1909. Exh: Alaska-Yukon Pacific Expo, Seattle, 1909.

WALDO, ANNA JANE (1846–1870) Painter.

WALES, ANNA H. Painter, oil, portraits. Lived in Whatcom County, Washington, 1909. Exh: Alaska-Yukon Pacific Expo, Seattle, 1909.

WALKER, E. A. Artist. Lived in Seattle, Washington, 1907.

WALKER, HERMAN Painter, gouache. Lived in Spokane, Washington, 1945. Exh: Seattle Art Museum 1945–47.

WALKER, J. A. Artist. Lived in Seattle, Washington, 1907.

WALKER, LESTER CARL JR. (1912–) Painter, oil, watercolor. Printmaker, block print. Teacher. Born in Idaho. Lived in Caldwell, Idaho, 1940. Study: Carnegie Scholarship, Harvard University. Exh: Boise Art Association, 1938. Professor of Art, College of Idaho, Caldwell.

WALKER, NANCY S. Artist. Lived in Seattle, Washington, 1916.

WALKER, ROSALIE F. (1905–1967) Painter, oil, watercolor, portraits, religious paintings. Teacher. Lived in Tacoma, Washington. She & her husband formed Pacific Gallery Artists, 1947. Member: Tacoma Art League. Exh: Tacoma Civic Art Association, 1932; Washington State Historical Society, 1945.

WALKINSHAW, JEANIE W. (1885–1976) Painter, oil, portraits. Draw-

ing, pen & ink, sanguine. Lived in Seattle, Washington. Studied: Rene Menard; Lucien Semon, Paris; Robert Henri, New York. Member: National League of American Pen Women; Northwest Academy of Arts (President). Exh: Corcoran Art Gallery, Washington, D.C.; Spring Salon, Paris; Seattle Art Museum 1931–58. Illustrated, *On the Puget Sound* in the 1930's.

WALKINSHAW, VALERIE B. (1921–) Painter, oil, portraits. Drawing, pencil, crayon. Born in and lived in Seattle, Washington. Pupil: Cornish Art School, Seattle. Exh: Seattle Art Museum, 1936; Western Washington Fair, 1938.

WALKUP, HAROLD (1942–) Painter, watercolor, landscapes, genre. Pupil: Texas Tech University, advertising art and design; Portland Community College; Zolton Szabo; Robert E. Wood. Member: Oregon Watercolor Society; The Oregon Critique Group; signature member, Northwest Watercolor Society. Exh: Watercolor Society of Oregon; Oregon Historical Society; many galleries in the Northwest.

WALL, ANDREW M. (MRS.) Artist. Lived in Tacoma, Washington, 1932.

WALL, BERNHARDT T. (1872–1953) Illustrator. Etcher. Historian. Craftsman. Work: Huntington Library, San Marino, California; The British Museum. Pupil: Art Students League, New York. He visited the West in 1915–16 completing the etchings issued later as 'Under Western Skies".

WALL, JOHN Commercial artist. Studio in Spokane, Washngton, 1950. Member: Washington Art Association, 1950.

WALLACE, DAVID Artist. Lived in Spokane, Washington, 1929. Exh: Seattle Fine Arts Association, 1927.

WALLIS, WILLIAM HENRY (1868–) Painter, oil, watercolor. Born in England. Lived in Vancouver, B.C., 1940. Studied in London. Work: many public buildings in Canada.

WALMSLEY, W. H. Artist. Lived in Hoquiam, Washington, 1910.

WALSH, JOHN PHILIP (1876–) Painter, oil, watercolor, landscapes. Founder of the South Dakota Society of Fine Arts. Exh: Independent Art League of America, New York, 1924; Seattle Fine Arts Society, 1925.

WALSH, M. FLORENCE Artist. lived in Seattle, Washington, 1909.

WALSH, PATRICIA RUTH Painter, oil, watercolor. Pupil: Art Students League, New York. Exh: Northwest Printmakers; Seattle Art Museum. Work: Oakland Museum; San Jose Civic Art Center; Palo Alto Cultural Center, California.

WALTERS, CARL (1883–1955) Painter. Pupil: Robert Henri. Work: Metropolitan Museum of Art; Whitney Museum, New York; Chicago Art Institute; Portland Art Museum.

WALTERS, EMILE (1920–) Painter. Pupil: Chicago Art Institute; Pennsylvania Academy of Fine Arts. Exh: Seattle Art Museum; many others. Many national awards.

WALTON, ROBERT Painter, oil, mountain landscapes. Born in Tacoma, Washington. Study: University of the Puget Sound, majoring in geology. A self-taught artist. Exh: many major galleries in the Northwest region and in regional shows.

WANDESFORDE, JAMES BUCKINGHAM, JR. (1911–) Painter, oil, (knife), watercolor. Born and lived in Seattle, Washington. Pupil: Univer-

sity of Washington, Seattle; Cornish Art School, Seattle; Art Center, Los Angeles. Member: Puget Sound Group of Northwest Men Painters. Exh: Seattle Art Museum, 1935, 1937, 1946; Frye Museum, Seattle, 1963.

WANDESFORDE, ROBERT, H. (1920–) Painter, acrylic, watercolor. Lived in Seattle, Washington, 1951. Member: Seattle Art Director's Society; Puget Sound Group of Northwest Men Painters; Professional Graphic Artists. Exh: Seattle Art Museum, 1947.

WANKER, MAUDE WALLING (1881–) Painter, oil, watercolor, pastel. Architectural painter. Teacher. Museum Director. Born in and lived in Portland, Oregon, 1940. Pupil: Chicago Art Institute; Museum Art School, Portland, Oregon. Member: Oregon Sociey of Artists; American Artists Professional League. Exh: Seattle Art Museum, 1937–38. Work: Oregon Historical Society.

WARASHINE, PATRICIA Ceramist, ceramic sculpture. Teacher. Pupil: University of Washington, Seattle. Work: Henry Gallery, University of Washington, Seattle; Smithsonian Institute, Washington, D.C.; Victoria & Albert Museum, London. Professor of Art, University of Washington.

WARD, J. STEPHEN (1876–) Painter, watercolor. Born in Wisconsin. Member: Oregon Society of Artists. Exh: Oregon State Fair, 1930.

WARD, JOHN QUINCY ADAMS (1830–1910) The "dean of American sculptors" in the West and Northwest about 1860. In 1857 he made his first study for "Indian Hunter" traveling to the West and Northwest, visiting the Indians for sketches and waxes. The final work was exhibited in Paris in 1867 and purchased for Central Park, New York City.

WARD, NORMA E. (1900–1978) Painter. Lived in Tacoma, Washington.

WARD, WINNIFRED Artist. Lived in Seattle, Washington, 1924–27. Member: Seattle Fine Arts Society, 1926.

WARDMAN, JOHN (1906–) Painter. Illustrator. Printmaker, block printer. Born in England. Resident of Los Angeles, 1934 and Mountain View, California, 1945. Exh: Portland Art Museum, 1935.

WARE, FLORENCE ELLEN (1891–1971) Painter, murals. Illustrator. Teacher, University of Utah. Member: Laguna Beach Art Association. Work: "Edge of the Pacific", Walla Walla, Washington; Whitman College.

WARE, M. B. (MRS.) Artist. Lived in Spokane, Washington, 1923.

WARHANIK, ELIZABETH (1880–1968) Painter, oil, watercolor. Printmaker, wood block. Lived in Seattle, Washington. Study: Wellsley College, with Charles Woodbury; University of Washington, with Edgar Forkner; H. Varley. Member: founder, Women Painters of Washington, 1931. Exh: Seattle Art Museum, solo show, 1930, 1938. Seattle Fine Arts Society; Northwest Printmakers, 1937; Grant Gallery, New York, 1937, 1938; Pennsylvania Academy of Fine Arts, 1933–35; Portland Art Museum, 1936, 1938.

WARNE, WALTER C. Artist. Lived in Seattle, Washington, 1920.

WARNER, E. J. (MRS.) Painter, oil. Lived in Sunnyside, Washington, 1926.

WARNER, HARRY M. Commercial artist. Cartographer. Lived in Bellevue, Washington, 1938.

WARNER, MAY M. (See MARSHALL)

WARNER, MILDRED Painter, watercolor. Active in Oregon in the 1950's. Pupil: Santa Barbara Art Museum, California; Fashion Academy, San Francisco, California. Exh: Lincoln County Art Center, Delake, Oregon; Riverside Museum, New York. Member: Northwest Watercolor Society; Oregon Society of Artists; American Artist Professional League (prize). Active from Alaska to Central America.

WARNER, OLIN LEVI (1844–1896) Sculptor. Designer. Executed many figures, fountains, statues, etc. Study: Ecole des Beaux-Arts, Paris. Upon his return he opened a studio in New York City. He was in the Northwest in 1889–91 doing bas relief portrait busts of Indians taken from life.

WARNER, PAULINE (1918–) Painter, oil. Sculptor. Born in and lived in Seattle, Washington. Pupil: University of Washington, Seattle. Member: Seattle Artists League. Exh: Seattle Art Museum, 1937, 1939.

WARNER SIDNEY, G. Artist. Teacher. Lived in Seattle, Washington, 1937. Professor of Art, University of Washington, Seattle, 1935

WARNOCK, SADA (1882–) Painter. Sculptor. Born near Halsey, Oregon. Lived in Oswego, Oregon, 1940. Pupil: University of Oregon, Portland. Member: Oregon Society of Artists. Award: Oregon Society of Artists, 1935, 1939, 1940. Exh: Meier & Frank, Portland; Portland Art Museum.

WARRE, HENRY J. (1819–1898) Sketcher, watercolor, pencil. Born in England. In 1845–46 the British Army ordered a military reconnaissance of the Oregon territory. Warre served in the expedition as a topographical artist, sketching around the Northwest. These were subsequently published as lithographs in his "Sketches in North America and Oregon Territories", London, 1848.

WARREN, BETTIE Painter, oil. Exh: Alaska-Yukon Pacific Expo, Seattle, 1909.

WARREN, HARVEY ALLEN (1916–) Painter, oil, watercolor. Born in Tacoma, Washington. Lived in Seattle, Washington, 1941. Pupil: University of Washington, Seattle. Exh: Seattle Art Museum, 1937.

WARREN, MARAJANE J. Painter, oil. Lived in Seattle, Washington, 1932–37. Exh: Seattle Art Museum, 1934.

WARREN, V. A. Commercial Artist. Lived in Spokane, Washington. 1929.

WARNER, PAULINE (1918–) Painter, oil, watercolor. Sculptor. Pupil: University of Washington, Seattle. Member: Seattle Artists League. Exh: Seattle Art Museum, 1939.

WARSHAWSKY, ABEL GEORGE (1883–1962) Painter, landscapes, portraits. Spent 30 years painting in France with much success being made a Knight of the Legion of Honor. Left France at the onset of World War II and settled in Monterey, California where he remained until his death. Work: Frye Museum, Seattle, Washington; among many others. His works appear frequently in the Northwest.

WARSINSKE, NORMAN GEORGE, FR. (1929–) Painter. Sculptor. Pupil: University of Montana; University of Washington. Commission: bronze fountains, King College, Medical Building, Seattle; many private and public commissions. Exh: Northwest Annual; Seattle Art Museum. Member: Northwest Craft Center, president.

WASHINGTON, JAMES W., JR. (1909–) Painter, watercolor. Print-

maker. Sculptor. Pupil: Mark Tobey. Exh: Seattle Art Museum, 1945; San Francisco Art Museum; Museum of Fine Arts, Boston. Changed from painting to sculpture in 1956. Work: Island Park School, Mercer Island, Seattle; Seattle Art Museum. Award: Oakland Art Museum, 1957, Seattle World's Fair, 1962.

WASLEY, G. H. Commercial artist. Lived in Chehalis, Washington, 1926.

WATER, DORY Painter, oil. Lived in Seattle, Washington, 1949. Exh: Seattle Art Museum, 1949.

WATERMAN, ABBIE Artist. Lived in Tacoma, Washington, 1897.

WATERS, V. S. Artist. Lived in Seattle, Washington, 1907.

WATKINS, CARLETON E. One of America's foremost 19th century photographers. He specialized in the West traveling from the Canadian border to Mexico, photographing the world as he saw it through the giant lense of his camera.

WATSON, H. W. Artist. Lived in Seattle, Washington, 1907.

WATSON, MAAVIE F. Painter, oil, watercolor. Lived in Tacoma, Washington, 1919–21. Member: Tacoma Art League, 1916. Exh: Western Washington Fair, 1906.

WATSON, DR. WILLIAM (– 1980) Painter, oil, landscape impressionist. Oregon artist. Many works found in Portland, Central Oregon, and Vancouver, Washington.

WATSON, WILLIS T. Painter, landscapes, barns. Active in Oregon in the early to mid 20th century. A friend of Clyde L. Keller.

WATT, ANDREW M. Commercial artist. Lived in Tacoma, Washington, 1930.

WATT, ROBIN Artist. Studio in Seattle, Washington, 1932.

WATTS, EVA A. (MOSSBERGER) (1862–) Painter. Born in Missouri. Settled in Boise, Idaho in 1900.

WAUD, ALFRED R. (1828–1891) Illustrator. Pupil: the Royal Academy, London. An important illustrator during the Civil War and the West for *Harper's Weekly* and *New York Illustrated News*, 1859–64. Illustrations by Waud of the "Northwest" were published in *Picturesque America* in 1872. He signed many of his works, A.R.W. Today in the Library of Congress there exists nearly 2,300 original Civil War Sketches of A. R. Waud and his brother, William, many of which were published in *Harper's Weekly*, 1861–65.

WAYNICK, LYNNE CARLYLE ("BLACK EAGLE") (1891–1967) Painter, oil, bas relief, Indians, Indian ceremonials of the Northwest and Southwest. Lived in Burton, Washington. Adopted member of the Swinomish Tribe. Owner: Blockhouse Indian Museum, Burton, Washington.

WEATHERBIE, VERA O. (1909–1977) Painter, oil. Born in Vancouver, B.C. Pupil: Vancouver, B.C. School of Art; Royal Academy, London; FH Varley. Exh: Seattle Art Museum, 1930; Vancouver Art Gallery.

WEATHERWAX BEN K. (1909–) Painter, oil, watercolor. Drawing, pen & ink. Wood carver. Born in and lived in Aberdeen, Washington, 1941. Pupil: University of Oregon, Eugene; Leon Derbyshire; Lance Hart; Robert Lahr. Exh: Women's Gallery, State College of Washington, Pullman, 1929.

WEATHERWAX, G. (MRS.) Painter, watercolor. Lived in Yakima County, Washington, 1909. Exh: Alaska-Yukon Pacific Expo, Seattle, 1909.

WEAVER, RENE (1897–1984) Painter, watercolor, landscapes. Com-

mercial artist. He worked for an advertising agency in Portland, Oregon in 1922 before settling in San Francisco. Member: Society of Western Artists; The Attic Sketch Group, Portland.

WEBB, HERBERT C. Painter. Lived in Seattle, Washington, 1924.

WEBB, VONNA OWINGS (1876–1964) Painter. Married Samuel Webb in 1905. Moved to Seaside, Oregon in 1910, where she was active in the arts and local organizations. Moved to Laguna Beach, California in 1929 and was still painting near the end of her life.

WEBBER, CATHARINE T. (1909–) Sculptor. Born in and lived in Seattle, Washington, 1941. Pupil: University of Washington, Seattle; School of the Museum of Fine Arts, Boston; Ecole des Beaux Arts, France. Member: Women Painters of Washington. Exh: Seattle Art Museum, 1936–39.

WEBBER, FLORENCE C. Painter, Teacher. Lived in Tacoma, Washington, 1898. Member: Annie Wright Seminary Art Club, 1889; Tacoma Art League, 1892. Exh: Western Washington Industrial Exposition, 1891.

WEBBER, GLORIA H. (1922–) Painter, oil, watercolor, florals. Lived in Portland, Oregon, 1992. Member: Oregon Watercolor Society, president.

WEBBER, JOHN R. A., ENG. (1751–1793) Official draughtsman to Captain Cook on his third voyage. After his return to England, Webber was employed by the Admiralty to make finished drawings from sketches made during the expedition.

WEBER, CARL F. Artist. Lived in Spokane, Washington, 1920.

WEBER-BROOKS, MRS. DAVID (1904–) Painter, pastel. Teacher.

Lived in Quincy, Washington, 1940. Pupil: Central Washington College of Education, Ellensburg. Member: Vanderlyn Art Study Club, Spokane, Washington.

WEBLING, ETHEL Painter, landscapes, miniatures. Lived in Spokane, Washington, 1907. Exh: Interstate Fair, 1906.

WEBSTER, ESTHER BARROWS (1902–) Painter, oil, watercolor, oil wash on paper. Printmaker, block print. Lived in Port Angeles, Washington, 1954. Pupil: University of Washington, Seattle; Museum Art School. Portland; Art Students League, New York; George Gross. Exh: solo show, Seattle Art Museum, 1939; Northwest Printmakers, 1938–40.

WEBSTER, M. G. (MRS.) Artist. Lived in Spokane, Washington, 1902.

WECHSLER, ARABELLA KELLY (1875–1970) Painter. Etcher. Designer, needlework. Moved to Seattle, Washington in 1893. Many of her paintings & etchings have been copyrighted.

WEED, R. M. (MRS.) Artist. Member: Tacoma Art League, 1891, 1892. Exh: Western Washington Industrial Exposition, 1891.

WEEKS, KAROLYN C. Painter, oil. Lived in South Bend, Washington, 1949. Exh: Seattle Art Museum, 1949; Henry Gallery, University of Washington, Seattle, 1951.

WEEKS, KENNETH ROBERT (1942–) Painter.

WEEKS, SHIRLEY M. Painter. Award: Puget Sound Show, Washington; West Coast Oil Show, Washington Collection; Charles & Emma Frye Museum, Washington.

WEGNER, H. D. Painter, oil, landscapes. Lived in Tacoma, Washington, 1916.

WEHN, JAMES A. (1882–) Sculptor. Teacher. Lived in Seattle, Washington, 1934. Designed Alaskan seals, busts, reliefs & many others. Exh: many public buildings in Washington & Alaska.

WEHR, WESLEY CONRAD (1929–) Painter, consultant. Pupil: University of Washington; Mark Tobey. Work: Smithsonian Institute, Washington, D.C.; Baltimore Museum; others.

WEIDLICH, RAYMOND J. (1910–) Painter, watercolor. Member: Puget Sound Group of Northwest Men Painters; Northwest Watercolor Society. Exh: Seattle Art Museum, 1947; Dayton Art Museum, Dayton, Ohio, 1947.

WEIGEL, GEORGE Painter, impressionistic landscapes. Active in Oregon in the mid 20th century.

WIELBORN, ELLEN Painter, expressionist painting of Amish women, circa 1950.

WEILER, LOUIS (1893–) Painter, oil, watercolor. Born in Germany. Lived in Quincy, Washington, 1940. Studied in Bavaria. Exh: Society of Independent Artists, New York, 1930; Wenatchee, Washington, 1928–33.

WEINER, ELSIE RUTH (DEUTSCH) (1920–) Painter, oil, watercolor, acrylic. Lived in Bellevue, Washington, 1982. Pupil: University of Washington, Seattle; Cornish Art School, Seattle; Sergie Bongart. Member: Women Painters of Washington; Northwest Watercolor Society. Exh: Frye Museum, Seattle; Seattle Art Museum, 1945.

WELCH, DANIEL P. Artist. Lived in Ballard, Washington, 1907.

WELCH, THADDEUS (1844–1919) Painter, landscapes. Printmaker. Arrived in Yamhill County, Oregon, 1847, to Portland in 1863. Study: Munich and Paris. Exh: the Salon, Paris, 1880. Member: Bohemian Club; San Francisco Art Association. Work: Oakland Museum; San Diego Museum; Frye Museum, Seattle. In his day, he was compared to Bierstadt, Hill and Keith. Was called "The First Oregon Artist to achieve more than local distinction". Moved to Santa Barbara in 1905 for his health and remained there until his death.

WELLING, ADDIE M. Artist. Employed by Seattle Engraving Co. 1916.

WELLS, LUCY D. (1881–) Painter, oil. watercolor. Printmaker, monotype. Teacher. Born in Chicago. Lived in Seattle, Washington, 1940. Pupil: Chicago Art Institute; Broadmoor Art Academy, Colorado Springs; Ernest Lawson; Randall Davey. Member: National Association of Women Painters & Sculptors. Exh: Seattle Art Museum, 1935–38; Newhouse Gallery; Spokane Art Museum; Dallas Art Museum.

WELLS, MARJORIE W. Painter, oil. Lived in Seattle, Washington, 1937. Exh: Seattle Art Museum, 1935.

WELLS, THOMAS W. (1916–) Painter, oil. Marine artist. Sailor. Lived in Seattle, Washington, 1975. Study: Yale University, BFA. Member: Puget Sound Group of Northwest Men Painters, 1947. Exh: Henry Gallery, University of Washington, Seattle, 1951; Seattle Art Museum, 1953. Although his specialty has been sailing, his work includes contemporary works, church altars and mosaics.

WENTWORTH, LESLIE Artist. Lived in Spokane, Washington. Pupil: Chicago Academy of Fine Arts, 1926.

WENTZ, HENRY FREDERICK (1876–) Painter, oil, watercolor, tempera. Teacher. Born in The Dalles, Oregon. Lived in Portland, Oregon,

1940. Pupil: Art Students League of New York; studied in Europe. Exh: Portland Art Museum; Panama-Pacific Expo, San Francisco, 1915; Seattle Art Museum; Lewis & Clark Expo, Portland, 1905. Head instructor, Museum Art School, Portland.

WERNER, AUGUST (1894–1980) Painter, oil. Sculptor. Musician. Born in Norway. Lived in Seattle, Washington. Professor of Music, University of Washington, 1932–65. Work: bust of Beethoven, University of Washington, Seattle; bronze statue of Leif Eriksson, Shilshole Bay Marina, Seattle.

WERNER, MARGARET KROHG (1907–) Painter, watercolor. Born in Wisconsin. Lived in Coupeville, Washington, 1982. Pupil: Chicago Art Institute; Jerry Stitt; Deanne Lemley. Exh: extensively in Washington.

WERRBACH, WILLIAM H. (1925–) Painter, watercolor, acrylic, barns (with sun in each painting). Commercial artist. Lived in Seattle, Washington, 1964. Pupil: Art Students League, New York. Member: Puget Sound Group of Northwest Men Painters, 1949; Seattle Art Director's Society. Exh: Seattle Art Museum; Frye Museum; Northwest Watercolor Society.

WESSELLS, HELEN HENRY (1905–) Painter, oil, pen & ink, genre. Lived in Seattle, Washington. Studied in New York City. Exh: Montclair Art Museum, New Jersey; National Academy of Design, New York City; Art Students League, New York.

WESSELS, GLENN ANTHONY (1895–1982) Painter, oil, watercolor, acrylic. Lived in Pullman, Washington, although primarily a California artist. Pupil: University of California; California College of Arts & Crafts; University of California, Berkeley, MA (art). Exh: San Francisco Museum of Art; Oakland Art Museum; Seattle Art Museum, 1944; Vancouver Museum of Art, B.C. Professor of Drawing, Painting & Art Philosophy, University of California, Berkeley. Art Critic, *San Francisco. Fortnightly*, 1931–33. WPA, 1935–39. Many awards.

WEST, BARBARA (1894–) Painter, oil, watercolor. Born in London, England. Lived in Vancouver, B.C., 1940. Pupil: Vancouver School of Art; Federal Art School, Los Angeles; Frederick H. Varley. Exh: B.C. Artists Exhibit, 1934–37.

WEST, EVANGELINE Artist. Lived in Chehalis, Washington, 1940. Exh: Tacoma Fine Arts Association, 1940.

WEST, R. ROLLESTON (1894–) Painter, watercolor, black & white. Born in London, England. Lived in Vancouver, B.C., 1940. Pupil: Bonn University, Germany; Vancouver School of Art; Federal Art School, Los Angeles; F. H. Varley. Exh: B.C. Artists Exhibit, 1931–38.

WESTON, WILLIAM PERCIVAL (1879–1967) Painter, oil. Drawing, pen & ink, pencil. Teacher. Lived in Vancouver, B.C., 1940. Member: Royal Canadian Academy; Canadian Group of Painters; Founding member, Vancouver, B.C. Society of Fine Arts, 1919. Fellow: Royal Society of Arts, London. Exh: National Gallery of Canada, Ottawa; New York World's Fair, 1939; Tate Gallery, London. Teacher: Normal School, Vancouver, B.C.

WESTPHAL, KATHERINE V. Painter, oil, tempera. Teacher. Lived in Seattle, Washington, 1951. Teacher: University of Washington, 1951. Exh: Seattle Art Museum, 1946; Henry Gallery, University of Washington, Seattle, 1950.

WETLZIER, OSCAR Artist. Lived in Seattle, Washington, 1926.

WETTLAND, S. Marine painter. One work reproduced in Marine History of the Pacific Coast published in 1895.

WETZEL, HILDA B. Artist. Studio in Seattle, Washington, 1926.

WEYAHOK, SIKVOAN Painter, oil. Sculptor. Lived in Seattle, Washington, 1941. Pupil: University of Washington, Seattle. Exh: Seattle Art Museum, 1938.

WHALE, ROBERT (1805–1887) Early Canadian landscape painter originally from England, 1850's, already a professional artist.

WHEELER, AL Painter. Member: The Attic Studio, Portland, Oregon, 1929–67.

WHEELER, ALTA M. Artist. Lived in Tacoma, Washington, 1923.

WHEELER, EDWINA (See WILLS)

WHEELER, LA VERNE F. Painter. Lived in Seattle, Washington, 1916. Exh: Washington State Commission of Fine Arts, 1914.

WHEELER, SALLY Painter. Member: The Attic Studio, Portland, Oregon, 1929–67. Met and married artist Al Wheeler while attending the workshop.

WHEELON, DR. HOMER (1888–) Painter, oil, heavy impasto. Born in San Jose, California. Lived in Seattle, Washington, 1941. Self taught. Member: Physicians Art Association, 1938, 1939; Seattle Fine Arts Society. Exh: Annual Exhibition of Northwest Artists.

WHETSEL, GERTRUDE P. (1886– 1952) Painter, landscapes, marines. Lived in Portland, Oregon, 1923–31. Pupil: Clyde Keller. Appears to have moved to Los Angeles in the early 30's and was active there until her death in Orange County California. Member:

Portland Art Association. Exh: Oregon State Fair, 1922, first and second prizes. Member: Association of Painters & Sculptors of Los Angeles, 1936.

WHIPPLE, GEORGIA MORGAN Artist. Lived in Tacoma, Washington, 1896. Member: Tacoma Art League, 1891, 1892.

WHITE, E. F. Artist. Lived in Spokane, Washington, 1903.

WHITE, GEORGE GORAS (1835– 1898) Painter. Illustrator. Wood Engraver. Important Civil War artist. Although his illustrations include many western subjects as well as Mount Hood, it appears his works were executed from materials he collected in his studio in New York City.

WHITE, GEORGE HARLOW (1817– 1888) Painter. Early interpreter of Western Canada landscapes and genre. Exh: Royal Academy in London from 1839–1883.

WHITE, JOHN C. Painter. Illustrator for the Collins Telegraph in Victoria, 1880's.

WHITE, KEN (1920–) Sculptor. Born in Portland, Oregon. Lived in Seattle in 1941. Pupil: Dudley Pratt; University of Washington, Seattle. Exh: Annual Exhibition of Northwest Artists, 1939; Henry Gallery, University of Washington, Seattle, 1939; Seattle Art Museum, 1939.

WHITE, LOLA A. Artist. Member: Tacoma Art League, 1916.

WHITE, RUTH G. (GOULD) (1909–) Painter, oil, watercolor. Teacher. Born in Nebraska. Lived in Hood River, Oregon, 1941. Teacher, Oregon Public schools. Member: Oregon Society of Artists. Many prizes in State and County fairs.

WHITESIDE, DOROTHY M. Painter, oil. Lived in Seattle, Washing-

ton, 1951. Exh: Seattle Art Museum, 1947.

WHITFORD, DOTTIE Artist. Lived in Seattle, Washington, 1901.

WHITMORE, FRED W. Painter. Lived in Tacoma, Washington, 1932. Exh: Tacoma Civic Art Association, 1932.

WHITNEY, J. A. Artist. Lived in Seattle, Washington, 1909.

WHITNEY, RALPH E. Artist. Drawing, charcoal. Lived in Tacoma, Washington, 1920. Exh: Tacoma Fine Arts Association, 1919.

WHITSON, HARRIETTE (1910–) Painter, oil, watercolor. Printmaker, woodcut. Fashion illustrator. Born in Wenatchee, Washington. Member: Women Painters of Washington. Exh: Cleveland Art Museum; Seattle Art Museum; Pacific Coast Painters; Grant Galleries, New York.

WHITTAKER, CHARLES Artist. Lived in Spokane, Washington, 1911.

WHITTEN, ANDREW T. (1878–) Painter, oil, watercolor. Lived in Dufur, Oregon, 1940. Pupil: Chicago Art Institute; National Academy of Art. Member: Oregon Society of Artists. Exh: Meier & Frank, Portland, 1937–39.

WHYMPER, FREDERICK (1838–) Painter, watercolor. Author. Member of the Russian American Telegraph Exploring Expedition, 1865. Published *Travel & Adventure in the Territory of Alaska* in 1869. He did sketches for gold mining companies during the Cariboo gold rush. Active in San Francisco until 1882. Work: Oakland Museum. Exh: "Views of Alaska", the Mechanics' Institute Fair, 1869.

WICKES, ETHEL MARIAN (1872–1940) Painter, murals. Born in New York. Moved with her family to North-

ern California, 1886. Began painting in her early teens. Studied in Paris. Exh: first show in New York City at age 18. In 1911 she was in Seattle to place murals in the Florence Henry Memorial Chapel and while there she exhibited her works of California, Holland and Ireland at the Washington Art Association.

WICKS, RENDEL Painter, portraits. Member: Puget Sound Group of Northwest Men Painters. Exh: Western Washington Fair, Puyallup, 1935.

WIDEL, EDITH MACFARLANE (1908–) Painter, oil. Printmaker. Craftsperson, metal work, pottery, weaving. Born in Anglin, Washington. Lived in Brewster, Washington, 1941. Pupil: Cooper School, Spokane; Chicago Art Institute; University of Washington, Seattle. Exh: Seattle Art Museum, 1934; Northwest Printmakers, 1938.

WIDFORSS, GUNNAR MAURITZ (1879–1934) Painter, western landscapes. Illustrator. Born in Sweden. Study: Institute of Technology, Stockholm, 1896–1900. Settled in California in 1921. He toured the West painting the mountains of Washington and Oregon, Crater Lake, and along the Monterey Coast. In 1922 he illustrated the book, *Songs of Yosemite*. He spent his last years in a studio on the rim of the Grand Canyon where his paintings were called the finest of their kind out of the West. Known as the "Painter of the National Parks".

WIESER, ALBERT J. Artist. Lived in Tacoma, Washington, 1916. Exh: Tacoma Art League, 1916.

WIESER, EFFIE E. Painter, flowers. Lived in Tacoma, Washington, 1916. Exh: Tacoma Art League, 1915, 1916.

WIGGINS, MYRA ALBERT Painter, oil. Photographer. Teacher. Born in

Salem, Oregon. Lived in Seattle, Washington, 1941. Pupil: Dudley Pratt; Frederick H. Varley; Art Students League of New York. Member: Women Painters of Washington; Pacific Coast Painters; American Federation of Arts; American Artists Professional League. Exh: Seattle Art Museum, 1934; Vancouver Art Gallery; Seattle Art Institute, 1931. Work: many public places in the Northwest.

WILBUR, JUNE CARLSON (1914–) Designer, costume, textile. Writer. Teacher. Lived in Seattle, Washington, 1940. Pupil: University of Washington, Seattle.

WILCOX, M. EVA (1907–) Painter, oil, watercolor. Drawing, pencil, charcoal. Lived in Hermiston, Oregon, 1940. Pupil: Oregon State College, Corvallis.

WILDER, ETHEL H. (See ERNESTI)

WILES, ALFRED A. Artist. Studio in Bremerton, Washington, 1946.

WILEY, NAN K. (1899–) Painter. Sculptor. Craftsperson. Teacher. Born in Cedar Rapids, Iowa. Lived in Cheney, Washington, 1941. Pupil: Chicago Academy of Fine Arts; University of Oregon, Eugene; studied in Paris. Exh: Seattle Art Museum, 1937. Teacher: Eastern Washington College of Education, Cheney.

WILEY, RICHARD (1919–) Painter, oil, watercolor, portraits, landscapes, still lifes. Illustrator, fashion. Commercial artist. Moved to Portland, Oregon, 1942. Currently living in Lake Oswego Oregon, 1992. Pupil: Syracuse University, College of Fine Arts, New York. Member: Advertising Art Association, Portland; The Attic Studio, Portland. Award: grand prize, National Portrait Seminar, New York City, 1980. Known for his portraits of Oregon's college presidents, judges, tribal chiefs and corporate executives.

WILEY, VIRGIL Painter. Lived in Lake Oswego, Oregon, 1992. Member: The Attic Studio, Portland, Oregon, 1929–67.

WILHELM, MARY R. painter, oil. Exh: Pacific Northwest Artists Annual Exhibition, Spokane, 1948.

WILKINS, ELIZABETH A. Artist. Lived in Seattle, Washington, 1901.

WILKINSON, JACK (1913–) Painter. Teacher. Pupil: University of Oregon, Eugene; studied in Paris. During the 1930's he was a resident of San Francisco and then taught at the University of Oregon at Eugene, 1941–47. Exh: Portland Art Museum, 1945. Member: San Francisco Art Association, 1937. Work: Burns, Oregon Post Office; San Francisco Museum of Art. WPA artist.

WILLARD, VIRGIL Painter, oil. Lived in Seattle, Washington, 1934. Exh: Seattle Art Museum, 1934.

WILLEMSE, BRYCE Painter. Craftsman, stained glass. Immigrated to the United States from Holland after WWII. Member: The Attic Studio, Portland Oregon. Began a stained glass fabricating plant in Scapoose, Oregon that is in operation today.

WILLEY, EDITH MARING (1891–) Painter, oil, watercolor. Printmaker, etching. Writer. Born in Seattle, Washington. Lived in Bremerton, Washington, 1962. Pupil: Eustace Ziegler; Peter Camfferman; C. C. Maring; A. C. Foresman; E. Forkner. Member: Women Painters of Washington; National League of American Pen Women. Exh: Northwest Gallery, Seattle, 1933; Seattle Art Museum, 1933–40's; Portland Art Museum, 1932–34; Grant Galleries, New York; Women Painters of Washington 1933–34.

WILLIAMS, LOUISE HOUSTON (1883–) Painter, oil, watercolor. Printmaker, block print, lithography. Teacher. Born in Kansas. Lived in Anacortes, Washington, 1941. Pupil: Kansas City Art Institute; Randall Davey; Edgar Forkner. Member: National Society of Arts and Sciences, New York. Exh: Seattle Art Museum; Boston Art Club; Women Painters of Washington, 1933–39.

WILLIAMS, MAMIE (See MCLEOD)

WILLIAMS, MARGARET Painter, landscapes. Designer. Teacher: Vancouver, B.C. School of Decorative Applied Arts.

WILLIAMS, MILTON FRANKLIN (1914–) Painter, oil. Designer. Sculptor, wood. Lived mostly in California, however lived in Seattle, Washington in the mid 1940's. Study: University of Washington. Exh: Seattle Art Museum, 1942; University of Washington, Seattle, 1943; Oakland Art Gallery. Billboard illustrator for Foster and Kleiser.

WILLIAMS, NICK (1877–) Painter, oil, watercolor, pastel. Drawing, pencil, crayon. Born in Odessa, Russia. Lived in Port Angeles, Washington, 1941. Exh: Association of Russian Artists, Odessa.

WILLIAMS, PHOEBE M. Painter, watercolor. Lived in Seattle, Washington, 1916. Exh: Washington State Arts & Crafts, 1909.

WILLIAMSON, MINNIE D. Painter, oil, landscapes, still lifes. Lived in Seattle, Washington, 1916. Exh: Washington State Arts & Crafts, 1909.

WILLIS, ELIZABETH BAYLEY (1902–) Painter, oil, pastel. Printmaker, linoleum and woodblock. Writer. Lived in Seattle, Washington, 1941. Pupil: Mills College, Oakland, California; Viola Patterson, Seattle.

Exh: Seattle Art Museum, 1938. Author: *Little Bay Creatures*, 1938.

WILLIS, ROSE M. (1885–) Painter, oil, watercolor. Born in Scotland. Lived in Victoria, B.C., 1941. Member: Island Arts and Crafts Society. Exh: solo show, Victoria, B.C., 1939.

WILLIS, W. L. Painter, landscapes. He was active in Northern California and Oregon around the turn of the century. Known works include scenes of Mt. Hood Oregon and Mt. Shasta California executed in a style similiar to Holdredge and Schaefer.

WILLISON, GERTRUDE D. (1873–) Painter, miniature portraits. Lived in Seattle, Washington, 1907. Study: Annie Wright Seminary, Tacoma, Washington; Harriett Foster Beecher; San Francisco; Chicago; New York. A descendent of Sam Houston, her father was one of the framers of the Washington State Constitution. Painted portraits of prominent Seattle people. Exh: Alaska-Yukon Pacific Expo, Seattle, 1909.

WILLOUGHBY, ADELINE (See MCCORMACK)

WILLOUGHBY, SARAH CHENEY (1841–1913) Painter, oil, watercolor, Indian utensils, weapons, clothing. Drawing, pencil, crayon. Teacher. Moved to Seattle in 1862 to teach art at the Territorial University of Washington, teaching music instead because of no students. Work: Smithsonian Institute, Washington, D.C.; University of Washington Library.

WILLS, EDWINA WHEELER (1915–) Painter, oil, watercolor. Sculptor. Born in Iowa. Lived in Waitsburg, Washington, 1941. Pupil: State College of Washington, Pullman; Grinnell College. Exh: Seattle Art Museum, 1938.

WILLSON, SUSAN B. Painter, oil, watercolor. Craftsperson. Lived in Seattle, Washington, 1941. Pupil: University of Washington; Edgar Forkner; Franz Bischoff. Member: Women Painters of Washington.

WILSON, FLORENCE H. (1879– 1973) Painter, oil. Etcher. Lived in Tacoma, Washington. Teacher: Tacoma Public Schools for many years.

WILSON, FLOYD (1887–) Painter. Lived in Portland, Oregon, 1915.

WILSON, HELEN HUGHES (1908–) Painter, oil, watercolor. Drawing, conte. Illustrator. Born in Boise. Lived in Nyssa, Oregon, 1941. Pupil: University of Idaho; Chicago Art Institute (scholarships, 1930, 1931). Illustrator for Caxton Press, Caldwell, Idaho.

WILSON, JOANNA S. BURNABY (1896–) Painter, oil, watercolor, B.C. coastal Indian scenes and flowers. Born in Scotland. Lived in Vancouver, B.C., 1941. Pupil: Edinburgh College of Art. Member: B.C. Artists Association. Exh: Vancouver Art Gallery.

WILSON, L. K. (MRS.) Artist. Lived in Spokane, Washington, 1903.

WILSON, MARY E. Artist. Lived in Tacoma, Washington, 1940. Exh: Tacoma Fine Art Association, 1940.

WILSON, MILTON (1923–) Painter, contemporary abstracts. Pupil: Portland Art Museum School. Exh: Gumps, San Francisco; Portland Art Museum.

WILSON, RUTH M. Artist. Lived in Spokane, Washington, 1934.

WILSON, THOMAS HARRINGTON Painter, portraits, genre. Engraver. Born in England. Sketches from an expedition to establish a new route to the boom town at the Cariboo diggings in British Columbia are reproduced in *The Northwest Passage by Land* written by Viscount Milton and Dr. W. B. Cheadle about 1864. Wilson did not accompany the expedition but rather worked from photographs and such he found in London. Exh: London, 1842– 1886.

WIMAN, VERN (legally Verna) (1912– 1977) Painter. Muralist. Cartoonist. Illustrator. Born in San Francisco California. She died there a spinster. Exh: Portland Oregon Art Museum.

WINDREM, ROBERT C. (1905– 1985) Painter, oil, acrylic, landscapes. Printmaker. Born in Madera, California. Moved to Washington, 1946. Study: University of California, Berkeley. He was active as an artist there until the mid 1960's. His last years were spent in Vancouver, Washington.

WINGARD, TILLIE Painter, oil. Lived in Tacoma, Washington, 1932. Exh: Tacoma Art Association, 1932.

WINKLEPLECK, ESSA Artist. Lived in Spokane, Washington, 1903.

WINQUIST, ERIK H. (1907–) Painter, oil, watercolor. Born in Sweden. Lived in Seattle, Washington, 1941. Studied in Stockholm. Member: Puget Sound Group of Northwest Men Painters. Exh: Seattle Art Museum, 1936–40.

WINSLOW, CLYDE (1894–) Commercial artist. Lived in Seattle, Washington, 1921, although he is a longtime California resident.

WINSLOW, E. LEO Artist. Lived in Spokane, Washington, 1940.

WINSOR, ANNE E. Artist. Lived in Seattle, Washington, 1901.

WINTEMUTE, ISABEL Artist. Pupil: F. H. Varley; Vancouver, B.C. Art School, 1930's.

WINTER, LLOYD Photographer, native Alaskan life. Exh: "Images from the Inside Passage, 1893–1910". 100 photos of Tlingit Indians.

WINTERBURN, PHYLLIS (1898–1984) Painter, watercolor. Printmaker. Born in San Francisco where she remained until her death. Member: Northwest Printmakers.

WIRE, BESS (MRS. MELVILLE T.) Painter, watercolor, pastel. Printmaker, block print. Born in Wisconsin. Lived in Ashland, Oregon, 1941. Pupil: Southern Oregon School of Education, Ashland. Member: Oregon Society of Artists; Amererican Artists Professional League, 1938.

WIRE, MELVILLE T. (REV.) (1877–1966) Painter, oil. Printmaker, etching. Born in Austin, Illinois. Lived in Ashland, Oregon, 1941. Pupil: Willamette University, Salem Oregon. Member: American Artists Professional League; Oregon Society Artists. Exh: Panama Pacific Expo, San Francisco, 1915; Meier & Frank, Portland, 1936–38. For 61 years he was a pastor of the Methodist church of Oregon and traveled the countryside of the Northwest preaching the word and painting. He died in Salem, Oregon. Work: Library of Congress; Oregon Historical Society; Cleveland Museum.

WISE, VERA Painter. Study: Willamette University, Salem, Oregon; Chicago Academy of Fine Art. Work: Idaho State College.

WISMER, FRANCES LEE (1906–) Painter, oil. Illustrator. Printmaker. Lived in Seattle, Washington, 1937. Pupil: A. Patterson; Walter Isaacs; H. Rhodes; University of Washington. Member: Northwest Printmakers. Exh: Seattle Art Museum, 1935.

WISSENBACH, REV. FREDERICK CHARLES (1887–) Painter, oil, watercolor, black & white. Born in Germany. Lived in Pendelton, Oregon, 1940. Study: Germany and Paris. Work: twelve Indian portraits, Vert Memorial, Pendleton, Oregon. Exh: Oregon Society of Artists, Portland, 1937–39. Art lecturer in the West.

WITHAM, VERNON CLINT (1925–) Painter. Collector. Pupil: University of Oregon; California School Fine Arts. Work: University of Oregon Museum of Art, Eugene; University of Wyoming Museum of Art. Exh: Portland Art Museum; California Palace of Legion of Honor.

WITHROW, EVELYN ALMOND (EVA) (1858–1928) Painter, oil, watercolor, pastel, genre, portraits, still lifes, depictions of the Southwestern and Southern California Indians. Born in California. Study: J. Frank Currier; Munich; Paris; College of the Pacific, San Francisco. Exh: Alaska-Yukon Pacific Expo, Seattle, 1909. Work: Louvre, Paris; Mills College, Oakland California

WITT, WILLIAM PRESTON (1912–) Painter. Sculptor. Born in Missouri. Lived in New York, 1941. Exh: Federal Art Project, Portland, Oregon, 1940.

WOESSNER, HENRIETTE ENGLISH (1905–) Painter, watercolor. Printmaker. Teacher. Studio in Seattle, Washington, 1982. Member: Women Painters of Washington; Northwest Watercolor Society; American Pen Women. Work: Seattle Art Museum; European collections. Established the Woessner Gallery, Seattle.

WOLF, HAMILTON ACHILLE (1883–1967) Painter. Illustrator. Pupil: National Academy of Design; Art Students League, New York; Academie Colarossi, Paris, 1909; Chase; Henri. Head of Art Department, University of Washington, Seattle 1916–18. Exh:

Seattle Art Society, 1917; Oakland Art Gallery, 1929, 1950. Work: Huntington Library, San Marino, California; Washington County Museum; University of Washington; Oakland Museum.

WOLF, RUDYARD C. Commercial artist. Lived in Seattle, Washington, 1926.

WOLFF, GUSTAVE (1863–) Painter. Pupil: Paul Cornoyer. Studied in Europe. Award: silver medal, Portland, Oregon, 1905.

WONSMOS, MINNIE Painter, oil, landscapes, coastal genre. Lived in Seaside, Oregon in the 1950's.

WONZOR, MAY LUCIAN Painter. Teacher. Lived in Tacoma, Washington, 1896.

WOOD, ALEXANDER M. (1849– 1925) Painter, landscapes. Born in Scotland. Worked in many regions of the Northwest, including B.C. Great friend of Admiral Cooper who often joined him on painting trips into the Northwest. Maintained a studio in San Francisco until his death.

WOOD, CHARLES ERSKINE SCOTT (1852–1944) Painter. Lived in Portland, Oregon. Very colorful Northwest character. Lifelong friend of Chief Joseph. Became the leading maritime lawyer on the Pacific Coast. His "View of Portland" painting was reproduced on the cover of *Pacific Monthly*. He fought in several Indian campaigns and explored the Yukon and Alaska. By 1884 he had moved to Portland where he practiced law until 1919. Moved to Saratoga, California in 1929. Wrote several books about Indians and liberal social causes.

WOOD, JOHN STEDMAN (1894– 1983) Painter, oil, watercolor, landscapes. Engraver. Co-owner, Tacoma Engraving Company. Commissioned to do a tourist brochure for the Highway Department.

WOOD, LEONA (1921–) Painter, oil, watercolor. Printmaker, wood engraving, woodcut. Craftsperson. Born and lived in Seattle, Washington, 1941. Pupil: scholarship, Rudolph Schaeffer School of Design, San Francisco. Member: West Seattle Art Club. Exh: Seattle Art Museum, 1938; Western Washington Fair, Puyallup, 1937. Work: mural, West Seattle High School.

WOOD, STED Painter. Lived in Tacoma, Washington, 1941. Member: Puget Sound Group of Northwest Men Painters.

WOODMAN, SELDEN JAMES (1834– 1923) Painter, portraits. Studied in Paris. Worked in Portland in 1905.

WOODRUFF, JULIA S. Painter, oil, watercolor, miniatures. Lived in Seattle, Washington, 1924. Pupil: B. Harrison. Exh: Society of Seattle Artists, 1908.

WOODS, EMILY Painter, Teacher. Turn of the century in Victoria, B.C. Her most famous student was Emily Carr.

WOODS, HARRY I. Artist. Lived in Seattle, Washington, 1929.

WOODVILLE, RICHARD CATON, JR. (1856–1937) Painter. Illustrator. Military artist. Born in England. He began his illustrating career in the West in 1884 arriving there in 1890 assigned to depict American and Canadian outdoor life. He painted "North American Indians Running Cattle", then along with Remington, covered the 1890–91 Sioux Indian War. Exh: massive historical paintings at the Royal Academy.

WOODWARD, GLADYS CLOVELLY (1885–) Painter, watercolor, landscapes. Born in England. Lived in Victoria, 1941. Exh: Vancouver Art Gallery; Island Arts and Crafts Society, Victoria.

WORMAN, EUGENIA A. Painter, oil, landscapes. Lived in Seattle, Washington, 1942. Exh: Seattle Fine Arts Association, 1922–24. Art Professor, University of Washington, 1922–24.

WORONIECKI, HELEN Painter, oil. Lived in Seattle, Washington, 1940. Exh: Seattle Art Museum, 1940.

WRIGHT, ANNA E. Artist. Lived in Spokane, Washington, 1909.

WRIGHT, ANNIE BARKELEY (See ROGERS)

WRIGHT, CHARLES CLIFFORD Painter, tempera. Lived in Seattle, Washington, 1944. Exh: Seattle Art Museum, 1945.

WRIGHT, CORA BERNICE (1868– 1948) Painter, china, still lifes, landscapes, easel painting. Teacher. Born in Martinez, California. Study: Manuel Valencia. Settled in Eureka, California (close to the Oregon border.) Accompanied Charles Wilson on many painting expeditions into the Northwest country.

WRIGHT, G. ALAN (1927–) Sculptor. Work: Johnson Wax Collection; Seattle Art Museum; Denver Art Museum; Seattle Science Pavillion; many public commissions.

WRIGHT, JENNIE E. Painter, landscapes. Lived in Portland, Oregon, 1904.

WURSTER, WILLIAM Painter, watercolor. Advertising artist. Lived in Seattle, Washington, 1951. Member: Puget Sound Group of Northwest Men Painters. Exh: Seattle Art Museum, 1947.

WYCKOFF, JANE BROWN (1905– 1990) Painter, oil. Born in Michigan. Lived in Seattle, Washington, 1941. Pupil: University of Washington; Art Students League of New York. Exh: Seattle Art Museum, 1934–46. Work appeared in *Vogue* Magazine.

— **X** —

XAVIER, K. Painter, watercolor, tempera. Lived in Seattle, Washington, 1946. Exh: Seattle Art Museum, 1946.

— **Y** —

YAMAGISHI, TEIZO Painter, watercolor. Born in Japan. Lived in Seattle, Washington, 1941. Pupil: Tokyo Fine Arts College. Member: The Koyukai. Exh: Seattle Art Museum, 1937, 1938.

YANCEY, CLEO L. Painter. Lived in Seattle, Washington, 1927.

YANCEY, D. A. Painter, watercolor. Exh: Washington State Arts and Crafts, 1909.

YARROW, IRENE Artist. Lived in Seattle, Washington, 1917.

YELLAND, RAYMOND DABB (1848–1900) Painter, landscapes, coastal scenery. Teacher. Primarily a California artist. Pupil: National Academy of Design, New York; studied in Paris. Teacher: the California School of Design, 1877–97. Through the years he traveled to the Northwest painting the mountains and scenery, i.e., Mount Hood, 1883.

YING, MAY CHIN Painter. Lived in Washington, 1948. Member: Puget Sound Group of Northwest Men Painters, 1948.

YOUNG, ANNA E. Painter, oil, landscapes. Exh: Washington State Arts and Crafts, 1909; Washington State Commission of Fine Arts, 1914.

YOUNG, EDITH (–1978) Painter. Lived in Seattle, Washington. Member: Women Painters of Washington, 1948.

YOUNG, EVA J. Painter, oil, watercolor, pastel. Drawing, pencils. Teacher. Born in Iowa. Lived in Wenatchee, Washington, 1941. Teacher, Wenatchee Public Schools for 25 years.

YOUNG, HALLIE R. Artist. Lived in Seattle, Washington, 1926.

YOUNG, HARVEY OTIS (1840–1901) Painter, mountain landscapes. In 1859 he sailed to California to prospect for gold and sketch the mountains of Nevada and Oregon. During the Civil War he was stationed at Walla Walla with Bret Harte, the writer. He maintained a studio in San Francisco from 1866–1869 returning to New York City, marrying and returning west again in 1879.

YOUNG, JOHN J. (1830–1879) Painter. Engraver. Staff artist for the War Department. In 1855 Young was draftsman for the Lt. Williamson railway survey to connect California's Sacramento Valley with Oregon's Columbia River. He painted 14 mountain scenes of the Cascade Range and the Oregon Territory. He stayed with the War Department until his death, painting the Western routes.

YOUNG, JULIA E. Artist. Lived in Spokane, Washington, 1913.

YOUNG, JULIET (1878–) Painter, oil, watercolor. Vancouver, B.C. artist. Study: New York and Europe. Member: British Watercolor Society. Exh: Vancouver Art Gallery, 1935.

YOUNG, LEWIS Artist. Lived in Tacoma, Washington, 1894.

YOUNG, P. M. Painter, watercolor. Lived in Vancouver, B.C., 1940. Member: Island Arts and Crafts Society; Victoria, B.C. Victoria Sketch Club. Exh: Vancouver Art Gallery.

YOUNG, PAT B. (1908–) Painter, watercolor, landscapes. Ceramicist. Ballet teacher. Born in Tacoma, Washington. Lived in Lake Oswego, Oregon, 1984. Pupil: Robert Wood; George Post; Rex Brandt. Exh: Washington State Historical Society, 1968. Signed her name: PA/NG

YOUNGS, MAUDE B. Painter, watercolor. Lived in Seattle, Washington, 1964. Member: Women Painters of Washington, 1932. Exh: Seattle Art Museum, 1934–1938.

YPHANTIS, GEORGE (1899–) Painter. Printmaker. Illustrator. Teacher. American artist. Born in Turkey, he moved and worked all over the country. Work: Seattle Art Museum.

YUNCKER, LILLIAN (1882–1980) Painter, watercolor, landscapes, florals, China painter. Lived and died in the historical home of her father, J. F. Yuncker in Tacoma, Washington. Pupil: Visitation Academy, Tacoma.

Member: Tacoma Fine Arts Association; Tacoma Art League. Exh: Alaska-Yukon Pacific Expo, Seattle, 1909; Washington State Historical Society, 1945.

—Z—

ZACH, JAN (1914) Painter. Sculptor. Study: Czechoslavakia. Work: Czech Pavillion, New York World's Fair, 1938. Exh: Victoria Art Gallery, B.C.; Museum of Art, University of Oregon, Eugene; Portland Art Museum. Teacher: Banff BC; University of Oregon, Eugene. Exh: internationally.

ZAHN, FRED Artist. Lived in Spokane, Washington, 1903.

ZAHRLY, EDWARD Artist. Lived in Spokane, Washington, 1903.

ZALLINGER, FRANZ X. (1894–1962) Painter, oil, watercolor. Muralist. Decorator. Born in Austria. Lived in Seattle, Washington, 1941. Study: School of Fine Art, Bavaria. Member: Puget Sound Group of Northwest Men Painters. Exh: Seattle Art Museum.

ZALLINGER, RUDOLPH FRANZ (1919–) Painter, oil, watercolor. Born in Siberia. Immigrated to Seattle, Washington in 1923. Pupil: his father, Franz X. Zallinger; Eustace Ziegler; Cornish Art School, Seattle; Yale University. Member: Puget Sound Group of Northwest Men Painters. Exh: Seattle Art Museum; Grand Central Palace, New York.

ZANE, NOWLAND BRITTIN (1885–) Painter, oil, watercolor, pastel. Muralist. Teacher. Writer. Born in Pennsylvania. Lived in Eugene, Oregon, 1941. Pupil: Chicago Art Institute; Pennsylvania Academy of Art. Exh: Portland Art Museum; Grand Central Palace, New York, 1940. Associate Professor of Fine Arts, University of Oregon, Eugene.

ZAROSINSKI, DARLENE MERLE SKINNER (1932–) Painter, watercolor, wet-on-wet. Lived in Klamath Falls, Oregon, 1992. Study: Lewis and Clark College, Portland, Oregon; Stephen Quiller; Richard L. Nelson; Judi Betts; Al Brouiletts; Merlin Enobnit; Maxine Masterfield. Member: Watercolor Society of Oregon; Klamath Art Association. Exh: solo show, Oregon Technical Institute.

ZELL, CALDONA Painter, watercolor. Exh: Pacific Northwest Artists Annual Exhibit Spokane, 1948.

ZIEGLER, EUSTACE PAUL (1881–1969) Painter, oil, watercolor, landscapes. Printmaker, dry point, wood engraving. Teacher. One of the Alaska Four. Born in Detroit, Michigan. Lived in Seattle, Washington. Pupil: Detroit School of Fine Arts; Yale University. Member: Puget Sound Group of Northwest Men Painters; Northwest Academy of Arts; Annual Exhibition of Northwest Artists. Exh: Seattle Art Museum; Palace of the Legion of Honor, San Francisco; Anderson Galleries, New York; Frye Museum, Seattle, 1969; Detroit Museum of Art. Immigrated to Seattle in 1909 on his way to Alaska where he spent 12 years as an Episcopal priest. In 1922 he left the ministry to devote his full time to art, settling permanently in

Seattle. He spent his summers in Alaska and became well-known for his landscapes. A prolific artist and inspired teacher. At the time of his death he left an estimated 3,000 oils & watercolors as well as drawings, etchings, etc.

ZILLIG, FRITZ (1885–1950) Painter, watercolor, abstract. Caricaturist. Born in Germany. Primarily a California artist. Member: Puget Sound Group of Northwest Men Painters, 1947. Exh: Seattle Art Museum, 1945.

ZIMMERMAN, FREDERICK AL-MOND (1886–1974) Painter. Born in Ohio. Work: John Muir Public School, Seattle, Washington. Primarily a California artist.

ZIMMERMAN, L. C. (MRS.) Artist. Lived in Seattle, Washington, 1912.

ZINSLEY, ANN CATHERINE (1886–1959) Painter, genre scenes. Lithographer. Born in Germany. Lived in Portland, Oregon. Exh: Annual Oregon Print Expo, 1952. Member: Portland Art Museum.

ZINSTRY, A. L. Little is known of this artist except for some works executed in the Portland area in the 1880's.

ZOGBAUM, RUFUS F. (1849–1925) Painter, military and naval artist. Illustrator. Writer. Pupil: Art Students League, New York; Leon J. D. Bonnat, Paris. As a result of his many Western trips made for the Army there are a number of important Western paintings. He is also noted for his western illustrations for *Harper's Weekly*. Between 1885 and 1889, 15 illustrations appear depicting a journey to the Pacific Northwest accompanied by articles. He painted the cowboy at play and visually told the story of the untamed western portion of the United States.

ZUMSTEG, BESSIE Artist. Lived in Spokane, Washington, 1913.

ZUMSTEG, VERA COLLINGS (1906–) Painter, watercolor. Born in Washington. Lived in Vancouver, B.C. Pupil: University of Oregon, Eugene, 1929.

APPENDIX
Directory of Northwest
Art Museums, Associations and Schools

Alaska Artists Guild, Box 101888-99510, Anchorage, (907) 274-5460

Alaska Four (The)—private group: Sidney Laurence, Eustace Ziegler, Theodore Lambert, Jules Dahlager

Alaska State Council on the Arts, 411 W. Fourth Ave., Ste. 1-E, Anchorage, Alaska 99501, (907) 279-1558, Robert Miller, chmn.

Alaska State Museum, 395 Whittier St., Juneau 99801, (907) 465-2901, Bruce Kato, director.

Alaska University Museum, 907 Yukon Dr., Anchorage 99775, James E. Dixon, director.

Allied Artists of Seattle, 107 S. Main St., Seattle, Washington 98104, (206) 624-0432, Richard Mann, director.

Allied Arts Council of Yakima Valley, Morehouse Gallery, 5000 W. Lincoln Ave., Yakima, Washington 98908, (509) 966-0930, Anne Finch Byerrum, exec. director.

Alturas Arts Council, Box 1113, Hailey, Idaho, Martha Burke, director.

American Artists Professional League, Oregon Chapter, no information available.

American Artists Professional League, Washington Chapter, no information available.

American Falls Arts Council, Box 547, American Falls, Idaho 83211-0547, Erma Crompton.

Anchorage Historical and Fine Arts Museum, 121 W. Seventh Ave., Anchorage, Alaska 99501, Dave Nichols, curator.

Annie Wright Seminary, Tacoma, Washington (now known as the Kemper Center).

Art Gallery of Greater Victoria, 1040 Moss St., V8V 4P1, Victoria, B.C., Patricia Bovey, director, (604) 384-4101.

Art Institute of Seattle, Washington, founded in 1928. Reorganized and renamed by Dr. Richard Fuller (founder of the Seattle Art Museum) in 1931.

Artisans Association, Box 1659, McCall, Idaho 83638, Edna Lunt.

Artists Council of Washington, no longer active.

Artists Equity Association, 430 S. 124th St., Seattle, Washington 98168.

Artists Trust, 1402 3rd Ave., Ste. 415, Seattle, Washington 98101, (206) 467-8734, Marshel Paul, exec. director.

Arts Alliance, 367 4th St., Courtenay, B.C., B9N 1G8, (604) 338-6211, Adele Bailey.

231

Arts in Orofino, U.S. Forest Service, 12370 Highway 12, Orofino, Idaho 83544, Ginger Barker.

Ashton Arts Council, Box 657, Ashton, Idaho 83420, Darrell Reinke.

Asian Art Society, Box 5685, Station B.C., V8R 6S4, Victoria, B.C., (604) 598-2897, Hilda Hale.

The Attic Sketch Club (1926–1967), Portland, Oregon, Clyde Archibald, Director, 14430 NW Perimeter Dr., Beaverton, Oregon 97006. Founding members, 1926 (no longer active): Leslie Beaton, Harold Detji, H. H. (Hal) Grundy, Jack Jelacie (original organizer), Paul Keller, Wm. Pierce, Taylor Poore, Errol Proctor, Ernest Richardson, Jeffrey Tester, Rene Weaver.

Bear Lake Arts Council, Box 57, Fish Haven, Idaho 83261-0057, Mary Evelyn Izatt.

Bellevue Art Museum, 301 Bellevue Sq., Seattle, Washington 98031, (206) 454-3322, Diane Douglas, director. Founded in 1977.

Bellevue Arts Commission, 11511 Main St., Bellevue, Washington 98009.

Boise (Idaho) Art Association, Founding agency of the Boise Art Museum. Association formed in 1932, moved to Museum building, 1936.

Boise Art Museum, 670 S. Julia Davis Dr., Boise, Idaho 83702, (208) 345-8330, Dennis O'Leary, director.

Boise City Arts Commission, Box 500, Boise, Idaho 83702.

Boise State University Library, 1910 University Dr., Boise, Idaho 83725.

Bonner County Art Association, 430 S. Division, Sandpoint, Idaho 83864, Susan Zoller.

Brush & Palette Club, Tacoma, Washington, no information available.

Buhl Arts Council, Rt. 4, Box 292-C, Buhl, Idaho 83316, Gayle Barigar.

Burney School of Fine Art, Seattle, Washington, no longer active.

Carnegie Art Center, 109 S. Palouse St., Walla Walla, Washington 99362, Christine Bishop, director.

Center of Contemporary Art, 1309 First Ave., Seattle, Washington, Larry Reid, director.

Central Idaho Art Association, 620 Northwest 2nd St., Grangeville, Idaho 83530, Blanche Rockwell.

Chas. H. Scott Gallery (See, Emily Carr School of Art), Victoria, B.C., Greg Bellerby, director, (604) 687-2345.

Cheney Cowles Museum, 2316 W. First Ave., Spokane, Washington 90204, (509) 456-3931, Glen Mason, director.

Children's Free Creative Art School, Seattle, Washington, no information available.

Citizen's Council for the Arts, Box 901, Coeur d'Alene, Idaho 83814-0901, Sue Flammia, president.

City Arts Center, 41 3rd. St., South, Nampa, Idaho 83651, Olivia Vincent.

Clearwater Art Association, Box 1482, Orofino, Idaho 83544.

Clymer Museum, Box 1102, Ellensburg, Washington 98926.

Coeur d'Alene Art Association, Box 77, Coeur d'Alene, Idaho 83814.

Community Arts Council of Victoria, B.C., 511 620 View St., V8W 1J6, (604) 381-2787, Pat George.

Coos Art Museum, 235 Anderson Ave., Coos Bay, Oregon 97420, (503) 267-3901, Wineva Johnson, president of the board.

Coquille Valley Art Association, HC 83, Box 625, Coquille, Oregon 97423, (503) 396-3294, Anna Crosby, president.

Cornish School of Allied Arts, 710 E. Ray St., Seattle, Washington 98102, (206) 323-1400, Greg Skinner, director.

Council Cultural Arts, Box 86, Council, Idaho 83612, Patty Hasselstrom.

The Dalles Art Association, Oregon Trail Art Gallery, The Dalles Art Center, 220 E. 4th St. & Washington St., The Dalles, Oregon 97058, (503) 296-4759, Patty Lewis, director.

Emerald Empire Art Gallery, 421 N. A St., Springfield, Oregon 97477, (503) 726-8595, Phyliss K. Coffin, president.

Emily Carr College of Art and Design, 1399 Johnston St., V6H 3RD Vancouver, B.C., Canada, (604) 687-2345, Alan Barkley, president.

Esquimalt Arts & Crafts Society, 869 Cunningham Rd., Victoria, B.C. V9A 4M7, (604) 382-0974, Betty Borroughs.

Everett Drama League, Washington, no information available.

Favell Museum of Art, 125 W. Main St., Klamath Falls, Oregon 97601, (503) 882-9996, Gene H. Favell, president.

Federation of Canadian Artists, Victoria Chapter, 3745 Don Caster Dr., Victoria, B.C., V8P 3W8, (604) 721-4809.

Ferry Museum, Tacoma, Washington, no information available.

Firth Arts Council, Box 422, Firth, Idaho 83236, Laraine Shafer.

Frye Museum of Art, 704 Terry St., Seattle, Washington 98114, I. K. Greathouse, director.

Gordon Gilkey Print Center, Portland Art Museum, 1219 Park Ave., Portland, Oregon 97205, (503) 226-2811, Ext. 234, Gordon Gilkey, director.

Grangeville Arts Inc., 121 E. South First St., Grangeville, Idaho 83530, Sonya Turner.

Grapha Techna Mens Art Honorary, University of Washington, Seattle

Group of Twelve, Seattle, Washington (private membership, no longer active): Kenneth Callahan, Margaret Gove Camfferman, Peter M. Camfferman, Elizabeth Cooper, Earl T. Fields, Takuichi Fujii, Morris Graves, Walter F. Isaacs, Kenjiro Nomura, Ambrose Patterson, Viola Patterson, Kamekichi Tokita.

Henry Art Gallery, University of Washington, 15th Ave. NE & NE 41st St., Seattle, Washington 98195, Richard Andrews, director.

Herrett Museum, College of Southern Idaho, Twin Falls, Idaho 83303.

High Desert Museum, 59800 Hwy 97, Bend, Oregon 97702, (503) 382-4754, Donald M. Kerr, president.

Horner Museum, Oregon State University, 26th St., Gill Coliseum, Corvallis, Oregon 97331, (503) 737-2951, Lucy Skjelstad, director.

Idaho Art Association, 3001½ Barton Rd., Pocatello, Idaho 83204, Denice Girade, president.

Idaho City Arts Council, Box 219, Idaho City, Idaho 83631, Beeth A. Hilbert.

Idaho Commission on the Arts, 304 W. State St., Boise, Idaho 83720, (208) 334-2119, Margo Knight, director.

Idaho Falls Art Guild, Box 2542, Idaho Falls, Idaho 83403.

Idaho Falls Cultural Council, 545 Shoup St., Idaho Falls, Idaho 83402, Kay Ingram.

Idaho State University, Mind's Eye Gallery & John B. Davis Gallery, Box 8046, Pocatello, Idaho 83209-804, Art Wright, director.

Idaho Watercolor Society, 3589 Rugby Dr., Boise, Idaho 83704, Charles M. Fisher.

Island Illustrators, 620 View St., Ste. 504, Victoria, B.C. V8W 1J6, (694) 380-6562, Ron Stacy.

Juan de Fuca Arts & Crafts Guild, Box 7135, Dept. D, V9B 422 Victoria, B.C., (604) 478-6768, Genevieve Smith.

Junction City Arts Council, Box 786, Shoshone, Idaho 83352, Jeni Zech.

Kamiah Arts & Crafts Assoc., Rt. 2, Box 120-B, Kamiah, Idaho 83536, Janet Cruz.

Klamath Falls Art Association, Klamath Art Gallery, 120 Riverside Dr., Klamath Falls, Oregon 97601, (503) 883-1833, Mary Hyde Martin, president.

Lambda Rho, Women's Art Honorary, University of Washington, Seattle.

Lewis & Clark State College Artists, 8th Ave. & 6th Ave., Lewiston, Idaho 83501, Sharon Hatch.

Lincoln County Art Center, Delake, Oregon.

M. Carrie Mclean Museum, 200 E. Front St., Nome, Alaska 99762, (907) 443-2566, Darlene Orr, director.

McCall Arts Council, Box 250, McCall, Idaho 83638, Roberta Hamell.

Magic Valley Arts Council, Box 1158, Twin Falls, Idaho 83303.

Magic Valley Arts Guild, Rt. 1, Box 106A, Hansen, Idaho 83334.

Maryhill Museum of Art, 35 Maryhill Museum Dr., Goldendale, Washington 98620, Linda Brady Mountain, director.

Maude Kerns Art Center, Henry Horn Gallery, 1910 E. 15th Ave., Eugene, Oregon 97403, (503) 345-1571, Greg Wilbor, director.

Merlino Art Center, 508 6th Ave., Tacoma, Washington 98402.

Metchosin International Summer School of the Arts, 3505 Richmond Rd., Victoria, B.C. V8P 4P7, (604) 598-1695, Elizabeth Travis.

Metropolitan Arts Commission, Metropolitan Center for Public Arts, 1120 SW 5th St., Rm. 1023, Portland, Oregon 97204, W. Bulick, director.

Milano Arts & Crafts, 1900 Mayfair Dr., Ste. 226, Victoria, B.C. V8P 1P9, (604) 598-7417, Silvana Pavat & Raymond Mahy.

Moscow Arts Commission, Box 9203, Moscow, Idaho 83843-9203.

Nampa Art Guild, 324 4th St., South Nampa, Idaho 83651, Teresa Wagers.

Nez Perce Crossing Museum, 202 Main St., Joseph, Oregon 97846, David & Lee Manuel.

North Central Washington Museum, 127 S. Mission St., Wenatchee, Washington 98801, (509) 664-5989, Keith Williams, director.

North Idaho College, Union Gallery, Coeur d'Alene, Idaho 83814.

Northwest Arts & Crafts Network, 1611 Mushroom Lane, Poulsbo, Washington 98370, (206) 779-7936.

Northwest Figurative Artists Alliance, 1205 E. Olive St., #A, Seattle, Washington.

Northwest Pastel Society, 1420 Gilmore Blvd., Box 2732, Issaquah, Washington 98027-7001.

Northwest Print Council, 800 NW 6th Ave., Union Station 209, Portland, Oregon 97209, (503) 223-0280, founded in 1981, Stephanie Schlicting, director. Lyle Matoush, Gordon Gilkey, founding members.

Northwest Watercolor Society, 2703 Boyer Ave. E., Seattle, Washington 98102, (206) 324-8196.

Oakley Valley Arts Council, Box 176, Oakley, Idaho 83346, Kent Severe.

Olympia Arts Commission, 222 N. Columbia St., Olympia, Washington 98501, (206) 753-8380, Linda Oestreich, director.

Olympia Arts League, Washington (206) 352-9159, Eileen Johnson.

Oregon Art Institute, 1219 SW Park Ave., Portland, Oregon 97205, (503) 226-2811, Don L. Monroe, president.

Oregon Art Project, (WPA), Portland, formed in the late 1920s, no longer active.

Oregon Arts Commission, 3810 Watkins Lane, Eugene, Oregon 97405, (503) 344-3890, Carolyn Meeker, chairman.

Oregon School of Arts & Crafts, Hoffman Gallery, 8245 SW Barnes Rd., Portland, Oregon 97225, (503) 297-5544, John Lottes, president.

Oregon State Fair, Salem, Oregon (annual art exhibitions).

Oregon State Historical Society, 1230 SW Park Ave., Portland, Oregon 97205, (503) 222-1741, Garry Breckon, museum director.

Pacific Gallery Artists, 8617 Zircon Dr., #I-1, SW, Tacoma, Washington 98449, Kelly Johnson.

Pacific Northwest Arts & Crafts Association, Bellevue Art Museum, 301 Bellevue Sq., Bellevue, Washington 98004, (206) 454-3322, LaMar Harrington, director and curator.

Payette Arts Council, 10480 N. Iowa, Payette, Idaho, Susan Lowman-Thomas.

Pend Oreille Arts Council, Box 1694, Sandpoint, Idaho 83864, Ginny Robideaux.

Penninsula Art League, Box 1422, Gig Harbor, Washington 98335, Shirley Ewer.

Pocatello Cultural Arts Commission, Box 4169, Pocatello, Idaho 83201.

Portland Art Association, founded in 1892, moved to the new museum building in 1905 and became part of the Portland Art Museum, Oregon (see Portland Art Museum).

Portland Art Club, organized in 1885, Oregon, no longer active.

Portland Art Museum, 1219 SW Park St., Portland, Oregon 97205, (503) 226-2811, Gerald Boles, director.

Portland Art Museum School of Art, 1219 SW Park St., Portland, Oregon 97205, (503) 226-2811, began in 1909.

Portland State University, Littman Gallery, 725 SW Harrison St., Portland, Oregon 97201, (503) 725-4452, Patrick Teague, director.

Preston Arts Council, Box 472, Preston, Idaho 83263.

Puget Sound Art League, 16661 Northup Way, Bellevue, Washington 98008, (206) 641-7919, Ned Mueller, founder.

Puget Sound Group of Northwest Artists (formerly known as the Puget Sound Group of Northwest Men Painters). Formed in 1928, 1100 Olive Way, Ste. 1150, Seattle, Washington 98101.

Reed College, Douglas F. Cooley Memorial Art Gallery, 3203 SE Woodstock Blvd., Portland, Oregon 97202, (503) 771-1112, Jan Cavanaugh, curator.

Regional Artists of Southwest Washington, no information available.

Rogue Valley Art Association, Rogue Gallery, 40 S. Bartlett St., Medford, Oregon 97501, (503) 772-8118, Pat Blair, president.

Rosenthal Gallery, Albertson College of Idaho, Caldwell, Idaho 83605.

Saanich Penninsula Arts & Crafts, Box 2542, Sidney, B.C., (Vancouver Island) V8L 4B9, (604) 656-5403, Betty Fulton.

St. Maries Arts Council, 1117 Main St., River City Mall, St. Maries, Idaho 83861.

Salem Art Association, 600 Mission St., Salem, Oregon 97202, (503) 581-2228, Cynthia Green, director.

Salem Art Center, Bush Park, Salem, Oregon.

Salmon Arts Council, 200 Main St., Salmon, Idaho 83467.

Salmon River Art Guild, Box 5, Riggins, Idaho 83549.

School of Painting & Design, University of Washington, Seattle, established in 1918 by Ambrose Patterson.

Seattle Art Institute, Washington, founded in 1928, also known as Art Institute of Seattle (see listing as such).

Seattle Art Museum, Box 22000, Seattle, Washington 98122-9700, (206) 625-8900. Founded in 1931 by Dr. Richard Fuller; Jay Gates, director.

Seattle Arts Commission, 312 1st Ave., Seattle, Washington 98109, (206) 684-7171, Wendy Ceccherelli, director.

Seattle Arts League, Washington, no information available.

Seattle Fine Arts Society, established in 1906, moved to the Seattle Art Museum in 1933 where they continued to hold exhibitions, seminars, etc.

Seattle Historical Society, 2700 24th Ave., Seattle, Washington 98112, (206) 324-1126.

Seattle Museum of History & Industry, Seattle, Washington.

Snake River Fine Artists, Washington, no information available.

Society of Seattle Artists, Washington, no information available.

Soda Springs Arts Council, 150 E. 4th St., Soda Springs, Idaho, Michelle Thomsen, director.

Southeast Idaho Art Guild, 496 Adams St., Montpelier, Idaho 83256, Lois Jacobson.

Southern Oregon State College, Stevenson Union Gallery, 1250 Siskiyou Blvd., Ashland, Oregon 97520, (503) 482-6465, Phil Campbell, director.

Spokane Art Club, Washington, no information available.

Spokane Arts Commissions, 808 W. Spokane Falls Blvd., Spokane, Washington 99201, Sue Ellen Heflin, director.

Spokane Society of Washington Artists, no information available.

State Capitol Museum, 211 W. 21st. Ave., Olympia, Washington 98501, (206) 753-2580, Derek R. Valley, director.

Studio Museum, Western Washington College of Education, Bellingham, Washington.

Sun Valley Center on the Arts & Humanities, Box 656, Sun Valley, Idaho 83353, Julie Gorton.

Tacoma Art League, now known as the Tacoma Art Museum, 1102 Tacoma Ave., Tacoma, Washington 98402.

Tacoma Art Museum, 1102 Tacoma Ave., Tacoma, Washington 98402, (206) 272-4258, David Domkoski, gallery director.

Tacoma Arts & Crafts Association, 10101 Laurelcrest St., S.W., Tacoma, Washington 98498, Katherine Chappell, director.

Tacoma Arts Commission, 747 Market St., Rm. 900, Tacoma, Washington 98402, (206) 591-5191, Linda Martin, director.

Tacoma Civic Arts Association, Tacoma, Washington, no longer active.

Tacoma Fine Art Association, Washington, no information available. Is perhaps functioning under a new name.

Tacoma Public Library, Northwest Reference Room, 1102 Tacoma Ave. S., Tacoma, Washington 98402, (206) 591-5666, (206) 591-5622 (NW Ref. Rm).

Thornton, Nancy M. School of Art, established in 1847 in Oregon City, Oregon. Ms. Thornton is listed as Oregon's first woman artist.

Universal Art Association, Seattle, Washington, 1924, no longer active.

University Galleries, Boise State University, Boise, Idaho 83725.

University of British Columbia, Fine Arts Department, 6333 Memorial Rd., V6T 1W5, (604) 228-2757, James O. Caswell, department head.

University of Oregon Museum of Art, 1430 Johnson Lane, Eugene, Oregon 97403, (503) 346-3027, Stephen C. McGough, director.

University of Oregon School of Architecture and Allied Arts, Portland, Oregon. Formed in 1913.

University of Portland, Wilson M. Clark Memorial Library, 5000 N. Willamette Blvd., Portland, Oregon 97203, Joseph P. Browne, director.

University of the Puget Sound, Kittredge Gallery, 15th & Lawrence Sts., Tacoma, Washington, (206) 756-3348, Greg Bell, director.

Valley Art Center, 842 6th St., Clarkston, Washington 99403, (509) 588-8331, Pat Rosenberger, director.

Vancouver, B.C. (British Columbia) Art Gallery Museum, 750 Hornby St., Vancouver, B.C. V6Z 2H7, (604) 682-4668, Ian Thom, curator.

Vancouver, B.C. Artists Association, from 1932 to 1967, no longer active.

Vancouver, B.C. (British Columbia) Society of Fine Art. Original membership formed in 1909. Now part of the Vancouver, B.C. Art Museum: James W. Keagey, pres.; J. P. Fitz-Maurice, vp; Chas. Fergeson; W. Ferris; H. J. De-Forest; Statira Frame; T. W. Fripp, 1909 pres.; Mary Riter Hamilton; H. Hood; Grace Judge; Edith H. Killam; John Kyle; Margaret Longden; J. MacIntosh-Gow; C. Marega; Bernard McEvoy; C. H. Scott; Mabel Seal; G. Thorton Sharp; Kate A. Smith; Mary I. Stoddard; Stanley Tytler; Margaret Wake; W. P. Weston.

Visual Arts Center, 713 W. 5th Ave., Anchorage, Alaska 99510, (907) 274-9641.

Washington Art Project (WPA), Seattle, formed in the late 1930s.

Washington Artists Union, no information available.

Washington State Arts Commission, 110 9th St. & Columbia Blvd., Olympia, Washington 98504-4111, (206) 753-3860, Michael Bernazzani, chairman.

Washington State Historical Society, 315 N. Stadium Way, Tacoma, Washington 98403, (206) 593-2830, David Nicandre, director.

Washington State University, Museum of Art, Pullman, Washington 99164-2460, (509) 335-1910, Patricia Watkinson, Director.

Wendell Arts Council, 3356 S. 1800 East, Wendell, Idaho 83355, Linda Hillis.

West Coast Visual Art Group, 2789 Sooke River Rd., RR #3, Victoria, B.C. V0S 1N0, (604) 642-3909.

West Seattle Art Club, Washington, no information available.

Western Idaho State Fair, Boise, Idaho, (208) 376-3247, Evelyn Blake, Art Exhibits.

Western Oregon State College, Campbell Hall Gallery, 345 Monmouth Ave., Monmouth, Oregon 97361, (503) 838-8340, Don Hoskisson, Head of Art Department.

Western Washington College of Education, Studio Museum, Bellingham, Washington.

Western Washington State Fair, Puyallup, annual exhibitions.

Whatcom Museum of History & Art, 121 Prospect St., Bellingham, Washington 98225, George Thomas, director.

Willamette University, George Putman Library Center, 900 State St., Salem, Oregon 97301, (503) 370-6267, Robert Hess, director. Provided the region's first college level art program in 1866.

Women Painters of Washington, formed in 1930, Box 1666, Olympia, Washington 98507.

Wood River Advisory Council, Box 1679, Ketchum, Idaho 83340.

SELECTED BIBLIOGRAPHY

Books

Antonson, Joan M., and Wm. S. Hanable, *Alaska's Heritage*. Anchorage: Alaska Historical Commission Studies, 1986.

Appleton, Marion B., (editor), *Who's Who in Northwest Art*. Seattle, Wash.: Frank McCaffrey, 1942.

Barchus, Agnes, *Eliza R. Barchus, the Oregon Artist*. Portland, Ore.: Binford & Mort, 1974.

Besset, Maurice, *Art of the Twentieth Century*. New York: Universe Press, 1976.

Broder, Patricia Janis, *Great Paintings of the American West*. New York: Abbeville Press.

Broekhoff, Helen V., *Thadeus Welch, Pioneer and Painter*. Oakland, Calif.: Oakland Art Museum, 1966.

Cattell, Jaques, *Who's Who in American Art*. New York: Jaques Cattell Press, 1980.

Collins, James L., and Glenn B. Opitz, editors, *Women Artists in America, 1790–1980*. Poughkeepsie, N.Y.: Apollo Books, 1980.

Cummings, Paul, *A Dictionary of Contemporary American Artists*. New York: St. Martin's, 1966.

Curry, Larry, *The American West Painters from Catlin to Russell*. New York: Viking Press, 1972.

Davenport, R.J., *Davenport's Art Reference & Price Guide*, 1990–91 edition. Poughkeepsie, N.Y.: Apollo Books, 1990.

Dawdy, D.O., *Artists of the American West: A Biographical Dictionary*, 1 and 2. Chicago: The Swallow Press, 1981.

Falk, Peter H. (editor), *Who Was Who in American Art*, compiled from the *American Art Annual* (34 vols. 1898–1947). Madison, Conn.: Sound View Press, 1985.

Fielding, Mantle, *Dictionary of American Painters, Sculptors & Engravers*, rev. ed. Bridgeport, Conn.: Modern Books, 1975 (reprint of 1926 ed.). Poughkeepsie, N.Y.: Apollo Books.

Getlein, Frank, and Country Beautiful Co., *The Lure of the Great West*. Waukesha, Wis.: Country Beautiful, 1973.

Goetzmann, William H., *Looking at the Land of Promise: Pioneer Images of the Pacific Northwest*. Pullman, Wash.: Washington State University Press, 1988.

Groce, George C., and David Wallace, *New York Historical Society's Dictionary of Artists in America, 1564–1860*. New Haven, Conn.: Yale University Press, 1969.

Guggenheim, Peggy, *Art of This Century*. Salem, N.H.: Ayer Co. Publishing, 1968.

Harper, J. Russell, *Early Painters and Engravers in Canada.* Toronto: University of Toronto Press, 1970.

Havlice, Patricia Pate, *Index to Artistic Biography.* Metuchen, N.J.: The Scarecrow Press, 1973.

Heller, Nancy, and Julia Williams, *Painters of the American Scene.* New York: Galahad Books, 1982.

Howell, John, *California in the Fifties.* John Howell Books, 1936.

Hughes, Edan Milton, *Artists in California, 1786–1940,* 2nd ed. San Francisco: Hughes Publishing, 1989.

Hulley, Clarence C., *Alaska Past and Present.* Westport, Conn.: Greenwood Press, 1970.

The Idaho Encyclopedia. Compiled as a project of the WPA. Caldwell, Idaho: Caxton Printers, 1938.

Iverarity, Robert B., *Art of the Northwest Coast Indians.* Berkeley, Calif.: University of California Press, 1967.

Jacobs, Johanna, *Alaskan Voyage, 1881–1883, An Expedition to the Northwest Coast of America.* Chicago: University of Chicago Press, 1983.

Kingsbury, Martha, *Art of the Thirties, The Pacific Northwest.* Seattle, Wash.: University of Washington Press, 1974.

Kovinich, Phil, *The Woman Artist in the American West, 1860–1960.* Fullerton, Calif.: Muchenthaler Cultural Center, 1976.

McClelland, Gordon T., and Jay Lang, *The California Style, California Watercolor Artists, 1925–1955.* Beverly Hills, Calif.: Hillcrest Press, 1985.

McCracken, Harold, *Great Painters and Illustrators of the Old West.* New York: Dover, 1988.

MacDonald, Colen S., *A Dictionary of Canadian Artists.* Poughkeepsie, N.Y.: Apollo, 1968.

Neuhas, Eugen, *The Art of the Exposition, San Francisco.* Paul Elder & Co., 1915.

Petteys, Chris, *Dictionary of Women Artists: An International Dictionary of Women Artists Born Before 1900.* Boston: G.K. Hall & Co., 1987.

Rassmussen, Louise, *Art & Artists of Oregon, 1500–1900.* Author's notebook, 1940, Archives of the Oregon State Library, Portland.

The Regional Painters of the Puget Sound—Half Century of Fidelity and Nature. Toronto: Oxford University Press, 1960.

Ross, Marvin C., *George Catlin, Episodes from Life Among the Indians.* Norman, Okla.: University of Oklahoma Press, 1959.

Salisbury, Albert, and Jane Salisbury, *Two Captains West, an Historical Tour of the Lewis & Clark Trail.* New York: Bramhall House, 1950.

Samuels, Harold, and Peggy Samuels, *Samuels Encyclopedia of Artists of the American West.* Memphis, Tenn.: Castle Books, 1985.

Schmidt, Anthony C., *American Art Annual Biographical Directory of Painters & Sculptors.* Collingwood, New Jersey. Reprint of *American Art Annual,* 1933.

Schmidt, Anthony C., *Biographical Sketches of American Artists.* Collingwood, New Jersey.

Shadbolt, Doris, *Art of Emily Carr.* Seattle, Wash.: University of Washington Press, 1988.

Stenzel, Franz, *Cleveland Rockwell, Scientist and Artist, Portland Oregon.* Portland, Ore.: Oregon Historical Society, 1972.

Taft, Robert, *Artists & Illustrators of the Old West, 1850–1900.* New York: Scribner's, 1953.

Trip and Cook, *Washington State Art & Artists, 1850-1950.* Olympia, Wash.: Self published, 1992.
Trowbridge, Daniel (editor), *Mallett's Index of Artists.* Two volumes. New York: R.R. Bowker Co., 1948.
Tyler, Ron, *American Canvas: The Art, Eye & Spirit of Pioneer Artists.* New York: Portland House, 1990.
_____; Carol Clark; Linda Ayres; Warden J. Cadbury; Herman J. Viola; and Bernard Reilly, Jr., *American Frontier Life: Early Western Paintings & Prints.* New York: Abbeville Press, 1987.
Warre, Henry, *Sketches in North America and the Oregon Territory.* Barre, Mass.: Imprint Society, 1970.
Who's Who in the West. Chicago: Marquis & Co., 1949.
Who's Who on the Pacific Coast. Chicago: Marquis & Co., 1949.
Young, William, *Dictionary of American Artists, Sculptors and Engravers.* Cambridge, Mass.: William Young and Co., 1968.

Magazine Articles

"In the Northwest." *The Art Digest,* April 1937.
Queener, Janice, "The Alaska Four." *Western Art Digest,* Jan.-Feb. 1987.

Catalogs

"Alfred Jacob Miller, Artist on the Oregon Trail." Catalog raisonné. K. Reynolds & Wm. R. Johnston, Amon Carter Museum, 1982, Ft. Worth, Texas.
"American Painters of the Arctic," Mead Art Gallery, Amherst College and Coe Kerr Gallery, exhibition catalog, New York, 1975.
"An Anthology of Canadian Art," Oxford University Press, 1960, Toronto.
Anchorage Museum Exhibition Roster, Solo Shows.
"An Art Perspective of the Historic Pacific Northwest," from the Collection of Dr. F.R. Stenzel, Portland, Oregon, Exhibition: St. Helena, Montana Historical Society, 1963.
"Artists of the Explorations Overland, 1840-60," Oregon Historical Quarterly, 1942.
"Artists of the Northwest," Mountain Productions, Albuquerque, New Mexico, 1989.
"A Concise History of Canadian Painting," University of Toronto Press, 1973.
"A Dictionary of Canadian Artists," Vol. 4, Ottawa.
"Early Days in the Northwest," Portland Art Museum Catalog.
"Eugene Fuller Memorial Collection," Catalog, Seattle Art Museum.
"Female Artists Past & Present," California Women's Historical Research Center, 1974.
"Important Canadian Painting," Sothebys Auction Catalog, 1969, New York.
"Northwest History in Art, 1778-1963," Pacific Northwest Historical Society, Washington State Historical Society, 1963.
"Northwest History in Art," 1916, Tacoma Fine Art Association Catalog, Tacoma, Washington.
"100 Years of Idaho Art, 1850-1950," Boise Art Museum, 1990, Centennial Exhibition Catalog.
Oregon Historical Society Pamphlet, 1990, Portland, Oregon.

Oregon's Art Heritage, Oregon Historical Society Museum Exhibition, Portland, Oregon, 1990.

"300 Years of Canadian Art," National Gallery of Canada Exhibition, Ottawa, catalog by R.H. Hubbard and J.R. Ostiquy, 1967.

"Vancouver Art and Artists, 1931–83," Vancouver (B.C.) Art Gallery exhibition.

INDEX

The terms "painter," "oil," and "watercolor" appear so often throughout the book, they are not indexed, although other terms describing artists and media are.